FASHION
EVOLUTION

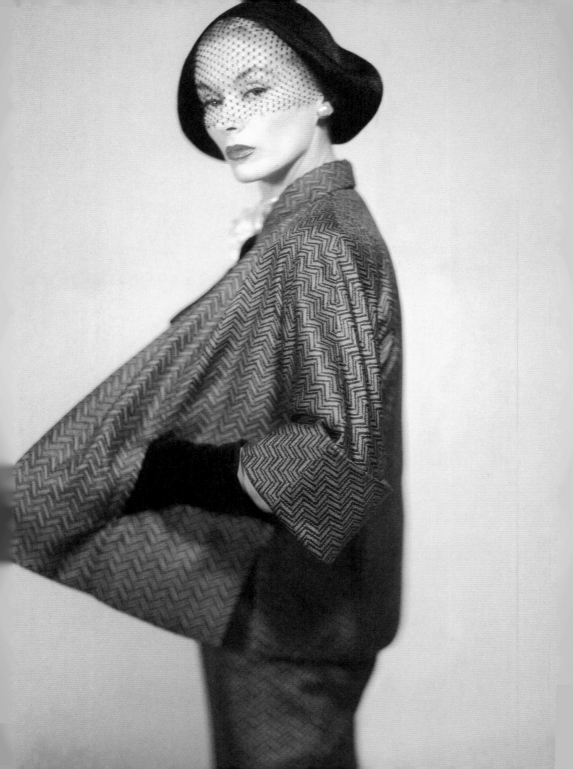

the
**DESIGN
MUSEUM**

FASHION
EVOLUTION

THE 250 LOOKS
THAT SHAPED
MODERN FASHION

PAULA REED

 conran
OCTOPUS

CONTENTS

1950s

1960s

1970s

1980s

1990s

INTRODUCTION

Entire careers are dedicated to chronicling the whims of fashion. Up close, its haphazard eddies and waves seem to reflect nothing more than superficial vagaries of taste: here today, irrelevant tomorrow. It's only hindsight that transforms the most ephemeral catwalk trivia into an illuminating reflection of deeper undercurrents.

In truth, we know nothing ever materializes out of thin air. Fashion reverberates with the spirit of the age; it is a mirror of our times. You could argue it's a small one, but it is a revealing one, nonetheless. This book selects 250 fashion moments from a possible choice of thousands spanning half a century. As well as being encyclopaedic, its aim is to identify the tremors registering most powerfully on the fashion Richter Scale.

The book starts in the 1950s – a gilded time of peace, growth and change. In Paris, the great centre of couture know-how, 20th-century fashion was born. At the beginning of the decade it was still the preserve of the aristocracy – a privileged circle of money and luxury. But, all over the world, whether fashionable women could afford to buy originals or copies, their wardrobes echoed the pronouncements from Paris.

Fifty years later, the map had been completely redrawn. Paris, Milan, New York, London, Tokyo, Antwerp, Los Angeles, Florence and Rome all jockeyed for position: the needle of influence swinging energetically from London to Paris to Milan and back again.

Almost inevitably the most dynamic social changes highlighted in this book are those driven by the change in women's roles. Breaking the glass ceiling and bringing female power to the corporate and political world were crucial advances in the second half of the 20th century, and fashion illuminated and even foretold the mood, reflecting every milestone, every falter, every advance.

Fashion tells us much about the couture era of heightened femininity in the 1950s, about the triggers behind the ready-to-wear democratization of fashion in the 1960s and the weaponization of clothes in the battle of the sexes during the 1970s. With every new cycle, fashion reinvented itself, shedding its skin like a dextrous snake and emerging glossy, vital and new again. Rumours of its demise have been frequently exaggerated along the way.

This book starts with a significant death. By the 1960s the couture was a dusty old business. Its status had been challenged by a disruptive new energy. The rarified domain of high society was giving way to the power of popular culture. A new elite delighted in rebelling against the establishment. They didn't have endless fittings in mirrored salons – they bought fashion from boutiques. Working women had their own money to spend and made choices for themselves. Society ladies ceded the covers of magazines to models, who in turn competed for attention with celebrities.

In the 1970s Milan challenged the hegemony of Paris with industrialized high-quality ready-to-wear and its superior commercial clout. Manufacturing technology became a major influence; from the development of synthetic fabrics to the computerization of the manufacturing process, fashion designers have been aided and spurred on by new ways of creating clothes.

At the same time, air travel was making the world more expansive and more immediate. Souvenirs from the hippy trail worked their way into wardrobes from Liverpool to Los Angeles. Fashion trends came in a torrent of theatrical ideas. And multiculturalism was a key influence, from Saint Laurent's bohemian decadence to Kenzo's riotous colour.

At the end of the decade a new sobriety became a platform for the simplicity of Jean Muir in London, Halston in New York and Giorgio Armani in Milan. A new generation of designers was focused on reinventing the way women dressed in line with their modern lives, ditching fussy, complicated clothes for a new luxury – the luxury of practicality and ease.

As the 1980s progressed, the economy boomed, the workforce grew and consumerism took a firm hold. Logos and labels became the ultimate status symbol. From interlocking Cs to interlocking Gs, fashion was once again an emblem of power and wealth – and it was for flaunting. The decade of excess was crowned in 1987 by the launch of a brand new couture house – Christian Lacroix.

An explosion of creativity meant anyone could wear their heart on an impeccably cut designer sleeve. Fashion became tribal, from Japanese radical intellectualism for savvy design sophisticates to Donna Karan's capsule wardrobe for her hardworking go-getters. And London boomed again with a new generation of young designers fresh from the iconoclastic ideas factory that was Central Saint Martins and the Royal College of Art.

Death loomed large again in the 1990s. This time, AIDS cut a swathe through the creative community and nihilistic grunge appeared to be fashion's terminal trend. But, again with hindsight, it was not fashion that had died so much as subservience to fashion dictators. Brands became bigger and fashion businesses more corporate. Multi-national luxury groups collected what were once family concerns. And luxury became a commodity traded on the stock market.

The century ended on a note of pluralism with infinite propositions from any number of designers. As many trends filtered up from the street as trickled down from the catwalk. And jockeying alongside for fashion kudos was the high street, whose lightning-fast fashion reflexes were transforming the seasonal wardrobe refresh for the few into a weekly fix for all.

Is there now any single dominant force? Arguably, and perhaps not unlike the days when the couture houses met every whim of their demanding clientele, the most powerful one is the customer.

1950s

The 1950s marked a sea change in fashion. And nothing would ever be the same again. Change came faster than hits in the pop charts. Fashion was emerging from behind the closed doors of the gilded salons, the exclusive preserve of the rich and titled, and was bursting onto the street. Customers of all ages and from all social backgrounds lapped up the new, sybaritic energy after years of wartime deprivation.

Members of a younger generation, finding its voice for the first time, began to use clothes to express themselves, exploring fashion's power as a symbol of identity: a mark of belonging and of difference. Defining the generation gap was becoming big business for the marketing men, and fashion was one of their most effective tools.

Fashion pages, for generations the preserve of the fashion magazine, were in demand from a much wider audience. Popular newspapers were no longer complete without a fashion desk, a fashion editor and a regular fashion headline, and as a result, trends became the dynamic engine driving sales. New easy-care fabrics and systems of mass production, coupled with comparative prosperity, enabled Mrs Average, everywhere, to be the best-dressed woman in the world.

Opposite: A model lounging on a bed, wearing Claire McCardell's pink-and-white striped dress of 1952.
Below: Christian Dior's black taffeta dinner ensemble of 1951. Rounded hip and shoulder lines, tiny waist and high bustline are achieved with a short, fitted jacket atop a voluminous skirt.

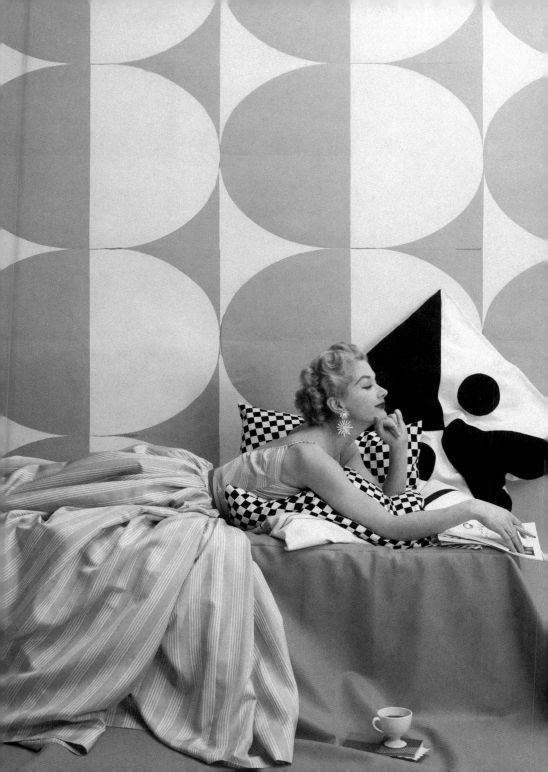

THE DUKE AND DUCHESS OF WINDSOR

High style

History does not look fondly on the Duke (1894–1972) and Duchess (1896–1986) of Windsor, one of the most controversial couples of the twentieth century. Their affair started while she was still married to her second husband, Ernest Simpson. In spite of being heir to the British throne, Edward's *raison d'être* became simply to be married to Wallis Simpson.

The world was stunned by the news that the American commoner had somehow seduced the man who was now king. Many wondered aloud: What could he possibly see in her? Give up the throne for – what? Sex? Wallis is credited with icily stating, 'No man is allowed to touch me below the Mason–Dixon Line.' There were also ugly and persistent rumours questioning her physical female endowments. And then there were the stories of her affairs, Nazi sympathies and shopping.

Nonetheless, the couple were fêted in fashionable society as the ultimate trendsetters. Wallis Simpson was known for her impeccable manner of dress, her extensive and precious jewellery collection, and her taste in interior design. He, as the Prince of Wales and later the Duke of Windsor, was also known as the 'Master of Style'. Men's fashion reverberates with his influence to this day. He is still widely referenced as one of the best-dressed men in all of history, with a personal style that was flawless, at times quirky, and always legendary. 'Did he have style?' Diana Vreeland (see page 126) once asked rhetorically. 'The Duke of Windsor had style in every buckle on his kilt, every check of his country suits.'

The Duke and Duchess's shared interest in fashion offers a glimpse into the reasons for the longevity of their relationship. Wallis Simpson once remarked: 'My husband gave up everything for me. I'm not a beautiful woman. I'm nothing to look at, so the only thing I can do is dress better than anyone else. If everyone looks at me when I enter a room, my husband can feel proud of me. That's my chief responsibility.' Her approach to her marriage was always to make the Duke feel like he was still the King.

In terms of style, hers was more restrained than his. He was an emblem of elegant hedonism. She liked simple, tailored clothes, without unnecessary detail or decoration. The photographer Cecil Beaton once said, 'She reminds one of the neatest, newest luggage and is as compact as a Vuitton travelling case.'

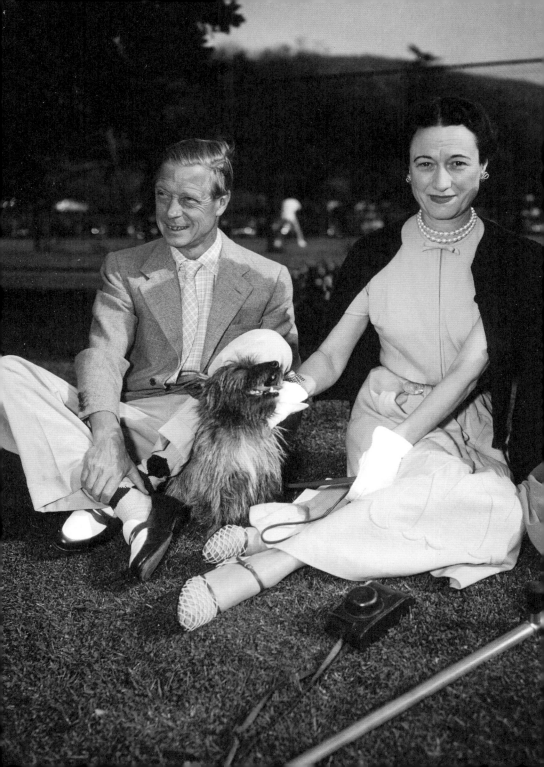

GYPSY ROSE LEE

'Let me make you smile'

'Let me entertain you, Let me make you smile…' The influence of Rose Louise Hovick (1911–70), whose 1957 memoir, *Gypsy*, became a Broadway smash and a film starring Natalie Wood, resonates still through the style and stage presence of burlesque stars such as Dita Von Teese. Brought up in the grinding poverty of the 1940s, the former child performer propelled herself from rags to riches through a combination of wisecracking repartee and business brains, as well as beauty. At an evening at the New York Public Library to celebrate the centenary of her birth, Karen Abbott, author of a biography of Rose, said: 'If Lady Gaga and Dorothy Parker had a secret love child, it would have been Gypsy Rose Lee.'

Born in Seattle in 1911, Rose worked in vaudeville alongside her sister, June, but while June had the makings of a star, Rose had no discernible talent at all. She only discovered by accident that she could make money in burlesque when a shoulder strap on one of her gowns gave way, causing it to fall to her feet. The audience applauded her desperate efforts to cover herself, and so she decided to make the 'accident' the focus of her performance.

She became one of the biggest stars of Minsky's Burlesque in New York, where the huge audiences were as likely to include longshoremen as the city's intelligentsia. Her style was a send-up of a striptease, with the emphasis firmly on the 'tease'. She brought a wry sense of humour to her performance which, in a world singularly lacking in sophistication, propelled her to mainstream stardom.

She got big laughs as she dropped the pins that held her costumes together into the tuba in the orchestra, and fussily straightened the crooked black bow on her nipple with an 'Oh dear!' She revealed little actual flesh, ending the show with the curtain draped coyly around her. The show was really more about comedy than sex, and men *and* their wives were often in the audience.

Gypsy Rose Lee's wardrobe of feather boas, ostrich fans, corsets and lace may well owe something to her mother's first career as a seamstress and milliner. Mrs Hovick specialized in extravagant hats and exotic lingerie, and spent months on the road visiting mining towns and lumber camps from Nevada to the Yukon, selling the flashy apparel to prostitutes.

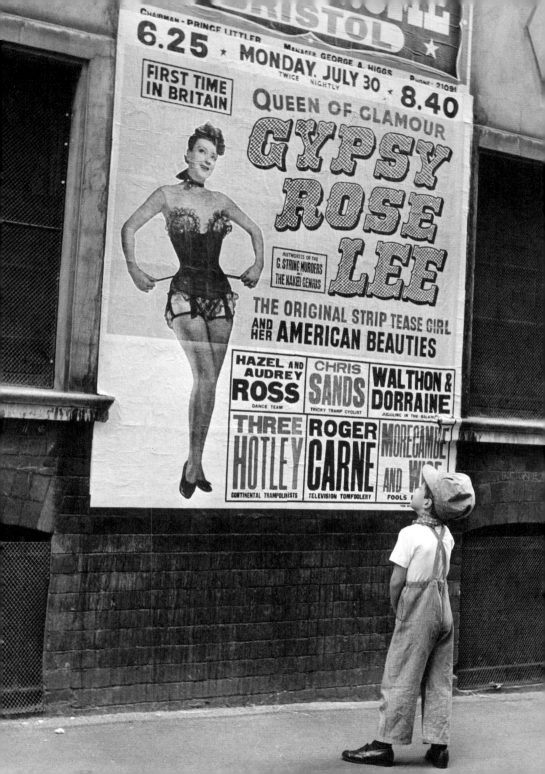

HARDY AMIES

1950

Understated English elegance

'A woman's day clothes must look equally good at Salisbury Station as the Ritz bar,' said Sir Hardy Amies (1909–2003), summing up his understated British style. He made his professional home on Savile Row, the home of British bespoke tailoring, and specialized, as he himself said, in a quiet English elegance that 'didn't frighten the horses'.

Born in Maida Vale, West London, Amies grew up to become one of the most important postwar names in British fashion. His mother, a *vendeuse* in a smart ladies' outfitters, introduced him to London couturier Lachasse where Amies obtained his first job in 1934. During World War II he served in British Intelligence.

Amies opened his own house on Savile Row after the war in 1946, financed by the Countess of Jersey, the first Mrs Cary Grant. To most, he will always be remembered for dressing the Queen. The association began in 1950, when Amies made several outfits for the then Princess Elizabeth's royal tour to Canada. And, although the couture side of the Hardy Amies business was traditionally less financially successful than the menswear business, the award of a Royal Warrant as official dressmaker in 1955 gave his house international kudos.

Highlights of his career also included a triumphant, if unlikely, collaboration with Stanley Kubrick, for whom he created costumes for the futuristic epic *2001: A Space Odyssey* (1968). He was also something of a commercial alchemist, managing to grow his business until it was worth more than £200 million.

Paris may have been the home of the scene-stealing fashion heroes, but Hardy Amies was the quintessential English couturier of the age. As he himself once said, 'I can't help it. I'm immensely impressed by all genuine upper-class manifestations.'

Hardy Amies may have become famous as the Queen's official dressmaker, but he also made a significant contribution to fashion history as a menswear designer. In fact, thanks to his use of men's tailoring techniques in womenswear, he is often considered one of the first proponents of power dressing.

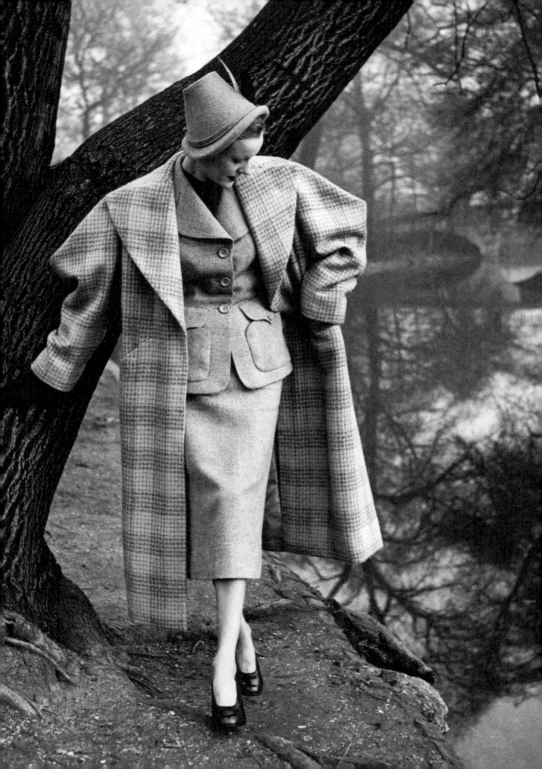

LISA FONSSAGRIVES-PENN 1950
'A good clothes hanger'

The Swedish-born model Lisa Fonssagrives-Penn (1911–92) worked with and inspired some of the most famous photographers of the 1950s, including Horst, George Hoyningen-Huene and Irving Penn. The Russian-American magazine editor Alexander Liberman has said of her: 'It is difficult to imagine the history of fashion photography without thinking of Lisa Fonssagrives-Penn.'

Born Lisa Bernstone, she had trained as a dancer but turned to modelling when work fell off. She was featured so frequently on the fashion pages of *Vogue* and *Harper's Bazaar* that her face, it was said, was as recognizable as the *Mona Lisa*. In 1948 she became the first model to make the cover of *Time* magazine. In the course of her career she hung perilously from the iron spars of the Eiffel Tower for Erwin Blumenfeld, disrobed for Horst and parachuted over the Paris skyline for Jean Moral.

In the late 1940s, when most models were paid $10–25 an hour, she was earning $40 an hour. When most models' careers ended before their 30th birthdays, hers flourished until she was past 40. She married Penn in 1950.

After her death in 1992, Liberman said, 'She was the inspiration and subject of some of Penn's greatest photographs. She epitomized a very noble period of fashion and couture. She gave a classical dignity to anything she wore.' Lisa Fonssagrives-Penn, however, had a more down-to-earth attitude to her contributions as a model. In the 1948 article in *Time* magazine, she was quoted as saying: 'It is always the dress, it is never, never the girl. I'm just a good clothes hanger.'

Fonssagrives-Penn's famous poise was down to her early ballet training. Asked how she maintained her figure, she always insisted on the importance of eating little and often, up to ten meals a day. But to her, a meal might mean only six grapes, a single slice of cheese, one cracker and half a glass of wine. Her motto was: 'Always eating, but never anything much.'

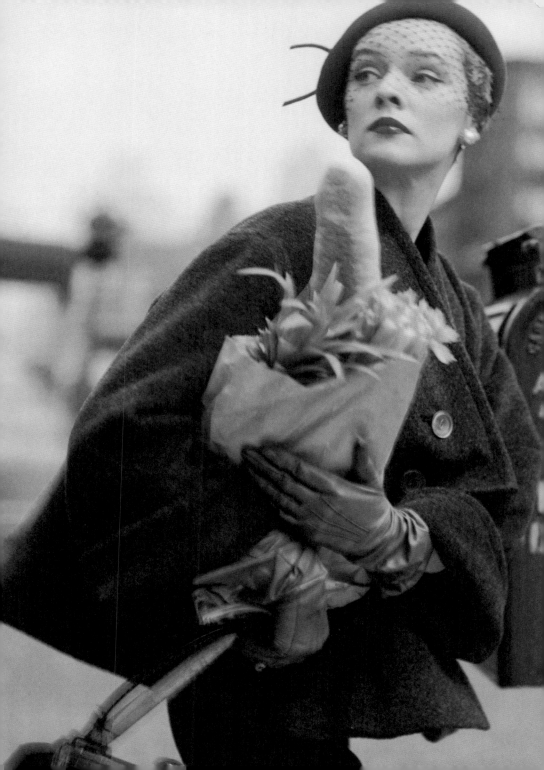

KATHARINE HEPBURN

Nonconformist style

A reluctant style icon, Katharine Hepburn (1907–2003) was the daughter of a suffragette who became the poster girl for androgynous chic. She appropriated a masculine style of dressing, but unlike Marlene Dietrich (1901–92), who had gone before her, she wore little makeup, preferring to be natural and comfortable rather than glamorous. As a child, she desperately wanted to be a boy, cutting her hair and adopting an alter ego named 'Jimmy'.

Hepburn had been wearing trousers, which were then considered quite unladylike, since the 1930s. Her style of dress and her outspoken manner didn't always endear her to the Hollywood Pooh-Bahs, at a time when the blonde bombshell was the general idea of a silver-screen star. And yet, as one contemporary fashion magazine noted, 'she almost single-handedly broke down the dress code for women' by insisting on wearing men's trousers both on and off the set.

In 1993 Hepburn declared, 'I realized long ago that skirts are hopeless. Any time I hear a man say he prefers a woman in a skirt, I say: "Try one. Try a skirt."' It is said that she never had a dress or skirt of her own. She popularized the plain colour palette and the oversized silhouette that she loved. The elements of the Hepburn look – wide-legged pleated trousers, flat loafers, soft mannish shirt and easy tailored jacket – are the instantly identifiable ingredients that constantly resurface on catwalks to this day. In 1986 the actress was acknowledged by the Council of Fashion Designers of America for her role as a nonconformist in 20th-century fashion.

It was said that when the costume department removed her trousers from the dressing room, Hepburn refused to put anything else on and walked around the studio in her underwear until they were returned. She was one of the few great Hollywood stars who made no attempt to sugar-coat her personality, a personality that was blunt and feisty. Her abiding motto was: 'if you obey all the rules you miss all the fun.'

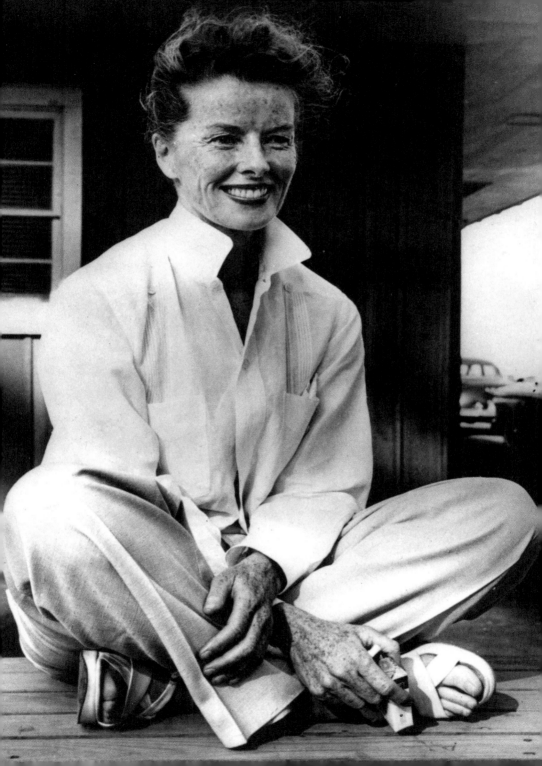

NORMAN NORELL

'Dean of American Fashion'

Norman David Levinson (1900–72), from Indiana, became Norman Norell when he moved to New York to study fashion illustration at Parsons School of Design. He started his working life in the costume department of Paramount Pictures, before meeting his mentor, Hattie Carnegie, in whose design studio he worked for 12 years, learning to curb his dramatic tendencies. Nevertheless, the rumour goes that he left over an argument with Ms Carnegie about the suitability of a sequined skirt he had designed for actress Gertrude Lawrence in *Lady in the Dark* (1944).

Setting out on his own, Norell was chosen by the American fashion critics as the first winner of the prestigious Coty Award in 1943. After the war, American designers still specialized in copying what happened on the Paris catwalk, but Norell was one of the few to win the respect of Parisian couturiers. In 1953 the *New Yorker* declared he 'was the fastest with lines that will later show up with Paris labels'. He was treasured at home as 'the American Balenciaga'.

Throughout the 1950s Norell honed his skill for combining day and evening elements. He showed lavishly full-skirted shirtwaist dresses in watered silk or lace combined with organdie. He paired satin-collared tweed jackets with satin ballgowns. He made trench coats out of taffeta and fitted white collars and cuffs on daytime shirtwaisters as well as silk ballgowns, and was famous for his sequined dresses that, with their slithery, skinny silhouettes, became known as 'mermaid dresses'.

As 'the Dean of American Fashion', Norell was the first to have his name on a dress label, and the first to produce a successful American fragrance with a designer name.

In this deceptively simple dress, the 'mushroom' pleats hang in plumb-line straight panels when the wearer stands still, and billow out when she moves. At the time, the outfit was offered at a retail price of $195. When American fashion trailed behind Paris and London, Norell's simple but stylish clothing was praised for its glamour, classic timelessness and the quality of its construction.

NYLONS
Wartime's most wanted luxury

Throughout much of the 1940s the manufacture of nylon stockings stopped, as nylon production was commandeered to help in the war effort. The making of parachutes and tents could not be interrupted for a fashion accessory, however morale-boosting. With the war over, the hosiery industry was allowed to gear up again and the demand for nylons rocketed. Orders were so numerous that sales quotas were imposed; riots broke out when promoters made special offers.

Nylons had been introduced to the market back in 1940, and not much had changed in the intervening decade. Without any qualities of stretch, they had to be 'fully fashioned' in a wide variety of sizes to fit all legs exactly. The seam down the back was not a fashion detail: it was created when the stocking was knitted together. However, at a time when nylon stockings were hard to come by, mimicking this seam with a steady hand and an eyebrow pencil could create a convincing impression of one of the war's most unattainable and coveted luxuries.

Freed from the exigencies of war, the hosiery technology of the 1950s progressed at a pace, and yarn manufacturers discovered they could add stretch by crimping nylon under heat. By 1959 DuPont was ready to launch Lycra, which could stretch to up to seven times its original length without breaking or changing shape. The days of the fully fashioned stocking were over, and circular knitting machines eliminated the need for seams.

Delicate stockings made way for the considerably more practical and robust industrial upgrade, and tights became a disposable, daily fashion staple.

When the war ended, Macy's entire stock of 50,000 pairs of nylons sold out in six hours. A newsreel from the time exclaimed, 'Nothing did more to brighten the postwar scene than the reconversion of the hosiery industry. A man with a pair of nylons in his pocket was better off than a GI in Germany with a hatful of chocolate bars.'

CHRISTIAN DIOR
The New Look

12 February 1947: a world that was slowly emerging from the deprivations of war was stunned by Christian Dior's couture collection. For women accustomed to improvising their wardrobes, the Dior 'Corolle' collection (named after the delicate petals at the centre of a flower) was an irresistible seduction. 'It's quite a revelation, dear Christian,' pronounced Carmel Snow, editor of the American fashion magazine *Harper's Bazaar*. 'Your dresses have such a new look.'

Key elements were sloping shoulders, narrow waists and full hips. 'I wanted my dresses to be constructed upon the curves of the feminine body whose sweep they would stylize,' said Mr Dior. In place of uniforms, he wooed women with traditional images pilfered from a romanticized past. Tiny waists were achieved with corsets called 'waspies'; the skirts were stuffed with petticoats. The world was midway through the 20th century, but the New Look restored Paris to the pinnacle of high fashion with a wardrobe that owed much to the Victorians.

Women loved it. The couture house was inundated with orders. Dior was invited to London by the royal family, although King George V forbade the princesses Elizabeth and Margaret from wearing the New Look, lest it set a bad example at a time when rationing was still a reality for most.

But the trickle-down effect was immediate. From the Sears catalogues that took fashion to the remotest corners of the US to the poodle skirt and ponytail worn by teenagers everywhere, the Dior look defined postwar exuberance in fashion. The New Look did not, however, outlast Dior's death in 1957 – perhaps because the design was so impractical for the growing number of working women. However, the wardrobes of the 1950s were defined by Dior's creation.

Dior achieved tiny waists with a 'waspie' corset. Hips were padded, and definition was accentuated with peplums on jackets and bustles on skirts. He used push-up bras to fill out the bustline, and full skirts were stuffed with petticoats. There was so much interlining, boning, stiffening and corsetry that it was said a New Look dress could stand up all on its own.

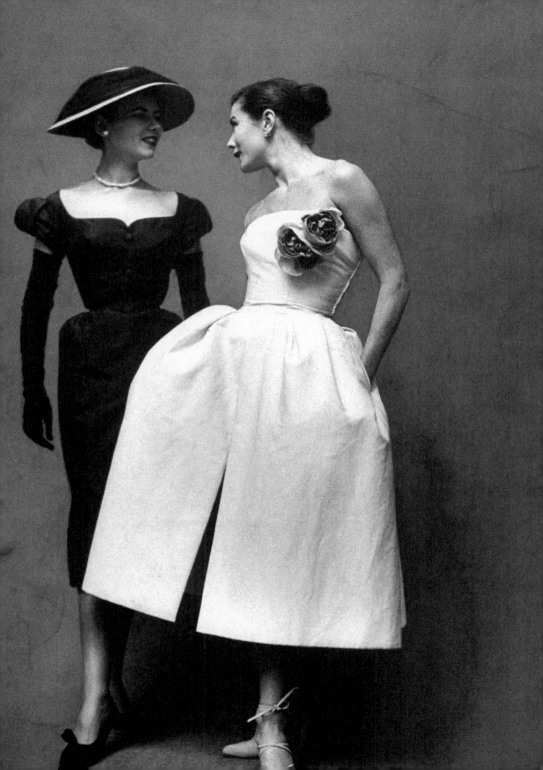

JACQUES FATH & BETTINA

Le style parisien

In the history of 1950s fashion, Christian Dior's shining star tends to eclipse all others. But Jacques Fath (1912–54) was also a dominant influence on postwar fashion. His was a short-lived but meteoric career. He opened his house in 1937 and died of leukaemia in 1954. During that time, he also mentored the fledgling careers of Hubert de Givenchy (see page 54) and Valentino Garavani (see page 194).

During World War II, Fath was known for 'wide fluttering skirts', which, the *New York Times* explained, 'he conceived for the benefit of women forced to ride bicycles during gasoline rationing'. His clients included Ava Gardner, Greta Garbo and Rita Hayworth, who wore a Fath dress for her wedding to Prince Aly Khan in 1949.

But he is best remembered for creating a look for the spirited, chic *parisienne*, offering a younger alternative to the styles of Balmain and Dior. And it was the 'supermodel' Simone Micheline Bodin (1925–2015), pet-named 'Bettina Graziani', who defined her. With her red hair and fresh face, Bettina personified the modernity, wit and accessibility of Fath's brand.

Magazine fans of the time may not all have been able to afford a Fath original, but they slavishly copied the details – his bathing-cap hat, long evening gloves pushed down to the wrist for daywear, rhinestone earrings and bracelets, and a string of graduated pearls were the accessories of the moment. Bettina may have famously lent her name to an iconic blouse from Hubert de Givenchy's first collection in 1952, but in interviews she has often cited her formative Fath years as the highlight of her career.

Fath's bold silhouettes, dramatic necklines and unorthodox flourishes – such as the 'flying saucer buttons' popularized by Bettina and Hollywood starlets – have reverberated down the generations, through the styles of Viktor & Rolf, John Galliano (see pages 408 and 496) and Giambattista Valli.

In an interview, Bettina explained the chemistry she had with Fath: 'He liked that I was "different": I wore no makeup and I had red hair. At the time, he was interested in conveying an American spirit and a brand-new attitude. He wanted to communicate a modern image to the media. So I became the face of Fath.'

LAUREN BACALL
One of the boys

Lauren Bacall (1924–2014) was a beacon of no-nonsense practical style in an era of feminine excess. One of the boys, she was considered an honorary female member of the Rat Pack in the 1950s.

Betty Joan Perske as she was known then, started out as a model, getting her big break as an actress when she was discovered on the cover of *Harper's Bazaar* by Nancy, the wife of the director Howard Hawks. It was Mrs Hawks who encouraged her to change her name to Lauren Bacall, had her voice trained to speak in a lower, more masculine tone, and suggested she tilt her trembling chin downward in screen tests to hide her nerves.

Bacall's wardrobe was an extension of her acting style: utilitarian, razor-sharp and fuss-free. She could carry off mannish tweeds and a trilby as well as any of the guys. Arguably, her style had more to do with the practical 1940s than the fragrant 1950s. Her best accessories were her knowing look and glacial poise. Bacall told *Vogue*: 'For my peculiar face I look best when I look as though I am not wearing any [makeup].' And when it came to clothes she told the magazine she preferred 'nothing itsy-bitsy – you shouldn't have to do too much to them, just wear them.'

In an era of the high-maintenance wardrobe, Lauren Bacall steered a course toward effortless minimalism. Statement jewellery and attention-grabbing accessories were not her thing. Her simple tailored clothes were a backdrop for what many fans tried but could not quite so easily copy – her steely allure and enigmatic femininity. Bacall's iconic loosely waved coiffure never had a hair out of place, yet her faultless grooming seemed a foil for her feisty and unconventional nature.

In their day, Humphrey Bogart and Lauren Bacall (photographed here with their son Steve) were the ultimate 'It' couple. Although their relationship was at first controversial (she was 21 and he was 45 and married), most agreed they were made for each other. When they were finally pronounced man and wife, the groom kissed the bride and the bride said, 'Oh, goody!'

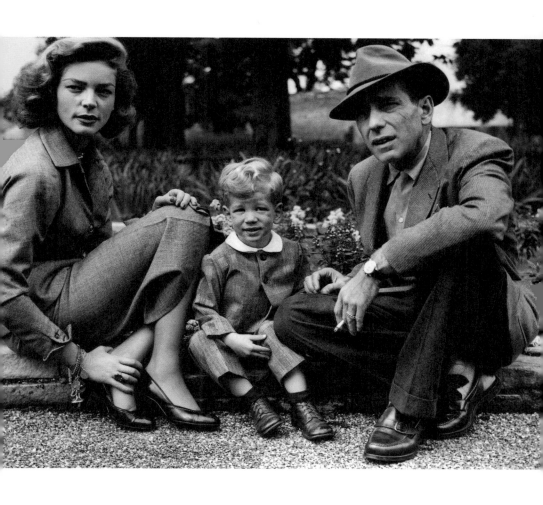

RENÉ GRUAU

The exuberant hand of fashion

In the late 1930s, when photography began to replace *Vogue*'s celebrated illustrated covers, the demand for fashion illustration went into dramatic decline. By the 1950s, René Gruau (1909–2004) stood alone as a star in a world that was increasingly dominated by photographers.

Gruau's style was instantly recognizable for its broad, sweeping brushstrokes. Executed in Indian ink and gouache, his drawings were an exuberant flourish of line on a background of flat colour. His stylistic influences ranged from the kabuki theatre and Japanese art, then at the height of fashion, to the lithographs of Henri Toulouse-Lautrec (1864–1901).

Above all, however, Gruau is recognized for his visual wit and storytelling. It was these that enabled him to engage his audience in an innately sophisticated way, reflecting not only his skill as an accomplished commercial artist, but also his canny sense of marketing and advertising, at a time when those industries were still in their infancy. Gruau worked for clients throughout the world of luxury and the arts. He was in demand as much for his designs of ballet sets and costumes as of film posters; he was as capable of depicting cars and brandy as haute couture.

It was Gruau's fashion work, however, that made him a superstar. He collaborated with many of the luminaries of the golden age of couture, including Balmain, Givenchy, Schiaparelli and Fath, but his work with the House of Dior cemented his reputation. Beginning with Dior's New Look in 1947 (see page 24), Gruau had a long relationship with the couture house that continued into the late 1990s. The 2011 Spring/Summer Haute Couture Collection of Christian Dior by John Galliano was heavily inspired by Gruau's works.

What set Gruau apart from (and often at odds with) his peers was that much of his best work was done for commercial purposes: advertising and marketing. But Gruau's work was an elegant and powerful stimulus at a time when the French fashion industry needed a boost to get back on its feet again.

CRISTÓBAL BALENCIAGA
Reimagining the silhouette

Born in Getaria, Spain, Cristóbal Balenciaga (1895–1972) carved a reputation early in his career as one of the few couturiers able to cut, fit and sew his own designs. Forced out of Madrid by the Spanish Civil War, in 1937 he opened his couture house in Paris on the fashionable avenue George V, where his peers were Chanel, Schiaparelli and Mainbocher.

He continued to work in Paris throughout World War II, although it was not until the postwar years that he truly shone: the 1950s were his decade. The silhouette he created was different from the hourglass shape of the New Look that had made Christian Dior the toast of Paris (see page 24). Balenciaga favoured fluid lines and experimented constantly with the way fabrics related to a woman's body.

In the course of the decade, Balenciaga cut a swathe through classic silhouettes, reworking shoulder lines and raising and dropping waistlines, regardless of natural shape. In 1953 he introduced the balloon jacket, which enveloped the upper body in a cocoon that appeared to lengthen the legs and set the face on a kind of pedestal. The year 1955 saw the launch of the tunic dress, and in 1957 came the high-waisted baby doll. His cocoon coat and his balloon skirt, shown as a single or double pouf, with one on top of the other, were in huge demand.

Considering how the waist was the focal point of the classic 1950s silhouette, it speaks volumes about his influence that neither of his most popular designs – the sack dress of 1957 and chemise dress of 1958 – had one. To this day, Balenciaga remains influential, having achieved fashion's most elusive goal: the creation of a unique and totally new silhouette.

During the 1950s, it was said that a woman 'graduated' from Dior to Balenciaga. Dior was never jealous of Balenciaga's skills. Balenciaga was the man Dior called 'maître'. A long-time client offered a fitting epitaph: 'Women did not have to be perfect or even beautiful to wear his clothes. His clothes made them beautiful.'

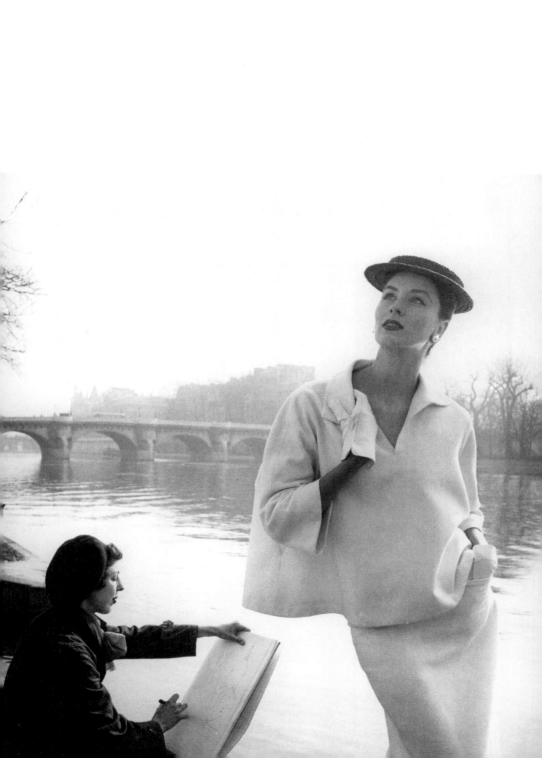

BARBARA GOALEN

The first British supermodel

It was in the 1950s that models first became household names. And Barbara Goalen (1921–2002) was arguably the first British supermodel – before the term was even invented. The best could earn handsome salaries: five guineas an hour, as much as the average weekly wage for girls in ordinary jobs. And because it looked so easy and glamorous, they inspired a generation of hopefuls who had no idea of the discipline that was involved.

In addition to being the consummate professional, Barbara Goalen also had the magic genetic ingredients that often define the extraordinary. Her 33-18-31-inch figure and her weight that never exceeded eight stone combined with an innate elegance to make her a perfect clotheshorse for the New Look. A widow with two small children, at 24 she became a couture model in a fashion showroom. Her big break came when she met the photographer John French, who at once recognized her photographic potential.

From 1950 Barbara Goalen appeared continually in *Vogue* and *Harper's Bazaar*, it was said she could make the simplest cotton dress look like the height of chic. She personified the aloof sophistication that was the code for elegance throughout the decade, and looked perfect in highly stylized clothes.

In the postwar years, models could achieve film star status. Designers started to talk about them as their inspiration or 'muses'. Barbara Goalen's clothes and doe-eyed makeup were widely copied, and her exploits were followed in gossip columns from the time she started working with John French until her marriage to the Lloyd's underwriter Nigel Campbell in 1956. Crowds of fans mobbed the couple at Caxton Hall, Westminster, where the wedding took place.

After the wedding, and while still at the top of her profession, she retired from modelling and had two more children.

Goalen epitomized the priviledged English classes and refused to compromise her lofty standards. After her retirement as a model, her fashion column in the *Daily Telegraph*, in the liberated 1960s, insisted on elbow-length black gloves with a cocktail frock and an above-elbow pair with a strapless ballgown: on the other hand, she happily played 'straight woman with arched eyebrow' opposite the Goons.

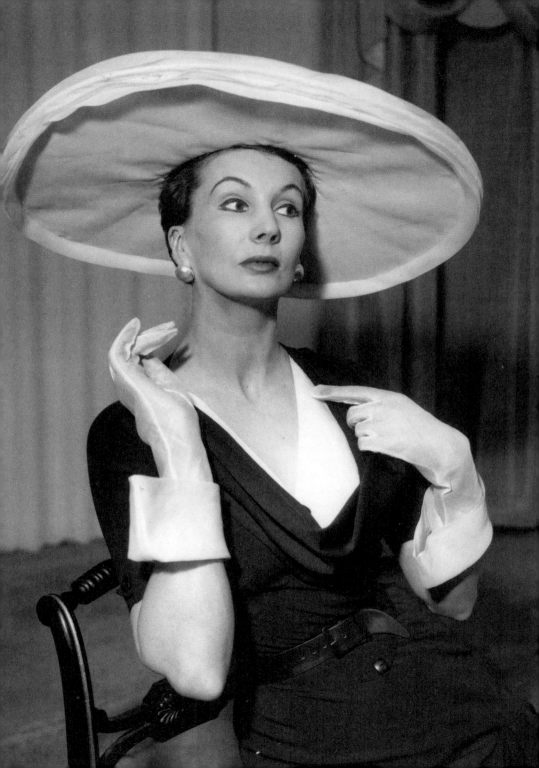

THE BIKINI

'The most important thing
since the atomic bomb'

The invention of the modern bikini is claimed by the French engineer Louis Réard in 1946. He is said to have named it after the Bikini Atoll in the Pacific – the site of a nuclear bomb test in 1946 – because he hoped its impact would be explosive. Legendary fashion editor Diana Vreeland (see page 126) can only have helped him in his mission when she famously proclaimed it was 'the most important thing since the atomic bomb'.

Fashion designers adored the daring two-piece. Back in 1944, Tina Leser's two-piece bathing suits were 'the most daring attire to appear on American beaches to date,' or so declared the photography magazine *Click*. 'Scanty swimsuits are designed to give the girls a maximum of vitamin D and the boys an eyeful.' But it wasn't until Brigitte Bardot (see page 68) was photographed wearing a bikini on a beach in the south of France that the two-piece became a commercial sensation. Bardot had one film credit to her name (*Manina, The Girl in the Bikini*, 1952) when she took Cannes by storm in 1953. The 19-year-old wowed paparazzi on the beach and, with her husband, the young director Roger Vadim, she became half of the world's hottest couple.

Bardot's bikini looks quite demure to modern eyes. But the constructed bandeau and strong horizontal waistline below the navel were the definition of extreme beachwear in the early 1950s. The combination of the starlet, the bikini and the venue worked a kind of magic that clings to the Cannes Film Festival even today.

The bikini was to become the favourite fashion statement of the body beautiful, a garment that would fundamentally change the face of fashion. As Mrs Vreeland remarked, it was 'a swoonsuit that exposed everything about a girl except her mother's maiden name'. In the postwar years this was strong and intoxicating stuff.

Brigitte Bardot single-handedly made the bikini a must-have fashion item, and Saint-Tropez the bikini-posing capital of the world. This picture was taken in the view of a US warship with a full crew of sailors on board. There were no reports of adverse effects on crew or ship. But the Catholic Church reportedly issued flyers ordering the faithful not to watch Bardot's films.

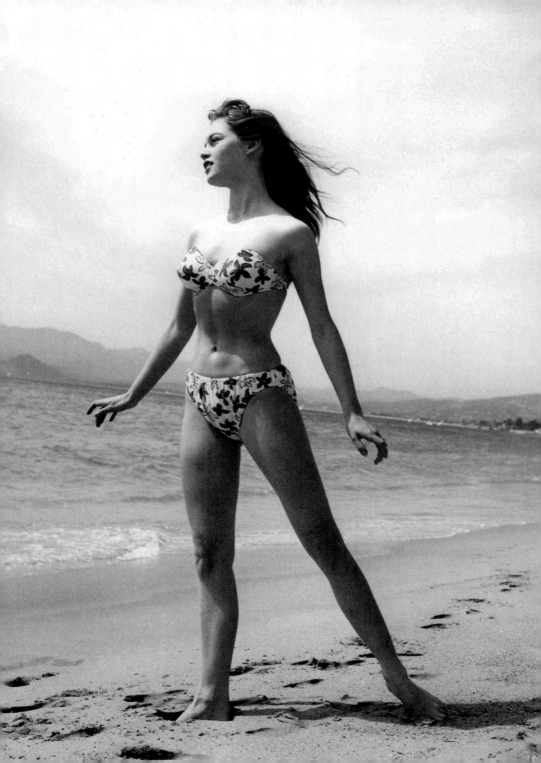

SALVATORE FERRAGAMO

Italian style

Born into poverty in the south of Italy, Salvatore Ferragamo (1898–1960) qualified as a shoemaker and moved to the USA at the age of 16. He started making shoes for Hollywood in 1923, working on costumes for the filmmaker Cecil B DeMille. But his business grew out of an increasing demand among the stars for off-duty shoes. Lillian Gish and Mary Pickford were among his first customers.

In 1929, Ferragamo returned to Italy where, eventually, the privations of World War II were to propel him to stardom as a great design innovator. In the absence of leather, he used cellophane, fish skin and canvas for the uppers of cork-soled shoes. When the steel to support the shanks of high-heeled shoes became unobtainable, he devised wedge heels.

The 1950s were Ferragamo's decade. Italy was becoming a mecca for style and fashion, and attracted tourists from all over the world. There was a booming film industry in Rome's Cinecittà Studios, and this brought the world's greatest and most glamorous stars to his doorstep. And he made shoes for them all. He produced 70 pairs for Greta Garbo, made an annual spring order for the Duchess of Windsor, and created a ballerina shoe for Audrey Hepburn (see pages 52 and 122) that is still part of the label's classic collection today.

By the time of his death, Ferragamo had retail stores in most of the major cities of the world. His showmanship made him one of fashion's most enduring stars. But his commercial success was built on a deep understanding of the physiology of the foot, and on his ability to deliver comfort with style.

Salvatore Ferragamo was one of the few designers who patented his ideas, and he patented every design that could be produced in multiples. The postwar years of economic recovery were especially prolific. In those days it was the designer, not the design team, who reigned supreme. In total, Ferragamo created more than 20,000 models of footwear and took out 350 patents.

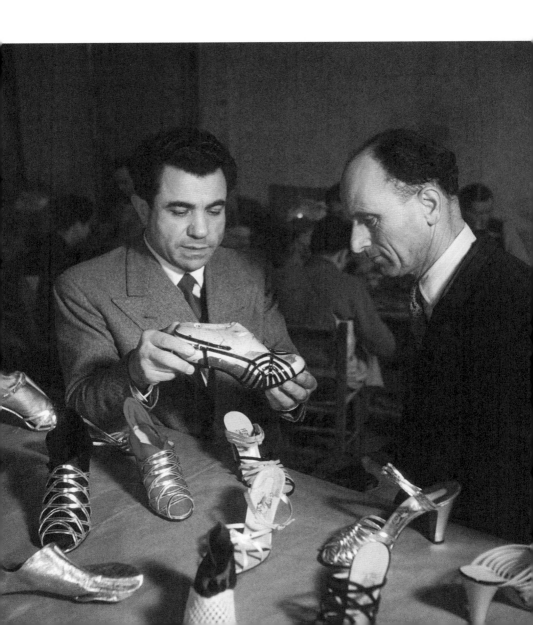

FIONA CAMPBELL-WALTER

Vogue's 'most beautiful' model

In 1954 Fiona Campbell-Walter was at the peak of her relatively short career and the height of her influence. Audrey Hepburn was, admittedly, better known and more widely copied after her role in *Sabrina* (see page 52), but it was Campbell-Walter who was hailed as *Vogue*'s 'most beautiful' model.

Born in Auckland, New Zealand, on 25 June 1932, she first shot to stardom in Britain, where the 'society girl' was a popular heroine and Campbell-Walter was adored because she played the part to perfection. She made an impact in her career as the model who could wear tweeds or the grandest ballgowns with equal elegance. A beauty of otherworldly purity, she was as intimidating a role model for women of 'normal' proportions then as contemporary supermodels are now.

The wardrobes of Christina Hendricks and January Jones in the television series *Mad Men* (2007–15) are celebrated for their comparative accessibility to 'real women'. But it is interesting to note that few real women could emulate Fiona Campbell-Walter's proportions without the aid of a suffocating corset and highly engineered bra. At a time when Elizabeth Taylor and Gina Lollobrigida were among stars rumoured to have had ribs removed to achieve a hand-span waist, Fiona Campbell-Walter's was entirely natural.

She was whisked into marriage and retirement by one of the richest men in Europe, Baron Hans Heinrich Thyssen-Bornemisza de Kászon, who made her his third wife. The couple married in 1956, and she followed the path of many of her peers into aristocratic anonymity. She resurfaced again only briefly in 1969, when her affair with Aristotle Onassis's son Alexander hit the scandal sheets.

Fiona Campbell-Walter (left), here photographed with Ann Gunning, could command daily fees of up to £2,000: an extortionate amount in the 1950s. Cecil Beaton claimed her as his favourite model, while another photographer gushed: 'Her skin wouldn't support makeup, she was so fresh and beautiful, with that marvellous profile and great allure.'

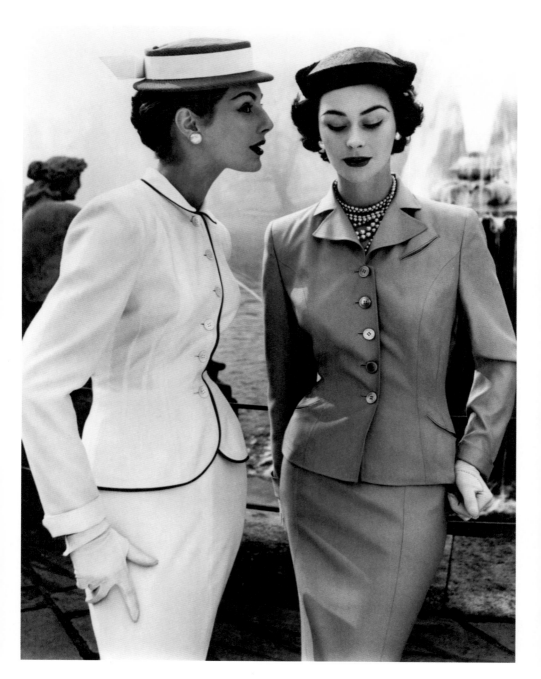

JEANS
A new American aesthetic

Looking back from the vantage point of 1969, William Burroughs wrote: 'Jack Kerouac was responsible for selling a million pairs of jeans with *On the Road*.' It didn't seem to matter that none of the cast of characters in Kerouac's 1957 manifesto for the Beat Movement actually wore jeans at the time. It was more that with his book, the writer gave birth to a new American aesthetic in which the ubiquity of denim became inevitable.

Of course, jeans were part of the American fashion vocabulary before Kerouac. In the Midwest they were the uniform of the cowboy, the all-American hero. In California, jeans were standard issue for the miners as well as for the petrolheads who tinkered with their Harley-Davidsons and who were romanticized on screen by Marlon Brando in *The Wild One* (1953).

In New York, jeans were a staple part of the uniform for counter-culture heroes and intellectuals. Roy Lichtenstein and Bob Dylan gave them cool East Coast cred. Even though Elvis is considered a denim icon, it was Eddie Cochran who really made them rock 'n' roll. Growing up in Mississippi, where jeans were the ordinary clothes of the sharecropper, Elvis never thought them right for the stage. Eddie grew up in Minnesota where they didn't carry the same stigma.

It was Marilyn Monroe (see page 46) who would give denim the stamp of glamour, by wearing Levi's jeans and a Lee Storm Rider, the blanket-lined 101J jacket with corduroy collar, on the set of *The Misfits* (1961). France was the first major European market for Levi's, with Brigitte Bardot (see page 68) frequently seen in 501s.

By the 1950s, jeans had spread beyond their original California heartland, and the selection of denim products had expanded. Denim built up an elusive cachet, becoming a badge of cool. Producer Stanley Kramer's movie *The Wild One* inspired a generation of biker rebels.

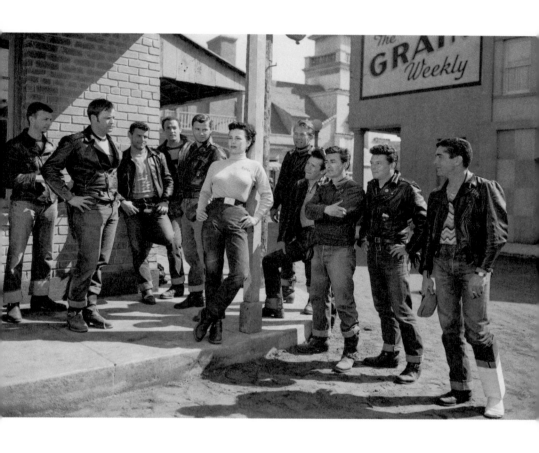

THE CORONATION DRESS 1953
Norman Hartnell designs for Queen Elizabeth II

The high watermark of Norman Hartnell's career was undoubtedly Queen Elizabeth II's coronation gown. It was one of the most important dresses of the 20th century. What is often forgotten, however, is that it was single-handedly responsible for turning London into a design centre, and enabling it if not to rival Paris, then at least to challenge its supremacy.

For before Norman Hartnell (1908– 75), British designers such as Charles Worth and Edward Molyneux moved their operations to Paris. Those who chose to stay at home found their style somewhat curtailed by a market who was more concerned with their country pursuits, with its leisure time revolving around grand but chilly houses. Their international reputation was built upon the creation of finely tailored but rather serviceable tweeds.

The Paris couture industry was supported by a vast subindustry of ateliers that sewed on beading and feathers. It was a system that was much less evolved in London, and yet the coronation dress is considered to be one of the most lavishly decorated of the era. 'I thought of lilies, roses, marguerites and golden corn,' Hartnell wrote in his autobiography. 'I thought of altar clothes and sacred vestments; I thought of the sky, the earth, the sun, the moon, the stars and everything heavenly that might be embroidered on a dress destined to be historic.'

The Queen had requested that Hartnell base the silhouette on that of her wedding gown. The final gown was the eighth design, and was embroidered with floral emblems of each country in the UK – Irish shamrocks, Scottish thistles, Tudor roses, Welsh leeks, oak leaves and acorns. It also included the lotus flower of Ceylon, the South African protea, the Canadian maple leaf and the silver fern of New Zealand. The designer added an extra four-leaf shamrock on the left side of the dress as an omen of good fortune that the Queen's left hand would touch often throughout the day. When she tried it on, the Queen declared it to be 'glorious'.

Millions watched the ceremony on television – for many their first experience of the new medium.

Hartnell submitted eight ideas that started with 'almost severe simplicity and proceeded towards elaboration'. The ultimate design included the emblems of Britain and the Commonwealth. By the time of the coronation Hartnell had 350 employees, and every detail was created by hand in his studio, taking nine weeks and 3,000 man-hours to complete.

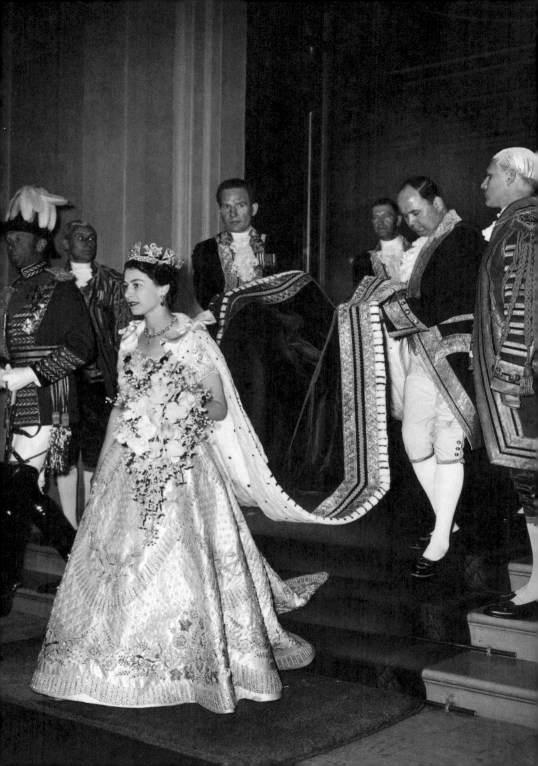

MARILYN MONROE

William Travilla dresses the decade's sex goddess

Gentlemen Prefer Blondes (1953) was the breakthrough movie for Marilyn Monroe (1926–62). She proved to be an accomplished singer and dancer, and an actress with skilful comic timing. And overnight, the world gained its most famous blonde bombshell.

Shot in vibrant colour, the movie dazzles in every way, not least because of Monroe's voluptuous curves, draped in William Travilla's amazing gowns. Marilyn's costumes, especially the one in which she sings 'Diamonds Are a Girl's Best Friend', were actually intended to be more revealing, but the studio got cold feet. In the wardrobe fittings, executives caught one glimpse of her pneumatic figure draped in spangled fishnet and asked Travilla to cover her up. It hardly mattered. Even in long gloves and an ankle-length gown, an iconic sex symbol was born.

Marilyn dominated the movie, with that unique combination of sensuality and innocence that became the hallmark of her fame. She is recognized by many as a trailblazer for the sexual revolution because of the way she sold her sensuality, pushing the boundaries of public acceptance and skirting the limits of approbation. English cultural commentator Julie Burchill has written, 'She played stupid girls who thought they were smart but she was a smart girl who thought she was stupid.'

The potency of Monroe's on-screen sex goddess image – her halo of platinum curls, her curvaceous figure, her pouting mouth, batting lashes and beauty spot – continues to mesmerize. She has always remained a powerful figure in the popular imagination, inspiring the likes of Madonna (see page 360), Gwen Stefani and countless impersonators.

Monroe's pink dress was auctioned on 11 June 2010, with an estimated price of between $150,000 and $250,000 and described as 'the most important film costume to ever come to auction'. It sold for $310,000. Paradoxically, considering her role in the movie as a blonde 'mantrap', in real life she was the least materialistic of Hollywood stars.

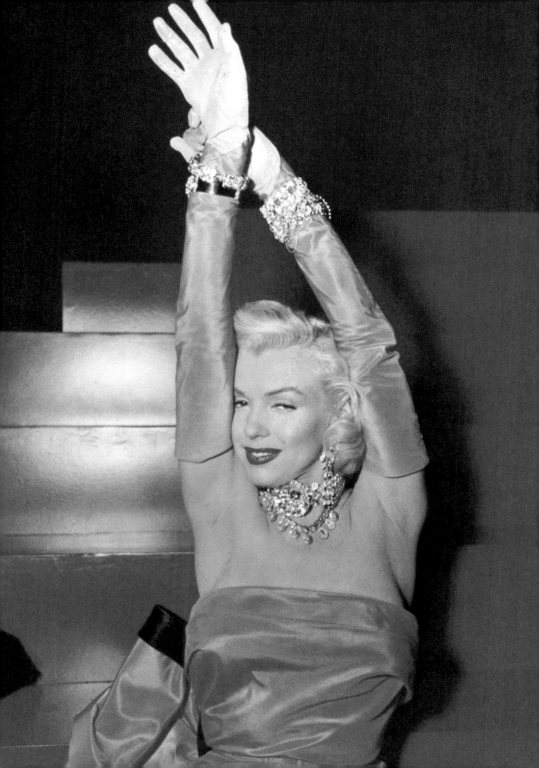

TEENAGERS
The decade's dominant fashion force

The 1950s saw a radical demographic shift, and with it arrived the 'teenager'. Teenagers set a new agenda, distancing themselves from the world of adults. They had cash from paid work, or pocket money from newly affluent parents, and a strong sense of their own style. They took their lead from popular culture: rock 'n' roll idols such as Elvis Presley, Bill Hayley and Jerry Lee Lewis, and film stars including James Dean and Marlon Brando.

Teenage style was expressed through its own music, cafés and even forms of transportation (scooters became the vehicle of choice). Fashion news spread fast, as television and fashion magazines documented and disseminated every emerging trend. In these early days of youth culture, America led and European teenagers followed.

Tribes such as 'greasers' and 'preppies' inspired dogged loyalty. Greasers were the denim- and biker-jacketed rebels who took their cue from Marlon Brando in *The Wild One* (1953). It was a bonus, of course, that the conservative older generation found them terrifying. Preppies, on the other hand, were paragons of neatness. A preppy teen wardrobe ranged from full dirndl or sunray-pleated skirt to T-shirts and sweaters with large appliqués. Tight-fitting blouses tucked into 'Capri' pants or 'pedal pushers', short ankle socks, scarves tied around the neck and cropped cardigans completed the preppy look.

As new role models sprang weekly from the movie theatre and record store, revolutionary fabrics such as polyester and spandex made it faster and easier to get their look. By the end of the decade, teenage fashion had emerged as a huge industry. Teenagers were suddenly a dominant force and a marketing man's dream.

Here 18-year-old Italian actress Elsa Martinelli (on the set of her first film *Le Rouge et la Noir*, 1954) shows how keenly European youth was influenced by American teenage style.

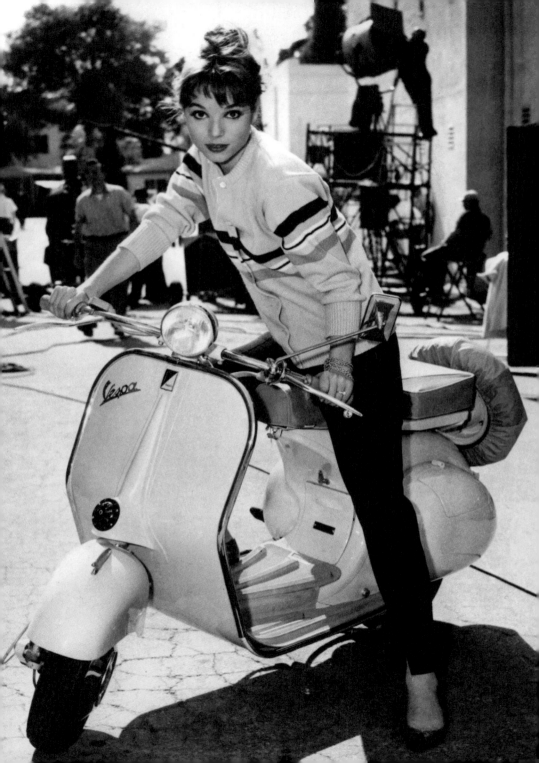

THE FIRST CHANEL SUIT
Coco's comeback classic

At the outbreak of World War II, Gabrielle 'Coco' Chanel (1883–1971) was already a fashion superstar. By loosening the corseted silhouette and commandeering unorthodox fabrics such as the jersey used for men's underwear, she had made a name for herself. Her 'look' started with her own wardrobe and lifestyle. With her tanned skin, financial independence and boyish figure, she was the living embodiment of the Chanel fashion ideal and an early example of the power of personality in fashion marketing.

Having established her headquarters in 1918 at 31, rue Cambon in Paris (where the Chanel fashion house remains to this day), she closed when Germany invaded France in 1940.

She railed against fashion's first postwar hit: Dior's New Look (see page 24). In her eyes, that corseted silhouette with its nipped-in waist and full skirt was an affront to the liberated women who had played such vital and active roles during the war. It was the antithesis of everything she stood for. In much the same way as she had done following World War I, Chanel saw it as her mission to rescue and reinvigorate women's fashion.

Her comeback was not an instant critical success. But her collection for Winter 1954 saw the launch of her reworking of her classic tweeds in the form of the Chanel suit. With its slim skirt and collarless jacket trimmed in braid with gold buttons, patch pockets, and – sewn into the hem – a gold-coloured chain, which together ensured a perfect line from the shoulder, it became a status symbol for a new generation and remains a classic to this day.

In 1954 Chanel was goaded into action because, she said, 'there are too many men in this business, and they don't know how to make clothes for women. How can a woman wear a dress that's cut so she can't lift up her arm to pick up a telephone?' Her famous suit was an enormous hit.

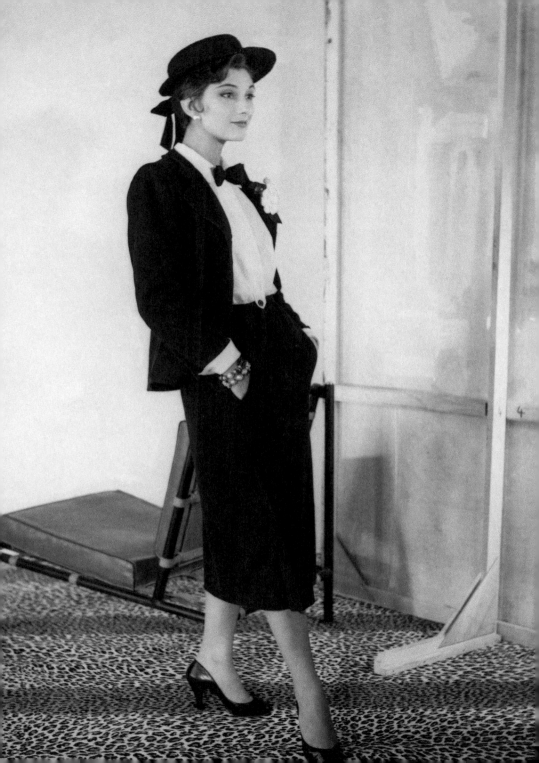

AUDREY HEPBURN IN
SABRINA

Hepburn meets Givenchy and one of
fashion's longest collaborations begins

Audrey Hepburn's collaboration with Givenchy started with the film *Sabrina* (1954) and caused an earthquake among the style conscious. Like Coco Chanel, she not only changed the way women dressed but also altered forever the way they viewed themselves, broadening the definition of beauty and offering the world a less submissive, less blatantly sexual model than the pin-ups of the day.

Every woman wanted to be Audrey Hepburn (1929–93). The embrace of her style went farther than the clothes on her back. 'Everyone on the street was copying Audrey's hair,' Dreda Mele, *directrice* of Givenchy (see page 54) at the time, recalled, 'the way she moved, the way she spoke. They copied her for ten solid years after.'

Hubert de Givenchy's name is missing from the credits on *Sabrina* because credit was contractually bound to go to Edith Head (see page 58), the famed costume designer at Paramount, who at the time also tried to take the plaudits for Givenchy's 'décolleté Sabrina' (the simple black cocktail dress Hepburn wore in the romantic comedy). In spite of this tricky start, the movie marked the beginning of Hollywood's longest-running wardrobe collaboration.

Givenchy designed Hepburn's wardrobe for *Funny Face* (1957), *Love in the Afternoon* (1957), *Breakfast at Tiffany's* (1961), *Charade* (1963), *Paris When It Sizzles* (1964) and *How to Steal a Million* (1966). He also designed her dress for her second wedding and her sons' christening gowns. Together they developed the crisp lines, simple colour and extraordinary workmanship that defined Audrey's style – described by the Spanish shoe designer Manolo Blahnik (see page 398) as 'the most important look of the twentieth century'.

Givenchy confirmed that Audrey's elevation to global style leader was no accident: 'She knew exactly what she wanted. She, moreover, knew perfectly her body's fine points and faults: she wanted a bare-shouldered evening dress modified to hide the hollows behind her collarbone. What I invented for her eventually became a style so popular that I named it the décolleté Sabrina.'

Hepburn's style was of a subtle, grown-up kind for the newly style-conscious America that would, in a few short years, embrace the heady optimism of the Kennedys', Camelot and the 1960s. Billy Wilder, the director and producer of *Sabrina*, picked up on Hepburn's sophisticated appeal, saying, 'This girl, singlehandedly, may make bosoms a thing of the past.'

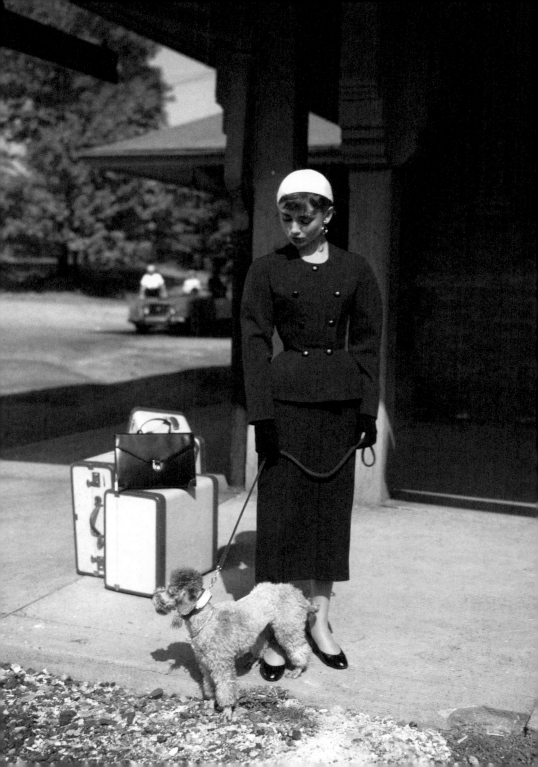

HUBERT DE GIVENCHY

The aristocratic designer

The aristocratic Hubert de Givenchy (1927–2018) arrived in Paris at the age of 17 to work with Jacques Fath (see page 26) and to realize his childhood dream to be a dress designer. By the time he set up his own house in 1952, he had added experience with Robert Piguet, Lucien Lelong and Elsa Schiaparelli to his CV.

The house of Givenchy debuted with a collection that included the Bettina blouse, named after his PR director and model of the day, Bettina Graziani (see page 26). It was a look that was to be a Givenchy signature for the length of his career. The blouse was made from the raw cotton 'shirting' that had previously been used only for couture fittings.

It wasn't long before Givenchy was attracting notable clients. Indeed, during more than 40 years as a couturier he dressed some of the most memorable women of the century. Grace Kelly (see page 60) wore an emerald-green Givenchy on her first official visit to President Kennedy in Washington, DC in 1961. He created the wardrobe for Jackie Kennedy's state visit to France in the same year (see page 172), and in 1972 the Duchess of Windsor (see page 10) wore a black coat by Givenchy to her husband's funeral.

But it was his association with Audrey Hepburn (see pages 52 and 122) that was to last the longest and be the most influential. Givenchy designed the black sheath dress that the actress wore in *Breakfast at Tiffany's* (1961), as well as costumes for the films *Sabrina* (1954), *Funny Face* (1957) and *Charade* (1963) and clothes for her off-screen life.

When the pair first met, Givenchy was expecting an encounter with the then much more famous Katharine Hepburn (see page 18). However, when Audrey turned up dressed in a knotted T-shirt, flat sandals and a gondolier's hat, they discovered an instant rapport that was to lead to a lifelong friendship between the French designer and his muse.

Givenchy dispensed with the boning, padding and stuffing that characterized the competition. His was a simpler approach: separates that could be worn together or in a variety of combinations. No big deal today, but his uncomplicated and young style was revolutionary in its time – and a huge success. On the first day of selling, Givenchy Couture was reported to have racked up sales of seven million francs.

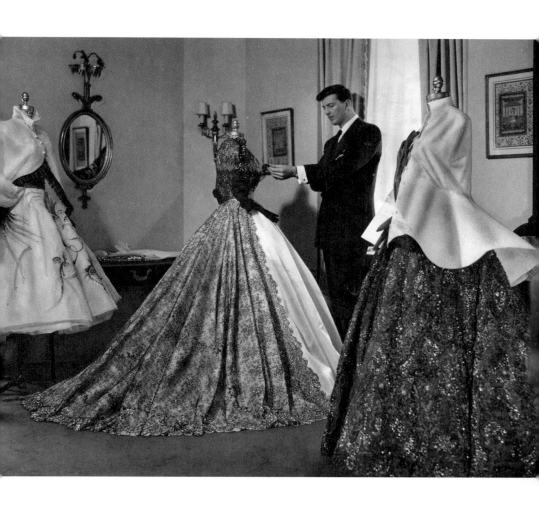

C Z GUEST
Patrician East Coast chic

'She came into the bar of the Ritz wearing a knee-length tweed skirt, a twinset and moccasins – and in a time when everyone else was tarted up in Dior's New Look [see page 24], she stopped traffic,' remembered designer Bill Blass of C Z Guest (1920–2003).

She was the archetypal WASP icey blonde, an impeccably raised young lady and an accomplished horsewoman who competed all over America, but who nevertheless ran away to become a showgirl in Darryl Zanuck's Ziegfeld Follies and was painted nude by Diego Rivera. She put her early years behind her when, in 1947, she married Winston Guest on Ernest Hemingway's plantation in Cuba. She was an unassuming style icon. Commenting on her role as a designer muse, she said, 'I like fitted clothes that show off the body. I wasn't the inspiration for Mainbocher. My style was his style.'

Early in the 1950s, the New York Dress Institute cited Guest as one of the best-dressed women in the world, and she remained on the list for years until her elevation to the Fashion Hall of Fame. *Time* magazine had her photographed by Horst for the cover of an issue in 1962 that ran with the headline, 'A Legend in Her Own Time'.

Guest's look was classic American thoroughbred: blonde hair, pale complexion and a slim, athletic figure dressed in simple lines, luxurious fabrics and a combination of neutral and fondant pastel colours. Her unfussy, clean-cut style defined the archetypical patrician American look. It is the foundation on which Grace Kelly (see page 60) built a career and Ralph Lauren (see page 324) an empire. It became the blueprint of acceptability in the enclaves of Palm Beach and Southampton: a sporty, outdoorsy look that eschewed makeup, hairspray and, heaven forbid, anything resembling a trend.

C Z Guest stands out among the novelist Truman Capote's fabled 'swans' as the smoothest of the flock. The 'cool vanilla lady', as he called her, had an 'ice cream reserve' that measured up to her sartorial discipline. 'She dreads overdressing,' *Vogue* observed in 1959. Here she poses with Joanne Connolly (right) beside the Grecian temple pool of her Palm Beach estate.

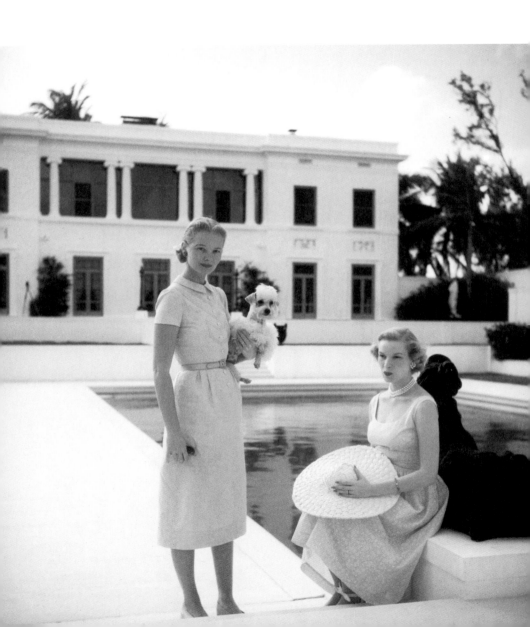

EDITH HEAD

Pillar of the Hollywood studio
system and American fashion

Edith Head (1897–1981) was the fabled costume designer who worked for Paramount Pictures for 43 years. She was Hitchcock's favourite costume designer; she created Dorothy Lamour's famous sarong dress for *The Hurricane* (1937), and she also dressed Audrey Hepburn (see pages 52 and 122) in *Roman Holiday* (1953).

But the gossip in Hollywood was that Paramount's formidable doyenne of the costume department wasn't a designer at all. Detractors dismissed her as 'the queen of the shirtwaisters'. It was said she didn't even know how to draw. She admitted to getting her first job interview with someone else's sketches, and it was rumoured that she continued to add her distinctive looping signature at the bottom of others' work. She controversially got credit for Givenchy's designs for Audrey Hepburn, claiming the 'décolleté Sabrina' as her own, having in reality designed only the ragamuffin-living-over-the-garage costumes in the movie.

While her design credentials may have been suspect, she was nonetheless an accomplished handler of people. In the hierarchical studio system, Edith was famous for being the only person who could be both 'subservient and behave like a star'. Leading Hollywood ladies such as Ginger Rogers, Shirley MacLaine, Barbara Stanwyck, Elizabeth Taylor and Natalie Wood demanded to work with her. In a world full of prima donnas, Head had the hard-nosed acumen of a corporate executive. She subtly made herself indispensable to those above her in the power chain. Whenever a star or an important executive's wife needed to borrow a dress to go to a premiere or a party at Romanoff's, Edith happily lent them something.

Head is immortalized as the firebrand Edna Mode in Pixar's 2004 cartoon feature *The Incredibles*.

During her 58-year career, Head received more than a thousand screen credits, won 35 Oscar nominations, and got the Academy Award for costume design an unprecedented eight times. Her ability to placate difficult personalities and to camouflage problem figures made her a huge success and a Hollywood legend.

GRACE KELLY
The idealized 1950s blonde

Grace Kelly (1929–82) was the perfect 1950s beauty. If she did not necessarily lead fashion, she certainly became a byword for an impeccably polished look: one that would inspire designers and stylists for generations.

It was New York fashion designer Oleg Cassini, briefly engaged to Kelly, who claimed to have created the Kelly look, but it was the director Alfred Hitchcock who honed it. Even the mighty costume mistress Edith Head (see page 58) admits she deferred to his vision. The director was obsessed with creating Kelly as a 'credible hybrid of elegance and sex'. And the pastel shades and pristine white that he believed best suited his ideal blonde became her signature.

Even in mufti, dressed, as Cassini described her, 'like a school teacher' in her wool skirts, cashmere cardies and horn-rimmed glasses, she had 'a white-gloved glow'. She had studied ballet and never lost a dancer's awareness of her limbs and posture. Her unique walk became part of her style: regal above the waist and floating below, it was compared to a geisha's glide.

Hitchcock and Kelly understood the appealing edge added by the conflict implicit in her style. At once ladylike and elemental, it carried beneath its ice-cool exterior a suggestion of something more passionate. Her remoteness on screen became a reality when, after a fleeting five years of Hollywood fame, she disappeared to marry Prince Rainier of Monaco and join a European royal family.

And yet Kelly was down-to-earth with a reserved, bluestocking style. Brought up in a disciplined and conservative household, even at the height of her Hollywood fame she eschewed couture. This didn't stop her becoming joint number one on the 1955 'best dressed' list, alongside socialite Babe Paley (see page 98) who wore Mainbocher. Her likeness, that year, was used to create a line of mannequins.

In *To Catch a Thief* (1955), Kelly's gowns were based on classical draping, with sheer trains and scarves creating wafting breezes around her neck. Reflecting the Hellenistic sculpting of 1950s couturier Madame Grès, they gave Kelly the allure of an earthbound goddess. Fitted bodices and billowing skirts in a palette of pastel and white were a quintessentially Kelly-esque fusion of the balletic and the sporty.

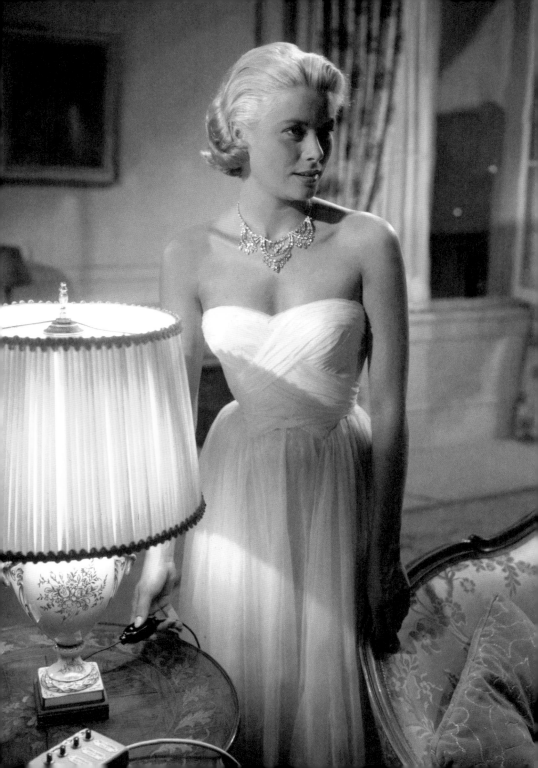

SOPHIA LOREN

Italian bombshell glamour

1955

The Italian bombshell of the 1950s was a reluctant style icon. Sophia Loren (1934–) made it through a rough, poverty-stricken childhood and, as an aspiring beauty queen, was discovered in Rome by film producer Carlo Ponti, the man who would later become her husband.

She became the benchmark of Italian glamour throughout the 1950s and 1960s. No one has ever worn a corset with the same sophisticated and sizzling aplomb as Sophia Loren in *Marriage Italian Style* (1964). And, now well into her eighties, she continues to inspire the red-carpet style of contemporary starlets. There is more than a soupçon of Sophia in the likes of Scarlett Johansson and Eva Mendes. An Italian national treasure and a fashion inspiration, she remains a front-row presence at Giorgio Armani (see page 336) and Valentino (see page 194) fashion shows.

Loren is quoted as saying, 'Everything you see, I owe to spaghetti.' And even though she has denied ever having said this, it was indeed her curvaceous figure and seductive joie de vivre that catapulted her to global stardom. Her voluptuous curves were a constant reminder that her first stage name was 'Sofia Lazzaro' – as it was claimed her beauty could raise men from the dead.

Dolce & Gabbana's Summer 2012 collection was dedicated to the image of Loren in *Pane, amore e …* (1955). The scoop-necked dresses with nipped-in waists and full skirts in sunny summer prints, accessorized with straw baskets, stilettoes and headscarves, were pure Sophia.

'A woman's dress should be like a barbed-wire fence,' Loren once declared, 'serving its purpose without obstructing the view.'

Sophia Loren burned up the silver screen to become the epitome of the Cinecittà sex symbol. In the comedy *Pane, amore e …* she played a lovely fishmonger with an unfeasibly gorgeous wardrobe. Circling her 70th birthday, she was placed sixth in *Playboy*'s 100 Sexiest Women of the Century.

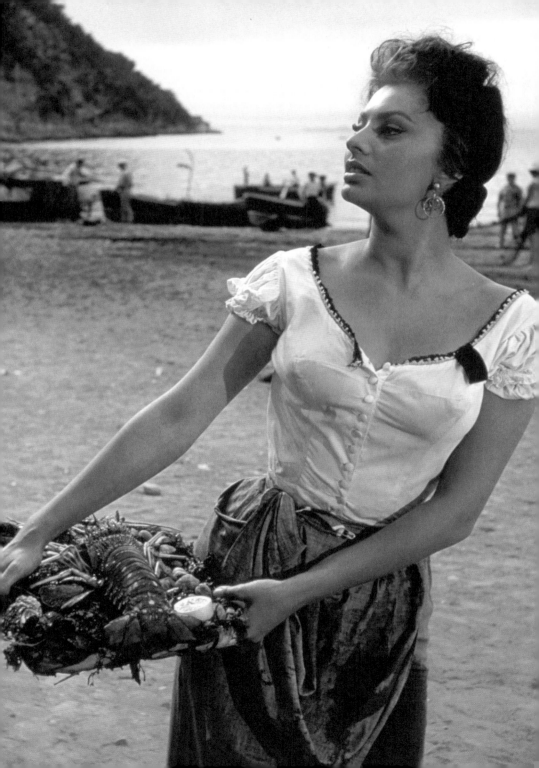

BEATNIK STYLE

Art delinquents who believed the
pen is mightier than the sword

The new youth-culture movements of the 1950s tended to take root first among the working classes. However, the beatniks who emerged in America and Europe during the middle of the decade were firmly entrenched in the middle class.

Beatniks rebelled against the establishment and their parents. They shored up the generation gap, questioning not only their own upbringing, but also authority, the government, the arms race and all bastions of middle-class affluence. In America the Beat movement thrived in New York in the Greenwich Village bars and coffeehouses where the acolytes of writers Jack Kerouac and William Burroughs gathered. In Paris they gravitated to the company of philosopher Jean-Paul Sartre and chanteuse Juliette Gréco in the cafés of St-Germain-des-Prés.

The Beat Generation were the early precursors of the hippy movement, producing a culture of dropping out of society and rejecting its familiar touchstones. Dropouts need a uniform to set themselves apart from society, and their particular sartorial statement was made in head-to-toe black. It was described as a combination of the 'French bohemian, English intellectual and US hobo'. They wore polo-necks and jeans, duffel coats and dark glasses. They were art delinquents who loved jazz and poetry, who believed the pen was mightier than the sword. They were immortalized on screen in glorious VistaVision by the character played by Audrey Hepburn (see page 122) in the 1957 film *Funny Face*.

Journalist Lee Gibb commented: 'They have replaced the American haircut with the French haircut. They have replaced high heels by low heels, low heels by no heels and no heels by bare feet.'

The idealism of Kerouac became a fashion statement, thanks to Audrey Hepburn in *Funny Face*. Writer Joyce Johnson defined its value to the marketing men when she said, 'the "Beat Generation" sold books, black turtleneck sweaters and bongos, berets and dark glasses, sold a way of life that seemed like dangerous fun.'

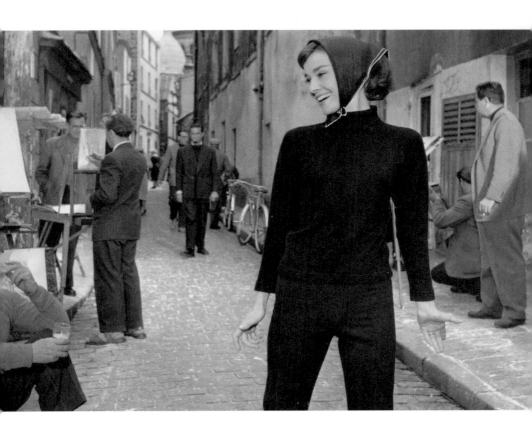

EASY-CARE FABRICS

Space-age technology produces miracle yarns

With post World War II economic expansion came a new generation of synthetic fabrics. In the summer of 1952 the term 'wash and wear' was coined to describe a new blend of cotton and acrylic. The 'easy-care' fabric family was to grow and grow.

Acrylic was marketed alongside nylon and other synthetics as a 'miracle fabric' – crease-proof, shrink-proof and quick-drying. 'Drip-dry' nylon and Dacron could retain heat-set pleats after washing, and became immensely popular. Polyester came along in 1953, offering a fabric that would keep its shape in spite of the most brutal crushing and which did not wrinkle with everyday wear. A tagline from an Orlon advertisement stresses the uncreasability of the DuPont acrylic, showing an impeccably dressed mother in New Look silhouette greeting her family off a plane: 'With Orlon you hide the miles you've traveled.'

The clothing industry went into creative overdrive with the new design possibilities presented by the new materials. By the mid-1950s a boom in women's knitwear was under way, and acrylic, perfectly suited to imitate expensive wool, was there to meet the demand. By the 1960s sales were worth £1 million a year.

The availability of synthetic fibres profoundly influenced the way Americans and Europeans clothed themselves and lived. Women had to handle the family wash at home. Synthetics made that not just easier, but in many cases possible. The new fibres also represented a trade-off – they were easier to iron and longer-lasting, but harder to keep clean and uncomfortable for some uses (shirts and underwear, for example).

Wrinkle-resistant and durable, synthetic fibres were embraced by a culture that equated crisp clothing and neat home furnishings with bourgeois respectability.

The dream wardrobe of the future was available in the present to middle-class consumers with increasing spending power. Mass clothing manufacturers made lavish and creative use of 'miracle fibres' to produce fashion that, a generation before, would have been beyond the reach of all but the wealthiest.

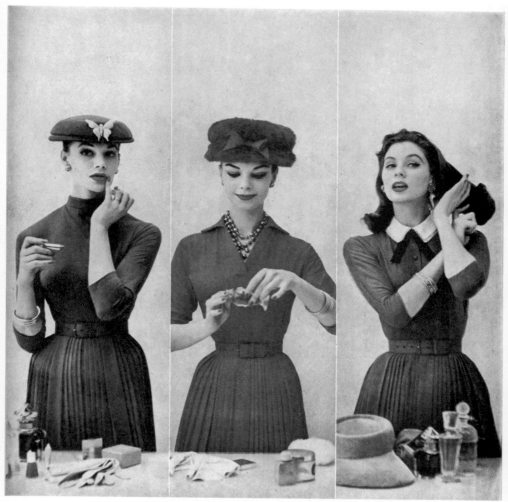

now: jersey you can wash and wear! It's 100%

ACRILAN

Machine-wash (or hand-wash if you prefer). Use a warm-water setting; drip-dry. Pleats stay crisp, shape will stay luscious with little if any ironing. Rich to see and feel, too: *this* jersey's 100% Acrilan acrylic fiber! *styled by Kay Busgang for* ALICE STUART

BRIGITTE BARDOT

A sensuous idol

In the pantheon of legendary blondes, Brigitte Bardot (1934–) reigns at the right hand of Marilyn Monroe. She took the ingredients of the classic 1950s heroine – the breathless, wide-eyed, innocent blonde – and put a flirtatious French spin on her. *Vogue* called her 'the sensuous idol, a potent mixture of the sexy and the babyish, a seething milky bosom below a childish pout'. The phrase 'sex kitten' was coined to describe her.

She captured the imagination of intellectuals and film fans alike. The French feminist Simone de Beauvoir described her as 'a locomotive of women's history' and declared her the first and most liberated woman of postwar France. She became a national treasure, and in 1969 was chosen to model for the face of Marianne, a previously anonymous figure representing the state of France.

Bardot was the personification of a new carefree, laissez-faire lifestyle and she enjoyed the heady existence that represented the time. She made her home in Saint-Tropez, thereby putting that small fishing village on the fashion map. Saint-Tropez characterized the lifestyle she embodied – one of scruffy insouciance and spontaneous chic – and, having received the benediction of the luminaries of the Nouvelle Vague, it gave birth to trends that were adopted on beaches around the world. Thanks to Bardot, the bikini became a global, barnstorming fashion success (see page 36).

Bardot started out as a model and a dancer, appearing on the pages of French *Elle* at 15 and enrolling at the Conservatoire nationale de danse in Paris before becoming an actress.

The elements of Bardot's style were a polka-dot scarf, short shorts, a full-skirted gingham dress, a sweep of eyeliner and the 'choucroute' hairstyle. The Bardot neckline (a wide open sweep that reveals the shoulders) is a recurring catwalk detail that to this day signals her enduring fashion influence.

Bardot was one of the few European actresses of the 1950s and 1960s to achieve success in the US. Idolized by the public and stars alike (including John Lennon, Paul McCartney and Bob Dylan), she was propelled to fame by her 'sex kitten' image. In 1956 her role in *Et Dieu ... créa la femme* pushed the limits of censorship in America, and her ever-increasing army of fans loved it.

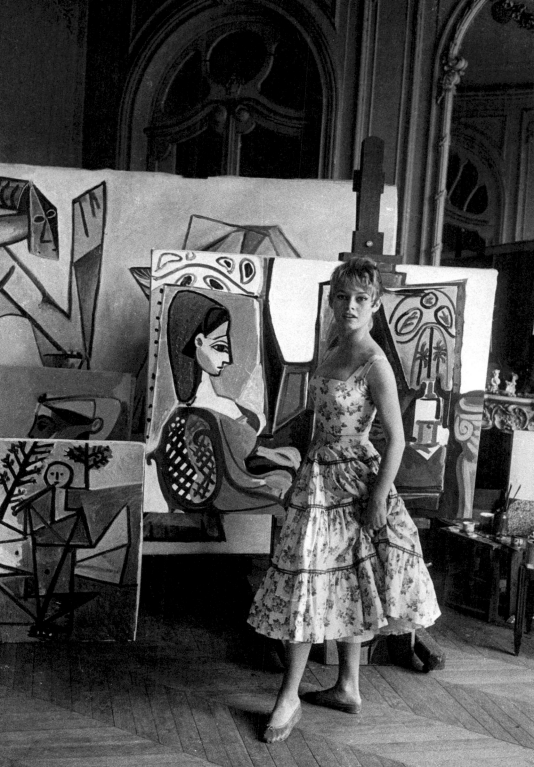

FRANÇOISE SAGAN
The 'charming little monster'

During the 1950s Françoise Sagan (1935–2004) became a star, expressing all the rebelliousness of her peers in the French bourgeoisie. A Sorbonne dropout, she famously blew her advance for *Bonjour Tristesse* (1954), her first novel, on a black sweater and rounds of whisky for her friends. The English translation of *Bonjour Tristesse* went to number one in the *New York Times* bestseller list the following year, and in 1958 Otto Preminger directed the movie version starring Jean Seberg (see page 114).

This meteoric success made Françoise Sagan independently wealthy at the age of 19. And she lived large. With the early proceeds of her first novel she bought a mink coat for her mother and a Jaguar for herself. She drank till dawn and gambled lavishly. It has been reported that she once made a killing at the gaming tables of Deauville and used the money to buy herself a turn-of-the-century chateau. She suffered severe head trauma when she overturned her Aston Martin in 1957.

Sagan was the symbol of fashionable rebellion in postwar Europe. One critic called her 'a notorious representative of the younger generation'. The writer François Mauriac described her as 'a charming little monster'. With her gamine face and her thirst for hard liquor, shiny sports cars and thrilling sex, Sagan resembled a sensuous tomboy. Her life in the 1950s reads like one long lunch, drinking and carousing session with the likes of Tennessee Williams, Henry Miller, Roger Vadim, Jean-Luc Godard and Juliette Gréco.

Sagan was the archetype of the teenage rebel in a postwar Paris that was electric with beatniks, jazz and existentialism. She articulated teenage angst with unique style: like a literary Keith Richards, she was a breath of fresh air in the hyper-bourgeois France of the 1950s.

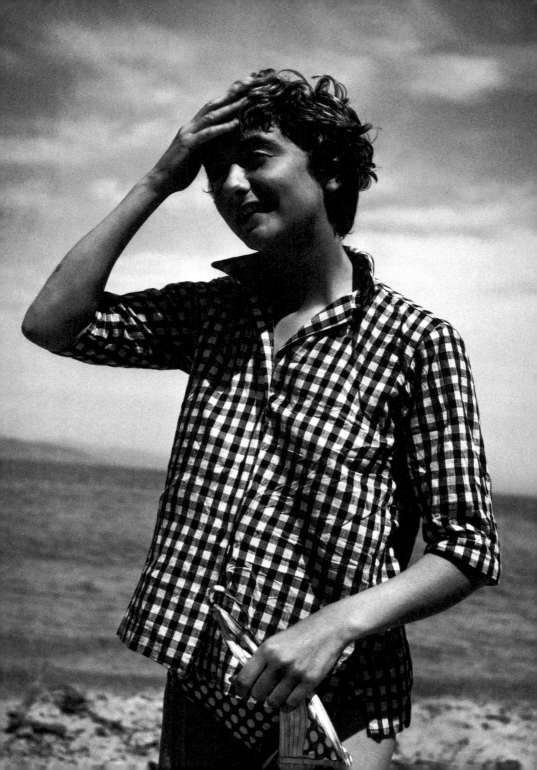

GRACE KELLY'S WEDDING DRESS

One of the most copied gowns of all time

It was dubbed the 'Wedding of the Century'. Grace Kelly (see also page 60) privately referred to it as the 'Carnival of the Century'. Whichever way you look at it, the wedding of Prince Rainier of Monaco and Grace Kelly on 19 April 1956 in Saint Nicholas Cathedral of Monaco, watched by 30 million people, was arguably the first multimedia event on a modern scale.

The gown Grace Kelly wore is one of the most copied wedding dresses of all time. More than 50 years later, commentators noted that, at another wedding of the century, Kate Middleton's dress by Sarah Burton for Alexander McQueen had distinct 'echoes of Grace Kelly's style'.

At the Monaco wedding, nearly two thousand reporters and photographers were present to record the picture-perfect ideal of postwar 1950s culture. Even the pink cathedral atop its white steps looked like a Marguerite Patten cake. Grace walked up the aisle watched by guests including Ava Gardner, François Mitterrand and Jean Cocteau.

It was a ceremony of epic Hollywood proportions, with a wardrobe to match. Little wonder – given that, in exchange for the termination of her contract, Grace had granted MGM exclusive rights to produce *The Wedding in Monaco*, a half-hour documentary chronicling the nuptials. The studio bankrolled the extravagant Monte Carlo wedding and also paid for the wedding dress.

However, Grace's own attitude hinted at the conflict that would define her future life as a public figure exposed to almost continuous and intrusive scrutiny. As Prince Rainier himself said, 'Grace would have loved to run off and be married in a simple little chapel in the mountains. This unrealistic idea really enchanted me.'

The dress – 25 yards of silk taffeta, antique rose-point lace and pearls – was created by Helen Rose, an MGM costume designer. It was she who had dressed Kelly in safari chic for *Mogambo* (1953) and in the memorable fit-and-flare looks of *High Society* (1956).

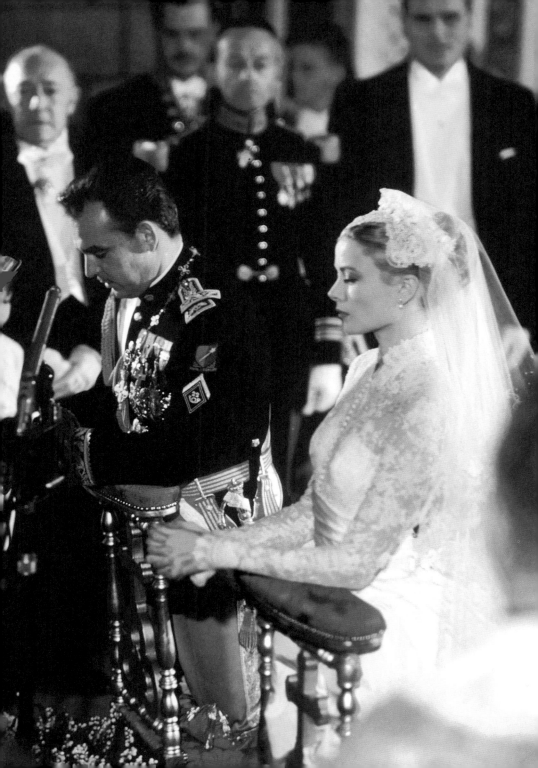

THE KELLY BAG

Fashion's most enduring 'It' bag

It was the director Alfred Hitchcock who was behind fashion's first ever 'It' bag. For it was he who suggested to costume designer Edith Head (see page 58) that she go to Hermès in Paris to buy accessories for the 1954 movie *To Catch a Thief*. Of their visit to the Faubourg St-Honoré store, Head recalled that she and Grace Kelly (see page 60) 'were like two girls in an ice cream shop. We fell in love with everything we saw.'

The boxy handbag that was Kelly's favourite was to become the icon of the house that endures today. It was a descendant of the 1930s Hermès saddlebag (the *sac à dépêches pour dames*) that was originally called the *haut à courroies*. But two years later, in 1956, Hermès rechristened it, after Princess Grace used a version in brown pigskin to hide her pregnancy from prying paparazzi. The photograph appeared in *Life* magazine and the phenomenon of 'the Kelly' was born.

Impeccably made in small production runs by craftsmen in the Hermès factory, the simple bag rapidly achieved iconic, 'must-have' fashion status. The Birkin, Hermès's other bestselling bag, may have an element of showy glamour about it, but, by contrast, the Kelly remains an understated classic – the bag that has played a supporting role to stylish women of all ages for more than 80 years. Despite a prohibitive price starting at £3,500, there are long waiting lists at Hermès stores around the world for the opportunity to buy one.

To this day, only one craftsperson, who may have been employed by the company for decades, makes a single handbag at a time, hand-stitching individual pieces with linen thread and an awl. One bag might take 18 to 24 hours to produce.

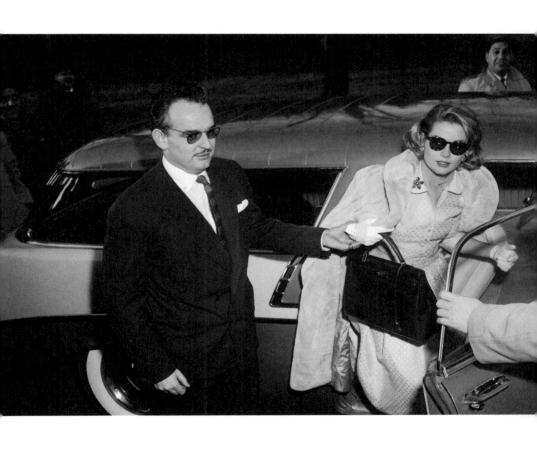

JAYNE MANSFIELD

Blonde ambition

Jayne Mansfield (1933–67) was frequently branded a poor man's Marilyn Monroe (see page 46). Certainly the blonde bombshell from Pennsylvania lived up to the stereotype she helped to create. But while she may have been the archetypical Hollywood blonde, her style gives clues to more intriguing contradictions.

Swathed in figure-clinging dresses and tight-fitting sweaters, and with arms and ears piled up with paste costume jewellery, she was unmissable. Her hair was peroxide-white blonde and her lips were extravagantly red. So far so ditsy, but she was far greater than the sum of her eye-popping parts. With an IQ of 163, she was a proficient musician and an actress with a flair for comedic timing.

In a world where women were paragons of pastel-dressed perfection, Jayne was bold, brash and modern, with a daredevil spirit. She was also a crusading self-promoter. She was a head-turning presence, but if she startled she also inspired, and the classic 1950s silhouette of curvaceous slim waist and underwired 'missile' bosom was all Mansfield.

She saw her main rival as Marilyn Monroe, but their personalities and looks were quite different. Jayne was more confident about her appearance and would use it to get publicity and attention. She happily traded on her figure and sexuality, becoming Hollywood's first on-screen nude. She cheerfully went out in public in see-through dresses that scandalized audiences. One appearance was in a leopard-print bikini, accessorized by her Mr Universe husband, Mickey Hargitay, dressed as Tarzan.

Mansfield defined 1950s extravagance and decadence. Larger than life, she was a caricature of the blonde starlets of the era. However, she was also one of 1950s Tinseltown's legendary phenomena.

In the years 1956 and 1957 Mansfield's photo was published on separate occasions in more than 2,500 newspapers. She was a household name and was frequently compared to Marilyn Monroe. In response to this, she was quoted as saying, 'Cleavage, of course, helped me get to where I am. I don't know how she got there.'

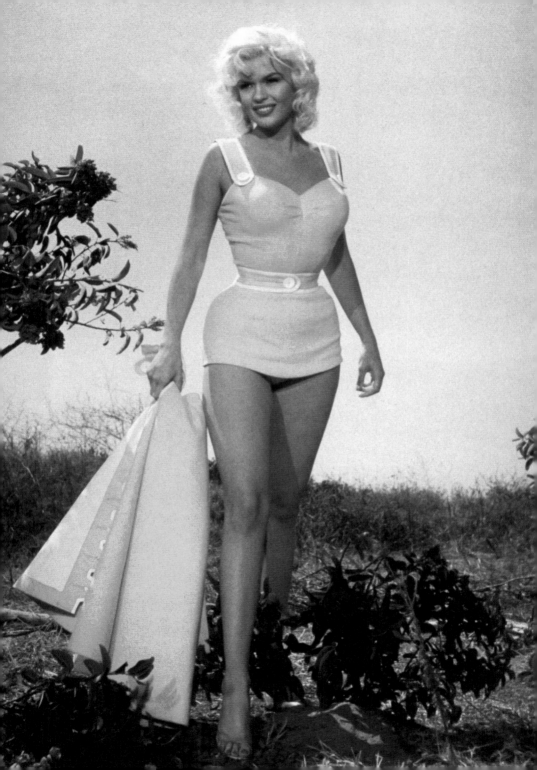

THE JET SET

London for breakfast, New York for lunch

Travel opened up after the war, although not for everyone. In the 1950s, the new jet passenger services were primarily marketed to the rich. The 'jet set' was a group of wealthy people whose busy social diaries included engagements in chic and rarefied locations all over the world. Their lifestyles were glamorous and stratospherically beyond the reach of the majority, whose existences revolved around the daily commute and weekend socializing in the suburbs.

The new jet set were the children of the café society, freed to travel from one fabulously stylish place to another by the jet aircraft. BOAC inaugurated the first commercial scheduled jet service on 2 May 1952, from London to New York. As other routes opened up, so too did the diaries of the jet set. Other cities on the standard jet-set routes were Paris, Rome and Los Angeles. Jet-set resorts such as Acapulco, Nassau and Bermuda flourished, while the formerly sleepy towns of Saint-Tropez, Capri and Cannes became the busy hubs of the social universe.

The original members of this elite group of glamorous global nomads were socialites who were not shy of publicity, and whose nightly entertainments took place in semi-public places such as nightclubs and restaurants, where the 'paparazzi' – another jet-set phenomenon – photographed them. They were fantastically aspirational figures: superstars of the first generation who might weekend in Paris or fly to Rome just for a party. Their lifestyle was memorably captured in Fellini's *La Dolce Vita* (1960, see page 118).

Long before the advent of budget airlines, passengers dressed for travel. One BOAC flight from Southampton to Johannesburg boasted a lounge/dining area on the upper deck, two dressing rooms on the lower deck, and 'day and night accommodation' for 24 passengers.

ROCKABILLY
'Postwar punk rockers'

Rockabilly, the music of Elvis, Buddy Holly and Bill Haley, and one of the earliest forms of rock 'n' roll, emerged early in the decade. The name is a hybrid of 'rock ['n' roll]' and 'hillbilly', a reference to country music (which was often called hillbilly music in the 1940s and 1950s). The music and the style were inextricably linked.

With the end of World War II and prosperity on the rise, young people had the opportunity for the first time to create identities that had nothing to do with the generation that had gone before. Their parents might have needed to get jobs to support their families, but young people in the 1950s had much more free time on their hands. Youth culture had arrived. Some stayed on longer at school. But the clean-cut preppy was the polar opposite of the rebellious rockabilly youth. The latter were menacing, outrageous and frightening: for a sense of their impact, think 'postwar punk rockers' in customized cars or on roaring motorbikes.

Men wore well-greased pompadours (a style that Elvis had copied from the truckers in the Southern states), jeans (a staple of the working man's wardrobe, see page 42) and tough leather jackets. Women wore wide circular skirts held out with nylon petticoats, scoop-neck blouses, back-to-front cardigans, tight sweaters or polo necks, and three-quarter-sleeve fitted shirts, often with a scarf knotted in cowboy fashion at the neck. Both music and fashion were neatly calculated to distance youthful rockabillies from the previous generation.

In Britain, rockabilly fans were called 'Teddy boys' on account of their Edwardian frock-coats, which they wore with black drainpipe jeans and brothel creepers. By the early 1960s, they had morphed into rockers and adopted the classic 'greaser' look of jeans and leather jackets to go with their heavily slicked quiffs.

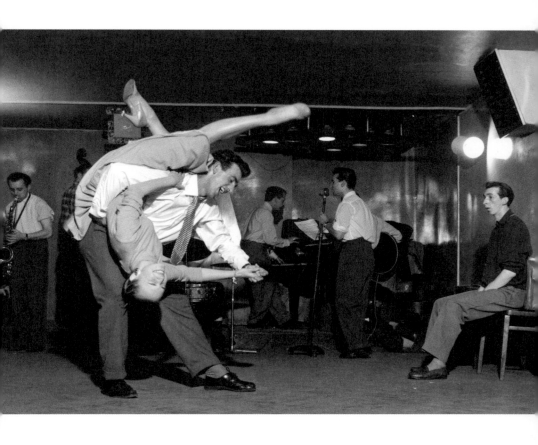

WILLIAM KLEIN
Fashion's fabulous iconoclast

In the 1950s, photographers and models achieved star status and became household names for the first time. They were heroes of a new popular culture that flourished in magazines. At the same time, newspaper editors became more interested in them, and not just for the gossip columns. They realized that fashion pages could be a dynamic and glamorous presence in their papers. And, understanding that men as well as women looked at these features, they started to use the pictures that were a little sexier and more sensational. Photographers began to use models in a more provocative way.

At the cutting edge of this new mood was William Klein (1928–), a young American photographer living in Paris. Through his work he brought an unusually acidic and ironic approach to fashion photography. In the world of haute couture, where the haughty froideur of well-born beauties was a given, Klein was an iconoclast.

The edgy environments he chose in which to shoot his fashion stories were as important as the clothes. He managed to capture the qualities of movies and television in his dynamic images. Klein's models looked independent and tough, with a kind of knowing air. They looked streetwise, versed in the rules of the city, not the salon. It was a world away from what qualified as the classic chic of the time. And it set a new standard for fashion photography.

'I used semi-nuts,' he said. 'I liked the tough girls from New York and the backstreets rather than the socialites. In my photos the girls are always in trouble, always askew. Or I play two girls off each other. Helmut Newton's pictures come out of mine because I was the first to use hard girls.'

Klein, the artist turned photographer, has combined a career as a photographer and photojournalist with that of film maker, and his fashion images, such as this, have all the drama of a movie still.

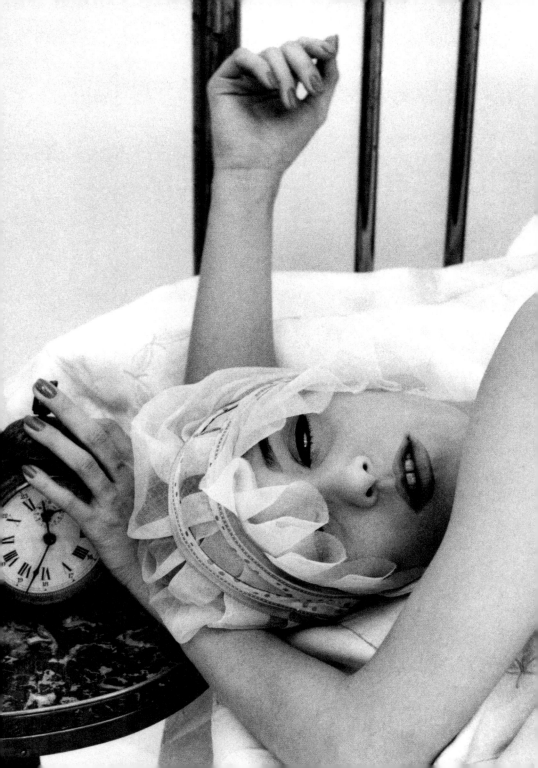

CLARE McCARDELL

The American modernist

After the war years of militaristic suits, armoured shoulder pads and nose-cone breasts, McCardell liberated the women of the 1950s from the strictures of mother's girdle. According to *Vogue*, the ideal Claire McCardell woman was 'a long-legged tennis-playing swimming girl…She looked exactly like the typical American girl, just as real, only prettier.'

Claire McCardell (1905–58) made clothes that were revolutionary and also right for every girl in America. There was something of the pioneer woman in the frugal but beautiful cut of the suit; something unapologetically practical in the stout welt seaming. McCardell invented things within the limits of mass production at a time of couture. She could take $5 of common cotton and turn out a dress a smart woman could wear anywhere. Her clothes were relatively inexpensive because she used cotton instead of satin and silk.

'Clothes ought to be useful and comfortable,' McCardell said. 'I've often wondered why they had to be delicate – why they couldn't be practical and sturdy as well as feminine.' One of her constants was the monastic dress, which could be full or slim as long as it didn't have a built-in waistline – she preferred her customers to determine where their own waist should be by selling her dresses with tie sashes.

McCardell also created a six-piece interchangeable wardrobe for the woman traveller, with skirt, jacket, blouse, trousers, shorts and halter top in either denim or black butcher cloth. Her inspiration, McCardell claimed, came from solving problems.

The story of American fashion owes much to Claire McCardell, who has been described as having introduced 'the American Look', in contrast to Dior's New Look. The feminist Betty Friedan described her as 'the girl who defied Dior'.

SUZY PARKER

The vivacious face of the 1950s

It was Suzy Parker (1932–2003) who inspired the beatnik character played by Audrey Hepburn (see page 122) in *Funny Face* (1957). She was also the favourite model of the movie's visual consultant, the photographer Richard Avedon. He said she gave modelling 'emotion and reality. She invented the form and no one surpassed her.' She was, he declared, 'the most challenging and complicated' of his muses.

It was Avedon who introduced spirited animation into fashion photography, and it was Parker who realized his vision in front of the camera. She roller-skated in the place de la Concorde for his camera – in a Dior dress, of course. Her elder sister was Dorian Leigh, a famous model of the 1940s who introduced her, at the tender age of 14, to Eileen Ford. The legendary model agent said of her afterward: 'She was the most beautiful creature you can imagine; she was everybody's everything.'

Parker travelled to Paris at 17 for *Harper's Bazaar* and stayed on, exploring the Left Bank clad in existential black. Although modelling gave her access to anywhere she wanted to go, she dropped it to become apprentice to the photographer Henri Cartier-Bresson and to edit French *Vogue*. But the money was alluring – at $200 an hour she was the highest-paid 'face' of the time. And as the fashion editor Diana Vreeland (see page 126) once remarked, 'Hers was the face of the '50s.'

Suzy Parker was an icon for the relaunched house of Chanel. Charles Revson of Revlon cosmetics was obsessed with her, and she was able to demand the exclusive contract that only became commonplace decades later, even though Mr Revson was of the opinion that 'the sheer joy of working for Revlon should be enough'.

Parker was given a cameo in *Funny Face* by its director, Stanley Donen, who also cast her in *Kiss Them for Me* (1957) with Cary Grant and Jayne Mansfield. But she was something of a flop on the big screen: her vivacity did not translate.

'Suzy Parker didn't stop talking when I first tried to take her picture,' recalled, the photographer Horst. 'I said, "You keep talking," and I left. When she got into the movies, I joked that maybe she would do for the movies what she would never do for me – hold still.'

THE GOSSARD CORSET

A girl's best hope of achieving fashion's impossible ideal

1958

In her 1959 book *Wife Dressing*, the American designer Anne Fogarty advocated wearing a girdle 'with everything' – a practice that she blithely compared with Chinese foot binding. Her 18-inch waist was a great source of personal pride, and her favourite cocktail dresses were the ones that were so structured she could only stand up in them. She felt very strongly that clothes should fit snugly, especially after 5 pm. 'You are not meant to suffer,' she reassured her readers, but the feeling should 'be one of constraint rather than comfort'.

Nor was she a lone voice in the wilderness. Of all the elements of the New Look silhouette (see page 24), the waistline was probably both the most coveted and the most difficult to achieve. Engineered undergarments were critical for the perfect foundation. Dior employed traditional corsetry techniques, but developments in new synthetics made corset-dependent fashion possible for all women. The new contraptions had nicknames such as the 'waspie', and could achieve 'quite the tiniest waistline in three decades'. Fashion editors ran pages of advice on how to achieve the almost caricatured femininity that had come to replace the dreary utilitarian wardrobe of the war years.

Contemporary fashion illustrated a key female function of the decade, which was to entertain and attend social gatherings – usually to promote a spouse's career. This new formality is reflected in highly structured garments. *Good Housekeeping* magazine noted at the time that, 'we are going to be feminine with greater accent on a tiny waist, fuller hips, higher heels', and advised: 'like an old-fashioned corselet, a nylon marquisette shrinks your waist and rounds your hip line.'

The ideal was the tiny waist and concave stomach that Nancy White, a fashion columnist at the time, called the 'gasp waist'.

We may well laugh, but foundation garments such as these were fundamental to the way women dressed until well into the 1960s. Nowadays, instead of whalebone, we have the workout; the ideal shape is achieved through diet and exercise. And for those who want more, there are Spanx. *Plus ça change*!

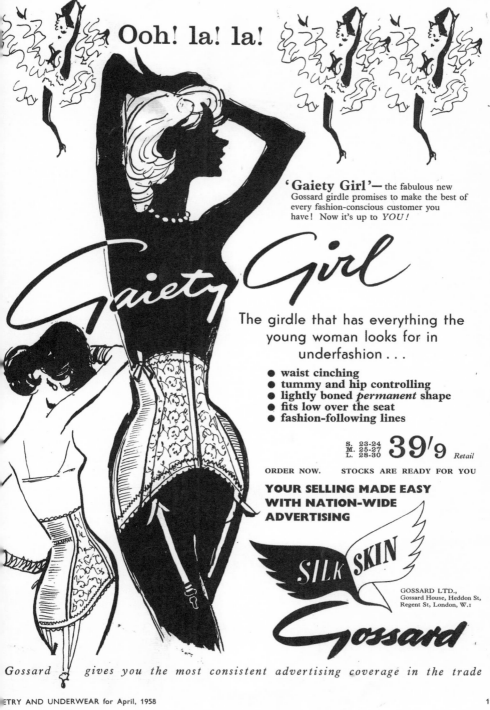

Ooh! la! la!

'Gaiety Girl'— the fabulous new Gossard girdle promises to make the best of every fashion-conscious customer you have! Now it's up to *YOU!*

Gaiety Girl

The girdle that has everything the young woman looks for in underfashion . . .

- waist cinching
- tummy and hip controlling
- lightly boned *permanent* shape
- fits low over the seat
- fashion-following lines

S. 23-24
M. 25-27
L. 28-30 **39'9** *Retail*

ORDER NOW. STOCKS ARE READY FOR YOU

**YOUR SELLING MADE EASY
WITH NATION-WIDE
ADVERTISING**

SILK SKIN

GOSSARD LTD.,
Gossard House, Heddon St,
Regent St, London, W.1

Gossard

Gossard gives you the most consistent advertising coverage in the trade

MARIA CALLAS

The diva who reinvented herself

Maria Callas (1923–77) was a prima donna assoluta in the time-honoured tradition. Her unique voice, musicianship, magnetic stage presence and flaming temperament ensured she was in the news wherever she went. Her playground was the ranks of the highest international society. She dated billionaires. On and off the stage, she was glamour incarnate.

Born in New York, Callas first became an opera star at La Scala in Milan in the early 1950s. By the time she was ready for her American debut at the Metropolitan Opera, she had crafted herself into the image of a global superstar. She had shed 32kg (70lb) and weighed in at a slim 61kg (135lb). At 1.72m (5ft 8in) tall, and with a face defined by strikingly broad cheekbones and architecturally arched brows, she was one of the handsome women of the operatic stage. Callas's reputation was such that announcements of her appearances generated long lines outside the box office of the opera houses where she was to sing. Yves Saint Laurent and Christian Dior designed for her.

To her audiences Maria Callas became a figure of almost mythical stature. The last time she sang in Carnegie Hall, a voice bellowed from the balcony: 'You are opera!' Her fans were resolutely loyal, even as she was beset by vocal difficulties at the end of her career. To them, she was the one singer who represented opera as theatre – the artist who lived her roles and made them come to life. Her recordings make her one of the bestselling opera stars to this day.

The Austrian American composer Arnold Schoenberg later said of her, 'Tall, slim, commanding, exotically beautiful, Miss Callas had a unique combination of electricity and brains.'

With her weight loss and image change, Maria Callas became one of the most beautiful singers ever. No longer simply an opera star, she became La Divina. Her popularity had increased dramatically. People idolized her, and in the 1950s Maria Callas became an international celebrity.

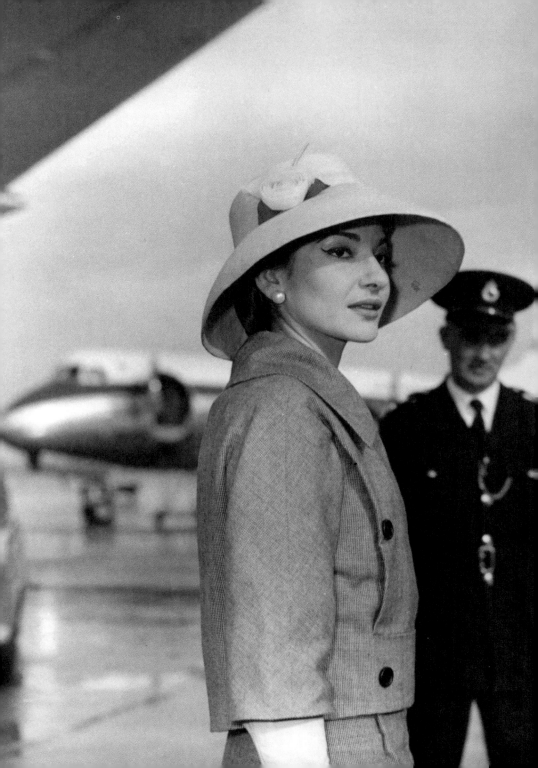

MARTHA GRAHAM
Dancer of the century

In the 1950s, Martha Graham (1894–1991) raised modern dance to a new level of popularity, helping to forge a new language of movement. She remains a towering figure to this day. In 1951 she was among the people who established the dance programme at the Juilliard School in New York City.

Among Graham's students were Bette Davis, Liza Minnelli and film director Woody Allen. Madonna (see page 360), also a pupil, tells the story in an interview for BBC radio of her first encounter with one of the few people who ever intimidated her: 'She was part Norma Desmond in *Sunset Boulevard*. The rest of her was a cross between a Kabuki dancer and a nun. She just looked at me with what I thought was interest but was probably only disapproval. She was both small and big at the same time. It was my first encounter with a goddess.'

In 1998 *Time* magazine named Graham as the 'Dancer of the Century' and as one of the most important people of the 20th century. Her creativity crossed artistic boundaries and embraced every artistic genre. She collaborated with and commissioned work from the leading visual artists, musicians and designers of her day, including the sculptor Isamu Noguchi and the fashion designers Halston (see page 296), Donna Karan (see page 318) and Calvin Klein (see page 444). Graham used costume as a pivotal device in the creation of visual effects on stage. Designer Rifat Ozbek (see page 404) dedicated a collection to her in 1989, and as recently as 2011 Marni founder and designer Consuelo Castiglioni cited her as one of her key inspirations.

Costumes were a vital part of Martha Graham's dance pieces. The swirling jerseys were integral to the overall visual effect. In her everyday wardrobe she favoured pieces that enhanced the movement of her body, even if she was simply walking down the street.

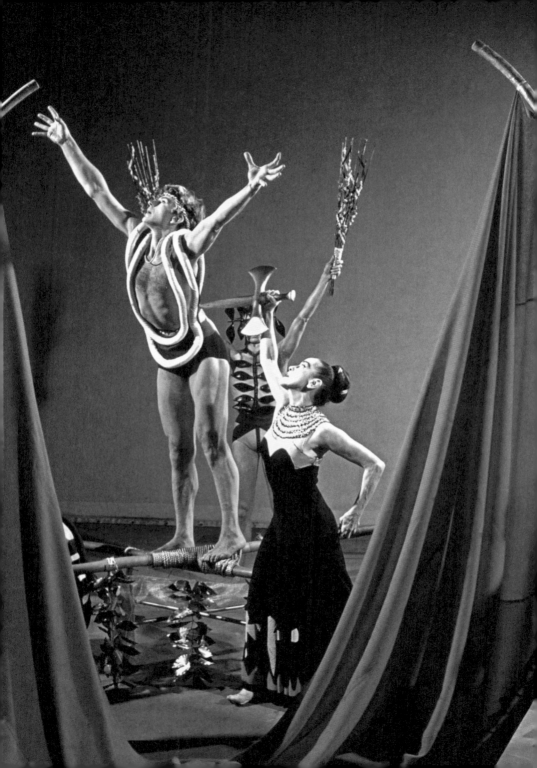

NORMAN PARKINSON

Gentleman photographer

Norman Parkinson (1913–90) started his career in the stuffy world of 1930s society portraiture. 'All the girls had their knees bolted together,' he remembered. As a fashion photographer, he much preferred to take models out of the studio and into the real world. The style he developed owes much to his double life as both photographer and farmer. His love of the country, he said, was 'part of the secret of why I think and see as I do'.

Before Parkinson's arrival at British *Vogue* in the early 1940s, the magazine, then only starting to explore colour photography, had relied on imported photographers from Europe and America, and on material borrowed from its American sister publication. Once editorial budgets were restored after the war, Parkinson's English pastoralism gave British *Vogue* a distinct identity. Parkinson pioneered fashion shoots in exotic locations at a time when long-haul travel was still in its infancy. Foreign assignments in the 1950s took him to India, Australia, Jamaica, Tobago and Haiti.

Parkinson became a huge hit in America, not least because of his distinctive demeanour, which established him as a personality quite as much as his models and sitters. He became a walking 1.96m (6ft 5in) caricature of a dandyish Englishman with officer-class mustachio and furled umbrella.

He was rigorous in concealing the hard work that accompanied every assignment, but Parkinson's painstaking preparation before every picture was taken is remembered by those who worked with him. He made light of the graft, preferring to maintain the appearance of a spontaneous style. In later years, he conceded that 'almost every photograph that is particularly appealing and true has been arranged and rehearsed'.

In the 1980s Parkinson said he wished his obituary to read simply: 'He took photography out of the embalming trade.'

Norman Parkinson much preferred to work out of doors. He said, 'A studio is like an operating theatre. You go there to get part of yourself removed.' He took his models into the countryside, introducing a degree of realism. But the relaxed approach belied a rigorous perfectionism that made him a lovable taskmaster.

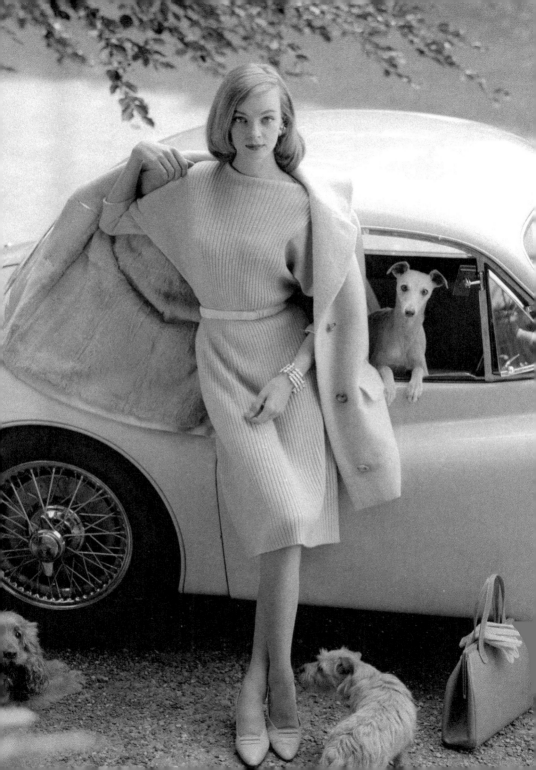

STILETTOES
Roger Vivier's greatest legacy

Both men and women had laboured through the war years in unflattering boots and shoes. Comfort and practicality had been the sole priorities. As a result, the postwar world hankered after gorgeous shoes.

Heels had been getting progressively higher as hemlines became shorter throughout the 20th century. High heels became the ne plus ultra, particularly in Hollywood, where actresses wore slim, sparkly heels that made the more traditional, mid-height French heel look positively dowdy by comparison.

With the launch of Dior's New Look (see page 24), it behoved shoe designers to step up to the mark with something equally groundbreaking. Enter French shoe designer Roger Vivier (1907–98), who mastered the technology that enabled women to wear a teetering heel that would perfectly set off a Christian Dior dress. It was strong stuff, and it was an instant hit. Ladies were offered lessons to help them walk properly, and there was considerable alarm over the damage stilettos might do to polished floors.

The 1950s stiletto was more innovation than invention, since women had been known to wear a version of what we now refer to as a stiletto as far back as Victorian times. But the steel-strengthened, pencil-thin heel was Vivier's great contribution. If the Frenchman perfected the engineering, it was the Italian Salvatore Ferragamo (see page 38) who gave the shoe its name, however, coining the term 'stiletto' from the Greek word *stylos*, meaning 'pillar'.

Roger Vivier had no truck with democracy. His shoes were unashamedly luxurious. He designed for several couturiers, including Elsa Schiaparelli in the 1930s, but notably for Christian Dior, with whom he redefined fashion in the 1950s and early 1960s. He was the only one of Dior's collaborators permitted to have a credit on the final design: 'Christian Dior créé par Roger Vivier' was marked inside every shoe.

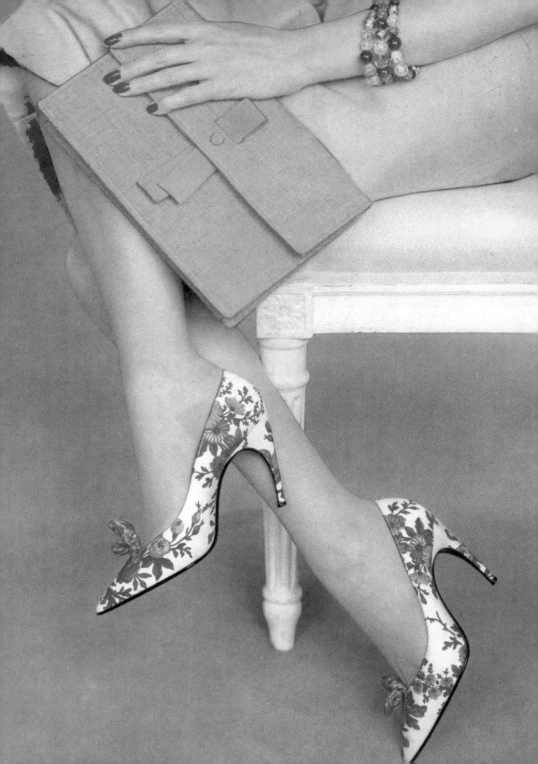

'BABE' PALEY

Style perfectionist

Truman Capote called 'Babe' Paley, C Z Guest (see page 56) and Gloria Guinness (see page 104) his 'swans'. From her marriage to CBS founder Bill Paley in 1947, Barbara Cushing Mortimer Paley (1915–78) reigned as high priestess of fashion and the social arts until her death.

Blessed with a slender figure and distinctively pale skin, Babe honed her style as a fashion editor at US *Vogue*, where she also modelled. As a divorced single mother living on a meagre budget with two young children, she was nonetheless able to maintain an enviable wardrobe. Charles James, Chanel (see page 50), Hubert de Givenchy (see page 54) and Norman Norell (see page 20) were among those who gave her clothes, realizing that hers was a very valuable stamp of approval.

Babe later married the fabulously wealthy Bill Paley, made the Best Dressed List 14 times and became an inspiration for store mannequins, fashion illustrators and photographers alike. A painstaking perfectionist, she washed and ironed her custom-made heavy white piqué blouses herself, 'because she wouldn't ask anyone else to do it'.

At a time when society women favoured sets of matching jewels, it was typical of her style to mix her precious Verdura and Schlumberger jewellery with cheap costume pieces. When, in her 50s, she decided to let her hair go grey, masses of women followed suit. Trouser suits might have been a controversial choice for a smart luncheon, but when Babe Paley wore them they became the height of modern chic. When photographers snapped her with a scarf casually tied to the side of her handbag (she had removed it en route because it was too warm), it became a fashion 'look'.

Babe Paley was a 'stylist' before the term was coined, making clothes uniquely her own. Ropes of pearls might be twined about the wrist or 'thrown to the back', as her friend Oscar de la Renta recalled in *Vogue* in 2009. 'Whatever she wore,' the designer said, 'she wore in a way you would never forget.'

Babe Paley is shown here being photographed by her husband William Paley beside the pool of their cottage in Round Hill, Jamaica. Eleanor Lambert, founder of the Best Dressed List, dubbed her 'The Super Dresser of all Time'.

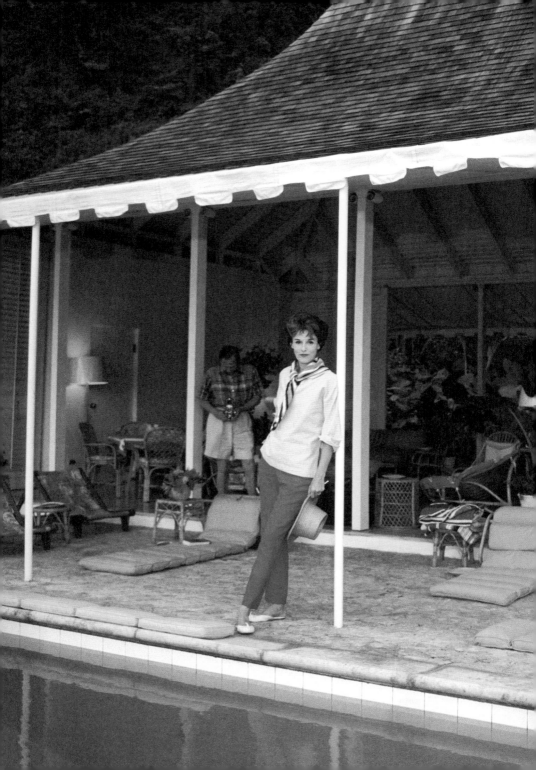

BARBIE

All a 1950s woman could want to be

Back in the early 1950s there was a little girl called Barbara ('Barbie') Handler, whose mother Ruth reckoned it was important for young girls to imagine life as an adult through the world of play, and therefore made her a doll on which to project her fantasies of grown-up life. It was convenient that Ruth and her husband Elliot had, some years earlier, founded the Mattel Corporation in their garage. Nonetheless, advertising executives at first rejected the idea, considering it both too expensive to develop and of limited appeal.

Ruth Handler persisted, however, and in February 1959 Barbie Millicent Roberts arrived, measuring 29cm (11$\frac{1}{2}$in) tall. She debuted at the American Toy Fair in New York City. For her first outing she was a blonde in a bold black-and-white striped swimsuit, with open-toed shoes, sunglasses and earrings. New, suburban lifestyles revolved around the consumption of luxury goods, and Barbie had lots of them – the raciest cars, the coolest outfits and the most wanted accessories.

She was an instant hit, and in the first year 351,000 dolls were sold at $3 each. Barbie's appearance was a precise reflection of Western society's attitude to women at the time. With her long legs, small waist and voluptuous, pert bosom, she was considered the ideal. She had a freckle-free complexion with long lashes and just a hint of makeup.

The box she arrived in was covered in stylized fashion drawings. Her wardrobe's key looks were a fluffy nightwear ensemble (perfect for sleepovers), an outfit for hosting a weekend 'barbie-Q' and, of course, a wedding dress. Barbie represented all that the marketing fraternity believed a woman could want to be in the 1950s – glamorous, famous, wealthy and popular.

A testament to Barbie's evergreen fashion status came with the celebration of her fiftieth anniversary, when a runway show in her honour formed part of the New York Collections. Fifty household-name American designers took part, including Diane von Furstenberg, Calvin Klein and Vera Wang.

LORD SNOWDON
Capturing the vibrancy of a new age

In the 1950s London was exciting international interest with its burgeoning music and fashion youth cultures. One of the pioneers of the spirited new English style was Antony Armstrong-Jones (1930–2017), later 1st Earl of Snowdon. After studying architecture at Cambridge, he started his career as a portrait photographer. But by 1956 he was working on advertising and fashion shoots for *Tatler*, *Vogue*, *Harper's Bazaar* and the *Daily Express* newspaper.

The young Armstrong-Jones captured all the excitement of London's cultural renaissance and the unique energy that was driving its fledgling fashion industry. The mood was electric with an iconoclastic cast of characters. There was the cult of the 'angry young men', such as the writers John Osborne and Kingsley Amis, mouthpieces for a generation disillusioned with traditional English society. And there was the amazing success of Mary Quant (see page 178) and the boutique called Bazaar, which she opened on the King's Road in 1955 – Armstrong-Jones documented it all.

Until then, fashion had been limited to the environs of the salons whose hallowed portals were open by appointment only. London's young fashion fans and its emerging designers were of a similar age and had similar tastes and interests. Quant, much like Coco Chanel (see page 50) and Claire McCardell (see page 84), was a designer who was not only a fashion designer in the way she dressed, but was also one of the most influential trendsetters; in her hands, fashion was low-priced, ready to wear and immediately available.

Armstrong-Jones captured the essence of the time. His photographs are memorable for their wit, zest and immediacy, and his young models look like they are having a fabulous time in odd situations. It might not have been photorealism, but it did define the glamour and vibrancy of a new age.

Armstrong-Jones's fashion pictures were spontaneous moments caught on camera when no one else was looking. A woman marches across the street (right) another totters', about to fall into a river; and a third knocks over glasses as she jumps up to embrace a man. His models carried on life regardless of the lens that observed them.

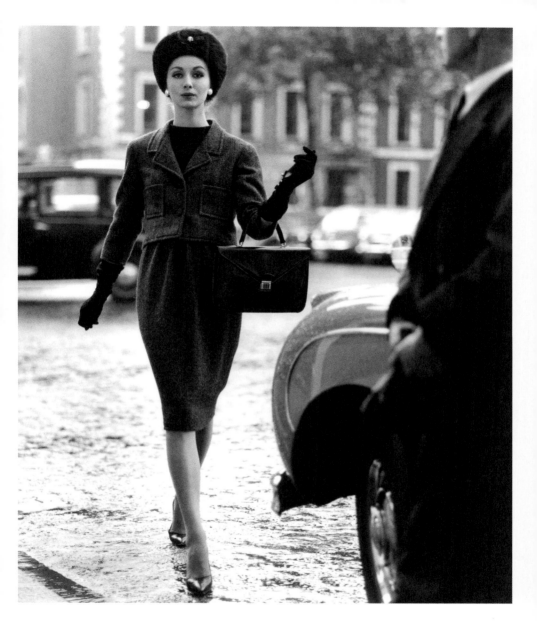

GLORIA GUINNESS

The magnificent minimalist

With her famous 'Nefertiti profile' and uncluttered approach to fashion, Gloria Guinness (1912–80), along with her fellow 'swans', ruled the style world from the 1950s until her death. A Mexican of humble origins, she married the English banking magnate Loel Guinness, and at a stroke wiped out the less-than-impeccable shadow cast by two previous marriages and a mysterious war record.

Guinness wrote her own script. 'When she was poor she told everyone that fur coats were tacky,' remembered the Venezuelan television host Reinaldo Herrera. Almost the only thing unfashionable about her, in a set where modesty was prized, were the sometimes crass declarations she made: 'Chic? It is absolutely innate. I was born with it.' And, as she told *W* magazine in 1976, 'I've never worn costume jewellery in my life. It's really self-defeating. Why should a man buy a woman real jewellery when she wears false pieces?'

In Paris before the war John Fairchild noted: 'La Guinness was the chicest of all in a black cardigan and black skirt.' As she climbed the social ladder, she had money for more extravagant clothes but never lost her minimalist look. Wealth only allowed her to carry her art of underdressing to a new level. Cristóbal Balenciaga (see page 32) was her favourite designer. He said she was the most elegant woman he dressed. 'I don't follow fashion,' she told an interviewer coolly, 'I believe in consistency. Every time I have changed my look I have been unhappy.'

Guinness accessorized couture dresses with cheap scarves, and when asked what she wore at home she said, 'comfortable robes I pick up for $12.95 a piece in Manhattan'. 1950s formality did not stop her making a look out of a Moroccan djellaba or accessorizing simple pants with a South American poncho.

Gloria Guinness told Balenciaga where to place the buttons and backed Antonio Castillo when he left Lanvin to open his own couture house. But while she had access to the best, she could also, as Oscar de la Renta once said, 'make an ordinary Hanes T-shirt look chic,' and would famously accessorize a couture dress with a scarf from Kmart.

HITCHCOCK'S 'FROSTY BLONDES'
Highly stylized sex appeal

The director Alfred Hitchcock fetishized the 'frosty blonde', and over the course of his career honed his image of the perfect woman. A succession of beautiful actresses combined feminine refinement and sex appeal in a way that was meticulously stylized. Hitchcock heroines tended to be lovely, cool blondes, who seemed proper at first, but when aroused by passion or danger, responded in a sensual, animal or even criminal way.

While they all shared some qualities, it would be a mistake to view them as cookie-cutter blondes. The continuous and symbolic evolution of the Hitchcock heroine – which has been studiously mapped by devotees for decades – made them very different from each other. For example, Greta Garbo, in *Stage Fright* (1950), was one of the earliest of the type and a knowing, glacial heroine. Kim Novak was more voluptuous, and throughout *Vertigo* (1958) tantalizingly wore her hair in a tightly coiled French twist – a thinly veiled Hitchcockian metaphor, of course, for tightly coiled feminine passion. Eva Marie Saint in *North by Northwest* (1959) possessed, by comparison, a brittle and seductive perfection.

Even the choice of lipstick colour could be loaded with symbolism. Hitchcock's 'good' female characters wore cool, barely-there makeup to minimize their sexuality, while red lipstick blatantly signified sex. For instance, Kim Novak as the idealized Madeleine in *Vertigo* has light-pink lips and blonde hair, but as 'imperfect' Judy has red hair and red lips.

But it was Grace Kelly (see page 60) who was the quintessential 'snow-covered volcano'. Kelly was one of the definitive beauties of the 1950s. An icon of elegance and refinement, she effortlessly portrayed the haughty allure that so appealed to Hitchcock, for whom she starred in *Dial M for Murder* (1954), *Rear Window* (1954) and *To Catch a Thief* (1955). 'You know why I favour sophisticated blondes in my films?' the director once asked. 'We're after the drawing-room type, the real ladies, who become whores once they're in the bedroom.'

Cary Grant and Eva Marie Saint in *North by Northwest*. Hitchcock's icy heroines have it all: beauty, brains, and bravery. They don't shy away from the heat of the action when the bullets start flying. Often they're the ones risking their lives to save the men. And through it all, they manage to stay perfectly coiffed and radiant.

WORKING WOMEN
A halting advance on the glass ceiling

It is no coincidence that, with thousands of demobbed men on the job market, many women in the 1950s faced the dilemma of the 'hearth V desk'. Many left the workforce they had joined in wartime to return home to resume their traditional roles of wife and mother. A struggle for workplace equality was beginning, and women who continued to work were expected to conform to a rigid image of appropriate womanly behaviour and appearance.

In 1959 Edith Head (see page 58), the legendary costume designer in Hollywood and one of the most successful career women of the decade, defined the style dilemma working women faced: 'No man wants a brisk executive at the dinner table and no man wants a too alluring creature gliding around his office.'

Success required steely determination, chutzpah and unflappable élan, typified by the observations of screen writer Anita Loos (*Gentlemen Prefer Blondes*, 1925), another standard-bearer for female success in a man's world: 'Any time we girls have to go to work, the result historically is that we do things better. I mean, gentlemen will go to the trouble of keeping office hours, holding board meetings and getting Mr Gallup to make a poll in order to reach a decision any blonde could reach while refurbishing her lipstick.'

The 1959 movie *The Best of Everything* was an early forerunner of the television series *Sex and the City* (1998-2004), a cautionary tale about life in the big city for three young women seeking independence. The characterization belies regressive attitudes. Like many young women of the 1950s, Caroline Bender, the central figure, takes a job in order to become more independent, but considers it as really just a way to pass the time while she waits to get married. Back then, the spectre of spinsterhood loomed large. The boss lady character played by Joan Crawford is inevitably waspish, bitter and 'truly lonely'. Caroline eventually scales the greasy pole. By the end of the movie she is a hat-wearing executive, but this feature film does not set her up as a shining example.

The Best of Everything (1959) was based on the bestselling novel by Rona Jaffe and starred Hope Lange, Joan Crawford and former model Suzy Parker (see page 86).

1960s

London defined the spirit of the 1960s like no other city in the world. For one glorious decade, even the couture salons of Paris were in thrall to the energy that was generated in the British capital. It was the city of opportunity, buoyed up by the iconoclastic enthusiasm of its youth.

Britain emerged from the turbulent years of the 1950s a changed country. 'In that period,' wrote American journalist John Crosby, in the *Daily Telegraph* colour supplement, 'youth captured this ancient island and took command in a country where youth had always before been kept properly in its place. Suddenly the young own the town.'

The new social order was unrecognizable to the old guard. As the Duchess of Westminster lamented ruefully to *Vogue*, 'London Society is a world which for better or worse no longer exists.'

In America, the young President and his wife inspired a new idealism. The charismatic Mrs Kennedy, 'eschewed the bunfight and the honky-tonk of American politics and is inclined to the gentler practice of painting, literature and fashion,' said *Vogue*.

In the cinema, long queues formed for the works of stars of the Nouvelle Vague, such as Claude Chabrol and Godard Jeau-Luc, while the pop art movement propelled the likes of David Hockney and Andy Warhol to cult hero status. And at the Edinburgh Festival in 1960 Kenneth Tynan remarked, 'England is complacent and the young are bored. There is the desire to hear breaking glass.'

For a decade the world sat back and watched the fireworks.

Opposite: bold, bright colours were a 1960s leitmotif, capturing the decade's optimistic, freewheeling spirit. Here the models wear chiffon designs by Marc Bohan for Dior.
Below: Michelangelo Antonioni's cult film *Blow-Up* (1966) both satirized and celebrated fashionable London. Its emblematic character was a fashion photographer, played by David Hemmings, who thinks he may have witnessed a murder through his camera.

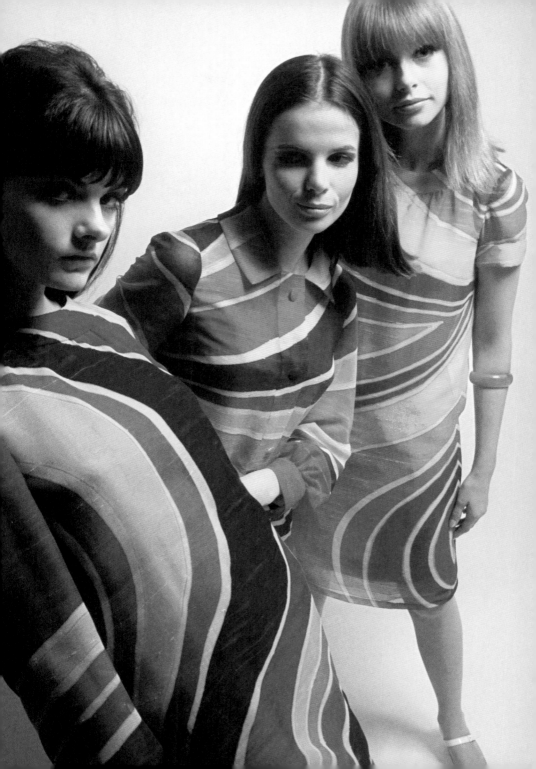

DUSTY SPRINGFIELD

Queen of the Mods

Mary O' Brien (1939–99) was born with a voice that would make her Britain's greatest female pop singer, but everything else that went into the making of the icon of Dusty Springfield was her own work. Her career started as part of a wholesome family folk group called The Springfields. A tomboy who was always at the heart of rough-and-tumble play in the dirt, she earned the nickname 'Dusty'.

In 1963, inspired by the music of American girl groups, she went solo. She left the wholesome Springfields behind, ditched her spectacles and embarked on a reinvention that would make her 'Queen of the Mods'. She became the Dusty known around the world in style as well as in name.

Her signature look was carefully crafted, using glittering evening gowns, heavy black mascara, panda-eye makeup and huge peroxide-blonde bouffant hairdos. Derek Wadsworth, who arranged a lot of her material in the studio, said, 'It was like putting a jigsaw together. Dusty would have made a great scientist because she analysed every detail. Dusty Springfield was a creation of Mary O'Brien. She was almost not like a real person. She put the whole package together – the hair, the shoes, the gestures – and she had impeccable taste.'

Dusty borrowed elements of her look from the blonde glamour queens of the 1950s, such as Brigitte Bardot (see page 68) and Catherine Deneuve (see page 166), and pasted them together just the way she liked them. She practised the way Peggy Lee put her eyes on one side halfway through a song and did a little smile. She invented a character the public loved, a face worthy of magazine covers and the breathy speaking voice of a giggly girl next door.

In spite of serial hits, she owned up to desperate insecurity: 'To be the star they wanted, I had to hide behind a mask, and I chose mascara.'

Dusty Springfield's artistic impact is often eclipsed by the glamorous excess of that towering beehive and panda-eye makeup. They made her an icon of camp, and inspire catwalk comebacks to this day. But the quality of her voice transcends trends.

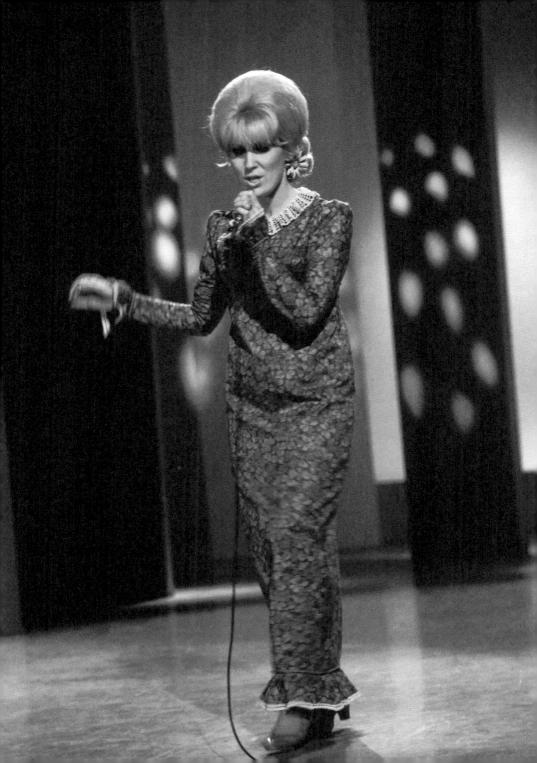

JEAN SEBERG
A preppy in Paris

Jean Seberg (1938–79) had already starred in dozens of Hollywood films before moving to Paris. Savage reviews of her work by the critics at home prompted her to seek success in Europe.

Ironically, it was her American preppy style, passed though the filter of French chic, that ended up creating the stereotype of the French gamine. She is remembered for her simple, sporty style that created a fashion look out of such unprepossessing pieces as an oversized man's shirt and ballet slippers. It was also in Paris that she got the famous pixie haircut for which she is most remembered.

At 17 and a complete unknown, she had starred in the Hollywood director Otto Preminger's epic *Saint Joan* (1957). But it was her role in Jean-Luc Godard's directorial debut *Breathless* (1960), opposite Jean-Paul Belmondo, that became her most famous. The image of Seberg as Patricia Franchini strolling down the Champs-Elysées in the *New York Herald Tribune* T-shirt made style news around the globe. And the image still resonates today. In 2010, on the fiftieth anniversary of the release of *Breathless*, Kate and Laura Mulleavy, the sisters behind the California cult label Rodarte, designed a T-shirt featuring the classic masthead that paid homage to the Seberg original. It sold out in days.

Other wardrobe classics for which we have to be eternally grateful to Seberg as Franchini include nautical striped T-shirts, the trilby hat, trench coats, oversized sunglasses, skinny pants and ballet pumps.

Jean Seberg's gamine crop continues to inspire actresses from Carey Mulligan to Michelle Williams. And Jean-Paul Belmondo still sets the standard for smoky French sex appeal. For fashion fans over the years, her newspaper seller's T-shirt is an evergreen style headline.

JEAN SHRIMPTON
'The London Look'

Jean Shrimpton (1942–) was the first high-fashion model also to be a popular pin-up. Her freewheeling style made it possible for a whole world of girls of her own age to connect with the elegant and expensive clothes she modelled. A graduate of the Lucie Clayton College, she was first spotted by David Bailey (see page 136). As a couple, the pair became emblems of London in the early 1960s. He said it was almost impossible to take a bad picture of her and that even in her passport picture she looked a great beauty. She later dumped him for actor Terence Stamp, but ultimately rejected the glittering celebrity lifestyle at the height of her career for a life in the country.

Shrimpton was always sanguine about fame, and told an interviewer in *About Town* magazine in 1962, 'I am not a classical beauty. Nor a beatnik really, but I am riding the crest of a wave. In a year everyone might be against my type of looks.'

In spite of her modesty, Shrimpton was a household name by the time she was 25. She is also credited with changing the course of popular fashion. The miniskirt may have been born on the catwalk, but Shrimpton's appearance in a minidress at the Melbourne Cup in Australia ensured that every woman wanted one. It came about quite by accident when Colin Rolfe, her dressmaker, found he didn't have enough fabric to finish the four outfits she wanted and cut them all above the knee.

Shrimpton was a totem for British fashion. British *Vogue* said: 'The world suddenly wants to copy the way we look. In New York it's the "London Look". In Paris it's "le style anglais". Every kind of English girl seems now to have the self-assurance that praise and admiration gives. Every girl is an individualist, a leader.' 'The Shrimp' was that girl.

Within months, David Bailey's camera turned Shrimpton, a mild-mannered country girl who hated to be stared at, into a sex icon as desirable as Marilyn Monroe, Elizabeth Taylor or Brigitte Bardot. For the first time, thanks to her, fashion pages were torn out to become pin-ups in bars and garages.

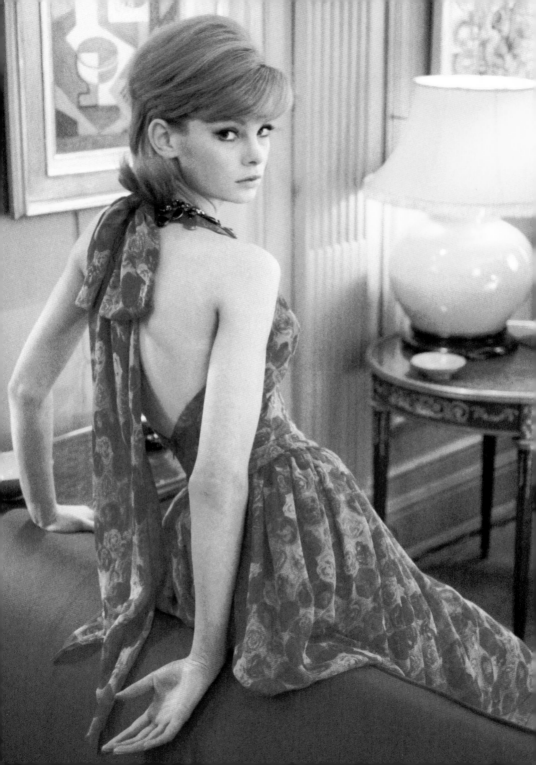

LA DOLCE VITA

The 'sweet life' with film, fashion and Fiat 500s

No film captured so vividly the flashbulb brilliance of Italy's postwar *miracolo economico* than Federico Fellini's 1960 masterpiece *La Dolce Vita*. After the miseries of war and fascism, the nation revelled in a consumer boom driven by film, fashion and Fiat 500s. Since then, Rome has never quite separated itself from the fantasy of the 'sweet life'.

Rome of the 1950s had become an outpost of Hollywood, attracting many American productions. Films such as *Ben Hur* (1958) and *Cleopatra* (1963, see page 132) were shot at Cinecittà, Rome's film studios, renowned as 'Hollywood on the Tiber'. The restaurants were full of American actors, producers and directors, together with the ever-present reporters who followed them around. Indeed, Paparazzo, the ubiquitous news photographer in Fellini's film, would give his name to the job.

Fellini brilliantly captured the atmosphere of postwar plenty and excess. To the ordinary men and women of the time, it must indeed have seemed as if the social elite were on a nonstop party circuit. With blithe disregard for schedules and apparently living only for leisurely nights, actors, aristocrats, playboys, dandies and fashionable intellectuals alike squandered time and resources as if there were no limits. But beneath the glittering surface, *La Dolce Vita* also probes the crisis of a society in transformation, struggling to come to terms with volatile values in an age of mass communication and consumption.

The *New York Times* praised Fellini for his 'brilliantly graphic estimation of a whole swath of society in sad decay' and his 'withering commentary on the tragedy of the over-civilized'. *La Dolce Vita* was the box-office hit of 1960, and launched Marcello Mastroianni as an international heart-throb. In London the release of every Fellini, Godard and Antonioni film was welcomed with long lines at the ticket offices, and together they had a profound influence on British directors and the birth of British neorealism.

Anita Ekberg shot to stardom in *La Dolce Vita*, which came to define the carefree days of the 1960s. On filming the famous scene fooling around with Marcello Mastroianni in the Trevi Fountain, cinematic legend has it that Mastroianni was so cold he needed a wet-suit and a bottle of vodka. It is also reported that Ms Ekberg managed to complete the scene unaided.

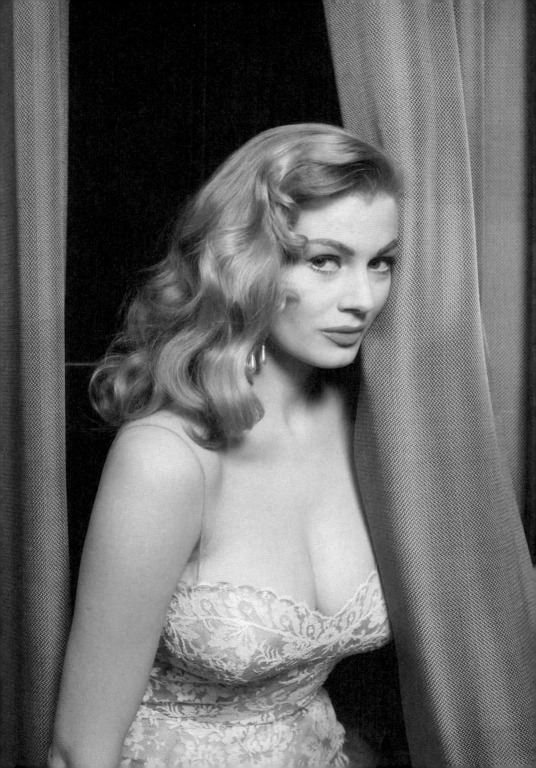

SANDIE SHAW

The barefoot diva from Dagenham

'The biggest star ever' – a grandiose claim, perhaps, but back in the mid-1960s, when the Beatles were still very young indeed, Sandie Shaw (1947–) was pretty much the biggest pop star ever – within UK shores, at least.

A 17-year-old sprite with knockout cheekbones and a gorgeous Vidal Sassoon bob (see page 140), she came seemingly from nowhere (actually Dagenham) to be the first woman to have three number-one hits and the first Briton to win the Eurovision Song Contest. More importantly, she managed, with her fey, barefoot performance style, to transform herself into an emblem of the countercultural spirit of the 1960s.

You might speak of her in the same breath as the other pop poppets of her era – Lulu, Cilla Black and Petula Clark – but she was, and remains, a much edgier customer. Her break came in the early 1960s, when she came second in the Ilford Palais talent contest. It led to an audition in London and an offer to sing at a charity concert in Hammersmith, where she was spotted by Adam Faith. Shaw went to number one in 1964 with the Burt Bacharach song '(There's) Always Something There to Remind Me'.

Shaw lived the 1960s dream, sneaking out from under her father's watchful eye to party with Jimi Hendrix, though never for very long, so busy was her work schedule. The original Brit girl, she was the picture of an independent girl about town. To the girls back home in Dagenham, it must have seemed as if she had everything: a number-one hit record at 17, a fur coat (which she wore during winter and summer) and a white Mercedes. Her record company celebrated her birthday with a cake topped with her famous feet made out of ice cream.

When she married fashion designer Jeff Banks in 1967, she was so famous that in order to give her adoring fans and the ever-present press the slip, she went to the registry office in disguise.

Sandie Shaw first took her shoes off during the recording session for 'As Long as You're Happy, Baby' (1964). Her manager was nonplussed but Adam Faith reassured him: 'Don't worry, she knows what she's doing.' The public loved it. She believed she sang better barefoot, and ever since has always performed without shoes.

AUDREY HEPBURN
Breakfast at Tiffany's

1961

After 1961 and *Breakfast at Tiffany's,* there was a veritable army of Audrey Hepburns scurrying around in black evening dresses. The movie's influence was so pervasive that the American Society for the Prevention of Cruelty to Animals reported an avalanche of requests for orange tabby cats. Cats aside, it marked the moment when the Audrey-Givenchy partnership (see page 52) blossomed, as Holly Golightly's hangover chic caused a run on triple-strand faux-pearl necklaces, sleeveless dresses and oversized dark glasses.

The persona Audrey Hepburn consistently projected was one of chic sophistication that was never brittle or cold. But until this point, she had specialized in the role of the ingénue; the moment when she first appears in the film on an empty Fifth Avenue still ranks as one of the great screen transformations of all time. *Silver Screen* magazine commented: 'She's changing Hollywood's taste in girls. From the full bosomed, sweater-filling type with more curves than The New York Central Railroad to the lean umbrella-shaped variety.'

There on Fifth Avenue, in her tiara-trimmed up-do, Givenchy gown and evening gloves, sipping from a cardboard cup and munching a Danish pastry, Hepburn won the hearts of audiences around the world.

When Truman Capote sold the movie rights of his novella to Paramount, he had wanted Marilyn Monroe (see page 46) to play Holly and complained that Hepburn was 'just wrong for the part'. Director Blake Edwards took a barrage of criticism from the serious cinema reviewers for his 'mawkish' interpretation. There were much higher expectations for leading man George Peppard, who was thought to be the next James Dean. But ever since, fashion editors have analysed, models have channelled, and women all over the world have copied and aspired to Audrey Hepburn's effortless elegance in *Breakfast at Tiffany's*.

Even now, the online movie site Rotten Tomatoes gives *Breakfast at Tiffany's* an 88 percent 'Fresh' rating, concluding: 'It contains some ugly anachronisms, but [director] Blake Edwards is at his funniest in this iconic classic, and Audrey Hepburn absolutely lights up the screen.'

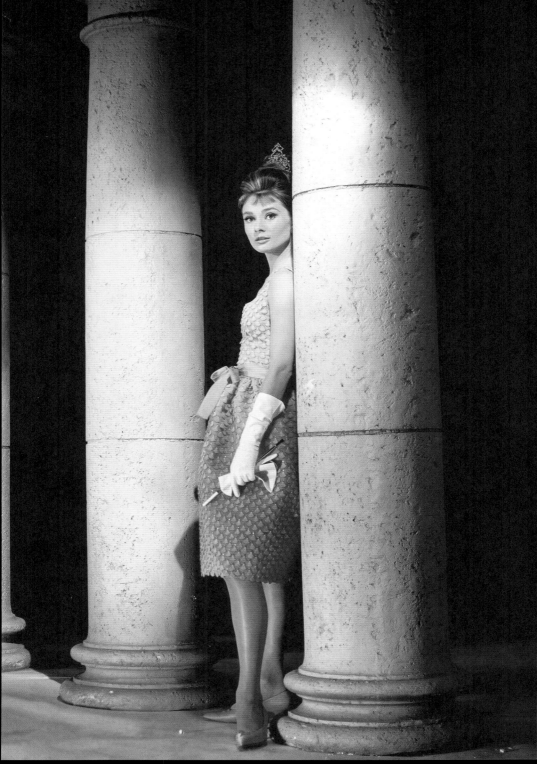

KENNETH BATTELLE

Haute coiffure

It's true, no one knew who did Mamie Eisenhower's hair, but everyone knew who did Jackie Kennedy's – Mr Kenneth. Kenneth Battelle (1927–2013) was the first celebrity hairdresser; he was also the first hairdresser who was commonly known simply by his first name.

Battelle became a legend in the 1960s, thanks to his famous clients who often called on him to perform minor miracles. He managed to transform Marilyn Monroe's permed and overbleached hair into a kittenish, candyfloss halo. His salon on East 54th Street was the epitome of uptown glamour, designed by the celebrated interior designer Billy Baldwin. Customers were highly likely to find themselves in the backwash next to the likes of Lauren Bacall (see page 28) or Audrey Hepburn (see pages 52 and 122), as well as the A-list of America's social register.

During the early 1960s, Battelle went from being an insider secret to a household name, when he became known as Mrs Kennedy's hairdresser. He created a tousled bouffant style for Jackie to balance her wide cheekbones and add height to her slim frame and broad shoulders. Legend has it that he set her hair in specially designed Lucite rollers before combing it out. Millions of women around the world copied her look.

He may have been a trusted member of the First Lady's style team, but in 1962 Battelle also styled Marilyn Monroe's hair for JFK's 45th birthday rally: the night she silenced Madison Square Garden (with her infamous rendition of 'Happy Birthday, Mr President'). Less than a year later, Battelle cut Jacqueline Kennedy's hair the morning before she left with her husband for Dallas, where he was assassinated on 22nd November 1963.

Arguably, the uptown New York hair salon known simply as Kenneth should have followed mid-century swank spots such as The Stork Club and El Morocco into obscurity. But Mr Kenneth managed to turn it into an institution, and the salon is still tending to the locks of a new generation of party-page luminaries.

DIANA VREELAND
Fashioning the fashion editor

Having been fashion editor of *Harper's Bazaar* during the postwar years, Diana Vreeland (1903–89) became editor of American *Vogue* in 1962, a tenure that lasted only nine years but which changed magazines forever. She was the original 'High Priestess of Fashion'.

Vreeland positively feasted on the energy and the new styles of the decade. Her imagination fed on the activities of the young, and for many of them she played an important mentoring role. Many influential designers and editors have named Diana Vreeland as an inspiration for their careers.

Vreeland's words were powerful and influential. She christened the new trends, along with the people who made them, with the catchy headlines and memorable metaphors for which she was famous. *Vogue*'s use of the term 'beautiful people' became a byword for the chic, rich lifestyle of the 1960s. And, to this day, the portmanteau 'Youthquake' sums up the creative vibrancy of the decade.

Many of Diana Vreeland's favourite photographers, including David Bailey (see page 136), Irving Penn and William Klein (see page 82), are considered to have done their best work with her at this time. Her favourite models redefined the image of modern beauty. To the likes of Veruschka (see page 196), Marisa Berenson, Twiggy (see page 184) and Jean Shrimpton (see page 116) she gave a free hand to construct their fantasies (or in the case of Penelope Tree (see page 180) – one of her discoveries – her 'fantas-trees'). She commented: 'a little bit of romance, a bit of splendour, a little luxe in our lives…it's what we all crave, yes?'

Open to everything that was new, different and wild, Mrs Vreeland's imagination and her acquisitive eye for the near future encouraged and defined the spirit of exaggeration that was in the air. She promoted the Space Age look of André Courrèges with the same enthusiasm as she had the classic fashion of Cristóbal Balenciaga: for her, they carried the same message of vitality and excitement.

Richard Avedon (see page 158) said of Vreeland: 'Diana invented the fashion editor. Before her it was just society ladies putting hats on other society ladies.'

There are so many Vreeland 'stories' that she has become almost a mythical character. As Marc Jacobs said, 'Diana Vreeland became both the archetype and stereotype of what it means to be a fashion editor. No one has ever been like her.'

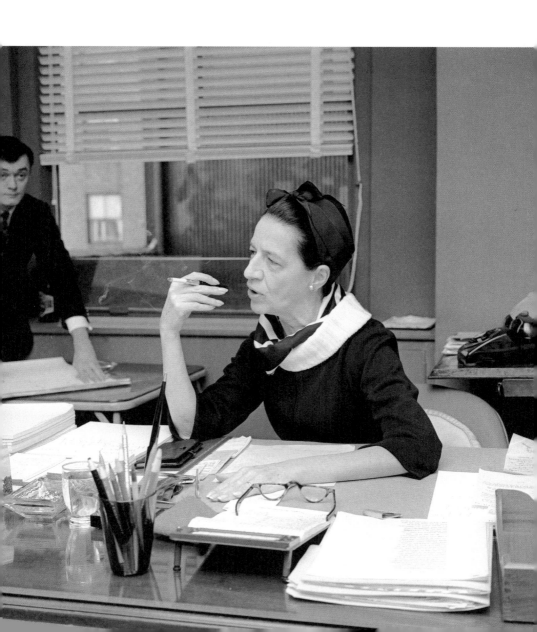

JEANNE MOREAU

The face of the Nouvelle Vague

Jeanne Moreau (1928–2017) is the Nouvelle Vague incarnate. The film critic Ginette Vincendeau defined her quality as 'beautiful, but in a kind of natural way; sexy, but intellectual at the same time, a kind of cerebral sexuality'. With her sultry glamour and dry, no-nonsense humour, Moreau became an icon for the fresh new face of French cinema, pioneered by the likes of Jean-Luc Godard and François Truffaut.

Moreau first drew attention in 1962, when Truffaut directed her in the part of the mercurial Catherine in what is his undoubted masterpiece, *Jules et Jim*. Truffaut wrote: 'Her qualities as an actress and as a woman made Catherine real, made her plausible, crazy, possessive, passionate, but above all adorable.' *Jules et Jim* took numerous prizes worldwide, was a commercial success and confirmed Moreau as a major actress. Her portrayal of a woman who lives for the moment and who goes where her passions lead her was a clarion call for a new generation of liberated women.

That Moreau's look in the movie became an instant fashion hit confirmed another dimension of her powerful influence. Women everywhere were suddenly wearing grandmother specs, long scarves, gaiters, boots, knickerbockers and poor boy hats. Her style influence endured, sending yet more women on the road to ringletted and ruffled romanticism, after she made the look famous in *Viva Maria!* (1965), in which she played opposite Brigitte Bardot (see page 68).

It was at this time that Jeanne met the designer Pierre Cardin. She was trying on one of his outfits and it was love at first sight. They spent five years together, their relationship captured by the press in exotic locations, such as Greece and Tahiti, or at home in Paris. She became his best-known model and he became the man behind her look. They were one of the most talked-about couples of their time, with the question of whether they would ever marry a frequent subject of speculation. (They never did.)

It was her performance as the alternately coquettish and commanding Catherine in Truffaut's masterpiece, *Jules et Jim* (1962), that made Moreau a star and defined her as an intellectual sex symbol. But she also worked with luminaries such as Buñuel, Antonioni and Orson Welles, who once called her 'the greatest actress in the world'.

CHRISTINE KEELER

1963

The scandalous siren of the sexual revolution

Christine Keeler (1942–2017) was only 16 when she met Stephen Ward. She came from grinding poverty in Berkshire, and ran away to London to work as a topless dancer. The 46-year-old Ward, a society osteopath by day, had a sideline introducing female companions to his well-born friends. Her affair with the Minister for War, John Profumo, brought down the government of Harold Macmillan, and caused a scandal that reverberated to the heart of the Kremlin.

Keeler paid the price for challenging society's moral code. She might have been a pariah at the time, but is now more generally viewed as the victim of an embarrassed and vengeful Establishment. With the protagonists safely out of the way, the political class were able to draw a veil over the whole nasty affair. Sex was now a cause célèbre, and the press had discovered that it could, and would, expose the private lives of public figures. With her dark, starlet looks, Keeler was also photogenic tabloid fodder. You could say the modern media age began here.

As hemlines went up in the 1960s, inhibitions came down. Christine Keeler's life reflects the evolution of a new society, one in which working-class youth – hitherto people with few choices about where to go and what to do in life – was suddenly confronted with multiple opportunities. Keeler was collateral damage in the social and political upheaval that not only defined the decade, but also changed the world.

The 1989 movie *Scandal*, starring Joanne Whalley, introduced Christine Keeler's story to a new generation. The Profumo Affair gave rise to the type of no-holds-barred tabloid journalism for which Britain is now world-famous and from which no public figure is safe.

ELIZABETH TAYLOR AS CLEOPATRA

1963

The queen who nearly sank 20th Century Fox

At the time when she took on the role of Cleopatra, Elizabeth Taylor (1932– 2011) was at the very height of her fame as an actress. Many beautiful and powerful female stars had gone before and came after her, but none have fascinated in quite the same way. A startling beauty, Taylor achieved global fame as a child star. Her background (she was born in London to American parents) afforded her a unique transatlantic status – she was both a British national treasure and American royalty.

The most famous scene from the 1963 movie is perhaps the defining image of Elizabeth Taylor's epic cinematic career. Cleopatra's arrival in Rome – featuring costumes of 24-carat gold, a cast of thousands and a budget that dwarfed (by almost threefold) the most expensive production that had gone before, nearly sank 20th Century Fox. Every prop and set was built life-sized. A replica Roman forum constructed for this scene was, according to the publicist, 'bigger than the original and about a hundred times as expensive'. The gold-beaded wig she wore to meet Caesar was sold shortly after her death for $11,000.

She lived as large off screen as on; nobody loved diamonds quite like Liz Taylor, and few possessed as many. Her collection was the stuff of legend, and in 2011 its sale at Christie's raised $137.2 million. As Taylor remarked, 'Undeniably, one of the biggest advantages to working on *Cleopatra* in Rome was Bulgari's nice little shop.'

It was the highest-grossing film of its year and yet *Cleopatra* still ran at a loss. The enduring appeal of Elizabeth Taylor as the Egyptian queen continues to inspire reinterpretations in the fashion world, not least by Kim Kardashian, who gave it her best shot in the March 2011 issue of American *Harper's Bazaar*.

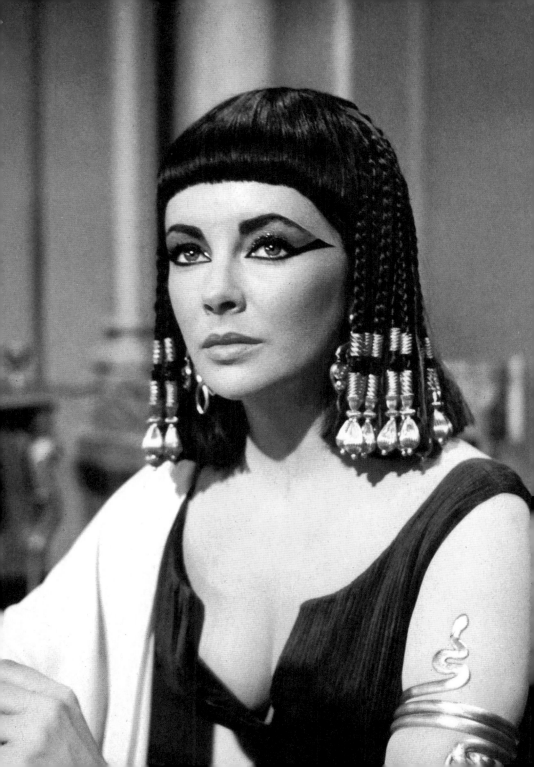

ANDRÉ COURRÈGES

A designer for the Space Age

André Courrèges (1923–2016) graduated as an engineer at the age of 25. In 1950 he went to Paris to work at the fashion house of Jeanne Lafaurie, before securing a position at Balenciaga. He worked for the couture master for ten years, honing his skills in the cut and construction of garments. In 1961, with his mentor's blessing, he left to set up his own house.

His look was radically different, not only from that of Balenciaga, but also from just about everything that was going on in contemporary fashion. His wife and partner, Coqueline, organized the presentation of his collections, which she conceived explicitly as 'a show', energized by loud music and young models dancing.

His spring 1964 collection, with its linear minidresses and futuristic tailoring, confounded the experts. The look was created using heavyweight fabrics such as gabardine that held a stiff, uncompromising shape. He used materials hitherto unheard of in the couture atelier: metal, plastic and a cutting-edge innovation called PVC. Many of the outfits had cutout panels, exposing backs, waists and midriffs, and shockingly they were also often worn without a bra.

Accessories included flat boots, goggles and helmets inspired by the equipment used by astronauts. With his stark shapes and white and metallic colourways, Courrèges was celebrated as the designer of the Space Age.

From the perspective of publicity, the collection was an absolute sensation. British *Vogue* declared 1964 'the year of Courrèges'. His clothes represented a couture version of the 'Youthquake' driven street style, and heralded the arrival of the 'moon girl' look. His career may have been short-lived but his influence was seismic. Courrèges made trousers acceptable as daywear for fashionable women, and to this day he vies with Mary Quant (see page 178) for the credit of being the inventor of the miniskirt.

Among the whackiest items in Courrèges's fashion legacy are a glow-in-the-dark dress and barely-there swimsuits, held together only by lacing up the sides. However, high-street retailers loved him. In 1964 the market was awash with plastic skirts and jackets, crash helmets, go-go boots and goggles.

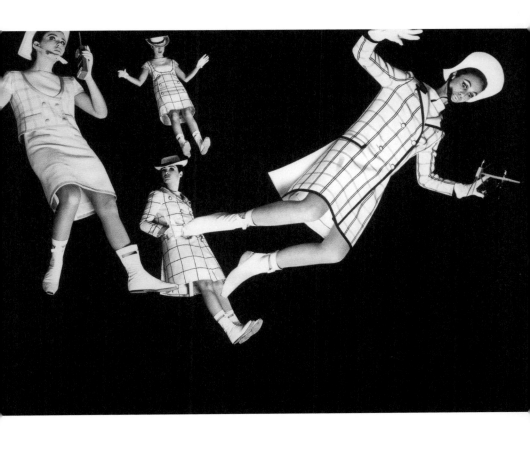

DAVID BAILEY

Sexing up the 1960s

A new band of photography stars emerged in the 1960s who hung out with the celebrities they photographed and became just as famous. It was they who propelled the creation of the Swinging London of the decade. David Bailey (1938–) was at the forefront of the group. From humble beginnings, Bailey's prestige sprang from his talent. He commented: 'I had a choice, aged 16. I could either be a jazz musician, an actor or a car thief. They said I couldn't be a fashion photographer because I didn't have my head in a cloud of chiffon. They forgot about one thing. I loved to look at women.'

The American journalist Tom Wolfe noted the cultural sea change: 'Once it was power that created high style, but now high style comes from low places.' Bailey projected his own youth and sexiness through his work. His images had an engaging and uncompromising toughness: black and white, minimalist and very graphic. 'I've always hated silly pictures and gimmicks,' he has said. With a small single-lens reflex camera he was freed from the constrictions of tripod and studio, and was just as likely to snap high fashion in the street as in an exotic location.

Bailey was every bit as interested in being part of the new style as he was in recording it. He dressed to suit his image and became a cult hero. When he married Catherine Deneuve in 1965, his best man was Mick Jagger. The event caused a media storm. In 1966 the movie *Blow-Up* (see page 152) concerned itself with the work and sexual adventures of a London fashion photographer who was largely based on Bailey.

David Bailey walked into *Vogue* in the summer of 1960 and changed fashion pictures into portraits full of sexual tension. He battled the fashion establishment in order to make his mark, and to this day remains one of the most distinguished British photographers.

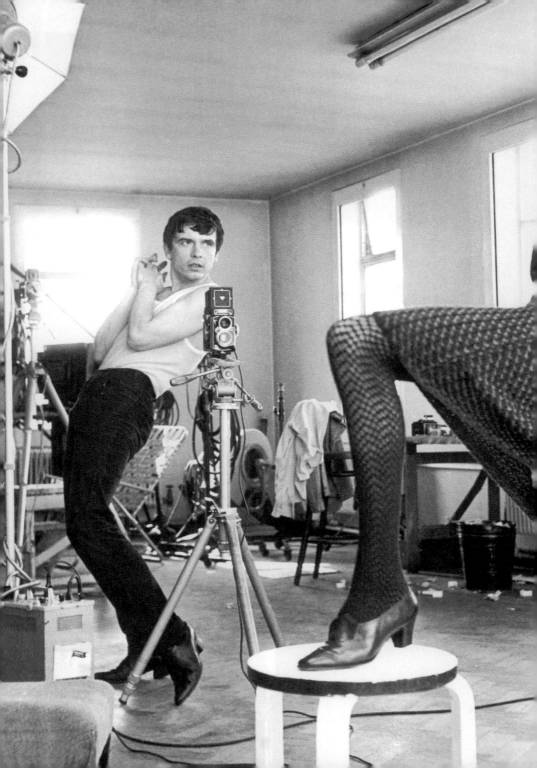

RUDI GERNREICH'S TOPLESS SWIMSUIT
Scandalizing the American public

Rudi Gernreich (1922–85) was the darling of the American avant-garde. Courrèges and Quant might have been showing the shortest skirts, but Gernreich went one step further and presented a topless dress, which made headlines (though not many sales).

He also made the monokini, a topless swimsuit that was worn by Peggy Moffitt, his favourite model. The skimpy garment might have chimed with the scantily clad sunbathers on European beaches, but it was banned in the US. The American public were scandalized. Throughout the country, statesmen and church officials pronounced the swimsuit immoral and tasteless.

Many people assumed the monokini was meant to be nothing more than a fashion stunt. However, despite the reaction of critics and churchmen, shoppers purchased it in unexpected numbers that summer. By the end of the season, Gernreich had sold 3,000 swimsuits at $24 a pop (a tidy profit for such a minuscule amount of fabric). Still, despite the number of swimsuits that were bought, fashion history records that very few monokinis seem to have ever been worn in public.

Gernreich is credited with other fashion firsts. His design goal was to perfect a slim body line with seaming and no darts, and, as the perfect foundation garment, he created the 'No-Bra', with cups made from triangles of sheer nylon net attached to shoulder straps and a narrow elastic band encircling the ribcage. He took the heavy inner construction out of bathing suits. He created early body stockings and leggings based on dancers' leotards and tights but using flesh-coloured mesh and black jersey. He experimented with an androgynous look by putting men in skirts, and was an early adopter of the use of heavy metal zips as decoration.

Gernreich, an enthusiastic nudist, became notorious with his topless swimsuit design. The mayor of San Francisco declared, 'Topless is at the bottom of porn.' In Russia it was dismissed as a 'sign of social decay'.

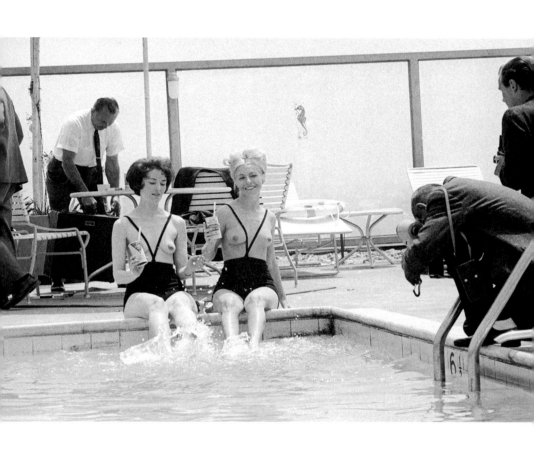

VIDAL SASSOON

Revolutionizing hairdressing with the five-point cut

Vidal Sassoon (1928–2012) made celebrity hair history when he was paid $5,000 to cut Mia Farrow's hair for her role in *Rosemary's Baby* (1968). At the time of the world-famous haircut Mia was married to Frank Sinatra, and media buzz sometimes blamed the demise of her marriage on her shockingly short pixie Sassoon cut. Whether it was true or not, it seasoned the fame of Sassoon.

It was his mother who helped the young Vidal land his first hairdressing apprenticeship in a salon in the East End of London, where he began to develop an appreciation of geometry. Sassoon had early dreams of being an architect before joining the Israeli Defense Forces in 1948, but his architectural approach to hair eventually made him the most sought-after hairdresser of the 1960s.

Sassoon cuts were all high fashion and low maintenance. Before him it was all roller sets and 'hair-dressing'. Sassoon created shapes that were so modern and so forward-thinking that they still look 'modern' nearly 50 years later. His lasting contributions include the five-point cut, worn by fashion designer Mary Quant (see page 178), and Nancy Kwan's angular bob in *The World of Suzie Wong* (1960). Alongside Quant, Sassoon 'styled' the 1960s. As the fashion designer herself says, 'I made the clothes, but he put the top on.'

The hairstyles relied on dark, straight and shiny hair, precision-cut into shape. Sassoon's geometric haircuts might have looked severely cut, but they were wash-and-go and entirely lacquer-free, relying on the natural shine of the hair for impact.

Sassoon was a key force in the commercial development of hairstyling, and built his worldwide empire by putting together a team of super-talented hairdressers. The 'architecture of the face' always guided his thinking, and he found constant inspiration in the work of the Bauhaus architects and designers. He considered it one of his greatest achievements when scholars of the German modernist school later recognized the Sassoon cuts as 'part of the forward movement of design'.

Vidal Sassoon admitted that his success owed much to Mary Quant, who came to him with a conundrum: 'Vidal, I am sick to death of all these chignons. Surely there is another way to keep the hair off the clothes.' Sassoon replied: 'Sure, you could cut the whole damn lot off.'

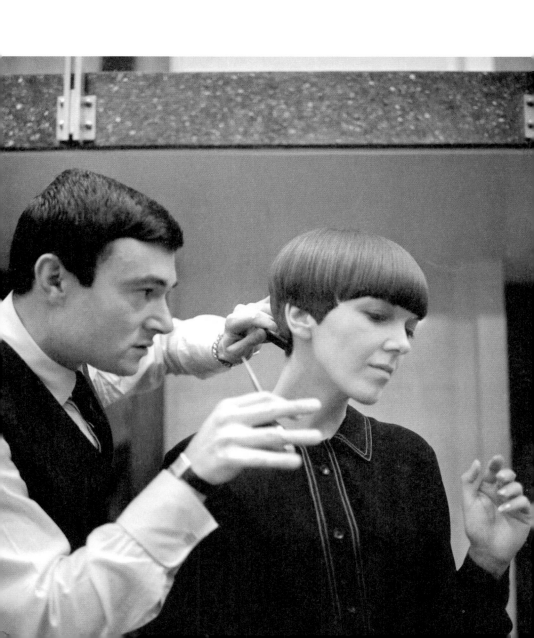

BRIDGET RILEY

Mesmerizing a decade with op art

The British artist Bridget Riley (1931–) was a reluctant fashion icon. In New York in 1965, for the opening of her highly anticipated Museum of Modern Art exhibition *The Responsive Eye*, she was horrified to see dresses with designs lifted from her paintings in the Madison Avenue shop window displays. She was incensed by the way her art was being 'vulgarized in the rag trade'. She even tried to sue an American clothing manufacturer who had produced a line of dresses inspired by one of her paintings: a piece of her work that he had bought for his own collection.

But Riley was fighting a losing battle. Her breakthrough had come as the explosion of 1960s youth culture gained momentum. Works such as *Blaze 1* (1962) and *White Discs 2* (1964) – the hypnotic black-and-white patterns of which gave the impression of swelling or warping movement – synthesized the hallucinogenic mood of the times. British fashion manufacturers found untold applications for Riley's artwork. Shopping bags, car bodies, paper napkins and furnishing fabrics were among some of the items produced in her monochrome motifs that most exasperated the artist.

If Riley thought she could ride out the passing fad at home, she was mistaken, as when The Who arrived in the US, she was discovered by a whole new audience who considered her work an essential part of the London Look. Riley went global, although perhaps not in quite the way she would have liked. In spite of her objections, Bridget Riley became one of the most influential people in the fashion world.

The fashion, design and advertising industries fell in love with op art's graphic patterns and mesmerizing, decorative impact. Across all design disciplines op art was cool, and Bridget Riley (shown here in a photograph by Tony Evans) became Great Britain's number-one art celebrity.

EDIE SEDGWICK

Poor little rich girl: Queen of The Factory

In 1965, at the age of 22, Edith ('Edie') Sedgwick (1943–71) met Andy Warhol at a party in New York. An heiress from a dysfunctional Californian family, the gamine bottle-blonde with cropped hair, kohl eyeliner and antique chandelier earrings captivated Warhol. Before the night was out he had cast her in *Vinyl* (1965), the movie he was making.

Punk-rock legend Patti Smith recalled: 'She was such a strong image that I thought, "That's it." It represented everything to me, radiating intelligence, speed, being connected with the moment.' Sedgwick became 'Queen of The Factory', the New York studio where the Warhol inner circle worked and partied. She was the antithesis of the society heiress of the time, and fascinated in her long dresses and bare feet, accessorized with her grandmother's jewels. Her opaque tights, leotards, false eyelashes and shoulder-grazing earrings inspired Edie-wannabies everywhere.

For a short time Warhol and Sedgwick were inseparable. She dyed her hair silver like his. He wore a striped jumper to match hers. By 1966 Sedgwick was no longer just a cult figure. She modelled for *Vogue*, which described her as 'white-haired with anthracite-black eyes and legs to swoon over'.

Ultimately, her relationship with Warhol was short-lived, but her style and image influenced a whole generation and continue to inspire – from Kate Moss's cropped haircut in 2001 to Sienna Miller's interpretation in the 2006 movie *Factory Girl*, and John Galliano's 2005 show for Christian Dior. Galliano cited Sedgwick as an influence, saying, 'She may only have had 15 minutes of fame but her style and image influenced a whole generation.'

For a woman with no discernible talent, Edie Sedgwick made a huge and lasting impact. Bob Dylan's 'Just Like a Woman' (1966), 'Leopard Skin Pillbox Hat' (1966) and 'Like a Rolling Stone' (1972) are all purportedly about Sedgwick. In 2006 Sienna Miller played her in the film *Factory Girl*.

JULIE CHRISTIE

Fashion drama on the frozen steppes

1965

The British actress Julie Christie (1941–) made a huge impact with a passing appearance in *Billy Liar* in 1963, and was immediately catapulted to *Vogue* style status. The fashion magazine called her a 'kooky blonde' and 'one of the best things in the film'. She quickly became a star in her own right, and shot to superstardom with her roles in *Doctor Zhivago* (1965) and *Far from the Madding Crowd* (1967).

As the impossibly beautiful Lara in *Doctor Zhivago*, she made the maxicoat a fashion must-have overnight. Few films have had a comparable influence on fashion. With the 1960s in full swing, the miniskirt had far from run its course, and yet John Fairchild, publisher of *Women's Wear Daily*, waged a personal crusade to drop hemlines after developing a fashion crush on Lara's wardrobe. Indeed, Christie's role ranks among the few that continue to inspire fashion designers to this day.

Doctor Zhivago's director David Lean championed his leading lady, carefully lighting her face and placing her in breathtaking locations and costumes. The epic tale of love in a war-torn Russia divided by revolution and ideology uses clothes to express the theme of social change. Thus Christie's elegant aristocratic wardrobe of the early part of the film gives way to sober military uniform. Inevitably, military tailoring also caught the popular imagination.

In 1967 *Time* magazine observed: 'What Julie Christie wears has more real impact on fashion than all of the clothes of the ten best-dressed women combined.' By this time Christie was a superstar who commanded $400,000 a movie.

Phyllis Dalton won an Oscar for her costumes in *Doctor Zhivago* (1965), but remembers the demands of the director, David Lean, who was concerned with every detail: 'He made all his actors wear period undergarments beneath all their costumes for added authenticity, even though they were never visible in any of the film's scenes.'

NICO

Counterculture femme fatale

Nico (1938–88) is best known as a member of the original Velvet Underground, and was a key player in the legend created around them by Andy Warhol. But even before those heady New York City days, Nico had enjoyed considerable success as a model and actress. Living in Paris at the beginning of the 1960s, she graced the pages of a number of iconic fashion magazines. And, while working as a model, she had also landed a part in *La Dolce Vita* (1960, see page 118) sung on a soundtrack composed by Serge Gainsbourg and had a child with Alain Delon.

Nico was born in Cologne, and her father was killed in action during World War II. She was discovered by a photographer in Berlin, became a model in Paris and then, in 1965, the Rolling Stones's guitarist, Brian Jones, introduced her to Andy Warhol in London. She looked him up again when she went to New York in 1966, as a model under contract to Eileen Ford.

Warhol remembered meeting her: 'She was sitting at a table with a pitcher in front of her, dipping her long beautiful fingers into the sangria, lifting out slices of wine-soaked oranges. When she saw us, she tilted her head to the side and brushed her hair back with her other hand and said very slowly, "I only like the fooood that flooooats in the wiiine."'

With her eye-skimming fringe and pale-blonde hair, Nico created her own distinctive look in slim-cut mannish tailoring. When Warhol began managing the Velvet Underground, he proposed they take on Nico as singer. She sang lead vocals on three songs ('Femme Fatale', 'All Tomorrow's Parties', 'I'll be Your Mirror') on the band's debut album, *The Velvet Underground and Nico* (1967), one of the most legendary rock albums of all time.

On Nico (second from right), the man's trouser suit became an effortlessly cool piece of clothing. The style icons' style icon, Chloë Sevigny, admits she has pictures of Nico on her walls. And she is cited as inspiration by musicians from Bauhaus and Marc Almond to Siouxsie Sioux and Björk.

THE ROMANTIC LOOK

Fashion reconnects with its softer side

'In fashion the revolution is over. A new quiet reigns.' So said *Vogue* in 1967, ushering in an era of exotic romance.

There was a marked change in direction from futurist to nostalgic fashion; from minimal to baroque; from hi-tech to handmade. In reaction to the uniformity of geometric haircuts and 'functional' fashion, stiff, carved tweed suits and creaking plastic, women wanted to dress up and look wild and beautiful. For evening wear, pure theatre came in the form of brilliant colour, lavish prints, rich embroidery and tall boots, imagined to be the staples of wardrobes in gypsy camps all over the Ukraine.

The movement had three style tribes. The youngest was the 'flower power' school (think Pattie Boyd with her Native American fringed suede, headbands and colour-clashing layers of crêpe and brocade). It was a kind of dressing-up-box style with tassels, fringes, bows and bells. Then there was the Mayfair version: a jet-set rendition of picturesque poverty that favoured ethnic gypsy dresses, Indian pantaloons, Afghan coats mixed with sheepskin and gold embroidery. In London, 'Indian' and 'Middle Eastern' boutiques sprang up everywhere.

The third tribe was the ruffle-and-ringlet lot inspired by the movie *Viva Maria!* (1965), starring Brigitte Bardot (see page 68) and Jeanne Moreau (see page 128). This favoured a daytime look of velvet knee-breeches and men's suits with ruffled shirts, and for evening, long demure dresses in fragile fabrics with frilled and tucked bodices, milkmaid sleeves, bib fronts and lace edgings. The hair was worn in ringlets or shoulder-length curls and tied in bunches with ribbons. Or it was left loose in Pre-Raphaelite waves and Ophelia ripples, with eyes painted icing green or harebell blue. London's King's Road looked like a Russian ballet, and 1920s beaded dresses became treasured pieces.

Ruffles and ringlets in the retro romp *Viva Maria!* became a huge hit, thanks to Bardot and Moreau. Only in the 1960s could a movie succeed as part epic Western, part sex comedy, part slapstick, part Marxist tract. Moreau and Bardot shone as women who invented striptease and led a Central American revolution.

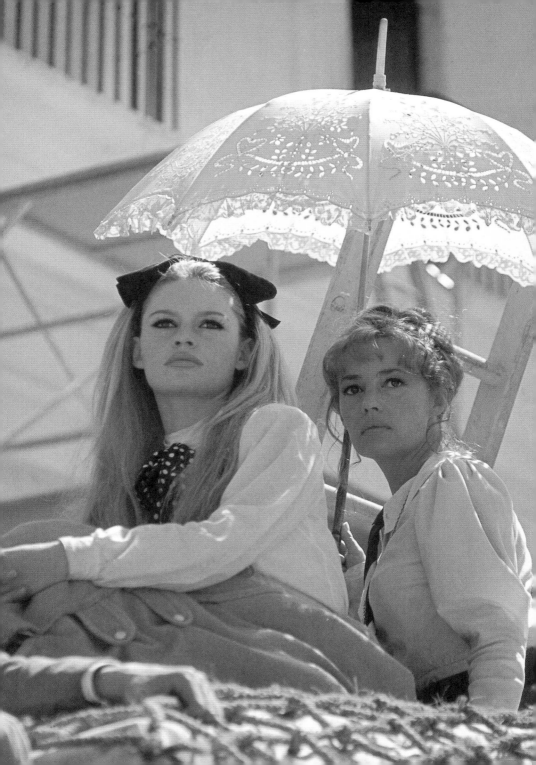

BLOW-UP

A snapshot of Swinging London

Director Michelangelo Antonioni's first English-language film was a sensation. It tells the story of a fashion photographer's accidental involvement with a murder and captures the atmosphere of Swinging London – from the hip parties, peopled with reefer-smoking dudes, to the gangs of earnest student mime artists let loose on the streets. Every bit as important as super-snapper Thomas and his dolly girls is the stylish world they inhabit: a world of fast cars, glossy magazines and rock 'n' roll.

Antonioni turns an outsider's eye on a London that was just beginning to swing, and captures the moment. But a film intended as an attack on a certain type of modern sophistication ended up celebrating the fashion and music of the very world it set out to criticize.

The film features David Hemmings (as Thomas), Vanessa Redgrave and Sarah Miles. Jane Birkin (see page 200) made her name in the movie playing 'the blonde'. One of the most famous models of the day, Veruschka (see page 196), has a cameo in a scene in the photographer's studio, which *Premiere* magazine called 'the sexiest cinematic moment in history'. Veruschka's writhing body, under Hemmings's close-quarters camerawork and breathless urgings, has also been mimicked and lampooned countlesstimes ever since.

Plot aside, *Blow-Up* marks the historical moment when the partnership of photographer and model achieved popular cult status. The fashion industry was spawning stars to equal screen idols. The photographer Thomas is generally considered to have been inspired by David Bailey (see page 136), but there is more than a hint of Terence Donovan in him, as well as a smattering of John Cowan (in whose studio the movie was in part shot).

Another notable cameo was by the Yardbirds, who perform 'Stroll On' (1966). Jeff Beck, playing alongside Jimmy Page, smashes his guitar over an amplifier in an obvious nod to The Who, a band who had been invited to appear in the film but refused.

In the late 1960s, with visionary art director Harri Peccinotti, *Nova* magazine became Britain's 'style bible' and a groundbreaking women's magazine. Launched in 1965, it arrived at the perfect time to chart and document the evolution and fallout of the 'Youthquake'. There was so much to talk about. Mary Quant (see page 178) had revolutionized wardrobes. Rock 'n' roll was one of Britain's most successful exports. The pirate radio station Radio Caroline was making waves in the conventional music media. And more and more people had a television, which brought world politics and culture into the home.

The iconic *Sunday Times Magazine,* which employed established as well as emerging photographic talent, had started publishing articles on fashion, lifestyle and interior decoration. *Nova* settled into the niche inhabited by intelligent women who wanted more from their magazine than simply fashion and cookery. It would be another six years before *Cosmopolitan* arrived with its no-holds-barred agenda of sex and celebrity, and another 20 before *Elle*.

Nova was the first of its kind; politically radical, unashamedly controversial and fearless in the pursuit of intelligent opinion. Its subject matter ranged from sex and the pill to feminism, homosexuality and racism. There were 5,000-word articles by Christopher Booker and Susan Sontag, Irma Kurtz, and photographs by Helmut Newton (see page 264) and Don McCullin. Its fashion editors, Molly Parkin and Caroline Baker, had a massive impact on the fashion of the era.

After a meteoric rise, *Nova* fell victim to aggressive competition and closed in 1975 after only ten years in operation.

Nova challenged everyone's idea of what a women's magazine should be, embracing risk and taking chances in features and photography. *Nova* epitomized the concept of the avant-garde and reshaped the scope of women's publications forever.

EMILIO PUCCI
The irresistible lure of colour

The psychedelia of the 1960s found high-fashion expression in the radiant prints of Emilio Pucci (1914–92). His slinky silks in vibrant swirling patterns became a wardrobe staple of the jet set (see page 78). His daring juxtaposition of acid yellows, lime greens, Aegean turquoises and fuchsia pinks became a distinctive design signature, recognized the world over to this day.

A dashing Florentine aristocrat, Pucci made his fashion debut quite by accident. In 1947 a ski suit that he designed for a friend was spotted on the slopes of Zermatt in Switzerland, and was subsequently featured in the pages of *Harper's Bazaar*. Thus began his career as a designer of sport and resort clothes. His social connections gave him a guaranteed entrée into the beau monde, and soon everyone from Sophia Loren (see page 62) to Jackie Kennedy (see page 172) was sporting his iridescent creations. Marilyn Monroe (see page 46) was even buried in one of his dresses. The Pucci trademarks spoke of colourful ease: sexy narrow-legged pants, soft tunic tops and loose blouses.

In 1965 a New York ad agency was hired by Braniff International Airways to update its image. Pucci was commissioned to design new clothes for the flight attendants. The advertising tagline read: 'The End of the Plain Plane'. The uniforms so captured the public imagination that Barbie (see page 100) had all four versions in her wardrobe. Among the more unusual innovations was a 'bubble helmet' – a clear plastic hood worn by flight attendants between terminal building and aircraft to protect their hairdos from the rain and the blast of the jet engines.

Imagine the joy of the jet-set traveller: to discover not only that could she fit dozens of Pucci outfits into a single bag, but also that they emerged wrinkle-free. In the sybaritic 1960s, this simple practicality contributed enormously to Emilio Pucci's overnight success.

RICHARD AVEDON

The man who turned fashion photography into art

When director Stanley Donen went looking for inspiration for the elegant fashion photographer played by Fred Astaire in his movie, *Funny Face* (1957), he looked no further than Richard Avedon. In a decade when fashion photographers were as famous as rock stars, Richard Avedon was the poster boy for his profession.

A high-school dropout, Avedon learned the rudiments of photography as a merchant marine in the 1940s. In 1945 he got his first break at *Harper's Bazaar*. He recalls: 'I was overwhelmed. Mrs Vreeland kept calling me Aberdeen and asking me if a wedding dress didn't make me want to cry. They are all serious, hard-working people. They just speak a different language. So I took my models out on the beach and photographed them barefoot, running, playing leapfrog.' The experiment was a hit and he became a staff photographer at *Harper's Bazaar*. Working alongside Alexey Brodovitch and Diana Vreeland, Avedon evolved a style that was rich in narrative, energy and movement.

Central to the appeal of *Harper's Bazaar* were the outdoor shoots and innovative photography, and Avedon was one of the magazine's stars. His style reverberates through the work of contemporary photographers such as Steven Meisel (see page 424) and David Sims, and anyone else who directs a model to stride or leap across a seamless background, or attempts to capture her in an unobserved private moment. Twiggy (see page 184), who had a relatively short career, is the poster girl of the 1960s largely because of his pictures of her.

While shooting the Paris collections for *Bazaar*, Avedon would take the clothes out of the salon and onto the street. He invented scenes and storylines for models such as Dovima, Dorian Leigh, and his first wife, Doe Avedon. Avedon's minimalist aesthetic and athletic power helped create some of the most memorable fashion images of the decade. He was the frenetic energy of the 1960s in human form. As his friend and fellow fashion photographer Lillian Bassman once said, 'Did you ever meet Dick? He was always jumping around.'

In 1965 Avedon left *Harper's Bazaar* and followed his close ally Diana Vreeland (see page 126) to *Vogue*. In total, their collaboration would span 40 years.

Avedon's photographic style has been widely imitated by photographers across the decades. Generations of models have leapt across white backdrops, struck an athletic attitude in a blank set or simply sat lost in thought in a café — all on account of Richard Avedon.

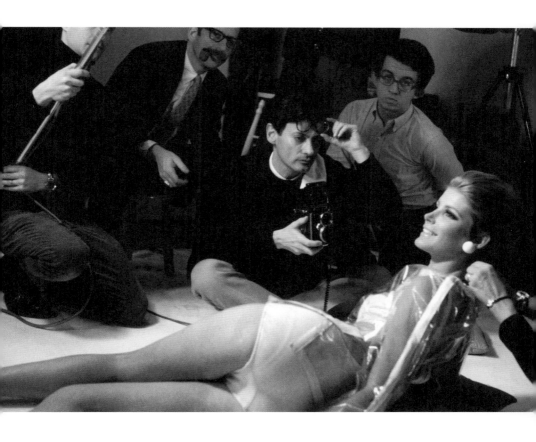

TRUMAN CAPOTE'S BLACK AND WHITE BALL

The night the writer made 500 friends
and 15,000 enemies

When the author Truman Capote threw a lavish ball to celebrate
the phenomenal success of his 'nonfiction novel' *In Cold Blood*
(1966), he conjured a way to make it the most talked-about party
of the decade. He would invite his friends, who included the most
famous people in the world. He would request they all wear black
or white. And he would have them hide their fabulous and much-
photographed faces behind masks.

'They rolled off the assembly line like dolls,' wrote Enid Nemy in
the *New York Times*, 'newly painted and freshly coiffed, packaged
in silk, satin and jewels and addressed to Truman Capote, the Plaza
Hotel.' CBS dedicated a special programme to the arrivals. Viewers
at home were rapt. 'This is how the other half lives,' quipped the
announcer before continuing archly, 'We know you were not rich,
social, or beautiful enough to be invited, or you wouldn't be up
watching the news.' He added, 'the "Henrys" are here, Ford and
Fonda…but not the "Edwards"…', meaning the Duke of Windsor and
Kennedy, who had both RSVP-ed 'non'.

Frank Sinatra came with Mia Farrow, who incited rumours of
pregnancy by wearing an empire-line dress, and mutterings of
curiosity by showing off the new gamine crop she had chosen for
the role in *Rosemary's Baby* (1968). Tallulah Bankhead, Babe Paley
(see page 98) and Gloria Guinness (see page 104) were belles of
the ball. Lauren Bacall (see page 28) danced with the choreographer
Jerome Robbins 'in a fashion', Truman Capote noted, 'that Fred
Astaire and Ginger Rogers might have envied'. Jackie Kennedy's
sister, Lee Radziwill, had to sit the dancing out in case beads from
her gown showered the dance floor.

Women wore multiple hairpieces, teased, tamed and twisted
by the hands of Kenneth Battelle (see page 124) – known as 'The Mr
Cool of the Haute Coiffure'. Leo Lerman told the *Life* photographer
Henry Grossman that he 'had never seen so many beautiful women
in one place at one time'.

Breakfast at Tiffany's
catapulted Truman Capote
to a level of stardom that few
writers reach. *In Cold Blood*
(1966) – his account of a
notorious quadruple murder
– created a wave of acclaim
and controversy that would
carry him for years to come.
But some say the Masked
Black and White Ball was truly
one of his greatest works.

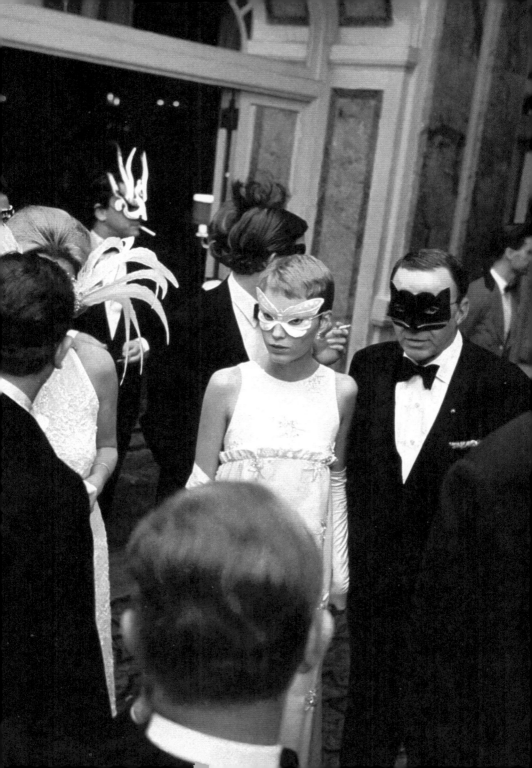

RIVE GAUCHE

YSL offers power to the people

In 1962 Yves Saint Laurent (1936–2008) left Dior, and on 29 January of that year the Yves Saint Laurent couture collection made its debut. *Life* magazine called it 'the best collection of suits since Chanel'.

Saint Laurent's reputation was built on his supreme tailoring. The first to feminize a man's tuxedo, with 'Le Smoking' in 1966 (see page 174), he anticipated power dressing by a decade. The Saint Laurent jacket became a symbol of success for career women throughout the world. The designer also knew that high fashion needed the energy of popular youth culture to inject new verve into its stale atmosphere, so he frequently visited London during the 1960s to find inspiration in the boutiques of the King's Road.

By the mid-1960s, although London was in full swing, Paris was still putting couture on a pedestal. In 1966 Yves Saint Laurent and his partner, the industrialist Pierre Bergé, were the first among the French fashion establishment to turn away from the rarefied couture ateliers to the relative accessibility of prêt-à-porter. From the early years of their business partnership, Pierre Bergé was astute enough to know that although couture equalled kudos, it was the glamorous accoutrements – perfume, accessories and cosmetics – that would turn YSL into an international force. It was Bergé who urged Saint Laurent to do ready-to-wear, and in 1967 the house opened a prêt-à-porter boutique – Rive Gauche (meaning Left Bank) – in a former bakery at 21, rue de Tournon.

A pioneer in his day, Saint Laurent was not only the first designer to popularize ready-to-wear fashion, but he also broke the social taboo around trousers for women and was the first to include black models in his runway shows. Pierre Bergé, who remained Yves Saint Laurent's close friend and business partner until the designer's death, has said that while Chanel gave women freedom, Yves Saint Laurent gave them power.

Barely five years after founding his couture house, Saint Laurent explained his prêt-à-porter project simply: 'I want to break away from the idea that haute couture is the sole image of fashion. Fashion is what can be worn. This is the main square, not a closed circle.'

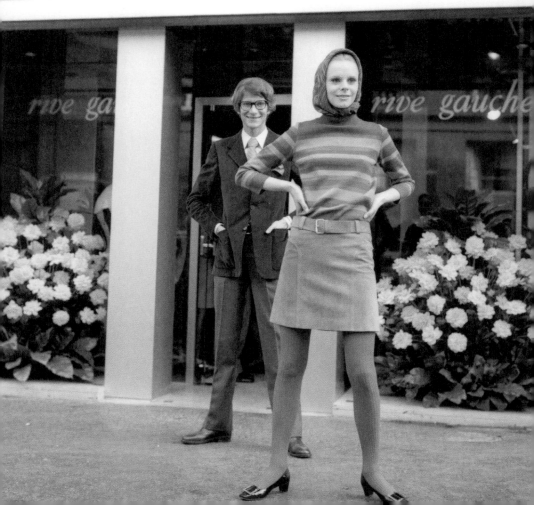

ANITA PALLENBERG

c.1967

'Evil glamour'

Anita Pallenberg (1944–2017) grew up in Rome and went to a German boarding school. Keith Richards famously said that when he first met her he was almost overwhelmed: 'She knew everything and she could say it in five languages. She scared the pants off me.'

Expelled from school at 16, Anita Pallenberg graduated to the upper echelons of cool. She first made her way to Rome and hung out with the *dolce vita* crowd, and then in New York with the Andy Warhol crowd, before moving to Paris to begin working as a model. In 1965 she met the Rolling Stones at a concert in Munich.

Brian Jones was the first to fall for what Marianne Faithfull called Pallenberg's 'evil glamour'. But a passion for mod fashion and the mysteries of the occult were not enough to sustain a relationship that was tempestuous and often violent. In 1967 she ran off with Keith Richards while the band was on holiday in Morocco.

Pallenberg made a living as an actress. Her credits include *Barbarella* (1968, Keith offered her £20,000 not to do it, but she did it anyway and *Performance* (1970) – the backdrop for an alleged affair with co-star Mick Jagger and her first encounter with heroin). 'Anita is a Rolling Stone,' said Jo Bergman, the band's one-time assistant. 'Her influence has been profound. She keeps things crazy.'

Pallenberg and Richards had two children before the band's lawyers urged a split. What followed were decades of addiction and notoriety. She once spent a month at the Grosvenor House Hotel in London without ever leaving her room, and claims to remember nothing of an occasion when a 17-year-old boy shot himself in her bedroom.

Her style and glamorous figure, a kohl-eyed icon of her time, has influenced the likes of Kate Moss (see page 426) and Sienna Miller.

Whenever a girl dons a shaggy fur coat, velvet trousers, floral minidress or floaty tunic and shorts, tops it off with a wide-brimmed hat and works that 'I'm with the band' vibe, she should remember, that she owes it all to Anita Pallenberg: the mother of all rock chicks.

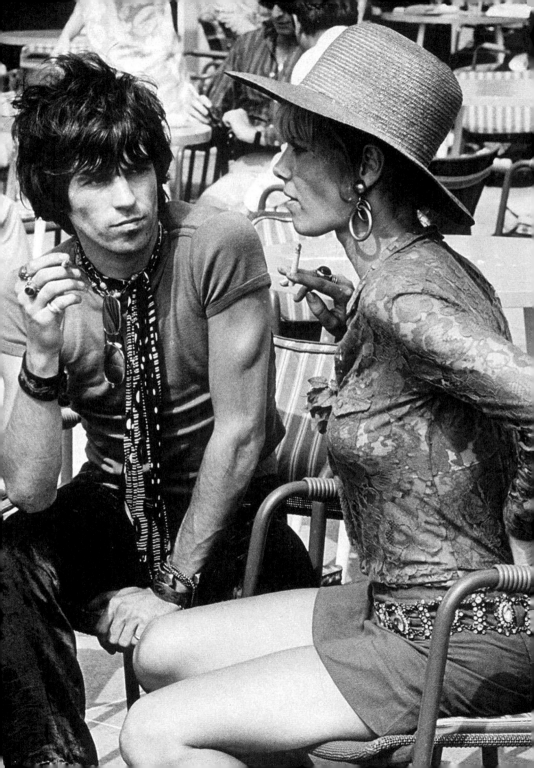

CATHERINE DENEUVE IN *BELLE DE JOUR*

1967

Chaste eroticism and French chic

In 1968 the critic Frances Wyndham dubbed Catherine Deneuve (1943–) 'a cool combination of the virginal and the vicious'. It was her portrayal of an icy, sexually adventurous housewife in Luis Buñuel's 1967 *Belle de Jour* that established her as one of the most compelling actresses of her generation, and Yves Saint Laurent as one of the most influential designers. The movie marked the beginning of what would be one of fashion's most significant partnerships, for it was then that the actress and designer first met. To this day, the YSL costumes that Deneuve wore in the film are continually referenced in fashion and pop culture.

Deneuve plays Séverine, a doctor's wife who leads a double life. A prostitute by day, turning her fantasies into reality, she becomes a housewife by night, when she settles into prim domesticity with her husband. The Saint Laurent wardrobe plays a supporting role that speaks volumes about her character. In tailored coats and dresses, she is the perfect Parisienne. In the brothel, in lingerie and silk, she becomes the confident seductress.

Saint Laurent had a decades-long relationship with Deneuve, and it would be alongside his muse that he took his bow at his very last show. It has been said that their relationship never advanced much beyond formal terms, but together their fashion influence has enjoyed an enduring incandescence.

'Saint Laurent designs for women with a double life,' Deneuve once said. 'His clothes for daywear help a woman to enter a world full of strangers. They enable her to go wherever she wants without arousing unwelcome attention, thanks to their somehow masculine quality. However, for the evening, when she may choose her company, he makes her seductive.'

Referencing the power of the actress's quiet elegance, Saint Laurent dismissed the more extreme designs of the day: 'It pains me physically to see a woman victimized, rendered pathetic, by fashion.'

Director Luis Buñuel cared less for Deneuve's nakedness than for the clothes that covered it in his fetishistic movie *Belle de Jour*. It's her glazed and highly polished feminine surface that takes centre stage, and her YSL wardrobe that plays the greatest supporting role.

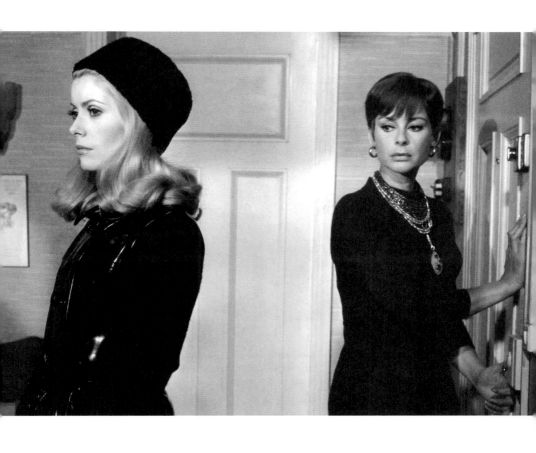

FAYE DUNAWAY IN
BONNIE AND CLYDE
The death of the mini

'They are young, they are in love, they kill people.'

Originally conceived as a stark black-and-white film about the notorious Texas outlaws, with a look based on the Dust Bowl-era photographs of Walker Evans, *Bonnie and Clyde* became a box-office hit in 1967 and a trendsetter for the decade. It was something entirely different: less neorealist, more stylish folk ballad. The movie presented its murderous couple as romanticized and immensely attractive nonconformists. It was a portrayal that chimed with young 1960s audiences, who strongly identified with the fugitive lovers.

Theadora Van Runkle's costumes had a massive impact on the world of international fashion, though she had struggled to get her ideas accepted. Faye Dunaway (1941–) had originally wanted to wear slacks as Bonnie Parker, since she realized that the character would need to move freely to race in and out of getaway cars. Theadora, however, went with a more glamorous wardrobe, with long skirts, a beret and a short jacket. And the 'Bonnie and Clyde Look' became a fashion rage.

Bonnie's outfits were fluid and looked as though they could be packed fast should the wearer need to go on the lam. They were feminine but suffused with a tomboy sexuality. Van Runkle remembered Ms Dunaway needed to be convinced. 'Faye thought I didn't care how she looked,' Van Runkle told a fashion critic. 'She thought I was trying to make her ugly.'

It is no exaggeration to say that Dunaway's wardrobe as Bonnie Parker triggered the death of the mini and ushered in the midi.

The film became a catalyst for a revival of ladylike chic across the US: berets and bobs were the quintessential headwear, while longer pencil skirts were rediscovered by the mini-wearing youth, creating a new breed of femme fatale.

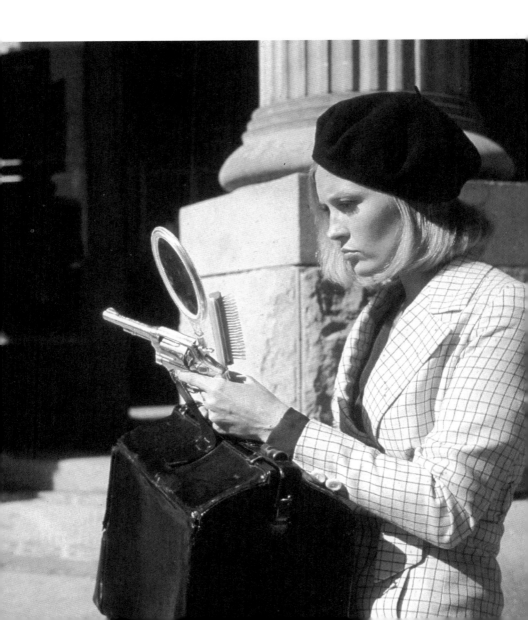

GRANNY TAKES A TRIP

The new face of fashion retailing

In the long history of retailing, Granny Takes a Trip was a mere blip that lasted only four years. But the little shop that opened in 1967 at 488 King's Road changed everything. The originators were the journalist Nigel Waymouth and his girlfriend Sheila Cohen, who intended to sell Sheila's collection of vintage clothes. The arrival of the Savile Row tailor John Pearse set the project off on a swirling, theatrical, psychedelic trajectory with enough creative energy to make London the shopping mecca of the world.

London's main shopping attraction of the day, Carnaby Street, was the hub of an early kind of fast fashion, pioneered by the queen of that scene, Mary Quant (see page 178). Granny Takes a Trip launched the King's Road as an alternative destination. And there were rich pickings on the second-hand market for the lavishly embroidered Savile Row uniforms that had become redundant in 1939 when men were no longer required to wear formal court dress. Anything braided, tailored, tasselled and swaggerworthy was becoming standard issue for any self-respecting rock god. The eclectic collection of vintage Victorian and Edwardian clothing, sold alongside Pearse's Savile Row tailoring, launched a boho chic that, to this day, remains an assuredly London look.

Behind a series of surreal (and temporary) shopfronts, Granny Takes a Trip peddled a mysterious and exotic glamour. It was like a grown-up dressing-up box in which psychedelic fantasy and fin-de-siècle romance collided. Among the first customers were the Beatles and the Rolling Stones, who wore Granny's clothes on the album sleeves of *Revolver* (1966) and *Between the Buttons* (1967). Jimi Hendrix, Ossie Clark, Anita Pallenberg, Brigitte Bardot and Andy Warhol hung out there, too.

Within three months the shop was featured in *Time* magazine, which was celebrating the arrival of Swinging London, and a few weeks later the team rang the changes with the first overhaul. Out went art nouveau and in came two giant and forbidding images of Native American chiefs, Low Dog and Kicking Bear, rendered as psychedelic portraits.

Granny Takes a Trip triggered the boutique boom and influenced the dozens of stores that followed in its wake. The original Granny's team went their separate ways in 1969.

Granny Takes a Trip transformed the way fashion and clothes were sold. A 'psychedelic art project' that became a mecca on the hippie pilgrimage, it sold a brand of renegade fashion that did exactly what it said on the tin.

JACKIE KENNEDY
Fashion's first lady

Jacqueline Kennedy (1929–94) was 31 when she became First Lady, a role that had been filled for the previous 64 years by women old enough to be her mother. After generations of matronly First Ladies, Jackie Kennedy gave the American public what they never knew they needed – glamour. Kennedy radiated enviable qualities – confidence, independence and intelligence. Well-bred and properly educated, she was the walking definition of class. She set a new example of how young American women ought to be.

The French-born but naturalized American Oleg Cassini was her first official designer, a choice that stunned the experts who had assumed she would have selected America's leading designer, Norman Norell. Yet it was a smart move by the 33-year-old, who was addicted to French couture but was nonetheless obliged to show the electorate that she bought American.

Early on, *Women's Wear Daily* – the American fashion bible – implied that Jackie had been smuggling French couture clothes into the White House. And when the President and Mrs Kennedy went to France, another guest at an Elysée reception discovered she had ordered a dress from Pierre Cardin's spring collection that was identical to the Cassini one worn by the First Lady – 'So identical that Paris couture couldn't believe their eyes.' To the industry, the Cassini factor suddenly made sense. She would not so easily have persuaded Norman Norell to knock off his French counterparts. When she made her stunning entrance at the Palace of Versailles in a Givenchy gown, all controversy was set aside and *WWD* dubbed Jackie 'Her Elegance'.

The average American housewife basked in Jackie's motherhood, her refinement and her lofty pursuits, which included riding to hounds and reading Proust. Jackie Kennedy was responsible for the mass adoption of styles such as the pillbox hat, the bouffant hairdo, the shift dress and the low-heeled pumps.

Jackie was a powerful weapon in the Washington diplomatic armoury. In this picture she is on a visit to Cambodia, which had broken relations with the US in criticism of the Johnson campaign in Vietnam. However, they rolled out the red carpet for the former First Lady and her party. And Prince Sihanouk declared her 'the best ambassadress America could send'.

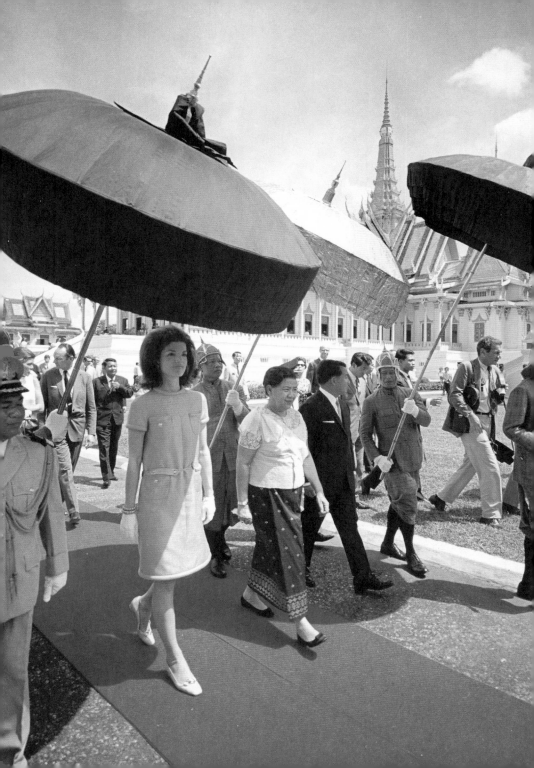

LE SMOKING

The new little black dress

When Yves Saint Laurent (see pages 162 and 288) first presented 'Le Smoking' as part of his 'Pop Art' collection, there were two versions: a jacket and trousers in grain de poudre with four button-down pockets; and a straight-cut, high-waisted satin version over a white organdie blouse. Both offered an initially controversial alternative to the classic little black dress or evening gown.

At first, editors and buyers didn't get it. *New York Times* critic Gloria Emerson panned the collection. It was, she said, 'lumpy' and 'outdated', arguing that Saint Laurent 'strains too hard to convince the world he is hand-in-hand and eye-to-eye with the very young'. Nonetheless, Le Smoking was instantly sanctioned by a chic collective of style icons, including Catherine Deneuve (see page 166), Betty Catroux, Françoise Hardy, Liza Minnelli, Loulou de la Falaise, Lauren Bacall (see page 28) and Bianca Jagger (see page 222).

Yves Saint Laurent was seen by many as empowering women by giving them the option to wear clothes that were normally reserved for men of influence and power. Over the next 30 years he reinvented his signature silhouette in hundreds of new and different guises, reissuing it as a dress, short suit and jumpsuit, and for day or evening wear.

Looking back, it's hard to believe that throughout the 1960s, society frowned upon a woman wearing trousers outside of her home. Even into the 1970s, very few 'good' restaurants would admit a woman in trousers. La Côte Basque in New York famously turned away YSL devotee Nan Kempner in Le Smoking. In response, she stripped off the trousers there and then, and marched into the restaurant wearing only the jacket, reappropriated as an ultra-short minidress.

'For a woman, Le Smoking is an indispensable garment with which she finds herself continually in fashion, because it is about style, not fashion,' said Saint Laurent. 'Fashions come and go, but style is forever.'

The Winter 1966 collection was not universally well-received: proof, perhaps, that critics are not always right. For with the introduction of Le Smoking, Saint Laurent found his definitive muse: the independent woman. The tuxedo would be included in YSL collections for the next 30 years and revolutionized the feminine wardrobe.

MARIMEKKO

The flowering of Finnish fashion

'One has to dream. And one must stand out from the rest.' This was the famous declaration of the Finnish textile designer Armi Ratia (1912–79), co-founder of Marimekko, at the start of her career. In a world mired in postwar malaise, Ratia's playful prints were a shot in the arm for the fashion industry.

The catalyst was the failure of her husband's business venture in an oilcloth factory. The facility was converted into a garment plant instead and Armi asked some artist friends to apply their graphic skills to textiles. In order to show how the fabrics could be used, the company then used them to design a line of simple dresses.

At the very first Marimekko fashion show, held in a hotel in Helsinki, women reportedly 'went wild' for her graphic print shift dresses and they were a sell-out success. Two pioneering designers set the tone for Marimekko: Vuokko Nurmesniemi (1930–) in the 1950s and Maija Isola (1927–2001) in the 1960s. Isola's iconic poppy print, designed in 1964, is a bestseller to this day.

Two key breakthrough moments set the company on the path to its meteoric rise in the 1960s. In 1957 Giorgio Armani (see page 336), then working as a window dresser for the Italian department store Rinascente, invited Ratia to display her relaxed cotton shift dresses there. And in 1959 Jackie Kennedy (see page 172) bought seven dresses from the then little-known Marimekko brand, and was featured on the cover of *Sports Illustrated* magazine wearing a loose-fitting sleeveless version in red.

The effect on sales was instant. More casual than what Paris had to offer, the Marimekko look chimed with new attitudes and increasingly relaxed dress codes. During the 1960s the company expanded globally, and became widely known for its casual, often unisex clothing aimed at a young clientele. Accessories and products for the entire home quickly followed.

The Marimekko Corporation in Finland not only sparked a revolution in printmaking, but also pioneered a new definition of fashion that embraced an entire lifestyle.

Idealism and optimism were the driving principles behind Marimekko's exuberant prints (here, the Keidas pattern designed by Annika Rimala). The brightly coloured textiles reflected the optimism of the decade, and shot to high-fashion status when Jackie Kennedy wore a Marimekko dress on her husband's presidential campaign.

MARY QUANT

The driving force behind democratic fashion

1967

Before the 1960s, the fashion industry was a stuffy institution. Few options were open to young designers. They could set up a boutique, join a couture house (and hope to work their way up) or start a wholesale business. Mary Quant (1934–) was one of the most business-savvy designers of a new generation. With her husband, Alexander Plunket Greene, she rebelled against the traditional bastions. 'We wanted to increase the availability of fun to everyone. We felt that expensive things were almost immoral and the New Look was totally irrelevant to us.'

Quant's King's Road store Bazaar opened in 1955 and was the first boutique to offer cheap clothes designed specifically for the young. She had not intended to make her own clothes, but couldn't find what she wanted among traditional wholesalers. Conventional knitwear companies balked at lengthening a cardigan by 30cm (12in) so she could sell it as a dress. She attended night classes and bought material from Harrods to make stock in her Chelsea bedsit.

Bazaar was a sensation, and lines formed around the block. Her vision of fashion democracy meant that girls and young women could have fashion that was made for them, not watered-down versions of stuff made for countesses and film stars. When the straight-cut shift was shown in Paris in the late 1950s, the fashion world was forced to take Bazaar seriously, as Mary Quant had been selling the shape for over a year by that time. By the mid-1960s – it was undoubtedly her decade – Quant's business was worth more than a million pounds.

In 1964 Quant spearheaded the introduction of the London Look in the US, reaching thousands of young American girls through J C Penney before the Beatles even made it Stateside. Her models in their thigh-high dresses stopped traffic on Broadway. All over the world, Mary Quant became the byword for contemporary British style.

Many in the fashion establishment hated the attention London was getting. When Chanel was told Mary Quant admired her beyond all others, she replied: 'From her, it is a very small compliment.' 'The amazing thing about being young', said Mary, 'is that – yes – you're scared, but you take it for granted that you can do it. And I did.'

PENELOPE TREE

The 1960s It Girl who changed the notion of beauty

For a dazzling and memorable moment at the end of the decade, the 1960s belonged to Penelope Tree (1949–). *Vogue* model and muse to David Bailey (see page 136), she seduced the photographer away from Catherine Deneuve (see page 166) and became the ultimate 1960s It Girl. Her eccentric looks and unconventional style which included barely-there minis and raccoon-tail skirts, often provoked furious reactions in the streets of New York.

Penelope Tree was born into a well-connected and wealthy family who had plans for her to study English literature at university. That changed when she was spotted, aged 17, by the legendary American *Vogue* editor Diana Vreeland (see page 126) at Truman Capote's Black and White Ball (see page 160). She was wearing a skinny tunic with split seams over thick black tights.

Together with Richard Avedon (see page 158), Vreeland changed her life. London might have had 'The Twig', but New York had 'The Tree'. 'She's perfect. Don't touch her,' said Avedon to an editor who suggested tweaking her look. Tree relished the possibilities a fashion career offered for escaping her conventional background. 'People thought I was a freak. I kind of liked that.' When John Lennon was asked to describe her in three words, he is said to have replied: 'Hot, hot, hot, smart, smart, smart!'

Tree's relationship with Bailey and her fashion career ended abruptly when late-onset acne left her with scarring. She has recently told Louise France in the *Guardian*: 'I went from being sought-after to being shunned, because nobody could bear to talk about the way I looked.'

According to photographer David Bailey, 'Penelope Tree is the most original model there's ever been. She's the most original-looking girl I've ever seen.' One of the 1960s' elegant survivors, in 2006 she came out of retirement to star in a Burberry ad campaign.

PSYCHEDELIA

Challenging boundaries and breaking rules, with love

Psychedelia was born in the hippie heyday in the Haight-Ashbury district of San Francisco. Style heroes were musicians from psychedelic rock bands, such as the Jimi Hendrix Experience, Pink Floyd and Jefferson Airplane, as well as funk artists such as Sly and the Family Stone, and folk musicians such as Bob Dylan and Joni Mitchell (see page 228). Psychedelic drugs fuelled the audiences at rock concerts and the clothes reflected the buzz of 'tripping out'.

The uniform was instantly recognizable: long hair and luxuriant facial hair for men, and hair tied back with headscarves for women; clashing colours and loud textures; bell-bottom trousers, love beads, tie-dyed T-shirts and peasant blouses. There was an obsession with just about any non-Western-inspired clothing: cue trends for anything Native American, African, Indian or Latin American. Much hippie clothing was self-made, in protest against Western consumer culture. The textures and curvilinear shapes of art nouveau were appropriated and mashed up with less romantic imagery from cult comics.

Many white hippies of the 1960s counterculture identified with the American Civil Rights Movement, and those with curly or 'nappy' hair wore it in afros in earnest imitation of African Americans. The twin ideals of peace and love governed a lifestyle that encompassed sexual openness, communal living, recreational drug use and a fondness for nudity. Vegetarianism together with a proclivity for Eastern religions and a fascination with mysticism further separated the 'love children' from the mainstream.

The low-cost utilitarian Volkswagen Bus became a counterculture symbol, and many were given flamboyant custom paint jobs. A peace symbol often replaced the VW logo.

The psychedelic hippie movement had only a brief flowering before being appropriated almost immediately by the mass market.

The summer of 1967, with its 'love-ins', 'be-ins' and 'flower power', came to be known as 'The Summer of Love', and was one of the seminal moments of a generation. No boundary, be it in music, fashion, politics, art or literature, was left uncrossed, frequently with the help of mind-expanding drugs.

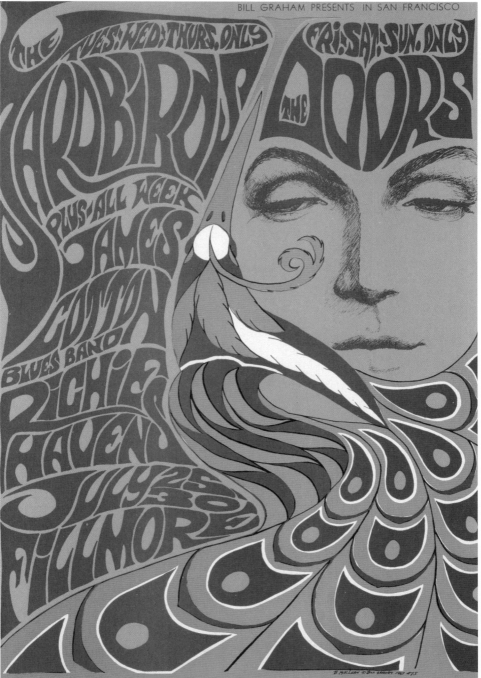

BILL GRAHAM PRESENTS IN SAN FRANCISCO

THE · TUES: WED: THURS. ONLY · YARDBIRDS

FRI: SAT: SUN. ONLY · THE DOORS

PLUS—ALL WEEK · JAMES COTTON BLUES BAND · RICHIE HAVENS

JULY 25–30 · FILLMORE

B. McLean © Bill Graham 1967 #75

TICKETS

SAN FRANCISCO: City Lights Bookstore; S.F. State College (Hut T-1); The Town Squire (1318 Polk); Kelley Galleries (3673 Sacramento);
Wild Colors (1418 Haight); Bally Lo (Union Square); BERKELEY: Discount Records; Shakespeare & Co.; SAN MATEO: Town & Country Records;
REDWOOD CITY: Redwood House of Music; PALO ALTO: Dana Morgan Music; SAN RAFAEL: Record King; SAUSALITO: The Tides Bookstore

TWIGGY
The world's first teenage supermodel

As a teenage model, Twiggy weighed just 41kg (90lbs). 'Much too thin,' she now says emphatically. 'I had a look – I can see that now – but I don't think I was beautiful. I was a skinny schoolgirl, stuffing tissues into my little 32A bra. I wasn't trying to be that thin, I was perfectly healthy, but still – that look is a total impossibility for women over the age of 20. Fashion has a lot to answer for, doesn't it?' But her body matched Diana Vreeland's (see page 126) description of the perfect contemporary silhouette: 'the smallest calves; the straightest legs; tiny, narrow, supple feet; and beautiful wrists and throat.' Accordingly, Twiggy was an incandescent overnight success.

As with so many romantic rags-to-riches stories, Twiggy's started with a happy accident. Early in 1966 she had been told that, at 1.68m (5ft 6in) she was too short to be a model. Her only booking had come from Leonard – hairdresser to London's smart set – who wanted to cut her shoulder-length hair into a new pixie crop for a shoot to promote his salon.

Barry Lategan's photographs were spotted by the *Daily Express* fashion editor Dierdre McSharry, who asked to meet the schoolgirl and invited her to tea. She arranged to have more pictures taken and, as Twiggy thought, that was the end of it. A few weeks later, on 23rd February, back home in Neasden, her father woke her up with a copy of the *Daily Express* in his hand that featured a headline announcing 'The Face of '66: The Cockney kid with a face to launch a thousand shapes…and she's only 16!'

Twiggy's first glossy magazine shoot was for *Vogue*. Bookings with superstar photographers such as Richard Avedon (see page 158), Cecil Beaton, Helmut Newton (see page 264), Guy Bourdin and Norman Parkinson (see page 94) followed, and assignments in New York and Paris filled her the diary. Within a year, her arrival at international airports was greeted by screaming fans.

By the age of 17, Twiggy was one of the most famous faces on the planet. Her career was a blip by modern standards, lasting only from 1966 to 1970, but it helped define a decade.

ASHRAM STYLE

Spiritual enlightement, rock-star style

It was the ultimate 1960s scene: the ashram in Rishikesh, India, where in February 1968 the Beatles, Donovan, Mia Farrow (recently divorced from Frank Sinatra) and a Beach Boy or two gathered along the shores of the Ganges, wreathed with marigolds, to meditate at the feet of the Maharishi Mahesh Yogi. The gathering received such frenzied worldwide attention that it is still considered a significant early encounter between Western pop culture and the mystical East.

The ideal of communal living had exploded with a surge of fervent idealism in the mid-1960s. The stereotypical commune was filled with devotees of yoga and vegetarianism, who wore kaftans, Jesus sandals and toe rings, and who practised a lifestyle of free sex and drug use. Young people, it seemed, were looking to escape what they believed was an irreparable society and build a new one.

The Beatles joined the quest for spiritual enlightenment. For them, it was 'an extraordinary period of creativity' that inspired some of their greatest songs including, 'While My Guitar Gently Weeps', 'Revolution' and many other songs from *The White Album* (1968). 'Dear Prudence' was written for Mia Farrow's sister, who was so absorbed in her spiritual journey that it was John and George's job to get her to 'come out to play'.

And yet they all came away bitterly disillusioned. Neil Aspinall, The Beatles' road manager, said of the Maharishi: 'This guy knows more about making deals than I do.' Lennon wrote the song 'Maharishi' (with the lines 'What have you done? You made a fool of everyone') as he was leaving. The title and lyrics were soon changed from 'Maharishi' to 'Sexy Sadie'.

The Beatles' ashram experience left an indelible mark on the decade – which is ironic considering just how brief it was. They first met the guru in the late summer of 1967 and by April 1968 it was all over. 'Why?' asked the Maharishi. 'Well, if you're so bloody cosmic, then you'll know, won't you?' Lennon retorted.

The line-up of devotees, wreathed in flowers, at the feet of the Maharishi is a 'who's who' of the 1960s music scene: Ringo Starr, Jane Asher, Paul McCartney, George Harrison, Patti Boyd, Cynthia Lennon, John Lennon and the Beach Boys' Mike Love. However, what started as a beautiful thing in 1967 ended in cynical disillusionment in 1968.

OSSIE CLARK AND CELIA BIRTWELL
Romantic femininity

Ossie Clark (1942–96) and Celia Birtwell (1941–) met as students in Manchester in 1959 and married in 1969. Their creative partnership began with their 1966 collection for the chic Chelsea boutique Quorum.

Owner Alice Pollock commissioned a collection of dresses after meeting Ossie at a party. He delivered a collection in white and cream chiffon that sold out immediately. For the follow-up, Pollock suggested he move things along by working in textiles designed by Birtwell. The result was a collection of dresses that invoked the laid-back glamour of the jet-set hippie. They were a sell-out success. And so began one of fashion's most famous collaborations. This partnership would last for almost all of Clark's career in fashion. Author Judith Watt comments: 'People say that Celia was Ossie's muse, which indeed she was, but their work absolutely went hand in hand. It was her designs that he used to create his.'

About Ossie, Celia Birtwell has said in a recent interview with the *Daily Telegraph*, 'He was a genius, better than Yves Saint Laurent. His cut – although he lifted it from the 1930s, he had his own take on it – even plump women felt pretty in. He didn't dress just the slimmest, which is always easier.' Birtwell's romantic and feminine designs, inspired by Léon Bakst (1866–1924) and Henri Matisse (1869–1954), provided the drama to Ossie Clark's cutting patterns. While she was busy in the design studio, he was often out partying with the drug-fuelled Chelsea set. But Ossie's hedonistic style combined with Celia's delicate prints made the pair an unbeatable design team.

Ossie Clark enjoyed meteoric success on both sides of the Atlantic. His was the look of the late 1960s and 1970s. His biographer, Linda Watson, has written that Clark's brilliance was in part a consequence of his bisexuality. 'He understood a woman's body in a way not many men can. He saw them as goddesses – as many gay designers do – but also intimately understood a woman's anatomy. His dresses were sensual, never vulgar or crude. They were man magnets.'

Ossie Clark's flattering cut combined with Celia Birtwell's romantic textiles to produce clothes that are highly prized by collectors to this day. Their glamorous but easy-to-wear dresses anticipated the mood of the hippie years and attracted a glamorous international following.

MARSHA HUNT

The original 'melting-pot' beauty

In 1969 Patrick Lichfield shot Marsha Hunt (1946–) for British *Vogue*: 'The pictures were supposed to be for the cover,' the model recalled, 'which would have made me the first black woman on the front page of *Vogue*. It didn't happen, but there was a huge spread inside. In those days, it was quite something.' The accompanying text declared: 'People stare at Marsha Hunt on London streets. She knows it. She doesn't mind. Who cares? She's she. She's free.'

Marsha was the embodiment of black beauty, a woman with a halo of hair. 'The natural' – as the afro was dubbed – was the symbol of the Black is Beautiful movement, and was as much of a countercultural statement as hippies' long hair. Lichfield's photograph showed her naked – appropriately enough for a London cast member of the musical *Hair* – and became a quintessentially iconic image of the 1960s.

Hunt, had impeccable 1960s credentials. She hailed from Philadelphia, the city of brotherly love, studied at Berkeley, and joined Jerry Rubin's anti-Vietnam protest marches. She moved to London in 1966 where, she remembered, 'anything seemed possible'.

In addition to her (relatively small) role in *Hair*, Marsha Hunt signed a recording contract in 1968 with the same company that had the Jimi Hendrix Experience, The Who, Thunderclap Newman and Arthur Brown.

She met Mick Jagger when the Rolling Stones asked Hunt to pose for an ad for 'Honky Tonk Women' (1969), which she refused to do because she 'didn't want to look like [she'd] just been had by all the Rolling Stones'. Jagger took her out and their nine- or ten-month affair began. They had a daughter, Karis, in 1970.

Europeans, Marsha discovered, identified her as an American, not as African-American or black. She herself describes her skin colour as 'oak with a hint of maple', and has said, 'Of the various races I know I comprise – African, American, Indian, German Jew and Irish – only one was acknowledged.' Hunt invented her own word to describe herself, a combination of the French word *mélange* (mixture) and melanin: the Melangian.

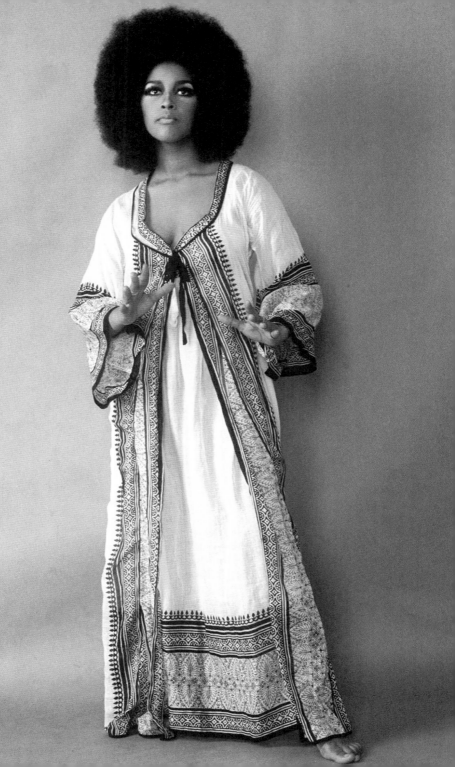

MISSONI

Masters of the not-so-traditional knit

Ottavio ('Tai') Missoni (1921–2013) began his career in fashion by making tracksuits. He met his wife and partner, Rosita, at the Olympics in London in1948 – he was representing Italy on the running track and she was in the crowd watching him compete, part of a school party chaperoned by nuns. They started their eponymous knitwear business together in 1953.

By 1958 the Missonis had produced a striped knitted shirt dress, and the crossover from sports to fashion was underway. Initially producing knitwear for other designers, the couple first came to the attention of the fashion world in the mid-1960s, when they created a knitwear collection for the French designer Emmanuelle Khanh. For their own label, however, they pushed the conventional boundaries of knitwear to new and daring limits. Influenced by folk art and design, they started with simple stripes, then graduated to more complex, kaleidoscopic zigzag patterns as their success enabled them to buy more sophisticated equipment. Never again could machine knit be dismissed as boring. In 1965 they got their big media break, with recognition from the influential Italian fashion writer Anna Piaggi.

Collections inspired by silhouettes of the 1920s were global Missoni hits in 1968 and 1969, and the couple became famous for their distinctive style. Their clothes are created from many types of fabrics – wool, cotton, linen, rayon and silk – and, of course, a dazzling array of colours. Their impact was such that by the early 1970s the Missonis' allegiance to Milan heralded that city's rise to pre-eminence as a fashion centre.

By the end of the decade and with only a few collections to their name, the Missonis had already snared Diana Vreeland and the mighty *Women's Wear Daily* as allies. *WWD* supported their debut with a dollop of name-making notoriety and the headline, 'Missoni; In the Lead with the Most Sinful Dresses'.

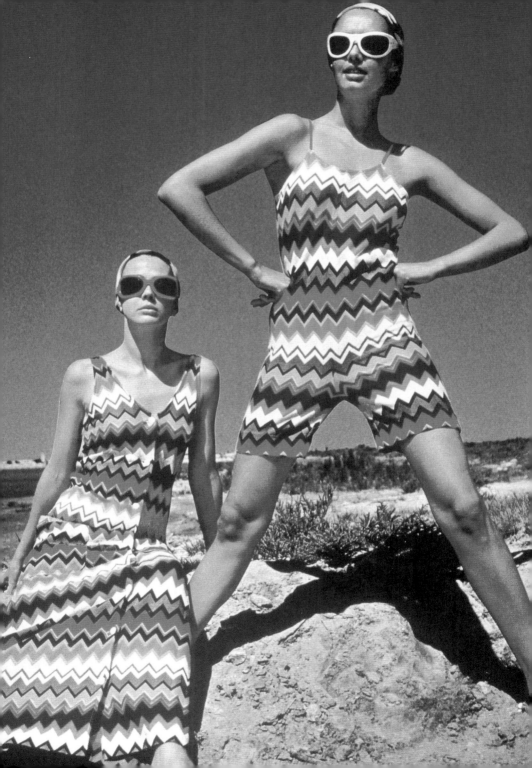

VALENTINO

Couture versus counterculture:
Valentino delivers a decisive blow

In 1959, after serving an apprenticeship at Jean Dessès and Guy Laroche in Paris, Valentino Garavani (1932–) opened his own house on Via Condotti in Rome.

Among his first customers was Elizabeth Taylor, who was in Rome with Richard Burton for the shooting of *Cleopatra* (1963). She ordered a white dress to wear to the premiere of *Spartacus* (1960). Numerous international stars from Audrey Hepburn (see pages 52 and 122) to Rita Hayworth, Italian icons from Sophia Loren (see page 62) to Claudia Cardinale, and glamorous royals such as Princess Margaret were to follow.

In the 1960s the world's fashion focus was on Swinging London with its boutiques and budget fashion. Valentino specialized in luxury and sought clients who enjoyed a privileged lifestyle that had nothing to do with the street, but he was ready to rise to the challenge. He created a ready-to-wear collection and, in the fashion press at least, claimed 1968 as his own. While the fashion world was obsessed with bright colour, he showed white. Vogue wrote: 'Valentino's white – the talk of Europe. And all triumphs for the 35-year-old designer who has become the idol of the young, a new symbol of modern luxury.'

The growth of the counterculture in the 1960s meant that elegant clothes were increasingly seen as an irrelevance. Valentino spent much of the decade swimming against the tide of popular trends. Paris was engulfed by student demonstrations in 1968, when Valentino opened his boutique on avenue Montaigne. But his talent was boosted by his fair share of good luck: in the same year Jackie Kennedy (see page 172) chose Valentino to design her wedding dress for her marriage to Aristotle Onassis, and he became a household name overnight. The designer said, 'I owe so much to Jacqueline Kennedy. She became a very close friend. I designed her entire wardrobe and she made me famous.'

His trademarks were black and white, but he also perfected his own shade of Valentino red, declaring, 'After black and white there is no finer colour.' And his animal prints, including leopard, zebra and giraffe, became timeless classics, yet were immediately identifiable with the start of the decade when fashion began to turn away from street fashion to rediscover luxury.

By 1968 the young Valentino Garavani had already made a name for himself with the red gowns which, to this day, are hallmarks of the house style. But the white collection of the same year was a smash hit, and proved that street fashion could not claim all the fashion limelight.

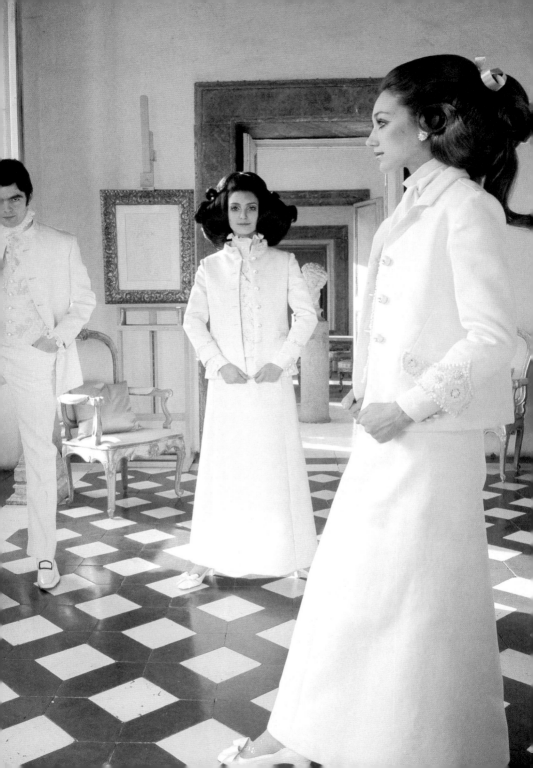

VERUSCHKA

Fashion's self-styled shape-shifter

Veruschka was born in 1939, the daughter of a German count. Her full name (with title) was Vera Gottliebe Anna Gräfin von Lehndorff-Steinort. Her father was executed after the 1944 assassination attempt on Adolf Hitler, and the family spent the rest of the war in labour camps. She studied art in Hamburg before moving to Florence, where she was discovered by Ugo Mulas, a photographer who was documenting the Italian avant-garde.

Veruschka was a powerful presence in a world of mannequins and quickly became one of Diana Vreeland's (see page 126) favourite models. But at over 1.88m (6ft 1in) tall Vera was not showered with offers for commercial work and, with a presence of mind that was decades ahead of its time, she set about reinventing herself. Vera became Veruschka, and made the most of her height and Amazonian build. When director Michelangelo Antonioni cast her in his 1966 film *Blow-Up* (see page 152), she became a star. Her performance may have lasted only five minutes, but her scene with David Hemmings straddling her writhing body is the most memorable of the movie.

After that, it was said she could earn up to $10,000 a day, a fantastical sum at the time. What is certain is that the best photographers in the world were lining up to work with her. But Veruschka was ambivalent about being a fashion star: 'I was frustrated very fast about being a model. I think that Diana Vreeland must have sensed it. She introduced me to Franco Rubartelli in Rome. I had the idea that the only way would be to work with a photographer, to have your own ideas and visions about how you wanted to transform yourself.'

Going back to her fine-art roots, Veruschka became a pioneer in the art of body painting and redefined herself again as a 'Creative Futurist'. She collaborated with stylists such as Giorgio di Sant' Angelo, with whom she created an unforgettable fashion story in Arizona equipped with only bolts of cloth, furs and a bag full of wigs.

In October 2010, at the age of 71, she modelled for Giles Deacon at London Fashion Week.

'I was always being different types of women,' admitted the Amazonian mannequin who, at six foot one with size 8 feet, was no standard fashion plate. She busied herself with pushing the boundaries of beauty and became one of the decade's most memorable faces. 'I copied Ursula Andress, Brigitte Bardot, Greta Garbo. Then I got bored so I painted myself as an animal.'

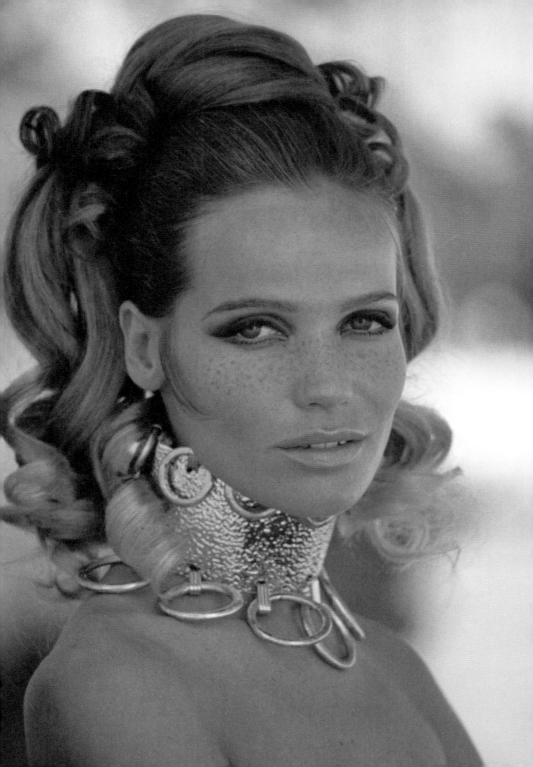

TALITHA GETTY

This photograph of Talitha and John Paul Getty Jr, taken by Patrick Lichfield on a Marrakesh rooftop, is one of the most enduring images of the 1960s. The town had become the ultimate destination for hippies in the late 1960s and the Gettys were some of its most charismatic residents.

As an actress, Talitha Dina Pol's CV extended no further than a bit part in *Barbarella* (1968), but as a fashion icon her style was the embodiment of a certain kind of 1960s glamour – a hippie de luxe style that has been reimagined over and over ever since. Everyone from Dries Van Noten to Roberto Cavalli, from Dolce & Gabbana (see page 452) to Matthew Williamson, has paid tribute to her influence with their collections.

When Rudolf Nureyev met Talitha in 1965, he was completely smitten. His biographer Julie Kavanagh speculates that he may have actually fallen in love with an androgynous reflection of himself. Nevertheless, he told friends that it was the first time he had been erotically stirred by a woman and he wanted to marry her. Talitha passed him over for Getty, the petroleum heir, whom she married in Rome in 1966. She wore a white mink-trimmed minidress for the ceremony.

The couple honeymooned in Marrakesh, where they set up home in the 19th-century Palais de la Zahia. Known as the 'Pleasure Palace', their home became infamous for extravagant, drug-fuelled house parties that often included the Beatles and the Rolling Stones among the guests. It was here, too, that Talitha and Yves Saint Laurent became friends. He first visited on holiday and became close to her in 1967, later claiming that 'when I knew Talitha Getty my vision completely changed'. He remembered the couple 'lying on a starlit terrace in Marrakesh, beautiful and damned'.

Talitha Getty was only 30 when she died of an overdose of heroin in 1971, in the same 12-month period that saw the deaths of Jimi Hendrix, Janis Joplin (see page 202), Edie Sedgwick (see page 144) and Jim Morrison.

Talitha and John Paul Getty Jr model Moroccan kaftans on the terrace of their holiday home in Marrakesh. Photographer Patrick Lichfield was commissioned by American *Vogue*.

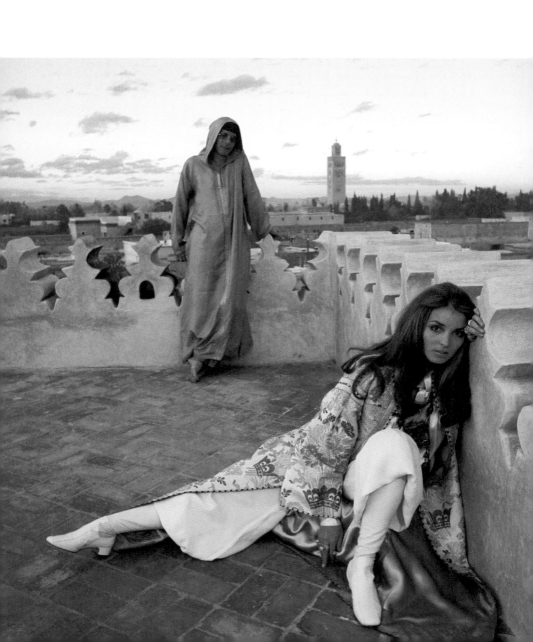

JANE BIRKIN

Innocent Lolita or femme fatale?

English-born Jane Birkin (1946–) first gained attention as an actress at the age of 20, when she snagged a minor role in Italian director Michelangelo Antonioni's *Blow-Up* (1966, see page 152), a controversial film about photography, sex and murder. Birkin played 'the blonde', a leggy model who takes off her clothes and jumps into an awkward 'Swingin' Sixties' sex scene that drew plenty of scandal at the time, but which now seems as camply ridiculous as a clip from an Austin Powers movie.

That same year, she auditioned in France for the lead female role in *Slogan* (1969). Though she did not speak French, Birkin won the role. She co-starred with Serge Gainsbourg and performed with him on the film's theme song, 'La chanson de slogan' – the first of many collaborations between the two. In 1969 she and Gainsbourg released the duet 'Je t'aime…moi non plus' (I love you…me neither), which Gainsbourg originally wrote for Brigitte Bardot (see page 68). The song caused a scandal for its sexual explicitness, and was banned by radio stations in Italy, Spain and the UK.

Birkin's head-turning fashion choices – her sheer knit minidress and cut-off shorts, as well as her classic trench and sober, low-heeled shoes – cast her as inspiration for any fashionable bohemian. She is loved by designers to this day for her effortless and dishevelled sex appeal: as potent in a glamorous evening dress as in jeans and a tight T-shirt.

From her signature straight-cut fringe and stringy brown hair to her almond eyes and mile-long legs, her beauty was a remarkable mix of both innocent Lolita and languorous femme fatale.

At the end of the 1960s the world was in thrall to a new type of beauty: the 'leggy soft-skinned blonde in country shoes, classic raincoat and grey flannel'. *Vogue* nominated perfect examples of the type in Jane Fonda, Françoise Hardy and Françoise Dorléac. But first among equals was Jane Birkin.

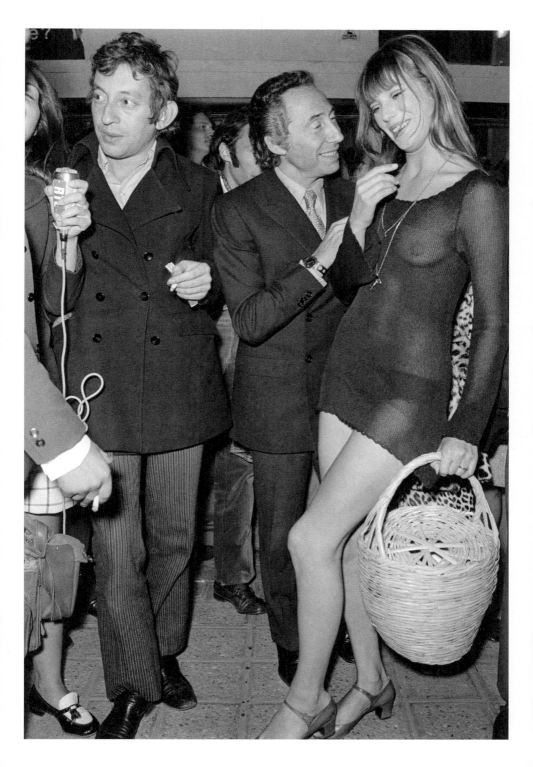

JANIS JOPLIN

Liberating style

Janis Joplin (1943–70) carved a place for herself as a hard-loving, hard-living, red-hot recording and performing star in the male-dominated world of rock 'n' roll. Contemporary critic Richard Goldstein described Joplin's stage presence as 'the total antithesis of the star entrance'. 'Her lumpen extraordinary face has no makeup. Her long brown hair doesn't shine. She screws up her eyes over constant cigarettes and her lubrication and sustenance seem to be sickly Southern Comfort.'

At the University of Texas Joplin was once nominated as the 'ugliest man on campus'. An outcast from her family and her home town, she moved to San Francisco. Her rise was meteoric but her isolation was constant. 'Onstage I make love to 25,000 people,' she said. 'And then I go home alone.'

By 1968 Joplin had become as famous for her idiosyncratic and influential style as for her music. At the Monterey Pop Festival she swapped her sweatshirts for lamé (which she pronounced as 'lame'), lynx and denim plastered with peace symbols. Her signature beads, bangles and feathers were imitated by other rock stars as well as fans alike. Sporting a small heart on her breast, she also helped popularize the tattoo. She wore so many long bead necklaces, she joked she didn't need to wear a shirt.

The 1960s rock critic Lillian Roxon credited Joplin with helping to liberate American women from girdles and boned bras. At festivals all over America, there were 'the daughters of Joplin, their tough and battered little faces defiantly free of makeup and other synthetic improvements.'

The Joplin meteor disappeared in a fiery crash when she died of a heroin overdose in 1970. Her biographer Alice Echols noted she was 'one of the last famous women whose deaths were in some way linked to the irreconcilability of being an artist and a woman'.

With her inimitable style, Joplin influenced fans and fellow rockers alike. She wore feathers through her hair and clothes, and made the tattoo cool. Her look, as with the rest of her life, was about excess: in colour, size and shape.

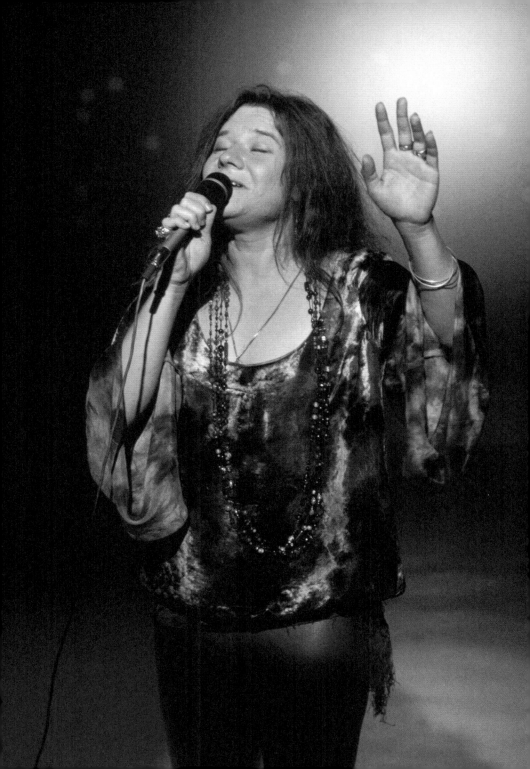

JEAN MUIR

Queen of the dress

1969

Jean Muir (1928–95) served apprenticeships at Liberty and Jaeger before starting her own business, Jane & Jane, in 1962. Before anyone talked of ready-to-wear, she blazed a trail in the fashion business, bridging the gap between mass market and couture. She carved a creative niche with her unique rigour of line and elegance of proportion. Her clothes were meticulously controlled and demure, yet managed to reveal every line of the body. 'I design feminine, not feminist clothes,' pronounced Miss Muir (as she liked to be addressed). 'I like my clothes to be womanly, not fussy.'

In 1966 Muir opened Jean Muir Ltd, and in 1967 a French magazine named her '*La reine de la robe*' (queen of the dress) – a tribute that raised her to the elite coterie that included Vionnet, Madame Grès and Chanel. She preferred the title of dressmaker to that of designer. She called fashion an 'exacting trade' requiring both work and intelligence. 'I love the fittings, getting the shape right. I love the mathematics of it.' Her version of simple reflected an elegant, almost austere persona. She herself wore only navy-blue clothes and her home was decorated entirely in white. She became known for her technical genius and the sheer craft of her work, which was based primarily on cut and meticulous detailing.

A lover of the ballet, Muir favoured fluid fabrics, especially matt jersey, and she used tucks instead of darts to create shape. As a result, the silhouettes had fluidity without sacrificing structure. 'Because I am small I never liked extra weight,' she said. 'I wanted to make clothes that looked like couture but were ready to wear. You had to eliminate a lot.'

Jean Muir believed that women designers were gifted with a common sense that enabled them to make elegant clothes that were also comfortable. 'I think men rather superimpose shapes on women. In today's rather complex world I think a woman has got infinitely more common sense.' Trendless and timeless, she was always more about evolution than revolution.

For her entire career, Jean Muir's design signature was honed with garments that were skilfully tailored and minimally detailed, with long, fluid lines. Favourite fabrics were always jersey, crêpe and suede, usually in dark, plain colours. To her, a fashion trend would have been an anathema. Style was the ultimate goal.

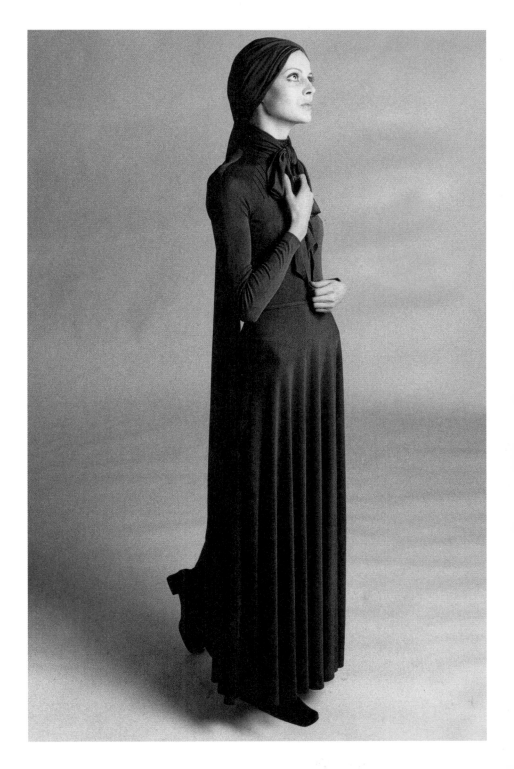

JOHN LENNON AND YOKO ONO

Giving peace a chance

Every generation has its couples who mesmerize the public. In the late 1960s, none felt the worldwide glare of the press more than John Lennon (1940–80) and Yoko Ono (1933–). They became the emblematic leaders of a universal cultural revolution.

The Vietnam War was front-page news when they met in 1966, at one of Ono's performance-art exhibitions, at the Indica Gallery in London. Having been frustrated in his search for spiritual enlightenment at an ashram (see page 186), Lennon became fascinated by Ono, whose path to maturity in traumatized postwar Tokyo gave him pause for thought. In her, he believed, his showy, empty life found a sense of purpose.

Lennon left his wife and their stockbroker-belt country mansion and set up house with Yoko in a London flat. In 1968 they released *Unfinished Music #1: Two Virgins*, with a self-shot nude photograph of themselves on the cover. They married in March 1969 at the British Consulate in Gibraltar, and posed for the official photographs (taken by David Nutter) with John in a white suit and white turtleneck sweater, and Yoko in a matching white minidress and high-domed floppy hat.

In the photo the couple are almost obscured by their own hair. Lennon and Ono represented a generation who were 'dropping out' all over America and Europe. The straggly hair and white suits reflected not only a change in fashion but a change in attitude. The love generation wanted more than the 1950s ideals of regular pay cheques, a good car and a life in suburbia.

The couple promised to stage many 'happenings'. The first was the honeymoon 'bed-in' for peace in the Amsterdam Hilton. Then there was the huge billboard in Times Square, New York: 'WAR IS OVER—if you want it.' For the next decade, they took aim at stiff white-collar America. Lennon's fame mingled perfectly with Ono's bold performance art to create photogenic anti-war messages.

Four days after this picture was taken of the newlyweds at Heathrow Airport, John and Yoko were in Canada to launch another 'bed-in'. Having spent their honeymoon in bed in Amsterdam and the intervening weeks pursuing fruitless efforts to engage world leaders in peace talks, they headed across the Atlantic. Their all-white look has become an enduring symbol of New Age styling.

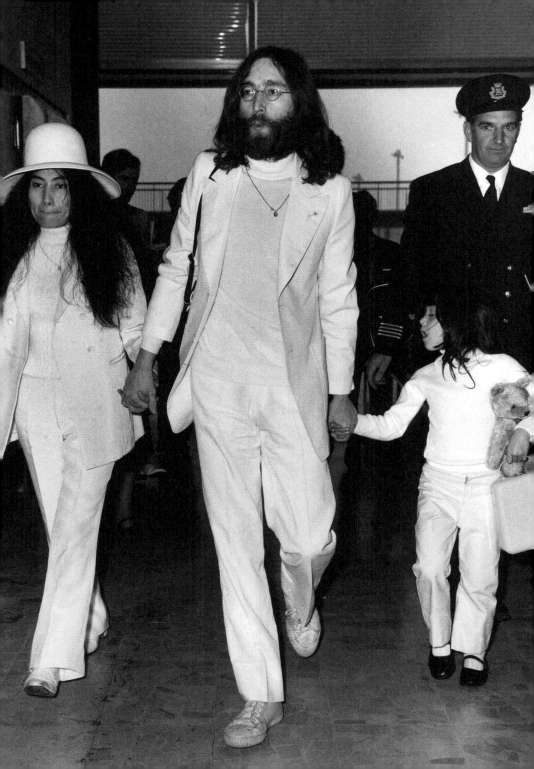

MARIANNE FAITHFULL

The eternal rock chick as years go by

The daughter of a British military officer and a former ballerina, Marianne Faithfull (1946–) was a teenager when she was first introduced to the court of the Rolling Stones in 1964. Jagger and Richards wrote 'As Tears Go By' (1964) for her, and she was the inspiration for many Rolling Stones records, including 'Let's Spend the Night Together' (1967), 'You Can't Always Get What You Want' (1969) and 'Wild Horses' (1971), and she wrote the lyrics for 'Sister Morphine' (1969).

With her wide-eyed look, long golden hair, flirty babydoll dresses and knee socks, Faithfull epitomized the style of the decade. She was a 1960s beauty who was also once memorably described as an 'angel with t—'. She also embodied the rock 'n' roll lifestyle.

Before she was 21 Faithfull had one marriage and a son behind her; she had rejected the advances of a lovestruck Bob Dylan, who dedicated poetry to her; had had brief affairs with both Brian Jones and then Keith Richards, who suggested that she and Mick Jagger would make a great couple. 'Go on, love, give him a jingle; he'll fall off his chair. He's not that bad when you get to know him', was Richards' advice to her.

When the police invaded the Stones' world in 1967 and found illegal pills that belonged to Faithfull, Jagger 'gallantly' accepted the blame. The London tabloids immortalized her in the headline 'Scantily Clad Woman at Drug Party'.

In the 1968 film *Girl on a Motorcycle*, Faithfull shocked audiences in a fur-lined leather jumpsuit. Her personal style effortlessly mixed rock 'n' roll cool with hippie chic. You don't have to delve too deeply to figure out that the Faithfull repertoire is where Kate Moss (see page 426) has got some of her best ideas.

By her own admission, in an interview with the *New Musical Express*, Faithfull's 'first move was to get a Rolling Stone as a boyfriend. I slept with three and decided the lead singer was the best bet.' As venal as that sounds, she is nevertheless credited with serving as inspiration for much of Jagger's finest work.

SAFARI JACKET

The ultimate in utilitarian luxury

Three years after opening the Rive Gauche store for women on rue de Tournon, Yves Saint Laurent opened a menswear store on the same street. He was photographed by Helmut Newton (see page 264) at the opening party wearing a safari jacket.

It was the birth of another Saint Laurent icon. The four-pocket classic has been a staple of the YSL wardrobe ever since, alongside the tuxedo, the pant suit and the pea coat. Over more than 40 years it has been reinterpreted as menswear and womenswear, outerwear, formal wear, a laid-back tunic and a seductive dress.

But in 1968 it belonged very much to the men's wardrobe, as characterized by the rugged machismo of Ernest Hemingway or the Afrika Korps. It may only have been a piece of clothing, but fashion's takeover and reinvention of this piece of utility kit perfectly symbolized the social and political tumult of the late 1960s, and further blurred the distinction between masculine and feminine.

Ironically, the first safari jacket was not made for a collection at all. It was made to order for an appearance in a safari-themed fashion story shot by Franco Rubartelli for French *Vogue* in 1968 and modelled by Veruschka (see page 196), who strode across the bush with a hunting knife in her belt and a rifle across her shoulders. The shoot itself had been inspired by the runaway success that was Saint Laurent's African collection of 1967. *Harper's Bazaar* of March 1967 described the garments as 'a fantasy of primitive genius, shells and jungle jewellery, clustered to cover the bosom and hips, latticed to bare the midriff.'

Short, sexy, worn with a belt with a ring-shaped buckle, the Veruschka piece embodied the spirit of liberty that was shaking up wardrobes. In the wake of its success, production of the Saint Laurent safari jacket was started immediately, and it was sold in Rive Gauche boutiques the following season. There has barely been a YSL collection without some manifestation of the safari jacket ever since.

Since its first magazine appearance, the safari jacket has appeared in the guise of glossy evening glamour, as a sharply tailored City suit or as a laid-back companion to dressed-down denim. It may have started as a happy fashion accident, but the '*saharienne*' remains a classic that is as cool today as it ever was.

1970s

This was the decade of women's lib. Key figures such as Betty Friedan (1921–2006) and Germaine Greer (1939– see page 224) set the sociological agenda. But women were a long way from gaining confidence about their place in the world. In fact, a look back at the fashion of the decade gives a startlingly clear view of the deep-seated uncertainties that plagued both sexes.

Retro-mania filled wardrobes with flea-market sequins and feathers, while in clubs dotted across the country boys in zoot suits and girls with 1940s flicks, eyeliner and platform shoes danced to Glenn Miller.

Britain was beset by economic crisis and mounting jobless figures. The outlook was bleak and the new leader of the Conservative Party, Margaret Thatcher – 'a mother of two with a taste for nice china' – rallied her supporters with her chilling diagnosis: 'We have lived like the heirs of an estate that could not be depleted, until we awoke one morning to find the bailiffs at the door.'

It doesn't take a PhD in psychology to work out that the layers that defined fashion's mainstream look all spoke in some way about protection. The short skirts over long skirts, the cropped sleeves over wrist-length sleeves, the dresses with tabards and aprons, the piling on of pattern and textures: all were like a regression into a gentler past. Meanwhile, the glittering feather-trimmed wardrobes of the disco divas were pure escapism. And fashion remained in flamboyant denial until punk exploded into the aggression of the 1980s.

In 1976 women took to wearing men's tweed jackets for day and tuxedos for the evenings, and it looked as though fashion might finally be ready to move forward. But it wasn't until 1979 that *Vogue* finally called time on 'a decade of onion dressing'.

Opposite: Diane von Furstenberg's elegantly simple wrap dress is perhaps one of the rare 1970s fashion icons that has stood the test of time. Below: With disco came everything that would get you noticed on the dance floor, whether it was hot pants, silver lamé, oceans of glitter or, as worn here by Donna Summer in 1976, acres of snow-white fringed chiffon.

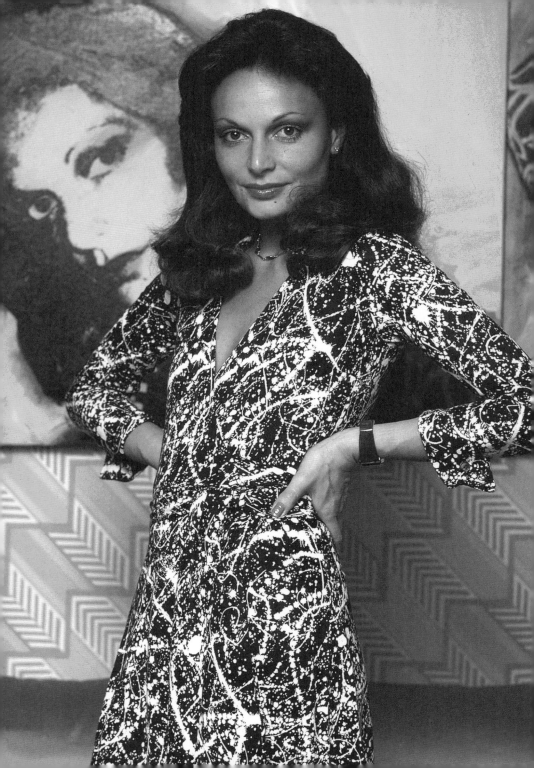

THE AFGHAN COAT

The fashion item that gave the hippies a bad smell

'Flower power' – attributed to the American Beat poet Allen Ginsberg (1926–97) – is a slogan that conjures up a powerful image of the hippies of the early 1970s. And the one wardrobe item with which the hippies are most closely associated is the malodorous Afghan coat.

The Afghan was made from sheep- or goatskin, with the fleece on the inside and the soft leather skin on the outside. The original really did not deserve the stinky reputation it later gained in the West. Sourced in Ghazni Province, between Kabul and Kandahar in Afghanistan, it was made from cured and tanned sheepskins that were then finely embroidered with silk thread.

Afghan coats first became available in the UK in the late 1960s, at Granny Takes a Trip on London's King's Road (see page 170). When the Beatles bought them and wore them inside out for the cover picture of the *Magical Mystery Tour* album (1967), a craze was born. Demand spiralled, and the Afghan artisans could not keep up. A backup supply was sourced in Iran and Turkey. Coarsely embroidered and poorly cured, these imitations turned putrid in the damp British climate, and became memorable for their room-clearing smell.

Fashion in the 1970s drew inspiration from every corner of the global village. Anything that was not rooted in Western consumer culture had wardrobe potential. Ethnic garments such as kaftans and Afghan coats retained their fashion currency well into the 1970s. They became the uniform for campaigning, peace-loving and protesting hippies everywhere – whether they were manning the barricades in Paris, protecting their squatters' rights in Notting Hill or chilling at the Pilton (later, Glastonbury) Festival, which started at Worthy Farm in Somerset in 1970.

At the heart of the 1970s legend of the Afghan coat is a horrible smell. Some said it smelled like something had died. Others that the pong was so strong you could smell it before you saw it. Improved curing techniques have ensured that the frequent shaggy revivals in subsequent years have been comparatively fragrant.

ALI MacGRAW
The all-American fashion heroine

Ali MacGraw's character Jenny Cavilleri, in the 1970 sob-fest *Love Story*, had a whole wardrobe of timeless classics: camel wrap coats, striped rugby scarves, satchel bags and knitted beanie hats. Overnight she became a fashion icon. Every girl in America in the early 1970s wanted to look like Ali MacGraw (1939–). 'She exemplified this great American style,' recalls Calvin Klein. 'In the beginning, there was that rich-hippie period. But it went beyond that, and her style put her among the greats: Katharine Hepburn, Jackie Onassis, C Z Guest, Babe Paley.'

Off screen, married to Steve McQueen she was one half of Hollywood's most gilded couple. With a wardrobe full of Halstons and a spot that appeared to be annually reserved for her on the Best Dressed List, her style status was unassailable. Almost 50 years later she still inspires designers such as Micheal Kors, Ralph Lauren (see page 324) and Marc Jacobs (see page 456).

Ali's earliest ambitions were to work in fashion, and on graduating from college she spent time as an assistant to the legendary Diana Vreeland (see page 126) on *Harpers Bazaar*. 'A crash course in all I did not know about fashion and the fashion world,' she remembered. Her career, she thought, would be behind the camera. As stylist for the photographer Melvin Sokolsky, Ali was mesmerized by the 'most ravishing beauties of the time,' never once confusing, 'my ability to help dress them with any possibility that I might be one of them.'

But as the 1960s ended, American fashion was emerging from Paris's shadow as a force in its own right. And the women who best represented it were, in style terms, the polar opposites of the patrician Parisiennes. When she got her unexpected movie break, it was Ali's own style, her bohemian preppy look, that was central to her Jenny Cavalleri character, and turned out to be the defining fashion moment of the decade.

Camel trench, pea coat, rib-knit scarf and pull-on hat, flared jeans over heels, hobo bag (all elements of Jenny Cavilleri's wardrobe in *Love Story*): Ali MacGraw's style was fetishized by fashion and coveted by women aiming to capture the elements of timeless, all-American chic.

BILL GIBB

British fashion's Celtic visionary

As the 1960s faded, an unprecedented surge of talent emerged from the Royal College of Art under the aegis of Professor Janey Ironside. Alongside Ossie Clark (see page 188), Anthony Price and Zandra Rhodes (see page 300) there was Bill Gibb, a farmer's son from Fraserburgh in Scotland.

Fashion at the time idealized the simple life where, in the hands of artisans, a new fashion look evolved in small workshops, such as Missoni in Italy (see page 192). The homespun became a game-changing fashion hit when Gibb met Kaffe Fassett, the American painter-turned-knitting guru (see page 268). The marriage of Gibb's Celtic romance combined with Fassett's technical skill was a defining influence on the look of the decade.

Gibb's Scottish background, his love for the historic, especially the Renaissance, and the American hippie culture introduced to him by Fassett, resulted in a collection that was pure escapism. Its hand-dyed tartans, bold checks, Gibb's painstaking re-creation of dream landscapes hand-painted onto yards of fabric and Fassett's fantastical hand knits were catwalk gold, beloved by the press, if almost impossible to produce in any significant quantities.

As the sharp realities of the new decade started to bite, Gibb offered a kind of fashion fantasy through his rich embroideries and lavish layering. His signature silhouette was a billowy, ankle-length, doll-like smock, often embroidered or decorated, however discreetly, with his motif – a little honey-bee.

Bill Gibb was voted Designer of the Year by *Vogue* in 1970, and his debut collection under his own name in 1972 had customers including Elizabeth Taylor (see page 132), Bianca Jagger (see page 222) and Twiggy (see page 184).

In 1971 Gibb wowed New York and became internationally famous overnight when he dressed Twiggy for her red carpet appearance for the premiere of Ken Russell's film *The Boy Friend*. His philosophy was simple: 'Reality is so horrific these days that only escapism makes it bearable at times.'

Bill Gibb grew up far from the excesses of high fashion and always remained a romantic idealist, shunning material wealth and possessions. Throughout his life, he remained much like his childhood self, the boy who 'had raided a dressing-up box to transform his sisters into miniature Rapunzels or wee Ladies of Shallot'.

SOUL TRAIN
The look of African-American soul

It was a launch pad for the giants of soul – Smokey Robinson, Aretha Franklin, Stevie Wonder, the O'Jays, Marvin Gaye, the Isley Brothers and Barry White all hitched a ride on *Soul Train*. Not only did it foster burgeoning music talent, but it was also the place where America tuned in to check out the hottest dance moves and coolest fashion trends. And it gave African-American music and popular culture an equal opportunity on the television airwaves.

The show's host and originator was Don Cornelius (1936-2012). With his stage swagger, his sharp suits and his smooth talking, he was the epitome of cool. The show launched in Chicago, where every week Cornelius showcased and interviewed the latest R&B acts and introduced dance numbers performed by the show's own 'Soul Train Gang'. It all took place on a club set – a format copied by music shows all over the world.

Key features were the 'Soul Train Scramble Board', where two dancers were given 60 seconds to unscramble a set of letters to reveal the name of that show's performer or of a notable person in African-American history. And then there was the 'Soul Train Line', in which the audience formed two lines with a space in the middle for dancers to strut down, catwalk style.

In the beginning the show was supported by two key sponsors: Sears Roebuck and Company, which wanted to promote its record players, and Johnson Products, makers of Afro Sheen hair-care products. Cornelius became an icon of the generation not only because he was the godfather of cool, but also because of his formidable commercial clout. Artists lined up to appear on *Soul Train*, as an appearance guaranteed an increase in sales and recognition.

In February 2012, fans gathered in their thousands to honour Cornelius, the recently deceased *Soul Train* creator. Donning Afros, they re-created a Soul Train Line in New York City's Times Square, which lasted almost an hour before police broke it up.

In the 1970s *Soul Train* was must-see television – a weekly extravaganza which became a pop culture juggernaut that broke new ground for African-American entertainment. It was a launch pad not only for music talent, but also for the dance moves and fashion trends that took hold in the clubs and on the streets of America within days of their endorsement on the show.

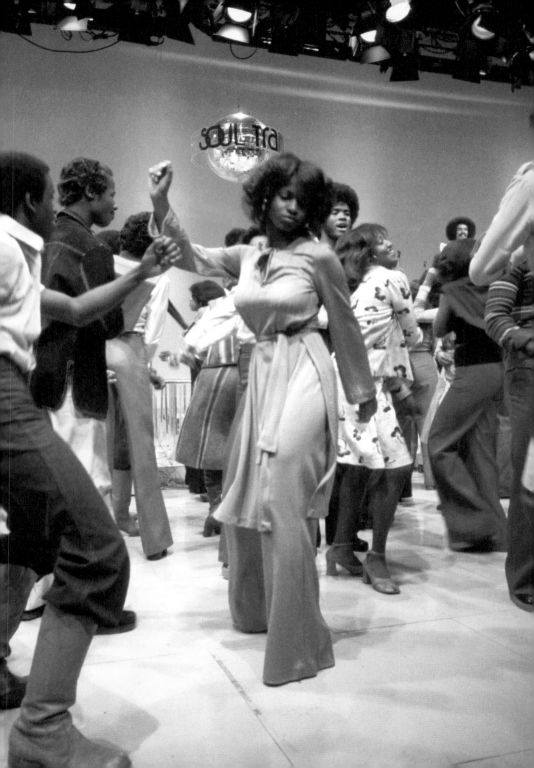

BIANCA JAGGER

The original rock 'n' roll bride

It was unlikely that Bianca Pérez-Mora de Macías (1945–) would ever be a traditional bride. The woman who was best friends with Andy Warhol, queen of the New York nightclub scene, a pillar of the Studio 54 set (see page 302) and an honorary 'Halstonette' had bagged a Rolling Stone and was getting married in Saint Tropez. She was never going to wear a billowing meringue of taffeta. Instead she went to Yves Saint Laurent.

He wore sneakers. She wore a white tuxedo. 'I had a very clear idea of what I wanted as a wedding dress,' she said. 'Contrary to popular wisdom, it wasn't a trouser suit: it was a long, narrow skirt and a jacket. He made the wide-brimmed hat with a veil and we decided that instead of carrying a bouquet I should wear a flower corsage on my wrist to go with the suit.'

Bianca set a new standard for the modern, minimalist bride. Some of it was happenstance: she wore the jacket with nothing underneath because she was four months pregnant (with daughter Jade) and the blouse that went with her ensemble no longer fitted. Some of it was by design: the floppy-brimmed hat was perfect for shielding her not only from the Saint-Tropez sunshine but also from the paparazzi – there in such numbers that the ceremony had to be postponed for over an hour. Nonetheless, it was a look that has been copied on catwalks and by brides all over the world ever since.

The hat and corsage were her only bridal accessories. The civil ceremony, which took place in the town hall, had a rocky start when an argument broke out between Mick Jagger's spokesman and local police over the number of paparazzi who had been allowed into the hall. Bianca must have been grateful for the big-brimmed hat and veil when, in a fit of pique, Jagger threatened to abandon the ceremony altogether, and made his bride cry.

Mick [Jagger] wore Tommy Nutter; Bianca wore YSL. Her wedding look may have been designed principally to disguise her pregnancy, but she still managed to inspire a decade with her nipped-in waist, sharp-shouldered silhouette and romantic veiled hat.

GERMAINE GREER

Standard-bearer for the sexual revolution

The 1970s was the period of women's liberation, when the dollybirds of the 1960s decided enough was enough. In 1970 Germaine Greer's book *The Female Eunuch* prompted a decade of political debate, and later in the decade magazines such as *Ms* and *Spare Rib* increasingly found their way into women's homes. The feminist publishing house Virago was launched in 1973. But in 1970 women working at the BBC still weren't allowed to wear trousers, and women were refused mortgages in their own right and required the signature of a male guarantor. In the same year, Barbara Castle, as Secretary of State for Employment, introduced the Equal Pay Act. It finally came into force in 1975, together with the Sex Discrimination Act.

A lecturer in English at Warwick University, the Australian-born Greer (1939–), was also an underground journalist, a singer, a dancer and an actress. She argued for revolutionary change in the social structure. Her aim was to get the message of women's liberation across, whether it meant writing about the hazards of going to bed with an Englishman who suggested 'Let's pretend you are dead', or how not to lose your temper when asked 'Do you hate men?'

When Greer opined that 'Bras are a ludicrous invention', it was an 'aha' moment for millions. In America, protesters encamped outside a Miss America beauty contest set up a 'Freedom Trash Can', which was filled with bras, high-heeled shoes, false eyelashes, girdles, curlers, hairspray, makeup, corsets, magazines such as *Playboy*, and other items thought to be accoutrements of 'enforced femininity'. Contrary to popular myth, no fire was lit.

The genie was out of the bottle. 'The body has become a sign of resistance,' feminists argued. And fashion, too, had become political. The new feminist ideals found expression in wardrobes that were functional, utilitarian and androgynous. The conservative Right might have railed against the 'braless, brainless broads', but throughout the decade women continued to experiment with the novelty of their new-found freedoms.

The prominent feminist Midge McKenzie described Greer as 'a phenomenon, a super heroine ...who raises the possibilities for other women. Although some of them feel there is only room for one girl who both enjoys sex and has a Ph.D.'

In *The Female Eunuch* Germaine Greer declared, 'I'm sick of pretending eternal youth...I'm sick of peering at the world through false eyelashes... I'm sick of weighting my head with a dead mane... I'm sick of the Powder Room.' In the 1970s, fashion became a central issue in the gender equality debate.

GUCCI

The Florentine artisan becomes a global luxury giant

Gucci's empire sprang from the seed of an idea that was sown in the mind of the young immigrant Guccio Gucci (1881–1953), who worked as a porter at the Savoy Hotel in London. He was fascinated with the luggage owned by aristocratic guests, and had the opportunity to examine the best of it up close. In 1920 he returned to his home town, Florence, to open a shop specializing in fine leather goods made by local artisans. It took fewer than 50 years for the small family business to become a world-class luxury goods label, and for the instantly recognizable logo of interlocking Gs to become the insignia of the jet set (see page 78) in VIP airport lounges across the globe.

In the 1930s, Gucci's three sons joined the business. The exigencies of World War II (when leather was in short supply) spawned the iconic canvas bags, but by the time the economy was booming again the company was ready with those famous interlocking Gs that were to become shorthand for a new kind of chic for the swinging generation. The best of Florentine artisanal skill met the postwar economic boom with treasures to tempt the newly moneyed, such as bags with curved bamboo handles, snaffle-bit loafers, and silks printed with flowers and butterflies.

Gucci became famous, but it was when Jackie Onassis was photographed carrying the classic hobo bag that fame became a frenzy. Gucci was one of the hottest – or should that be coolest? – labels of the 1970s. A ready-to-wear collection ensured that space was found for those famous GGs on everything from baby crocodile coats to cashmere scarves.

The brand became known as much for its audacious innovation as for its peerless Italian quality and craftsmanship. In 1977 the Beverly Hills flagship store was revamped with a private Gucci Gallery, where VIPs such as Rita Hayworth and Michael Caine could browse for $10,000 bags with detachable gold and diamond chains, or for platinum-fox bed throws.

With monogrammed leather, iconic hardware such as the snaffle-bit trim, or signature stylings such as the bamboo handle on a bag, Gucci devised a new language of luxury that was instantly recognizable and coveted all over the world. In the 1950s and 1960s, Gucci was a celebrity cult. In the 1970s, it became a global giant.

JONI MITCHELL

Songwriting siren and social commentator

A hybrid of the Californian beach babe, Norse goddess and coffee-bar intellectual, Joni Mitchell (1943–) reigned as the bohemian queen of the 1970s. Like most folk singers, the Canadian-born singer started by performing in coffee shops and busking on the street. Her unique songwriting, innovative guitar style and astonishing vocal range placed her at the forefront of the folk movement.

Mitchell also defined the look of the peacenik hippie. Her iconic hairstyle of free-flowing locks, scrubbed-clean face, eclectic jewellery and a wardrobe featuring everything from simple girlish minidresses to floaty maxi-dresses over bare feet became the look of choice for every arts-and-crafts, guitar-playing indie girl from New York to LA. Mitchell's style influence, like her music, reaches from counterculture to mainstream celebrities such as Nicole Richie and Rachel Zoe. It resurfaces every time boho chic makes a catwalk comeback.

With war raging in Vietnam and the anti-nuclear movement gaining momentum, student strikes and peace protests galvanized America's disaffected youth. The spirit of protest – the concept of the 'voice of the people' – found expression in contemporary folk music and spawned some of the greatest songwriters ever. Mitchell's contemporaries and collaborators were Crosby, Stills, Nash & Young, and Bob Dylan. Folk singers were at the forefront of social campaigns. The hit single from Joni Mitchell's *Ladies of the Canyon* (1970) album was the environmental anthem 'Big Yellow Taxi'.

Joni Mitchell rose to fame performing stripped-down acoustic music that encompassed both gloomy assessments of the world around her and exuberant expressions of romantic love – all rendered with her incredible vocal range and intimate lyrics. As Emma Thompson's brokenhearted character Karen, in *Love Actually* (2003), says: 'Joni Mitchell taught your cold English wife how to feel.'

Joni Mitchell held the record-buying public's attention with her heartfelt lyrics, her melancholy take on the world around her and her florid expressions of romantic love. She became the perfect poster girl for the hippie generation.

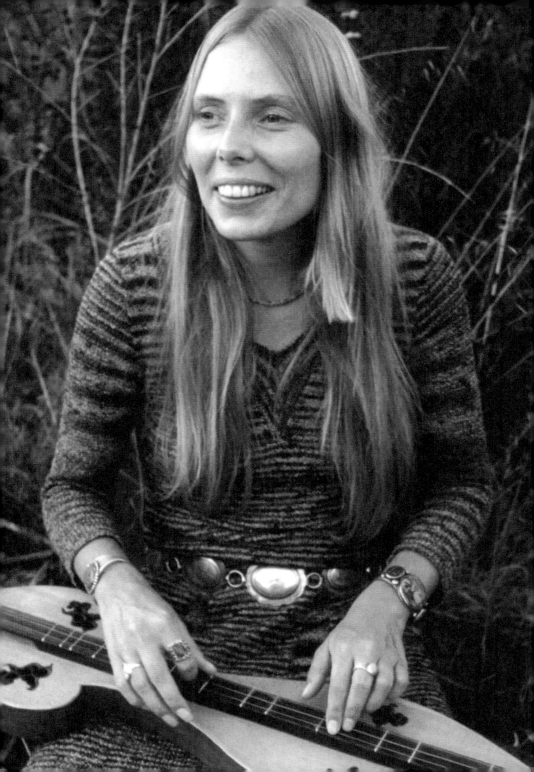

KANSAI YAMAMOTO
Japan's first great fashion export

In 1971, aged 27, Kansai Yamamoto (1944–) became the first Japanese designer to show in London. He was in the vanguard of the wave of Japanese fashion talent who made such a deep impact on Western fashion in the 1980s. But while he may have shared his compatriots' iconoclastic approach to shaping a silhouette, his flamboyance was diametrically opposed to the cerebral minimalism.

In his extravagant theatricality, Kansai Yamamoto pays homage to kabuki, the traditional Japanese dance-drama. His gaudy, larger-than-life intensity was much closer to being a Japanese counterpart of Western pop art than to the sober deconstructions of the designers who followed in his wake almost a decade later. He spun fashion out of fantastical images, blending a romantic vision of the past with sci-fi imaginings of a space-age future. In his silhouettes, the samurai met the intergalactic warrior.

Yamamoto is most famous as the man responsible for the wardrobe for David Bowie's Ziggy Stardust Tour. Legend has it that Bowie watched a video of a rock-fashion show that Yamamoto had staged in Japan, and fell in love with the costumes. He purchased the famous 'woodlands animal costume' – a knitted playsuit in saffron yellow – from Kansai's London boutique and went on to wear it at the Rainbow Concert in August 1972. Bowie then commissioned Yamamoto to create nine costumes for the 1973 UK tour. A stand-out piece was the knitted, multicoloured, one-legged body sock made of metallic yarn in sections of pink, red and blue with opposing patches of graphic back and white, which 'Ziggy' wore with a turquoise feather boa. And then there was the 'Space Samurai' costume, made from a glossy quilted material in black, red and blue, with legs flared in an extravagant curve.

Kansai Yamamoto products are widely licensed in Japan, and his fashion shows – the Kansai Super Shows – have been held in various international locations, including Moscow's Red Square (1993), and Beijing (2012) drawing audiences of hundreds of thousands.

Using diverse but distinctly Japanese references, from the silken kimono to samurai armour and kabuki theatre satins, Kansai Yamamoto became the 1970s' principal fashion fantasist. He forged a path into the Western market for the generation of Japanese designers who followed in his wake.

A PASSION FOR PRINT

When too much was never enough

As the 1970s dawned, *Vogue* announced, 'There are no rules in the fashion game now. You're playing it and you make up the game as you go... you write your own etiquette. Express yourself.' Indeed, the decade opened on a note of soft-focus fashion anarchy. There was no dominant 'look', no leading trend. On the contrary, every available element added to the vocabulary of the fashionable woman – even bad taste. In a feature in the summer of 1972, *Vogue* dedicated six pages to the question that some cynics believe defined the decade: 'Is Bad Taste a Bad Thing?'

Women were dressing for themselves. These were not clothes made to climb the career ladder. Nor did they have much sex appeal. Attracting men seemed to be of secondary importance in this wardrobe of pinafores, aprons, smocks, bare feet in clogs, faded cotton skirts, bonnets and Liberty-print blouses. Favourite locations for fashion shoots seemed to be sun-dappled picnic spots under ancient oak trees. And many fashion stories could easily have doubled as maternity features. It was a great time to be pregnant.

There was an explosion of prints, and designers and women were experimenting with ways to wear them. In Paris, Yves Saint Laurent styled big-collared spotted shirts with windowpane checked skirts and topped them off with patchwork-knit vests. In Italy, the Missonis worked with Spanish-shawl prints and brilliant stripes. They invited painters to try different effects in the factory in Milan, and adapted them for their new collections. The Missoni model (see page 192) of layering textures, patterns and colours was leading the way to a knitting revolution.

From the Paris catwalks to the King's Road boutiques, designers everywhere were mixing up the Liberty lawn cottons. Hand-knitters busied themselves with the production of vest tops, which were then layered over long-sleeved sweaters or shirts and blouses in patterns that might have been related, but certainly did not match. Women began to think in families of colours and pattern groups when putting their looks together. The fashion rule book had been shredded.

Clashing print, clashing textures, multiple layers of fabric and a love affair with colour (a love that some would say was blind) were what *Vogue* dubbed 'onion dressing'. For many, fashion's obsession with print and colour clash during the early 1970s explored the extreme limits of good taste.

BELL-BOTTOMS
Style crime or figure flatterer?

Flares, loons, parallels, bells, boot-cut, hip-huggers and elephant bell: to the casual observer they are all flared trousers, but the difference between them all is a wealth of fabric. In the 1970s, degrees of flare ranged from the modest 24cm (6in) boot-cut (so conservative that it has slipped into the annals of the classic wardrobe) to the elephant bell, with its absurdly wide 63.5cm (25in) flare.

Flares first arrived as high-fashion items on the Paris couture catwalks in the 1960s, progressed to hippie counterculture status around the turn of the decade, and hit the mainstream in the 1970s. To this day there are fashion commentators who blame Sonny and Cher for flared crimes against fashion, as the nationwide explosion of the trend in America appears to have gained traction just after they wore them on their prime-time television show.

Loons flared more from the knee than typical bell-bottoms, in which more of the leg was flared. They were much-loved by heavy-metal rock musicians such as Led Zeppelin, who were instantly recognizable in their loons, skin-tight T-shirts and tiny jackets, accompanied, more often than not, by a matching shock of flared hair. Disco music gave flares a new lease of unisex life in glorious and often shiny Technicolor.

Elephant bell, popular in the mid-to-late 1970s, were similar to loon pants but typically made of denim. Elephant bell had a marked flare below the knee, often covering the wearer's shoes, and were consequently taken up by performers of shorter stature such as James Brown, for whom the extra inches of height were a fashion godsend.

When the decade ended, most people hoped they had seen the back of bell-bottoms. However, they made a strong recovery in fashion circles in 2010.

For every crime against fashion that has been attributed to flared trousers, there is mitigating evidence that – given a slim enough line, a long enough leg and a high enough heel – the flared trouser is a useful weapon in the front line of the battle to lengthen legs and slim hips.

BEVERLY JOHNSON

American *Vogue*'s first black cover girl

Thanks to a single photograph in a blue polo-necked sweater, Beverly Johnson (1952–) became, almost overnight, a symbol of and a role model for the American Civil Rights Movement. She was invited to speak by the Reverend Jesse Jackson and was name checked alongside Rosa Parks and the Black Panthers.

'Except for the birth of my daughter, my *Vogue* cover was the best thing that ever happened to me,' says Johnson. The first black supermodel was raised in Buffalo, New York, and trained as a competitive swimmer, which, she said, made her 'a model with an athlete's mindset'. But, while Johnson had graced other American magazine covers, she had never made it onto the cover of *Vogue* – the gold medal in terms of modelling. Neither had Naomi Sims or Helen Williams, the two other leading African-American models of the time. But the early 1970s was a time of social upheaval, and things were about to change.

Johnson left her model agent Eileen Ford because Ford had told her she would never get the coveted prize. 'I thought it was because I wasn't her top model,' she said, 'not because I was black.' She signed with Ford's competitor, Wilhelmina, because she assured her it was within her reach. And it was. At 22 years old, Beverly Johnson became the first African-American woman on the cover of *Vogue,* with the issue of August 1974. A year later she was also the first black model on the cover of French *Elle*. She realizes just how important that *Vogue* cover was – and not just for her modelling career: 'Black beauty had not only been acknowledged in the mainstream, but celebrated.'

'Her' issue of *Vogue* sold out: 'The magazine was changing. It wasn't so much about the grand fashion fantasy as it had been in the 1960s. It was more about the girl next door.' The cover was shot by Francesco Scavullo. Johnson remembered that there weren't many photographers and makeup artists who really understood how to light women of colour. Scavullo – along with makeup artist Way Bandy and hairdresser Suga – got it.

Johnson was paid the princely sum of $100, which was the editorial day rate, but went on to become one of the highest-paid models in the industry, making about $100 per hour for advertising work.

Beverly Johnson became a 21-year-old trailblazer as the first African-American model to appear on the cover of American *Vogue*. She repeated her triumph in August 1975, and was followed by Peggy Dillard in August 1977. Naomi Campbell was the first black model to make the cover of a big fashion issue in September 1989.

CLOGS

Utilitarian, unisex, unpretentious…and ugly?

Clogs are the one fashion item that springs immediately to mind in support of any argument that the 1970s is 'the decade that style forgot'. For shoe connoisseurs, clogs are what happen when comfort and practicality trounce fashion and style. And so, for many fashion lovers, they are a classic cautionary tale.

They are also a fascinating window into the soul of the 1970s. It was a glamorous, frivolous decade, easily caricatured for some of its more extreme trends. But it was also a turbulent and often violent era, wracked by political scandal and economic crisis. On marches and demos throughout the 1970s, marginalized groups, including gay men, African-Americans and women, fought for the right to be treated as equal.

The hippie idealists of Europe and America were naturally drawn to the Scandinavian dream. Clogs, the footwear of workers in Sweden and the Netherlands, became not only fashionable but also emblematic of enlightened political thinking. The clog channelled the (very trendy) Scandinavian romantic folkloric tradition, but also came with a nod to eco-sensitivity and more than a whiff of the idealistic culture of communes. Swedish sexual liberation gave clogs a daring edge, too. They might have been heavy and bulky, but at least they could be slipped on and off easily.

As people expressed their disillusion with what they saw as the rampant consumerism of the West, those hippie ideals of peace, environmentalism and democratic socialism found their way from the margins of the music festival and into the mainstream. Clogs were utilitarian, unisex, comfortable and practical. Comprising wooden soles and leather strap or top with open heels, they were considered the shoes of both the conscience-stricken fashionable woman and the avant-garde man. They are enduring examples of accessories for the politically correct.

Speaking to the organic lifestyle and the utopian ideal of gender equality (at least via unisex footwear), the clog's 'worthier than thou' image gained no lasting fashion traction and quickly dropped off the fashion radar. Frequent attempts at revivals point to the clog's counter-intuitive longevity.

DIANE VON FURSTENBERG WRAP DRESS

1972

Taking over the world, one dress at a time

In 1976 Diane von Furstenberg (1946–) became the first designer to make the cover of *Newsweek* magazine, which called her the 'most marketable designer since Coco Chanel'. It had been only seven years since she had been interning in an Italian clothing factory and had just married Prince Egon von Furstenberg, one of Europe's most eligible bachelors. The couple had met at college. When the Prince's work took them to New York, she was determined to make a career for herself. 'When she discovered she was pregnant she admitted: 'I was humiliated, worried people would think I'd done it to get the "best catch in Europe".'

In 1972, with a $30,000 investment and some influential friends in the fashion press (Diana Vreeland, see page 126, was an early supporter), she launched the Diane von Furstenberg label with a cotton jersey shirt dress and a ballerina wrap top. A couple of years later, the shirt dress and top had morphed into one of fashion's all-time bestsellers – the wrap dress. And von Furstenberg was not only posing for photographs by Andy Warhol, lunching with Vreeland and appearing in the party pages of *Vogue*, she was even on the cover of the *Wall Street Journal*.

The wrap dress – sexy, simple, packable and good on women of many shapes and sizes – was an unprecedented success. By 1976, just two years after its launch, sales of the wrap dress had topped the five-million mark. Von Furstenberg explained its instant appeal: 'The wrap dress is the most traditional form of dressing: It's like a robe, a kimono, a toga. It doesn't have buttons or zippers. What made it different was that it was jersey; it made every woman look like a feline. And that's how it happened. It's not like I was thinking "Oh, I'm creating the It dress".'

It hasn't hurt that von Furstenberg is always perfectly PR-able. When, in the 1980s, a French journalist asked her to explain how 'that dress' came about, she added another layer to the fashion legend: 'Well, if you're trying to slip out without waking a sleeping man, zips are a nightmare.'

Diane von Furstenberg was making 15,000 dresses a week at it's peak appeal, to be worn by everyone from suburban housewives to Betty Ford and Gloria Steinem. As von Furstenberg herself says, 'The wrap dress was an interesting cultural phenomenon, one that has lasted 30 years.'

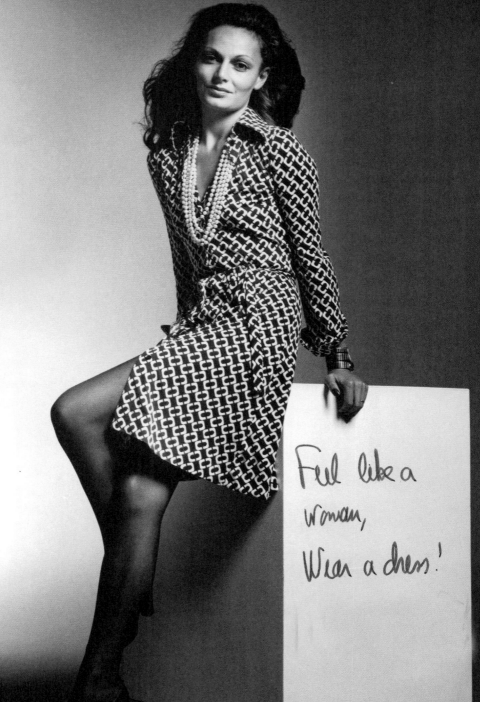

Feel like a
woman,
Wear a dress!

HOT PANTS

The booming business of body awareness takes off

By the winter of 1970–1 the midi-skirt had completely ousted the mini from the catwalks, and yet designers seemed loath to abandon bare legs. They proposed instead the shortest shorts, worn either on their own or under thigh-high slit dresses or showing beneath transparent layers. Yves Saint Laurent reinterpreted the 1940s with hot pants and wide-lapelled blazers, and Valentino (see page 194) showed a thigh-split, front-fastened skirt over white shorts.

Hot pants sold like hotcakes all over Europe and North America. 'Hot pants' entered the *Oxford English Dictionary*. And James Brown immortalized 'the girl over there with the funky hot pants on'. The craze might have enjoyed catwalk limelight for less than a year, but it was a benchmark for just how radically rules of dress and behaviour had changed. In that short time, it had become socially acceptable for women to wear them on the street, to the office, even to weddings. Even Jackie Onassis wore them.

But, as often happens, a fashion craze was the superficial representation of something much more significant. As the average woman got larger, models and celebrities were becoming thinner. A new culture of starvation had arrived, and a new market for diet pills, diet drinks and diet food had been identified. Hot pants reflected a new body awareness among Western women.

When hot pants fell out of favour in the summer of 1971, only months after they first took the world by storm, some fashion writers speculated that their disappearance was due to the fact that their revealing shape 'didn't work' with 'real' women's bodies. Others proposed that sex workers had killed the trend by adopting them as their own style statement. Whatever the reason for their early demise, by 1972 hot pants were no longer hot and were relegated to the disco, where they continued to enjoy life as an icon of the dance floor.

Hot pants were mainstream for a relatively short period of time. Southwest Airlines launched a business with free inflight cocktails and this advertising tagline: 'Remember What It Was Like before Southwest Airlines? You Didn't Have Hostesses in Hot Pants. Remember?' By 1976, there were no more free drinks and the hostesses were back in navy, knee-length, A-line skirts.

THE MULLET

Lord and Lady Mullet: Paul and
Linda McCartney shag the 1970s

In the 1970s Wings took America, and fashion's ugliest cut took hold like a global hairstyling pandemic. Throughout the decade the mullet's prevalence among England's rock 'n' roll royalty became a phenomenon, making what one American music critic was moved to call 'a blimey brotherhood of bitchin' hair'. The mullet came to define an entire subculture, which continues to unite a disparate tribe that takes in sporting and music legends alike.

Originally there was 'the shag', which was essentially a dishevelled and unruly mane with short, spiky tufts on top and shoulder-length strands down the back. A descendant of the mod haircut, it was popularized by Rod Stewart and Keith Richards, who, throughout the 'flower power' era, retained a cocky 'Jack the lad' attitude to go with their mod brush.

The 1970s was a dynamic period in the evolution of the mullet. There was the Midwest Metal mullet, also known as 'the Scorpion', as styled by Joe Elliot of Def Leppard. There was the Nashville mullet, or the 'Kentucky Waterfall', of which sightings were rarer, as it was generally covered by a cowboy hat. There were mullets with political significance, such as the Eastern Bloc mullet, also known as 'Prague Spring'. This style lasted all the way to the end of the 1980s and the collapse of the Berlin Wall, when the *Mulletkopf* – the German for 'mullet-head' – came to symbolize the struggle for freedom.

Soul brothers joined in with the African-American mullet, whose leading proponent was Barry White. And serious students of the hirsute need look no further than Linda McCartney for an example of the Lady mullet. The mullet, it seems, transcended boundaries of sex, nationality, politics, class and, most of all, taste.

The common link is undoubtedly Paul and Linda McCartney, who were the undisputed mullet originators.

It's a dark chapter in hairdressing history. Tom Jones is believed to have sported the first; David Bowie, the coolest. But Paul and Linda McCartney launched a trend that carries on to this day, and which at various times has gathered the likes of Suzi Quatro, Andre Agassi, Mel Gibson and Billy Ray Cyrus along the way.

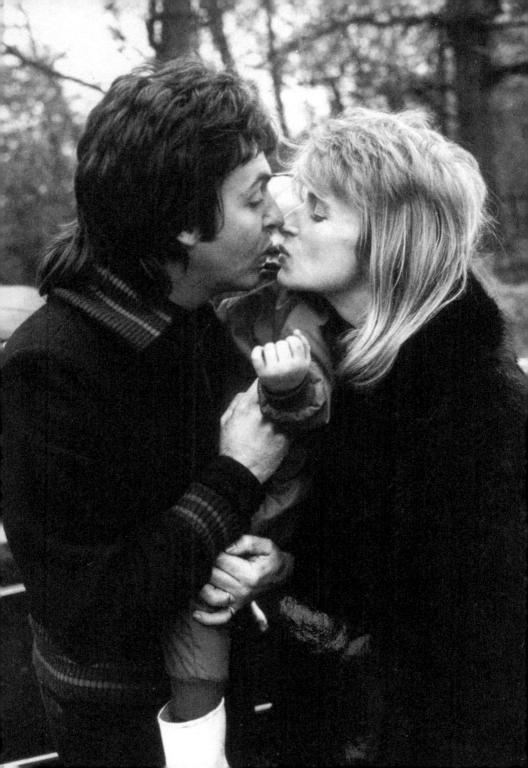

DAVID AND ANGIE BOWIE

The thin white Duke and his Duchess:
first couple of cool

There were John and Yoko, and Mick and Bianca, and then there were David Bowie (1947–2016) and Angela Barnett (1949–), the flame-haired, loud-mouthed American who inspired Bowie to develop his Ziggy Stardust, Aladdin Sane and Thin White Duke personae. David and Angie were British rock's quirky royal couple, looking and dressing alike in bright-red mullets and silk kimonos, and shocking the music world with scandalous tales of drugs, cross-dressing, threesomes and bisexual trysts.

The 1970s were characterized by sexual exploration. Terms such as homosexuality and androgyny became familiar, and it was the British glam rockers who were the flag-bearers for this sexual evolution. Glam was suddenly all the rage, on both sides of the Pond. Boys borrowed girls' boas, blouses, slinky shirts and, often, makeup.

Fashion was an integral part of David Bowie's image. As big glasses were to Elton John, so sequined leotards and feather boas were to Bowie's alter ego, Ziggy Stardust. The makeup skewed the gender lines even further. He became the most outrageous performer of the decade.

Bowie and Barnett met in London in 1969, through a mutual acquaintance, or, as Bowie put it, 'because we were both going out with the same man'. Angie's arrival encouraged Bowie to explore his androgynous side. She introduced Bowie to many of the arty eccentrics who would provide the blueprints for his future avatars.

The couple were married in 1970 and divorced in 1980. The decade was Bowie's most exciting period, his 'golden years'. It started with *The Man Who Sold the World* (1970) and closed with *Scary Monsters* (1980). During this period he made 12 successful albums, all seminal landmarks in music, and all with unforgettable fashion moments.

She was the daughter of a US army colonel. He was an aspiring rock star. They shared a talent for outrage. 'I was wild and David needed me to help him be wild,' said Angie. 'I chopped his hair off and dyed it and put him in a dress. I gave him notoriety. He gave me fame.' Together they created some of the most memorable fashion icons of the decade.

KENZO

Taking Paris in a riot of colour

The Japanese fashion invasion of Europe was led by Kenzo Takada (1939–), who proposed a completely different approach to silhouette and a radical use of texture and colour. Through him, Europe was to discover the Eastern tradition of covering the body in loose layers, rather than outlining it with a figure-hugging cut.

Kenzo was one of the first male students at Tokyo's Bunka Fashion College. In Japan at that time, traditional styles of dress dominated. The East was increasingly open to Western ideas and styles, but none of the Japanese designers had the confidence to challenge the supremacy of Paris until Kenzo arrived in the fashion capital in 1969. He rejected the untouchable image of Parisian couture, and his colourful, breezy style went off at a radical tangent to the past. In a challenge to the cold elegance of the Parisian shows, his models were lively and his presentations informal.

Kenzo found instant success with his debut for Spring 1970. Square-cut shapes reflected the ease of the kimono; unstructured clothes had a delicate sensuousness. Once asked why he didn't design sexy, close-fitting clothes, he winced and said: 'I couldn't, I'm too shy.' Through his work he channelled the vibrancy and colour he experienced on his travels, with the folklore of the Orient, Peru or India ever present. He drew on influences as disparate as calligraphy, military uniforms and ecclesiastical robes. Inspirations from the fine arts included Wassily Kandinsky and David Hockney.

At the heart of Kenzo's style was a vibrant international eclecticism. Yves Saint Laurent (see pages 162 and 288) might have turned ethnic motifs into fashion themes but Kenzo's ideal was the harmony of many cultural influences. He chose to call his early collections 'Jap', intending thereby to take the pejorative sting out of a racist slur. His peaceful internationalism was one of his most radical contributions.

Kenzo epitomized the fashion energy and imagination of the 1970s, and his brilliance brought style and global influences to bear on Paris fashion.

Kenzo epitomized the fashion energy and imagination of the 1970s, and his brilliance brought a combination of street style and ethnic themes to bear on Paris fashion. Under his influence, fashion fell in love with globalism. It is a passion that still resonates today.

LAURA ASHLEY
Taking fashion back to basics

Opening her first shop in London in 1967, Laura Ashley (1925–85) specialized in the Victorian milkmaid look – dresses in sprigged cottons and white high-necked blouses, which she sold at affordable prices. Ashley's clothes reflected the decade's strong anti-fashion mood as well as the back-to-nature movement that sprang from the hippie reaction to consumer-boom America and the environmental crisis that it had helped to create. The back-to-nature movement also inspired a nostalgia for a more innocent past, and embraced a Victorian fantasy of simple, homespun interiors and fashion.

'Surely you want to leave some contribution of the age we've lived in?' Laura Ashley's friend Terence Conran once needled her. Laura replied, 'I'm only interested in reopening people's eyes to what they have forgotten about.' Commentators theorized that her style was in part a feminine reaction against the sexist fashions of the 1960s. In contrast to that decade's preference for synthetics, Laura Ashley clothes were made from natural fabrics, such as cotton, and favoured soft, floral prints.

Having tapped the nostalgic mood, Laura Ashley enjoyed rapid success and went on to construct an entire lifestyle 'landscape' around her product – a pioneering innovation at that time. By 1981 there were 5,000 outlets worldwide stocking her product. Her pin-tucked bodices, leg o' mutton sleeves and floral printed cottons reminiscent of 19th-century china patterns were huge high-street hits. In no small way the Laura Ashley ethos was a reflection of the prevailing confusion about women's roles.

Laura's acquisition of a chateau in Picardy in 1978 is widely considered a watershed moment. Commentators saw no coincidence in the subsequent hike in the prices of garments that were once affordable to many, and were now edging out of their reach. Laura herself seemed to have become increasingly out of touch and in favour of a particularly heavy cotton in her bedding collection, arguing, 'Oh, but surely everyone sends their sheets to a laundry these days?'

The back-to-nature movement sprang from a reaction to the consumer boom, and through it handcrafts such as knitting, embroidery, natural dyeing and leather tanning enjoyed a revival. Laura Ashley harnessed the power of nostalgia for a simpler life, and with it built an empire.

MARC BOLAN

The 'National Elf' becomes
the poster boy for glam rock

Marc Bolan's rise was meteoric, dazzling – and brief. His career spawned an influence that ended in a fatal car crash after only 18 months of chart-topping success, yet still resonates through music and fashion, decades after his death.

Bolan (1947–77) was the 'National Elf'; a flamboyant troubadour with a dandy wardrobe and a penchant for tall tales. At the peak of his career in the early 1970s he sported a tumble of girlish curls and a head-turning look that was a mixture of Biba blouses, velvet trousers from Kensington Market, the obligatory Afghan (see page 214) and Mary Jane button strap shoes – a style he was said to favour because his feet were exceptionally small. On paper the elements don't add up to sex symbol, but he had a charisma that appealed to both genders.

'It was like being jealous of your best girlfriend,' recalled Cilla Black who performed with him. 'He had everything – the hair, the eyes, the make-up, the glam. The worrying thing was you did kind of fancy him, being this feminine-looking guy.' To the girls, Marc Bolan was a hybrid of the fairy-tale prince and a rampant boogie man. The boys had respect for a babe magnet when they saw one, even though he was dressed in satin and feathers.

In March 1971 Bolan's performance of 'Ride a White Swan' (1970) on *Top Of The Pops* became a national talking point. Parents were outraged by his sexual ambiguity. The press called it T-Rexstacy.

Clothes and storytelling had always been important to Bolan. As 14-year-old Mark Feld, he regaled *Town* magazine with a description of his expansive wardrobe including, '10 suits, 8 sports jackets, 15 pairs of slacks, 30 or 35 good shirts, 3 leather jackets, 2 suede jackets, and 30 exceptionally good ties.' Whether it was true or not, it made for colourful copy and, early on, he learned the PR power behind a good yarn.

At the height of his fame, Bolan charmed anyone who would listen with stories of how he had been befriended, in Paris, by a sorcerer; how he had sojourned in the chateau of a shaman and how he owned a 'magic cat'. It was all part of the Marc Bolan mystique that led girls and boys alike to take to the streets with tight tank tops, flapping flares and glitter glued to their faces.

The Bolan style spawned a new generation of superstars whose appeal depended as much on their image as on their music. In a decade of outrageous fashion, the glam-rock style was the most outrageous of all.

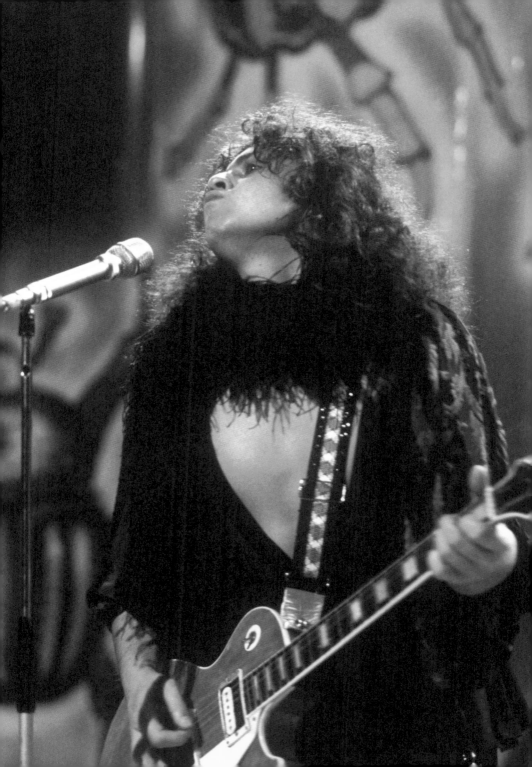

DAVID BOWIE AS ZIGGY STARDUST

Ziggy and Twiggy do *Vogue*

Alter ego 'Ziggy Stardust' made David Bowie (see also page 246) a megastar overnight. He was a torch-bearer for a generation that was disco-dancing its way into glam rock. Ziggy was a bisexual messiah: a flame-haired yob in lip gloss and mascara, silver jumpsuit and platform boots. He was a charismatic hybrid of androgynous spaceman, rent-boy Elvis and rock 'n' roll glitter queen.

Suzy Fussey was Angela Bowie's hairdresser. It was she who gave Angie her towering quiff and dyed it red, white and blue. Angie was so pleased with the results that she asked Fussey to work on David's hair. Between the three of them, they fashioned the iconic Ziggy look. After three days of trial and error (or should that be 'trial and terror'?) experimenting with a German dye called Red Hot Red and an anti-dandruff setting lotion called Guard, the scarlet rooster cut, with razored back and blow-dried front, was born.

The Ziggy haircut epitomized the androgyny of glam rock and was copied by both boys and girls. The Ziggy Stardust concept remains one of the most important and enduring phenomena of British youth culture. The look was reprised as recently as 2011, when Kate Moss (see page 426) was made over as Ziggy for the Christmas cover of French *Vogue*. Ziggy exploded onto the scene at a time of musical indulgence and sartorial apathy. He was a defiant stake in the ground in the face of advancing American cultural imperialism, while also pre-dating punk by four years.

The *Pin Ups* (1973) album cover, shot by Justin de Villeneuve (Twiggy's boyfriend and manager at the time), was originally commissioned by the editor of British *Vogue*, Bea Miller. However, de Villeneuve ended up giving the picture to Bowie to use on the album cover instead. The serene Twiggy (see page 184) was the perfect complement to Bowie's startled Ziggy. The album was the last of Bowie as Ziggy.

The *Pin Ups* album cover was originally commissioned for the cover of British *Vogue*. In just over a year, Ziggy Stardust had made it from being a cult figure on the margins to the very heart of popular culture. The false masks were copied by every nascent glam rocker in town, and sales from the album made Bowie the most successful artist of the year.

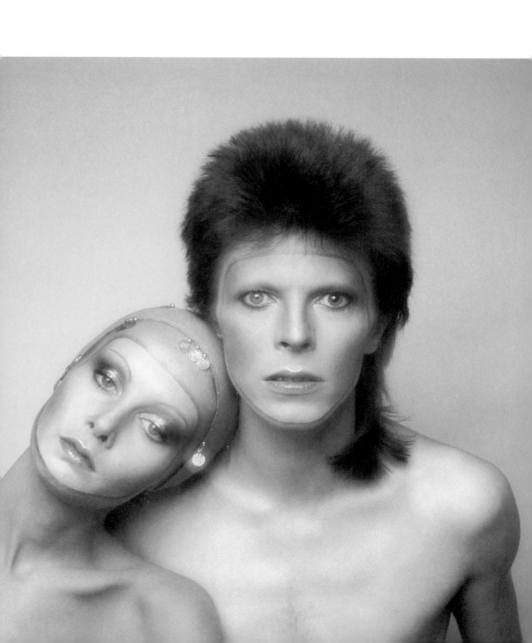

PLATFORM SHOES

Fashion goes for high-rise footwear

The opposing lures of nostalgia and futurism in fashion in the 1970s resulted in shoes that came with health warnings. Salvatore Ferragamo (see page 38) is credited with introducing the platform shoe in the late 1930s, an innovative move that typified the dynamic modernizing mood between the world wars. The romantic nostalgia of the 1970s sent stylists, fashion editors, photographers, designers and fashionable women back to a 40-year-old dressing-up box for inspiration, and the scene for a platform revival was set.

Simultaneously, these sculpted accessories became a wardrobe staple for glam rockers (who performed in them), Pop artists (who decorated them) and futuristic fantasists such as Ziggy Stardust (who built their entire image around them). But if platform shoes started on the margins, they went mainstream with startling speed. Quiz anyone about the dominant trends of the decade and most people would say flared trousers (see page 234) and platforms.

Designers such as Terry de Havilland – whose London shop Cobblers to the World became a place often visited by rock stars and celebrities – sold wedge shoes with ankle straps in peach, yellow, pistachio and blue snakeskin, and thigh-high, satin-lined black-leather boots. He made Tim Curry's platforms for *The Rocky Horror Show* (1975), and shoes to order for Bianca Jagger (see page 222) and David and Angela Bowie (see page 246).

By the end of the decade nothing was too much: not the exaggerated bulgy toes, the flaring heels, nor the outrageously curvaceous soles. 'Paint your own platforms' got full-page features in *Vogue*, and colourful metallic piecing, patchwork and embroidery became run of the mill.

Platform shoes started in the early 1970s with a relatively slim sole, a modest 2.5cm (1in). By the end of the decade, a 5cm (2in) sole and a 13cm (5in) heel were quite ordinary. The crossover from the world of fashion into rock music ensured they were more than a flash in the pan.

LAGERFELD FOR CHLOÉ

Catapulting Chloé into the forefront
of French ready-to-wear

Karl Lagerfeld (1933–2019) arrived at Chloé in the mid-1960s, at the peak of that decade's nostalgic revivalism. He had a passion for art deco, and the echoes of Peter Beardsley (1872–98) and Gustav Klimt (1862–1918) in his early collections perfectly captured the romantic mood. For Chloé he envisioned a floaty, almost ethereal femininity that remains at the heart of the label. His whimsical prints and fluid shapes were a sophisticated take on the ubiquitous bohemian, and made it one of the most successful collections of the decade.

The company's founder, Gaby Aghion, had started Chloé in 1952 with the intention of offering something completely different from the couture salon. Hers was to be 'luxury prêt-à-porter' – wearable yet beautiful daywear. The Chloé ateliers were equal to anything the couture houses had to offer, but they could deliver their collections off the rack, not as one-offs made to order. The spirit of Aghion's clothes had won legions of fans among fashionable young women. She had taken it a long way from the stiff formality of the chic Parisienne wardrobe in the early 1950s.

Before Lagerfeld's arrival the business had faltered. He was tasked with reviving the ailing house and he did it by acknowledging a need for clothes that were languid and laid back, but with unmistakable French chic. Its bohemian, feminine detailing attracted clients such as Grace Kelly (see page 60), Brigitte Bardot (see page 68) and Jackie Onassis.

Lagerfeld implicitly understood the spirit of the house, and adhered to the supple femininity for which Chloé was renowned. But he was also fearless in the design room. The house style remained firmly focused on pared-down sheath dresses that hovered around the figure with minimal decoration. But he also employed the embroidery skills of François Lesage to create show-stopping *trompe-l'œil* evening dresses, and he did not hesitate to take inspiration from sources that were decidedly not very Chloé at all: Carmen Miranda, for example, who provided an energizing jolt of bra top and scarf shawl among the tea dresses and cloche hats.

Karl Lagerfeld with a model wearing a dress from his Spring 1974 collection for Chloé. Under Lagerfeld's guidance, Chloé went from 'luxury prêt-à-porter' to something more widely accessible, in line with the pluralistic ethos of the 1970s. At Chloé, experimentation with myriad reference points became the designer's trademark. The fragrance Lagerfeld launched for the house in 1974 was an immediate commercial success, and Chloé continues to be one of the world's bestselling perfumes.

LAUREN HUTTON
'The greatest mannequin in history'

In 1974 Lauren Hutton (1943–) was the highest-paid model of the day, earning $200,000 a year as the Charles Revson Ultima II girl. The staggering fees that she commanded as the face of the beauty brand marked the turning point when fashion modelling became big business.

She had had a shaky start in the 1960s. Florida-born, Hutton went to New York aged 20 to seek fame and fortune. She was a $50-a-week house model for Dior, having been rejected by every agency before Eileen Ford took her up and advised her to fix her 'banana-shaped nose and gap teeth'. She had a commercial look compared to the typical fashion stars of the time – Twiggy (see page 184), Penelope Tree (see page 180) and Veruschka (see page 196). In 1966 Diana Vreeland (see page 126) picked her out from a line-up of 'run-throughs' because she had 'presence' and sent her to Richard Avedon (see page 158), who at first rejected her as 'just another pretty face'. Hutton remembered that she worked with him 'only when the stars were out of town'.

Full stardom flourished only when the 1971 recession and the midi-skirt arrived. Suddenly, fantasies were *de trop* and haughty mannequins no longer sold a casual trouser suit. From 1972, Hutton posed almost exclusively for Richard Avedon and the pair dominated the pages of *Vogue*.

Newsweek said, 'When haughty elegance was in, she kept her funny flaws. When distant deadpan was de rigueur, she posed smiling and laughing. When statuesque poses studded fashion magazines, she jumped and galloped across the page.' Hutton had a naturalness that was an antidote to the glittering excess of the 1970s. Avedon called her 'the link between the dream and the drugstore. She's the girl next door but she moved away.'

Described by fashion designer Halston (see page 296) as 'the greatest mannequin in history', Hutton easily made the transition from modelling to movies with *The Gambler* (1974), alongside James Caan, and *American Gigolo* (1980), starring Richard Gere. Her signature style, to this day, is effortless masculine tailoring. 'Fashion is what you are offered and style is what you choose,' she once astutely observed.

Fresh-faced, gap-toothed and tousle-haired, she was dubbed 'the million-dollar girl next door'. Hutton wisely ignored the advice of fashion experts and kept her 'imperfections'. And even though *Vogue* once wrote of her that 'her nose flies west, her mouth flies north', the magazine put her on its cover no fewer than 28 times.

BARBARA HULANICKI AND BIBA

Revivalism with a straight face

In the years leading up to the store's spectacular crash in 1975, Biba and its founder, the Warsaw-born fashion designer Barbara Hulanicki (1936–), played a central part in making London swing. The business was ten years old when Big Biba opened in 1974 in the building that had formerly housed the Derry & Toms department store on Kensington High Street.

The Aubrey Beardsley exhibition at the V&A in 1966 had been a tipping point in the evolution of London style. Hulanicki found the Victorian illustrator's style 'bewitching and a trifle decadent', and used it as a major inspiration as she pioneered a contemporary style that blended art nouveau, art deco, Victoriana and Hollywood. The Beatles' *Sgt. Pepper's Lonely Hearts Club Band* (1967) album cover was an ironic nostalgia trip. Hulanicki's foray into Victoriana, however, was unabashed escapism: revivalism with a straight face. Hers was a love of a style that had been unfashionable for too long.

People flocked to Biba's exotic interior, with its jumble of clothes, feathers, beads and Lurex that spilled out over the counters like treasures in a cave. Thousands visited the store every week. Twiggy (see page 184) recalled: 'If you didn't buy what you wanted there… it wasn't worth coming back next week and hoping it would still be there.' It attracted the 'beautiful people' like moths to a flame. And Hulanicki revelled in finessing every aspect of this perfect world. In her memoirs, she recalled how 'the postwar babies…grew into beautiful skinny people. A designer's dream. Our skinny sleeves were so tight they hindered circulation.'

There was a record department with listening booths, a bookstall, a kasbah area overflowing with North African products, menswear, womenswear, a mistress room with negligees and edible underwear, and even a storyteller for the kids shopping with their mothers on a Saturday. There was a food hall in the basement, and the Rainbow Room restaurant was open until 2am. The store hosted gigs by everyone from the New York Dolls to Liberace.

Hulanicki created the concept of shopping as an experience, a leisure activity, a social event.

Barbara Hulanicki, founder of Biba, pictured with her husband Stephen Fitz-Simon. Biba became a potent cult that is cherished to this day, even by those who never experienced it first-hand. The store was, according to *The Times*, 'an extraordinary creation, dominated by the personality of just one woman'.

HELMUT NEWTON

Master of the compelling and perverse

A particular photograph of a woman in *Vogue* caused a massive stir in the 1970s. She was dressed in a pretty summer print, lounging with legs apart, and – in a provocative reversal of roles – was eyeing up a passing man. The photographer was the German-born Australian Helmut Newton (1920–2004). Provocation was at the core of his work. Behind the image of the model in the pretty Calvin Klein summer dress was a combination of qualities that readers were not accustomed to finding on a glossy fashion page. Unease? Certainly. Menace? Perhaps.

Photographers of the 1970s faced challenges that their predecessors had not. They could no longer rely on the drama and theatricality of the clothes themselves, but had to find a way to make the reader stop and look at the girl, almost despite her laid-back wardrobe. Inspired by the novels of Raymond Chandler and Mickey Spillane, Newton preferred to shoot in the street or in 'real' interiors, rather than in the studio. He set up controversial scenarios – often involving the trappings of the bored and the rich – used bold lighting and constructed striking compositions. Sexual fantasy rather than the reality of fashion was his powerful way of communicating. Via his work, porno chic became part of the fashion lexicon.

His models were cool, stylish and maybe a little corrupt. He portrayed Amazonian women who, waking or sleeping, were rarely without immaculate makeup, jewellery and vertiginous heels. His models were towering incarnations of the blonde Prussian housemaids whom he remembered from his childhood in a wealthy household. The men in his photos typically appeared in submissive roles, as waiters, chauffeurs or mere onlookers. He shot some of his most famous images for Yves Saint Laurent (see pages 162 and 288), whose penchant for tight, wide-shouldered suits and powerful models inspired him.

Helmut's work mirrored the sexual revolution of the 1960s and 1970s, although to many feminists he was the Antichrist. He did nothing to assuage their antipathy with such blithely 'incorrect' comments as, 'Under certain conditions, every woman is available for love or something if paid …'

Helmut Newton captured the nuances of the feminist revolution, making women appear as sex objects, yet in control. Here, in an image for Calvin Klein, a fully clothed Lisa Taylor channelled the sexual revolution, sitting wide-legged while checking out the passing talent: archetypal male behaviour, not that of ladies in floral dresses.

DEBBIE HARRY
Queen of the New Wave scene

Debbie Harry (1945–) was the queen of New York's New Wave scene in the 1970s: a punk Marilyn Monroe sharing the bill at CBGBs in the Bowery along with the Ramones, Patti Smith and Television. She was already over 30 when Blondie became successful (a dinosaur in punk terms), but Harry's cool, understated sexuality and two-tone blonde hair made her an instant success in pop culture.

In England and America, at the beginning of the decade, the anti-Establishment torch was passed from peace-loving hippies to defiant and anarchic punks. Nothing made either group angrier than designer clothes and disco. Like the hippies before them, the punks set themselves apart from consumer society with homemade clothes, though theirs were dark and tight-fitting, and their attitude scornful and wary to match. By the mid-1970s, however, elements of punk rock and fashion had evolved further into a more pop-oriented, less 'dangerous' style on both sides of the Atlantic.

Enter Debbie Harry, Andy Warhol's favourite pop star and New Wave's poster girl. Her look was inspired partly by Marilyn Monroe (see page 46), but her attitude was more downtown. She might have started out as a *Playboy* Bunny Girl, but her figure had none of the voluptuous Marilyn curves. As Blondie's frontwoman, Harry went on to gain style-icon status for her wardrobe of thrift-store finds and DayGlo stage outfits masterminded by designer Stephen Sprouse.

Thanks to Sprouse, published images of her look were well known before her music, ensuring instant recognition as soon as she started recording and performing. She later said: 'Stephen would find things for me to wear or go through my collection of rags and put them together. He had all that experience at Halston [see page 296] creating collections. He really knew what he was doing.'

Harry's look was in large part a styling triumph for designer Stephen Sprouse. 'The counterculture look was a throwback to the Mod thing,' she recalled. 'It was all in vintage stores. We coupled that with torn-up stuff we'd find on the street. Stephen made me feel confident and beautiful.'

KAFFE FASSETT

A one-man knitting revolution

*c.*1975

In 1964 the American-born Kaffe Fassett (1937–) joined the great tide of British talent who were making London a fashion capital. With innovative designs and techniques, he introduced a tapestry-like pattern and colour to knitwear, which became central to the romantic look that defined the close of the decade.

Having studied fine art in Boston, Fassett moved to England at the age of 27. Once he arrived, he remembered: 'A three-month holiday turned into an indefinite stay…It was England that turned me from an easel painter into a fibre artist.' The timing for his personal transformation couldn't have been more perfect. An explosion of creative energy in the decade linked together many of the visual arts. When Fassett's painterly eye was applied to knitting it turned what had been a fireside skill into an art form.

On a trip to Scotland, Fassett bought 20 skeins of Shetland wool in an effort to capture the mesmerizing colours of the landscape. On the train back to London a fellow passenger taught him how to knit. His first designs appeared in 1969 as a full-page spread in *Vogue Knitting* magazine. Before long he was designing for Bill Gibb (see page 218) and Missoni of Italy (see page 192). 'I think knitting is just incredibly magic,' he says. 'I mean who would ever think that you could just take two sticks and rub them together with a bit of thread in between and out would come this incredible tapestry of colour?'

By avoiding complicated stitches at all costs, Fassett claims to have arrived at 'non-angst knitting': 'I wanted to make it elegant so there was no point in trying anything fancy which immediately goes wrong when you drop a stitch. If you make a mistake according to my method, it can be a positive benefit.' He works with as many as 150 colours in a single garment – 'anything worth doing is worth overdoing,' he says.

Kaffe Fassett turned a simple process into an art form. With designer Bill Gibb, he explored machine knitting for a while, but quickly rejected it for his favourite method: sitting barefoot and cross-legged and working intuitively with circular needles.

MARGARET THATCHER

The times they are a-changin'

In 1975 the Tories chose their first woman leader. Political commentator Ferdinand Mount said at the time: 'Mrs Thatcher has achieved something which Mrs Pankhurst would scarcely have dreamed possible – that just over 50 years after women gained the vote, a woman Prime Minister would be treated as nothing much out of the ordinary.' The MP for Finchley rejected any cause for great celebrations, saying: 'Good heavens, no. There's far too much work to be done.' Instead, the chronically able 'Mrs T' put in a brief appearance at a party in Pimlico before having a working dinner with Conservative Chief Whip, Humphrey Atkins, at Westminster. In 1979 she went on to win the general election to become the first female prime minister in the UK.

Over the decade, the world witnessed her evolution from suburban housewife to one of the most powerful women in the world. With her 'power-dressing' suits, brooch on her left lapel, pearls and boxy handbags, her style was instantly recognizable. And with her Asprey bag, Tomasz Starzewski evening dresses and Aquascutum suits, she fashioned herself as the 'Iron Lady'.

An avid fan of the pussycat bow, Thatcher had countless blouses, both printed and plain, with long ties. She said once, 'I often wear bows; they are rather softening, they are rather pretty'. It was suggested by an image adviser that Thatcher should give up her pearls, which had been given to her by her husband Dennis when their twins were born in 1953. She refused, and they became part of her signature style.

Thatcher once described her handbag as the only safe place in Downing Street, and it became a symbol of her style of government.

'Margaret was very intelligent about her image, says Conolata Boyle, costume designer of *The Iron Lady* (2011). 'She made herself look more efficient, more businesslike, but always with that underlying feminine touch. She very knowingly used her feminine powers as a woman among men.'

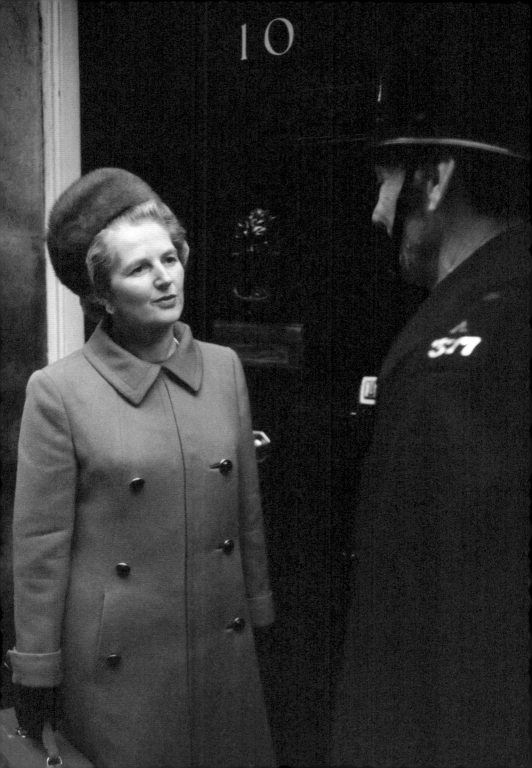

AGNÈS B.
Fashion with a democratic accent

Agnès Andrée Marguerite Troublé (1941–), known simply as agnès b., quietly grew her simple designs into an international brand, and has become one of the richest self-made women in France.

Many of her original pieces remain part of the agnés b. collection today: cardigans with pearl snaps, striped shirts made from the same hard-wearing cotton that rugby teams use for their shirts, and a leather jacket inspired by a portrait by the French impressionist painter Édouard Manet (1832–83). Other things have changed. Few, for example, miss the notorious communal changing rooms, though the original idea was an idealistic one: 'I thought it was interesting to encourage this relationship between the customers, so that they would be talking to each other.'

A freelance designer, agnès b. decided to open her own shop in the retail wasteland of Les Halles in 1976. Birds flew free in the cavernous space, built nests and hatched their chicks in the displays. 'It was very cool,' she says. 'We were writing on the walls.' Biographer Penelope Rowlands remembers: 'It was like going to Biba in London. I mean, you knew you were at the centre of the world somehow.' The environment was revolutionary and so was the product. Agnès recalls: 'I got back to designs that don't belong to anybody, like jeans – no one knows who designed jeans – plasterer jackets that we would dye in pink and red, waiters' jackets, herringbone painters' trousers. We made petticoats that we dyed ourselves in the bath. People would buy them still dripping wet.'

For a designer who had marched in the Paris student demonstrations of 1968, it was also subtly political: workers' clothes for everyone; fashion with a democratic accent; *liberté*, *égalité*, *fraternité*. Agnès b. remains an idealist. The company has never advertised because she thinks advertising is immoral, and her clothes are all made in France to avoid using exploited labour.

Agnès designs, she has often said, 'for people who have more important things to do than shop till they drop'. Agnès b. is a fashion tycoon, whose engagement with social issues has been matched only by her dedication to building a business. A diehard idealist, it is said she has never known how much money she makes.

BRYAN FERRY AND JERRY HALL
Britain's coolest couple

They were London's coolest couple. Bryan Ferry (1945–), 'the Electric Lounge Lizard', had global cred thanks to his songwriting partnership with Brian Eno in Roxy Music, his Antony Price suits, his connoisseurship of style and his refined taste for all the good things in life ('Roxy Music were more likely to redecorate a hotel room than trash it,' as one journalist quipped). Jerry Hall (1956–) was a rising fashion star and was to become one of the hottest models of the decade. She grew up in Mesquite, Texas, with ambitions to be glamorous. 'My mother and my sisters – five girls – were crazy about glamour and Hollywood movies. I styled myself on Veronica Lake and Marlene Dietrich.'

They met when Jerry was booked to appear as a mermaid on the cover of Roxy Music's 1975 album *Siren*. Legend has it that the blue paint they covered her in wouldn't come off, so Bryan offered to take her back to his house, claiming he would help her remove it (he had trained as an artist, after all). They started an affair and she moved into his Holland Park home. Five months later, they were engaged. He was 30, she was 19.

Hall might have been an established model when the couple met, but the *Siren* album cover propelled her to international celebrity. They were invited everywhere, including to dinner by Mick Jagger. This last engagement was to be the end of a dazzling affair. Hall left Ferry for Jagger in 1977: 'Bryan was flattered by Mick's attention, but he could also see that Mick was smitten with me. It couldn't have been nice for him.'

Jerry Hall is posing for a magazine shoot with Bryan Ferry in the Amstel Hotel in Amsterdam. Hall and Ferry had been going out for over a year and were engaged at the time. But within months she had left Ferry for Mick Jagger.

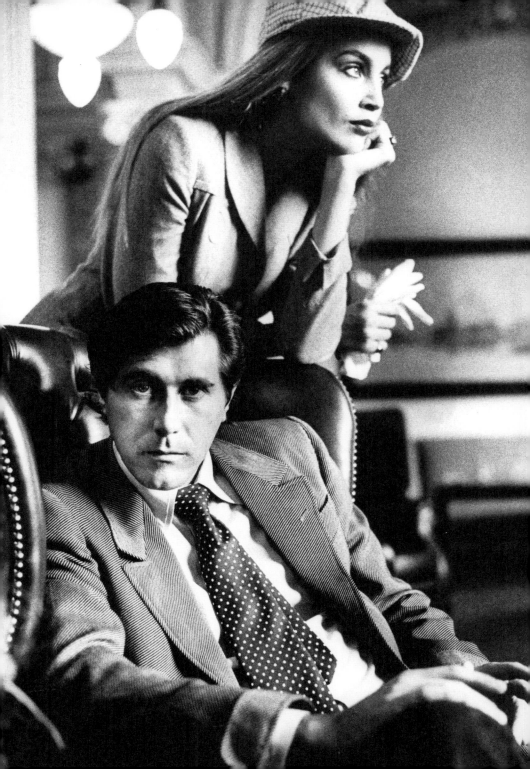

CHARLIE'S ANGELS

Crime-fighting sirens of the small screen

Television shows were a huge influence on fashion in the 1970s, and *Charlie's Angels* (1976–81) was one of the most successful. It was also one of the first to showcase women in roles traditionally reserved for men.

Kelly (Jaclyn Smith), Jill (Farrah Fawcett-Majors) and Sabrina (Kate Jackson) left their boring jobs with the police to work for the Townsend Detective Agency. They were strong and independent women who fought the baddies and rescued the innocent.

Sexual politics aside, the wardrobe created a lasting impression: the skinny, masculine-tailored suits with wide lapels, open-necked shirts and form-fitting waistcoats; the high-waisted, wide-leg jeans and platform shoes – never mind the carphones in the convertibles. They are consistently namechecked as inspiration by designers whenever a 1970s revival rolls round. From Phoebe Philo to Tommy Hilfiger (see page 488), *Charlie's Angels* is never far from designers' mood boards when there is a feeling of the go-getting 1970s' sex symbol in the air.

And then there was the hair. The 'Farrah Flick' became one of the most-wanted celebrity 'dos'. By the mid-1970s women had been freed from the tyranny of rollers by the blow-dryer and curling tongs, the versatility and portability of which launched a whole new approach to hairstyling. Farrah Fawcett-Majors' feathered blonde hair remained the most-copied style ever (until the 'Rachel cut' came along to offer some serious competition in the 1990s, see page 474), and her influence on style and fashion far outlasted the relatively brief time she spent on that iconic television show.

As the tomboy of the group, Fawcett-Majors often wore a pair of Nike running shoes with her jeans, thereby kick-starting the athletic trend. And the famous poster image of the actress in a swimsuit, head tilted back and grinning broadly, sold more than 12 million copies worldwide.

Jaclyn Smith, one of the original Angels, remembered, 'It wasn't meant to be Shakespeare. It was total escapism. I think young girls identified with us because we were emotionally independent, financially independent and we were role models.'

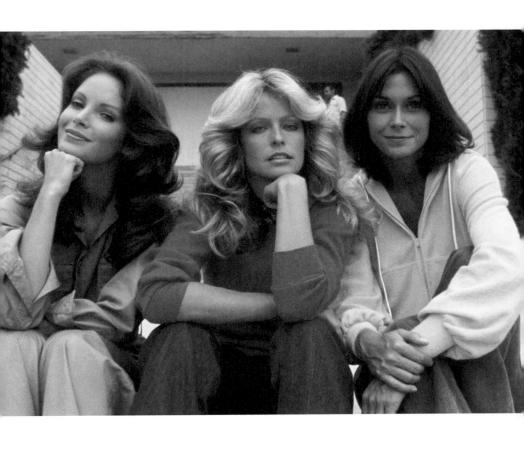

FIORUCCI

The daytime Studio 54

1976

Long before the concept of lifestyle became shorthand for the way fashion could reach the remotest corners of our lives, there was Fiorucci in Piazza San Babila, Milan, and its sister store nearby on the Via Torino. Young, hip Milanese went there for everything from jeans to gadgets, fast food and accessories. More importantly, it was a place to hang out. People met for 'five o'clock tea' and to browse the shop's antique market for vintage finds. The logo was based on a Victorian image of two little angels.

London got its first Fiorucci on the King's Road in 1975. And in 1976 it landed in New York next to Bloomingdale's. America fell in love with the magic of Italian styling. It became known as 'the daytime Studio 54' (see page 302), where many of the night-time revellers spent their daylight hours dissecting their exploits of the night before and planning their next evening's escapades over inky espressos at the Fiorucci coffee bar. The Italian architect and founder of the Memphis Group, Ettore Sottsass, designed the interiors. Andy Warhol held the launch party for *Interview* magazine there. Everyone from European royalty to Jackie Onassis, Cher and Elizabeth Taylor shopped there; Truman Capote signed books in the window; and the performance artist Joey Arias worked there as an assistant alongside Christopher Ciccone, Madonna's brother. Years later, Arias still had fond memories of the slippery floors: 'perfect for sliding across to catch shoplifters.'

There was even a Fiorucci car (an orange-and-blue Giulietta), which you could drive wearing your Fiorucci sunglasses (a designer first for the brand). In 1979 excitement about the opening of a shop in Beverly Hills was such that police had to assist with crowd control.

Fiorucci is credited with launching crazes for everything from designer jeans and sunglasses to parachute-cloth jumpsuits, leopard print and handbags made from workmen's metal lunchboxes. They were all icons of the disco age.

278

GLORIA VANDERBILT

Harnessing the selling power of celebrity

The 1970s were a golden age for denim: dungarees, bib-and-brace overalls, bell-bottoms (see page 234) and flares. It was the decade when denim became glamorous – a blank canvas to be painted, embroidered, fringed, frayed, studded and patched. Denim became a way to polish up a fusty image and didn't stop at clothing alone. In 1973 the Volkswagen Beetle was offered with denim seats and marketed as the Jeans Bug.

Gloria Vanderbilt (1924–) was a New York socialite and scion of one of America's oldest families. In 1976 the Indian designer Mohan Murjani proposed launching a line of designer jeans carrying Vanderbilt's name embossed in script on the back pocket, together with her swan logo. Although Calvin Klein (see page 444) is generally credited with the first breakthrough into what was to become the massive designer jeans market, it was Vanderbilt who took jeans a notch higher by harnessing the selling power of celebrity. By adding the lustre of her upper-class name and ritzy provenance to blue denim jeans, the venture became a global success. She was also one of the first designers to make public appearances.

Until the mid-1970s, the only blue jeans anyone really wore were made by Levi's, Lee or Wrangler. Gloria Vanderbilt jeans were designed exclusively to fit the contours of a woman's body and are cited as being the world's first designer jeans for women. Her jeans were also more tightly fitted than other jeans at the time.

Denim crossed the counterculture barrier and graduated to high-status garment, whether in Rodeo Drive or Saint-Tropez. Big designers from Ralph Lauren in New York (see page 324) to Giorgio Armani in Milan (see page 336) followed Vanderbilt's marketing lead. In the late 1970s, at the height of the brand's success, she was selling ten million pairs of jeans a year.

Gloria Vanderbilt's jeans were the day-to-night staple of the disco era. She used her social A-list status to load her label with fashion kudos. And she scored cool points by casting Debbie Harry of Blondie in her television advertising campaign.

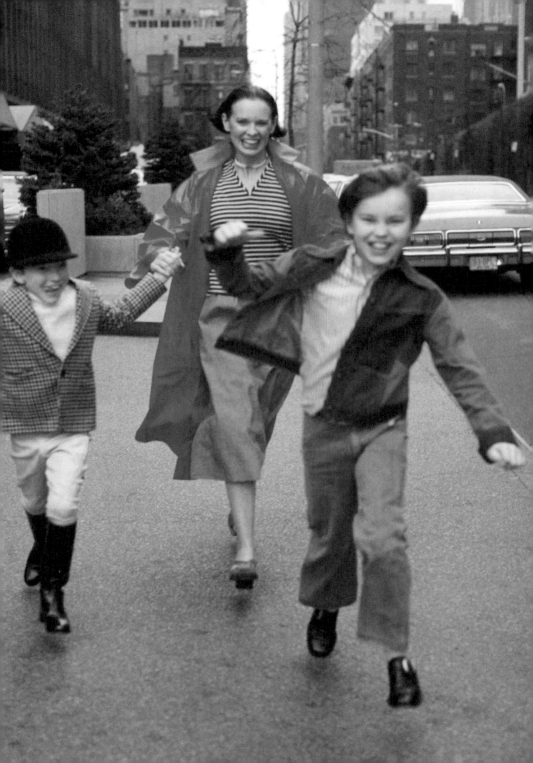

MARIE OSMOND
The decade's peachy keen teen heart-throb

The 1970s were a vintage decade for teen idols – Shaun Cassidy, Leif Garrett and the Bay City Rollers among them. But for millions around the world, posters of Marie Osmond and her brother Donny claimed more bedroom-wall acreage than any other. The *Donny & Marie* show (1976–81) was 'appointment television', broadcast in more than 17 different languages.

Marie Osmond was the only girl on the teen scene. She had success as a solo country music artist in the 1970s, covering the country pop ballad 'Paper Roses'. She was only 12 and made history as the youngest female artist to have her debut record go to number one in the charts. And she followed it up with a Grammy nomination.

Marie became the youngest-ever host of a national television variety show. And for five years, flush with pocket money to spend, she was a monumental trendsetter. The long, billowy smocks, the cherries tucked behind an ear framed with a blow-dried flick: this was a look that dominated the school discos of the decade. And as her teenage years advanced, many discovered in her wake the limitless potential of heated rollers. Osmond's appeal was such that she was immortalized in the first ever celebrity fashion doll.

The Osmonds were wholesome, toothsome role models – sanitized sex symbols for teenagers in a world were taboos were, frankly, taboo.

Marie was slated for the role of Sandy in *Grease* (1978). She turned it down because she did not approve of the film's moral content. All the same, her hairstyle was the most-requested look in salons across the world for the best part of a decade.

In the 1960s Sonia Rykiel (1930–2016) was dubbed 'the queen of knits' by her American fans. She was the most important of the women designers who emerged in France during that decade. The clothes that she designed for her husband's boutique, Laura, were hits with even the trendiest British mods.

In the early 1970s Rykiel pioneered clothes with exposed seams and no hems or linings. Well ahead of the Japanese and Belgians in exploring deconstruction and minimalism, she commented in *Women's Wear Daily*, 'people said making clothes inside out was not proper. I disagreed, because clothes that are inside out are as beautiful as a cathedral.'

Rykiel admitted that her femininity was at once one of her greatest qualifications and limitations as a designer. 'A man is sometimes more creative than a woman [designer] because he will not wear the clothes himself. Practical considerations to him are secondary. Women designers define things with a more practical eye because of the limitations of their body.'

Untrained, Rykiel began her career in fashion in 1962 'by accident', because she was pregnant and wanted a beautiful maternity dress. Success, however, came quickly – by 1967 Marylou Luther of the *Los Angeles Times* could write: 'Couture is not enough. You need a Rykiel.' Her major breakthrough, though, came in the 1970s, when her soft, knitted separates embodied a style that was both liberated and sophisticated, and which struck a chord with the modern generation of working women.

'When I was little I hated clothes,' Rykiel has said. 'I only liked the same old skirt and pullover. It was war between me and my mother.' One day, as an act of rebellion, she went out naked. Maybe it's no surprise that the little girl who always liked to wear the same old sweater grew up to design fluid knits which changed in form only gradually, and clothes that were as comfortable as a second skin.

Rykiel's fans loved her for her uniquely feminine approach. In 1970 a poll of French women voted her one of the most sensuous women in the world. Rykiel's look offered a fresh alternative to formal French wardrobes.

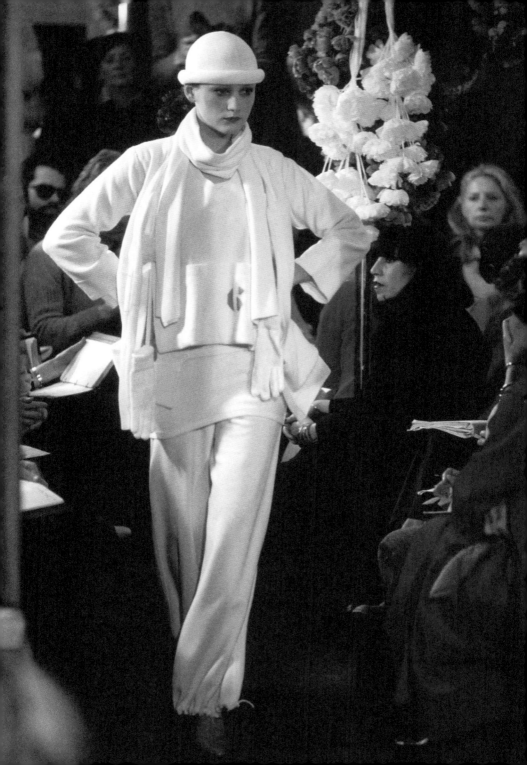

WONDER WOMAN

The 1970s feminist heroine

Wonder Woman (1976–9), starring Lynda Carter, was must-see television for the latter half of the decade. The super-heroine and her alter ego, Diana Prince, were icons of feminine strength. Immediate fashion fallout was the rise in popularity of knee-high boots, which the most adventurous wore with hot pants, though most were happy to style them with a miniskirt.

Created in 1942 as part of the DC comic series, *Wonder Woman* was the brainchild of Dr William Moulton Marston, a psychologist and feminist. In the vanguard of pro-feminist thinking, Marston wanted to create a female comic character who was just as powerful as her male counterparts, without a hint of the 'damsel in distress'. Her powers included a Lasso of Truth and bullet-repelling bracelets, powers she would lose if her wrists were bound together. An Amazonian princess, Diana originally came to the West to fight the threat of Nazism. But she was a more-than-welcome visitor in the 1970s, a decade marked by fear of nuclear war and paranoia about communist plots.

A propaganda vehicle in star-spangled hot pants? Probably. But she also most definitely reflected the new craze for the body beautiful, and the rapidly expanding market in aerobics and dance classes that popularized the leotard.

Wonder Woman always triumphed over the men who stood against her. Inevitably, her ample chest, thighs of steel and gold-plated headband also gave her sex-symbol status. But the 1970s embraced her as a feminist heroine.

As America celebrated its Bicentennial, the central character of the primetime hit *Wonder Woman*, broadcast the same year, was suitably dressed in patriotic emblems. Her stars-and-stripes costume with its golden belt of power, bullet-deflecting bracelets and unbreakable golden Lasso of Truth, is still a Halloween and costume-party bestseller.

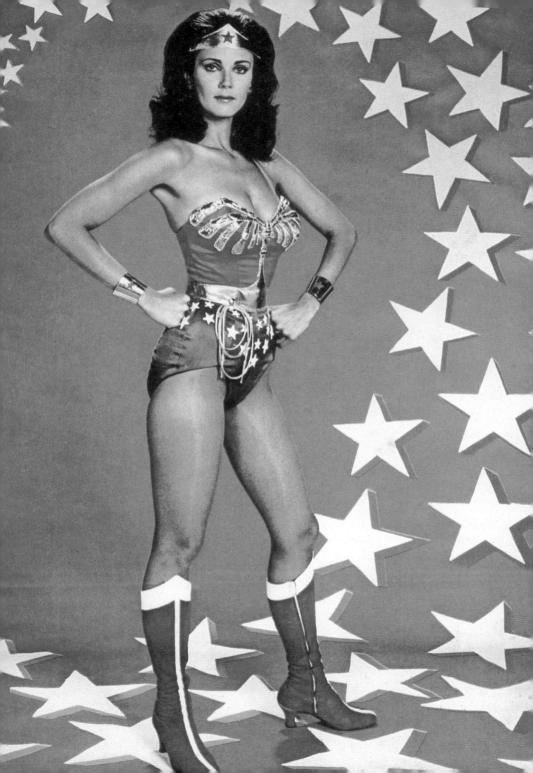

YVES SAINT LAURENT: THE RUSSIAN COLLECTION

Paris couture fights back

The 1970s found haute couture at a crossroads. For the first time its relevance was hotly debated. The centre of 1960s social life had switched from the aristocracy to the new meritocracy. Ready-to-wear designers dictated a new pace in fashion. And the best-dressed women were shopping for more informal wardrobes that were in step with the decade's increasingly casual dress codes.

Yves Saint Laurent was pursuing a clear goal with his collection of Winter 1976/7, his most expensive and lavish collection yet. 'It was my answer to the press which had disqualified the haute couture trade as old-fashioned and antiquated,' he said. With the collection, he made yet another lasting impact on fashion. His sable-trimmed Cossack coats in gold lamé, bright babushka dresses, gypsy skirts piped in gold, luxuriously embroidered waistcoats and tunics, whisper-thin glittering blouses with full sleeves, and golden Cossack boots set a new standard in luxury that was to reverberate into the 1980s.

'A revolution,' cheered the *International Herald Tribune*, 'the most dramatic and expensive show ever seen in Paris.' The press dubbed it the 'Ballets Russes' collection, in homage to Serge Diaghilev's Russian ballet troupe which had caused a similar sensation in Paris at the beginning of the century. And indeed there were distinct echoes of Léon Bakst, the company's unforgettable costume designer.

Each look was a celebration of the skills of the artisans who had contributed to it – the embroiderers, passementerie makers, lace weavers, feather workers and jewellery makers. Saint Laurent may be the designer who will be remembered for having made the greatest effort, with his Rive Gauche label (see page 162), to connect with women in their everyday lives and wardrobe requirements, but with this one collection he created a distinct distance between the couture and the ready-to-wear, and revived the taste for elegant excess. 'I don't know if it's my best collection, but it was certainly my most beautiful,' the designer later recalled.

With the Russian collection, Saint Laurent not only convinced the press of the artistic worth of luxury fashion; he also brought fantasy and romance back to the catwalk and energized a folklore wave that has never completely subsided since.

DEBORAH TURBEVILLE
Fashion photography's incurable romantic

1977

One of the most significant changes in fashion in the 1970s was the increasing numbers of influential women photographers. The prominence of the likes of Deborah Turbeville, Louise Dahl-Wolfe, Andrea Blanch, Eve Arnold and Sarah Moon reflected not only how women's place in society was changing, but also how women were perceiving other women and themselves. Men photographing women in the 1970s often presented them as something only to be desired. Women photographers tended to photograph fashion and women in a way that corresponded to their own realities, often producing images that draw strength from mood and atmosphere rather than the impact of a graphic image on the page.

The American Deborah Turbeville (1932–2013) was one of the most original and imitated of this new breed. As she put it, 'I am totally different from photographers like Newton (see page 264) and Bourdin. Their exciting and brilliant photographs put women down. They look pushed around in a hard way: totally vulnerable. For me there is no sensitivity in that. It is the psychological tone and mood that I work for.'

For inspiration Turbeville drew on 'silent films by Eisenstein, cinematic work of Cocteau, Diaghilev's ballet set drawings, Russian literature, and the faded palaces of Europe'. There is a psychological tension in Turbeville's work that reflects a preoccupation with cinematic style and atmosphere.

Turbeville shows women who desire something more than men can give. Simple daylight gives her images an enigmatic quality. Her women look delicate and even a little sinister as they gather in slightly odd environments, in faded ballrooms or wild gardens. Their oblique glances have a mysterious quality, and sometimes they look isolated or disturbed. Their surroundings are dreamlike and insubstantial. Their bodies say one thing and their clothes another. In the 1970s these ambivalences engaged many women in a powerful way.

Turbeville was hugely inspired by imagery from paintings, literature and architecture of the past. Her images were a lightning rod for the romance and nostalgia that inspired much of the fashion design of the decade.

DIANE KEATON IN *ANNIE HALL*

The movie that spawned an enduring fashion look

Only a handful of movies can claim to have spawned an entire fashion movement. In the 1970s women everywhere took on the look adopted by Diane Keaton (1946–) in *Annie Hall* (1977), layering oversized, mannish blazers over waistcoats and ties, billowy trousers or long skirts, and donning boots.

One of Woody Allen's most taxing dilemmas on the movie was Annie's wardrobe. Her character was that of a complicated, neurotic, intelligent ditz. And what she wore had to make that believable. While Ralph Lauren (see page 324) and costume designer Ruth Morley collaborated on the styling, it was Keaton who created the look using her own clothes. 'She came in,' Allen recalled in 1992, 'and Ruth Morley said, "Tell her not to wear that. She can't wear that. It's so crazy." And I said, "Leave her. She's a genius."' Keaton's gender-bending wardrobe blazed a trail for women in the late 1970s.

After the release and subsequent popularity of the film, the 'Annie Hall look' became standard attire for smart girls everywhere. Those grandfather shirts, baggy chinos, Ralph Lauren ties, big hats, flat shoes and glasses became code for the female intellectual. The clothes weren't just about the right to equality; they were also about the right to individuality. Annie Hall saw the birth of vintage chic.

'Her throwaway verbal style and her thrown-together dress style became symbols of the free, friendly, gracefully puzzled young women who were busy creating identities out of the epic miscellany of materials swirling in the American cultural centrifuge,' rhapsodized Jack Kroll, *Newsweek*'s film critic at the time. 'Her fashion influence in those days should not be underestimated,' says *Vogue* editor André Leon Talley, 'What Sarah Jessica Parker is to young women today, Diane Keaton was in that day.'

The 'Annie Hall look' became a global fashion phenomenon. In the syndicated *Doonesbury* comic strip, a radio interviewer asked a fictional Iranian revolutionary leader if the Ayatollah Khomeini would approve of the look for Iranian women. The response was: 'If worn with a veil, fine.'

In the 1970s Geoffrey Beene (1924–2004) was known and loved in America as much for his genteel Southern manner as for being the designer who had perfected his own ideal for a relaxed easy fit. He eschewed the tailored formality of blazers and pleated trousers in favour of pieces he would make his own: jumpsuits, pyjama pants, chemise shirt dresses and tunic blouses. And yet, New York's cerebral minimalist was just as well-known for his luxurious evening wear, and established a loyal following among ladies on the social circuit who knew just how to make an entrance in his signature polka - dot tulle.

Everything Beene designed had a handcrafted, artisanal character. This near-couture standard combined with his modern, easy aesthetic made him one of New York's best-known and most respected designers. 'I have never liked rigid clothes,' he said. 'I like freedom. I am an American. I love sweatshirts, skirt and loafers, and I have never deviated from the premise of freedom and effortlessness.'

Geoffrey Beene believed that the future of clothes lay in perfecting synthetics. He was one of ten leading designers approached by DuPont to promote a new synthetic, Qiana. He chose to have the yarn made up into satin velour. 'Working with this material proved to me that synthetics could be perfected, for it was exactly like a pure silk velour, only it did not crease.'

In 1974 the designer launched Beene Bag, a marketing innovation at the time. It was a cheaper line that sold widely and was used to subsidize the creative virtuosity of his main collection. One of Beene's greatest contributions was the respect he earned in Europe for American fashion. In 1976 he took a Beene Bag fashion show to Milan, showing young, sporty separates in inexpensive materials such as mattress ticking. By the end of the show, the Italians had enthusiastically come round to the idea that Americans could do more than just jeans.

At a time when women's fashion was heavily influenced by menswear, Geoffrey Beene was experimenting with an easy, relaxed fit. He rejected mannish elements, such as blazers and trousers, in favour of softer elements that he would make his own: full-skirted dirndls, jumpsuits and flowing pyjamas.

HALSTON

The designer who dressed the sexy 1970s

By the late 1970s Halston was a byword for American style, a combination of minimalism and glamour. His modernizing approach was all-encompassing, from the creation of a modern silhouette to the use of synthetics in high fashion. From perfumes in a signature sinuous bottle to uniforms for flight crews and even the girl scouts, Halston was the colossus of American fashion in the 1970s. Halston clothes were made in luxurious fabrics, such as six-ply cashmere and silk charmeuse, and were bereft of superfluous trimmings. They were comfortable and easy to wear, ideally suited to the lifestyles of a burgeoning group of jet-set revellers.

Roy Halston Frowick (1932–90) began his career as a milliner to socialites, and famously created the pillbox hat that Jackie Kennedy (see page 172) wore for the 1961 presidential inauguration. His debut fashion show at Bergdorf Goodman was an 18-piece capsule wardrobe of interchangeable items. Halston fashion shows were media events. Music played as smiling models sauntered down the runway. His ever-present favourites, including Anjelica Huston, Pat Cleveland (see page 312) and Elsa Peretti, became known as 'the Halstonettes'.

Halston's most famous design was the shirtwaist dress, inspired by a man's long-sleeved shirt. It was made using a synthetic mix of polyester and polyurethane – Ultrasuede. He saw the fabric for the first time in 1971, worn by the Japanese designer Issey Miyake (see page 338). Halston boasted that his Ultrasuede dresses could be washed in a machine. About 50,000 of those dresses were sold, and Ultrasuede for many years became a fashion staple.

In 1973 Halston was included in a presentation of leading American and French designers in Versailles. Halston was a huge hit, his luxurious simplicity receiving a standing ovation from the audience and his peers alike, Yves Saint Laurent included. His popularity in the 1970s made him a celebrity, and, most famously, he was a fixture among the Studio 54 set (see page 302). Bianca Jagger (opposite, see also page 222) and Liza Minnelli, Elizabeth Taylor (see page 132) and Martha Graham (see page 92) were friends and clients.

In 1978 Halston moved his salon to the 21st floor of the Olympic Tower, New York. With the spires of St Patrick's Cathedral towering behind his desk and a red carpet woven with double Hs, it was a setting fit for a superstar.

For both the fashion insider and the casual observer, Halston evokes visions of languid luxury. He dominated and defined an era: the sexy 1970s. He draped them in lamé, wrapped them in cashmere, enveloped them in jersey, decorated them with Elsa Peretti jewellery and upholstered them in Ultrasuede.

VIVIENNE WESTWOOD

Leading the charge of a disenchanted generation

Vivienne Westwood first became a fashion designer in the 1970s. She had been a primary school teacher until she met Malcolm McLaren, who, as manager of the Sex Pistols, became the most notorious man in London. As McLaren came up with ideas, Vivienne turned them into clothes.

The punk 'style in revolt' was a deliberately 'revolting style' that incorporated into fashion various offensive or threatening things, such as tampons, razor blades and lavatory chains. It was a cultural correction – a necessary reset that continues to inspire great music, art and fashion to this day. John Lydon of the Sex Pistols remembered: 'Early '70s Britain was a very depressing place: run-down, trash on the streets, total unemployment – everybody was on strike. The education system told you that if you came from the wrong side of the tracks…then you had no hope in hell.'

Westwood's confrontational dressing captured the essence of punk. Clothes became a subversive weapon for kids who were never going to drink cocktails on Sunset Boulevard. The guy on the bus in an 'Anarchy in the UK' T-shirt had impact. Punk happened on the street, not in the pages of a magazine. Kids refused to be beguiled by glossy images and hand-outs of style and culture.

Westwood and McLaren turned their 1950s-revival shop Let It Rock into one of the most notorious fetish shops in history. It became Sex in 1975, announcing itself in 1.2m- (4ft-) tall hot-pink foam letters mounted directly on the graffiti-covered storefront. It sold 'rubber for the street, rubber for the office'.

Westwood called her work 'clothes for heroes'. And at the time, you had to be pretty brave to wear them. Punks made a spectacle of themselves on the street, a show of force inciting opposition. But the irony of bondage was mostly lost on the authorities. The designer felt an affinity with Coco Chanel. 'Chanel probably designed for the same reasons I do: irritation with orthodox ways of thinking. She was a street fashion designer.'

Punk put London back on the fashion map for the first time since its swinging days in 1965.

Vivienne Westwood and Malcolm McLaren, pioneers of Brit punk.

ZANDRA RHODES

Bond Street and Madison Avenue anarchist

Zandra Rhodes (1940–) had an impeccable fashion pedigree. Her mother had been *première d'atelier* (head of the workroom) at the House of Worth in Paris, and after she returned to England she taught fashion at one of the country's leading colleges. Zandra's passion was textiles. She branched into fashion only because she had to show the wary market how her fabrics could be used. 'The patterns were considered too extreme, so I had to think how to win people around,' she recalls.

For Rhodes, silhouette was always going to play a supporting role to the virtuosity of the fabric and her head-turning use of colour. In 1970 she created her felt 'Dinosaur coat', with seams pinked and turned inside out, and in 1971 she created her first 'ripped' dress. It was toward the end of the decade, however, that she really came into her own.

This was a tumultuous time in Britain. In 1977, the year of the Queen's Silver Jubilee, royalist London jostled with punk London. The country was in an economic crisis and disaffected youth expressed their rage and frustration in music and fashion. Rhodes presented a 'punk' collection: a glamorization of the punk look with ripped and zipped evening dresses, complete with jewelled safety pins. With the collection, she became an instant fashion star in both America and the UK.

Overnight, Rhodes became the doyenne of British haute punk. The controversial creativity of punk provided rich pickings and quickly became a catwalk commodity that inspired the French avant-garde designers in Paris, too. Vivienne Westwood berated the Europeans for ripping off her ideas, but commented, 'I didn't mind Zandra copying punk rock because she did it in her own way.'

Rhodes once remarked that she didn't see why holes in cloths should be so inherently frightening. Didn't lace have holes, too?

Rhodes' work has always appealed to 'alternative thinkers', and, like Elsa Schiaparelli, she consolidated the link between fashion and art. But this was far from street fashion. In Rhodes' version of punk, the ripped garments were carefully pinned together with 18-carat-gold safety pins from Cartier.

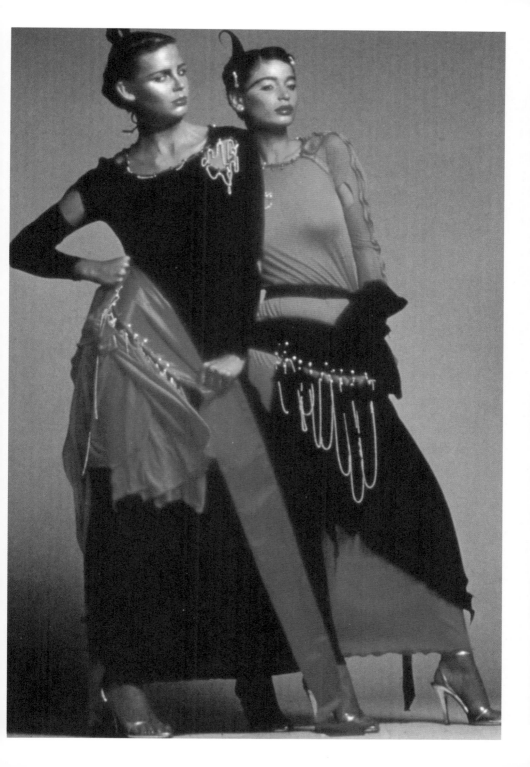

STUDIO 54

The biggest party ever thrown

1977

Founded by Steve Rubell and Ian Schrager in 1977, Studio 54 was an enormous discotheque which, during its heyday, was packed with thousands of people. The crowd included the rich and famous as well as the unknown but interesting, and embodied the glamorous decadence of the time. Drugs and sex of seemingly endless quantities and varieties were easily available.

Teams of architects, theatrical lighting impresarios, set designers and florists were employed to convert what had been an abandoned theatre into an ever-changing playground. Special 'one night only' performances by the hottest musical acts were regularly scheduled. Studio 54 took the nightclub scene by storm and was an instant, headline-grabbing success.

There was no VIP room. Everyone shared the same dance floor and banquette – if you could get in, that is. The club was notorious for its door policy. Rubell carefully selected the perfect mix of people to enter. On any night you might find Yves Saint Laurent catching up with Halston; Michael Jackson hanging out with Liza Minnelli and Liz Taylor; Mick and Bianca Jagger (see opposite), Jerry Hall, Diana Vreeland, Farrah Fawcett-Majors, Truman Capote, Elton John, John Travolta, Margaux Hemingway, Mikhail Baryshnikov, Grace Jones, Salvador Dalí, Brooke Shields, Donald Trump, Francesco Scavullo, Joan Collins, Cher, Martha Graham and Debbie Harry.

Andy Warhol said that Studio 54 was 'a dictatorship at the door and a democracy inside'. Once in, you were a star. Rubell and Schrager gave event planner Robert Isabell his first break with the planning of a memorable New Year's Eve party. Isabell had four tons of glitter dumped in a 10cm (4in) layer on the dance floor. Schrager described it as like 'standing on stardust'.

Even when the club was shut down by the police for want of a liquor licence, it stayed open selling fruit juice, and queues still wound around the block.

In 1977, '54' grossed an estimated $7 million. It was as famous for sex and drugs as for the phenomenal light-and-sound show. In 1978, after Rubell publicly bragged about the club's profits, armed federal agents raided the premises. The party was well and truly over.

KATE BUSH

Music's first high priestess of the New Age

Kate Bush (1958–), queen of the concept album, is a cult pop star in the truest sense of the term. Her first single, 'Wuthering Heights' (1978), inspired by the mid-19th-century Emily Brontë novel, was the song that launched her career. Since then her songs have gradually evolved into lengthy set-pieces full of drama and atmosphere.

Bush's arrival on the music scene coincided with the arrival of punk, and with her wild hair and New Age ideas she seemed every bit as anarchic. No one before her had engaged fans quite so earnestly in debates about astrology, reincarnation, UFOs and synchronicity.

While punk expressed headbanging rage, Bush struggled to make the connection between her music, imagery and ideas. She came from a classical background with training in dance and mime. She described her costumes and makeup as masks to hide behind. 'I don't want to be up there on the stage being me,' she told *Musician* magazine. 'I don't think I'm that interesting. What I want to do is to be the person that's in the song.'

Kate Bush is probably most famous for the white-robed ghost of Cathy in the promotional video made for her 1978 hit single, 'Wuthering Heights', which mesmerized the British public for the four gloomy January weeks that it held its number-one spot. Performing in a Victorian nightgown, the 'White Dress' Cathy video was mostly responsible for promoting the image of 'Bush the ethereal hippy'. But even in her spandex and batwing years, she has often appeared as much medium as message, channelling spirits that seem slightly beyond her control.

In 1979 Kate Bush undertook her first tour. Her innovative musical style was matched by an on stage persona that was by turns dreamily romantic and sexually provocative.

MARGAUX HEMINGWAY

The face of a generation

1978

Standing at 1.8m (6ft) in her bare feet – 'five foot twelve', she would often quip – Margaux Hemingway (1954–96), granddaughter of the writer Ernest Hemingway, rolled into New York as a 19-year-old graduate from Idaho on an internship with a local PR company. While she was having tea at her hotel, she was spotted by Errol Wetson, a hamburger-chain heir – 'He knocked on the door of my suite with a rose and a bottle of champagne,' she said, 'and I fell in love.'

Wetson became her Svengali, advising her what to wear and taking her to the right parties. With her sporty, outdoor looks and those caterpillar eyebrows, she became an instant succes – and overnight tweezers became a thing of the past. Within a year, Hemingway was on the covers of *Vogue* and *Time* magazine. On 16 June 1975, the cover of *Time* dubbed her one of the 'new beauties', while the September issue of American *Vogue* christened Hemingway as 'New York's New Supermodel'. In the same year, Joe Eula, the fashion illustrator at the epicentre of the Halston set, called her 'the face of a generation'.

Hemingway's meteoric rise to fame peaked when she became the spokesmodel for Fabergé's Babe perfume and landed the first ever million-dollar deal. She became a Studio 54 regular (see page 302), carousing alongside celebrities such as Liza Minnelli, Halston, Bianca Jagger, Andy Warhol and Grace Jones.

Hemingway's looks were so distinctive that when she went to a club she could be sure of instant access to VIP circles. 'I don't need any I.D.,' she joked, 'I have my eyebrows.' Her incandescence started to fade when she made her film debut in the 1976 drama *Lipstick* alongside her then 14-year-old sister, Mariel. Margaux's performance was panned. Mariel, though, got a Golden Globe nomination for 'Best Newcomer' that year and went on to star in Woody Allen's *Manhattan* (1979).

Hemingway, granddaughter of Ernest Hemingway, changed the spelling of her name from the usual Margot to Margaux, in honour of the wine alleged to have inspired her conception.

STEVIE NICKS

Rock's eccentrically dressed bohemian goddess

It is impossible to talk about 1970s fashion without bringing up that eccentrically dressed bohemian goddess, Stevie Nicks (1948–). With her shaggy blonde hair, top hats, draped jackets and slouchy boots, Stevie is the quintessential 1970s style icon to whom anyone in need of a little hippie inspiration turns.

The look came about as a disguise. 'My stage fright was and is terrible,' she says. 'So adding pressure with clothes was ridiculous. I didn't want to think about it. So I designed my little uniform. I knew from the beginning that I wanted to be famous when I was 70 and realized that being terribly sexy couldn't last.'

Her brief to Margi Kent, who still designs much of her wardrobe, was to create 'something urchin-like out of *Great Expectations* or *A Tale of Two Cities*', a chiffon-like, raggedy skirt that would still look beautiful with black velvet platform boots. 'We came up with the outfit: a Jantzen leotard, a little chiffon wrap blouse, a couple of little short jackets, two skirts and boots.' And, of course, the shawl, which is an essential part of her concert uniform. 'A shawl is a great prop,' says the star, who is just 1.55m (5ft 1in). 'It makes for big gestures. If you want to be seen at the back of that arena, you have to have very big movements.'

In their 2001 Fall collections, Anna Sui, Betsey Johnson and Oscar de la Renta seemed to invoke Nicks' look with bohemian skirts and ruffled shirts. And in 2010, once again, she was a key catwalk inspiration.

The fairy godmother of the gypsy romantic look, Stevie Nicks has inspired generations of fans to drape themselves in chiffon and velvet and add feathers to their accessory kit. She has become a reluctant fashion icon, responsible for keeping up sales of vintage white lace over three decades.

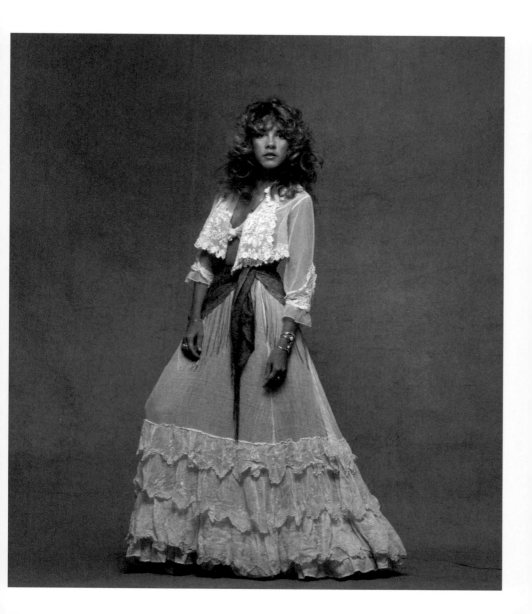

DISCO

A decade's energy let loose on the dance floor

Disco was born in 1970 with the opening of a club called The Loft in New York City, and pretty much died in 1980 with the proliferation of suburban clubs where dancing baby-boomers copied moves and looks from the 1977 film *Saturday Night Fever*. For the first eight years, however, disco was an underground movement that emerged from African-American and gay clubs in New York City. Legendary clubs such as Studio 54 (see page 302) became the definition of 1970s glamour, with a nightly VIP crowd that included Michael Jackson, Andy Warhol, Bianca Jagger (see page 222), Liza Minnelli and the designer Halston (see page 296).

Being at a disco was like being on stage. The greatest dancers wore what got them noticed. A shiny satin shirt or second-skin bodysuit and sequin jacket were staples of the disco wardrobe – your clothes could not be outshone by the glitter on those dance-floor mirror balls. Lycra leggings in hot colours and skintight stretch jeans were staples of the unisex wardrobe, and were often adapted from the kit of professional modern dancers. Gold lamé, leopardskin and white fabrics that glowed under the ultraviolet light were perfect for posing.

The liberation movement made it a woman's prerogative to wear whatever she felt like on any particular day. In disco the sexual liberation pioneered in the 1960s was embraced, but dressed up as a glamorous urban version in halterneck tops, sequin bandeau tops and stretch-satin catsuits.

The storyline of *Saturday Night Fever* sums up disco's seductive power for the man (or woman) in the street – Tony, the working-class Italian-American who was a hardware salesman by day and a disco king by night, was not the only one who seized the glamorous way out of the tedious daily grind. Thanks to disco, clubs got dress codes and door screening policies. Suddenly, you had to look the part to gain entry to that one night of paradise.

Disco had its detractors, of course. Punk scorned it, equating it with the cabaret culture of Weimar Germany for its ignorance of social ills and its escapism.

With her big hair, false eyelashes, plunging neck-lines, gold lamé and second-skin sequined dresses, Donna Summer was the undisputed 'Queen of Disco'. Her gospel-trained voice was a driving force of the sound, with hits such as 'Love to Love You Baby' (1975), 'I Feel Love' (1977) and 'Last Dance' (1978).

PAT CLEVELAND
Catwalk queen of the disco era

Before the term supermodel ever graced a headline, Pat Cleveland (1950–) was a pioneering beauty, and she is now considered one of fashion's first black 'supermodels'. She was the catwalk queen of the disco era. The black-Cherokee-Irish stunner took Paris and the world by storm with a runway walk that was like no other. Whether working for Halston (see page 296) or Yves Saint Laurent (see page 288), she owned the catwalk, twirling and dancing and leaving her audience speechless.

Pat was discovered in 1967 by Carrie Donovan, who was then a fashion editor at American *Vogue*. The 14-year-old student at Manhattan's LaGuardia High School of Performing Arts had a rocky start, but went on to become every designer's runway dream. Back then, black models were not considered as assets in the mainstream fashion industry, and successful models specialized in either print work for magazines or the runway – rarely both. Pat was a mainstream black model who excelled on the catwalk *and* the magazine covers.

Cleveland moved to Paris in 1971, and got a career-defining break in the winter of 1973. To celebrate the restoration of Louis XIV's opulent chateau of Versailles, a small coterie of American designers (Bill Blass, Stephen Burrows, Anne Klein, Halston and Oscar de la Renta) took part in a fashion gala opposite France's undisputed kings of fashion (Hubert de Givenchy, Yves Saint Laurent, Emanuel Ungaro and Pierre Cardin). The Americans' minimalist staging and cast of black models, including Billie Blair, Norma Jean Darden, Bethann Hardison and, of course, Pat Cleveland, made the baroque French presentation look instantly dated. The event became known as the 'Battle of Versailles' and the Americans emerged triumphant. Cleveland became a star.

One of the original 'Halstonettes', Cleveland held court through the 1970s at Studio 54, where she served as muse for Andy Warhol. But she was also the consummate professional, becoming an inspiration for Thierry Mugler, Paco Rabanne, Yves Saint Laurent, Karl Lagerfeld and Franco Moschino.

1980s

In Britain in 1981, the wedding of Lady Diana Spencer and Charles, Prince of Wales, and in America that same year, the arrival of Ronald and Nancy Reagan in the White House were the catalysts for fashion to pursue luxury and romance. It would be the decade of power dressing, but also the decade of subversion. The triumph of greed in the boardroom would be countered by a riotous energy in the streets.

In terms of fashion, if the 1960s belonged to London and the 1970s to New York, Paris seemed determined to claim the 1980s. It was a creative free-for-all. The catwalks reflected the exuberance of a time when everything was entirely possible and there were no creative restraints. The arrival of the Japanese, however, offered a more cerebral alternative to the glamorous French, sexy Italians and subversive British.

Shows took place in vast tents, not salons, and were no longer the reserve of the industry insider. They were events that were mobbed by fans and hangers-on, and people fought for a place among the audience. The Dé d'or (Golden Thimble) or French 'Fashion Oscars' were broadcast from the Palais Garnier. The new wave achieved equal footing with old-style couture.

The unpalatable reality of this new-found success was that it forced designers to learn to be businessmen and -women. Between the creativity and carousing there were fortunes to be made. The fashion world lost its nonchalance and became increasingly commercial. Fashion had become big business.

Some of the big names in 1980s' British fashion assemble to promote Fashion Aid, including David and Elizabeth Emanuel, Scott Crolla, Jerry Hall, Katharine Hamnett, Bruce Oldfield and Jasper Conran. It is an image that captures something of the eclecticism and exuberant brashness of the decade.

DALLAS AND *DYNASTY*

Never knowingly under-accessorized

The soap operas *Dallas* and *Dynasty* were the must-see television of the 1980s. Throughout the decade they jockeyed for position in a ratings war that attracted global audiences of more than 250 million. They tuned in for the bitchy asides ('Take your blonde tramp and get out of my house!' – Alexis Colby, played by Joan Collins); they tuned in for the catfights (Alexis versus Krystle (Linda Evans) in *Dynasty* and Sue Ellen (Linda Grey) versus Pamela (Victoria Principal in *Dallas*); but mostly they tuned in for the hairdos and clothes.

Even though Sue Ellen Ewing ran her own fashion line in *Dallas*, *Dynasty* had the undoubted fashion edge. The costume designer Nolan Miller was inundated with letters and calls inquiring about the *Dynasty* stars' wardrobes. Linda Evans's broad shoulders and Nolan Miller's designer vision evolved into the wasp-waisted power suit of the 1980s. Embellishments such as lace, brocade, fur and jewels accentuated the angular shape of the shoulder-padded silhouette.

The *Dynasty* women were never knowingly under-accessorized. Liberal helpings of statement costume jewellery were worn day and night by the show's female stars and drifted into mainstream fashion. Big gilt fashion earrings, several centimetres across, drew attention to faces bobbing above shoulder pads and under waves of moussed and lacquered hair. Evening wear was Miller's forte. Column gowns with intricate details played to the characters' archetypes: Krystle typically wore an understated palette of whites, creams and beiges; Alexis, on the other hand, favoured scarlets and blacks.

Miller's *Dynasty* collection was launched in New York's Bloomingdale's in 1984. The surge of 20,000 covetous fans forced management to temporarily close the doors. Miller attributed the success of the line to the characters' undeniable élan. 'I don't think any other show has ever concentrated…on the look.'

Dallas (below) and *Dynasty* (opposite) were set in an era when the *ne plus ultra* was to be rich, resplendent in shoulder pads worthy of a linebacker and blessed with a head of hair that could be whipped up to gravity-defying heights.

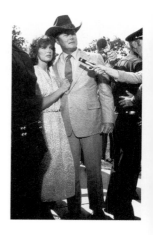

DONNA KARAN

Woman-friendly fashion

Donna Karan (1948–) built her fashion concept around the idea of a man's wardrobe – tops and bottoms rather than outfits. Women fell in love with the Karan staples: her iconic seven easy pieces. Her capsule wardrobe was made up of a slim dress, a wrap skirt, a white shirt, a cashmere sweater, easy-cut trousers, a sharp-shouldered jacket and, of course, the bodysuit – a fitted base layer with pop fasteners at the crotch so that it never came untucked or looked messy. The 'Body' became perhaps the decade's single most copied item of clothing.

Karan's fuss-free approach put her firmly in the fashion family of Alaïa, Zoran and Claire McCardell. She offered uncomplicated, sexy wearability – clothes that would 'travel, interchange and impress'. With the addition of her sculptural jewellery, designed by Robert Lee Morris of Artwear, a few Donna Karan pieces could take her customer from work to play – the concept of day-to-evening dressing was born here.

Donna Karan's designs were slimming and flattering. Her gathered skirts hid the tummy while her wedge-shaped dresses made women look taller. And women swore by her hosiery. Fortified by Lycra, Karan's tights were a breakthrough that made women's legs look longer and slimmer, and every hosiery manufacturer rushed to copy them. In 1989 Karan spawned another winner with the DKNY line, which became a $100–$1 million business in its first year.

'I design from my guts,' said Karen, describing her no-brainer approach. 'Before every season I open up my closet and see what's missing. Then I design what I want to wear.'

Donna Karan (with the designer Louis Dell'Olio) in 1980. The Donna Karan woman could afford to wear the designer creations of Bill Blass or Oscar de la Renta, but high-powered baby-boomers wanted a designer from their own generation.

GRACE JONES AND JEAN-PAUL GOUDE

The image makers

In the early 1970s, along with Jerry Hall (see page 274), Iman and Pat Cleveland (see page 312), Grace Jones (1948–) ruled over the glamorous dominions of the New York club scene and Paris catwalks. With her fine features (you could lacerate yourself on those cheeks, affectionately known in the industry as the 'Jones Bones') and athletic body, she rapidly became fashion's most sought-after black model. She began singing in 1977, subsequently signing with Island Records, where initially her contribution to popular music amounted to not much more than a series of dance tracks, played mainly in gay discos. Then she met the art director Jean-Paul Goude (1940–).

Together, Goude and Jones worked on hundreds of portraits of Grace, playing with her proportions and her sexuality in a variety of colourful and subversive images that usually involved montage or photorealist techniques. The result was the reinvention of Grace as 'the first black new wave artist'. They amped up her startling attributes: adding wide-shouldered men's Armani jackets, developing a robotic way of dancing and capitalizing on that raspy drawl. One of the most startling things about the reimagined Grace was her magnificent flat top (which had begun life on Goude's drawing board) – a haircut of head-turning geometric uniqueness.

Grace Jones in a 'Constructivist' maternity dress designed in collaboration with the fashion illustrator Antonio Lopez. Together, Jones, Goude and Lopez created one of the most powerful pop presences of the decade.

PRADA BLACK NYLON BAG

The first 'IT' bag

1980

Prada had begun life in Fratelli Prada, a shop in the fashionable Galleria Vittorio Emanuele in Milan selling Italian leather goods and imported English steamer trunks. Miuccia Prada (1949–), with a doctorate in political science and a passion for women's rights, was an unlikely choice to run a luggage shop. Nevertheless, in 1978 she took over the family business from her mother.

Her business partner was her new husband, Patrizio Bertelli, who took care of the business while she set about reinventing the product. They had entirely different but complementary skills. But both Miuccia and Patrizio were in agreement about one important thing: to market Prada using its *lack* of prestigious appeal, capitalizing on 'anti-status' and 'reverse snobbery'. The timing positioned the brand in the vanguard of a burgeoning cynicism about conspicuous consumption. The couple's talent for being tantalizingly ahead of the zeitgeist was to become one of the industry definers of the next 20 years. Together they would transform the family firm into a global powerhouse.

It made sense for a purveyor of luggage to bring out an accessories range first. From early versions developed at the beginning of the decade, the chicly understated but eminently practical bags became a cult hit among fashion insiders: the models and photographers who commuted between Milan, Paris, London and New York. They were made out of utilitarian black nylon: at first, the heavy-duty stuff that Miuccia's grandfather had used for the protective covers of his steamer trunks, and later, a more practical nylon twill that was developed specially for the purpose.

It would take only four years for Prada to have enough of a war chest to launch a ready-to-wear collection (see page 462), the clothing reflecting the same knack for classic understatement as the accessories.

The power of understatement in the decade of excess – the Prada black nylon bag.

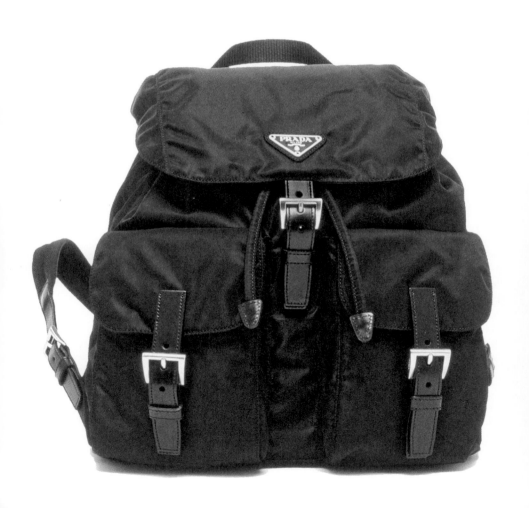

RALPH LAUREN
A world of luxury

Once a shadowy figure behind the label, the 1980s saw 'the designer' emerging to make videos and in-store appearances, to take top table at charity galas and, of course, to feature in their own advertising campaigns. First among these was Ralph Lauren (born Ralph Lifshitz in 1939). In 1981 a seven-spread advertisement in British *Vogue,* introducing the Polo store in London's Bond Street, opened with a full-page picture of the billionaire designer himself, clad in his signature denims and cowboy belt.

Lauren's philosophy, however, was not so much about self-aggrandizement as his innate understanding that modern fashion was about inclusion – about belonging to a world or lifestyle that felt good, looked good and, above all, was accessible. Like the American Dream, fashion had to appear available to all, regardless of the economic reality in which people lived. Lauren also passionately believed in the marketable appeal of American style. 'The American sensibility has become a very important international sensibility,' he said. 'We created sportswear. Ours is a more modern culture because of the way we live. We travel, we're athletic, we move.'

In 1986 Ralph Lauren opened his New York flagship store in the elegant Rhinelander Mansion on Madison Avenue, creating retail's most sumptuous *mise-en-scène*. With Cole Porter tunes drifting through the air, it was easy to get carried away – as millions of Americans and tourists did, trooping home with armloads of Polo shopping bags.

Ralph Lauren discussing fashion direction with fitting model Lynn Yeager, at his Seventh Avenue studio in Manhattan in 1980. Lauren's clothes epitomized the American Dream – aspirational and accessible.

BRIDESHEAD REVISITED

Small-screen chic

Arguably, the television hit of the decade was an extravagantly stylish series of 11 episodes that cost a splashy £11 million, was previewed in all the fashion magazines and, in television terms, has remained unrivalled for both viewing figures and fashion influence, until the arrival of *Downton Abbey* in 2010. *Brideshead Revisited*, an epic adaptation of Evelyn Waugh's 1945 novel about the decline and fall of an English aristocratic family in the 1920s and 1930s, starred Jeremy Irons as Charles Ryder, Anthony Andrews as Sebastian Flyte (along with Aloysius the bear), Diana Quick as Julia Flyte, Claire Bloom as Lady Marchmain and Sir Laurence Olivier as Lord Marchmain. The series also featured the city of Oxford as itself and Castle Howard in Yorkshire as Brideshead, the Marchmain family seat.

The clothes were as articulate as the script in portraying the nuances of a socially stratified time. Costume designer Jane Robinson skilfully managed to portray Flyte's social dexterity and Ryder's awkwardness by choosing impeccably tailored suits for the one and rather less stylish jackets and trousers for the other. Ryder's wardrobe, of course, evolves as he absorbs some of the sartorial smoothness of his aristocratic friend; by the time they reach Venice, in the second episode, he is wearing his cream linen suits and tying his silk ascots with impressive ease. Diana Quick's wardrobe inspired summers of dropped waists, cloche hats and fringed Oriental shawls wherever the series was broadcast.

Waugh was aware of the visual drama of the book: 'I am writing a very beautiful book, to bring tears, about very rich, beautiful people, who live in palaces and have no troubles except what they make themselves...'

The *Brideshead* look unleashed a wave of nostalgic fashions, from drop-waisted flapper dresses and shawls to knitted tank tops and impeccable linen suits.

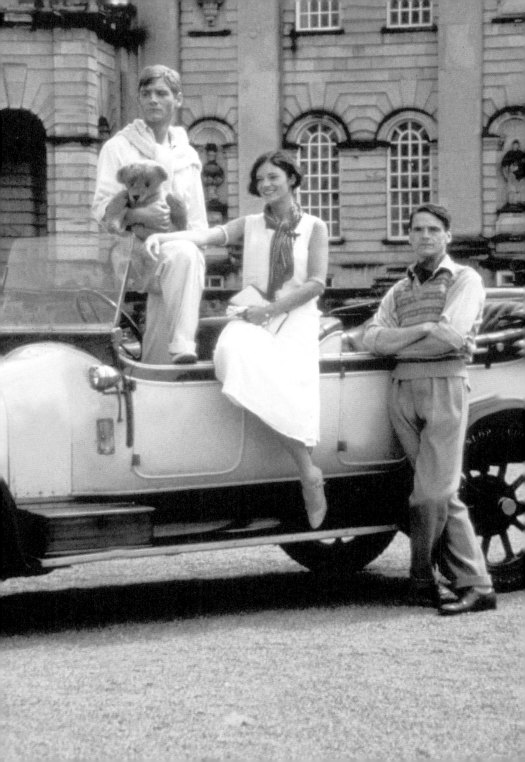

NANCY REAGAN
First Lady in red

In 1981 *Newsweek* ran a story with the headline 'Mrs. Reagan's Free Clothes', in which it was alleged that Nancy Reagan had accepted an unspecified number of gowns, jewels and gifts from top designers. By December that year a poll conducted for the same publication found that 62 per cent of the American public thought Nancy Reagan (1921–2016) put 'too much emphasis on style'. If it seemed unfair that Mrs Reagan was criticized for the very qualities that had been deemed admirable in Mrs Kennedy, it is worth remembering that the country was in recession and that central to Reaganomics were savage Federal budget cuts.

'Queen Nancy', as she was dubbed, was the poster girl of the charity ball set – for whom ostentation was the oxygen of social success. By the early 1980s the Arab ladies who had lined the pockets of couturiers in the 1970s had been joined on their shopping trips by the Americans. The Reagan-era 'ladies who lunched' – women such as Ivana Trump, Nan Kempner, Ann Getty, Pat Buckley and Lynn Wyatt – all headed to the Paris couture shows by Concorde, were known never to wear the same outfit twice, and happily blew $100,000 or more on a couture wardrobe in a single trip.

In her couture gowns from favourite designers Oscar de la Renta, Galanos, Adolfo and Bill Blass, Nancy Reagan presided over a set of world-class partygoers and -givers. Her white, hand-beaded, one-shoulder Galanos gown, worn for her husband's inauguration, was estimated to cost $10,000, while the overall price of her inaugural wardrobe was said to cost $25,000.

The official portrait from 1981. Nancy Reagan had a preference for red, which she called her 'picker-upper', and wore it until it became her style signature. In fact, Nancy's wardrobe included red so often that the fire-engine shade even became known as 'Reagan red'.

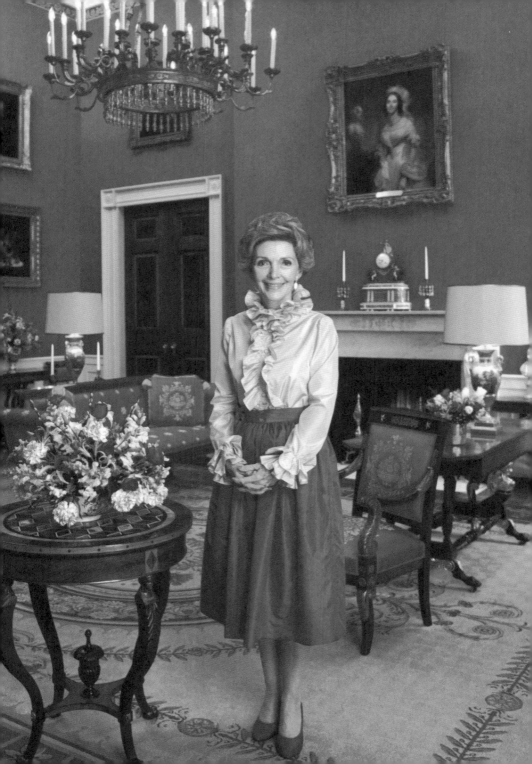

VIVIENNE WESTWOOD, 'PIRATES'

Dressing up punk

The cusp of the 1980s marked a turning point for Vivienne Westwood (1941–) as she switched her focus from the street to the salon and began her campaign to revolutionize fashion. The 'Pirates' collection of Autumn/Winter 1981–2 created a romantic unisex landscape inhabited by buccaneers and dandies. She changed the name and ambience of her King's Road boutique to match, transforming its interior into the cabin of an ocean-roving galleon and rechristening it 'Worlds End'.

After separating from Malcolm McLaren (see page 298) in 1983, Westwood began to build on a style of startling originality, often based on contemporary reworkings of traditional garments. Her 'Mini-Crini' collection of Spring/Summer 1985 was an impertinent reinterpretation of demure Victoriana. The corseted cut of her suits and shirts thrust the bust forward (spilling over 'like milk jellies', she said), nipped in the waist and arched the back and hips. High waists and shoulders free of padding reintroduced Regency swagger. Her 'Harris Tweed' collection of Autumn/Winter 1987–8 dusted off the wardrobe staples of the 17th century.

Westwood inspired respect and astonishment in equal measures. Audiences were dazzled as much by her technical skill as by her creative excess. Her goal was no less than a cultural revolution: 'It is an artist's job to wreak violence on a culture to give it new life … My aim is to make the poor look rich and the rich look poor.' She was unique among designers as someone who consistently justified what she did in broad cultural terms.

Model Lizzie Tear wearing the 'Pirates' look outside Westwood's Worlds End store. The plundering of the dressing-up box of historical fashion styles was to be the hallmark of the designer through the decade and beyond.

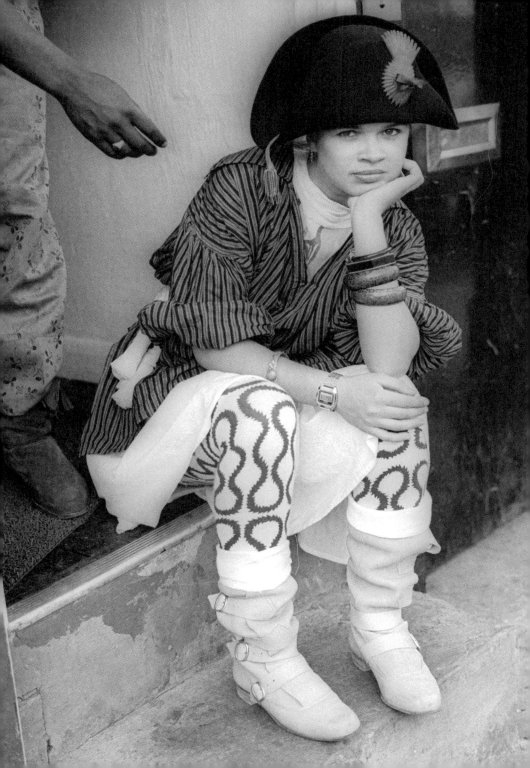

THE STYLE PRESS

New fashion bibles

There was a time when fashion was for those who could afford it and fashion magazines were symbols of wealth and unaffordable taste. Punk brought fashion down from the catwalk and onto the streets, taking the establishment by surprise. And it spawned a shelfful of magazines so caught up in the minutiae and evolution of every new trend that they were more than mere style magazines – they were style bibles.

Blitz magazine (published 1980–91) enabled stylists such as Kim Bowen and Iain R Webb, flamboyant regulars at its namesake club, to express themselves on paper. Nick Logan's magazine *The Face* (1980–2004) led the field with radical art direction and innovative fonts by designer Neville Brody. Terry Jones's *i-D* (1980–) was originally a stapled fanzine, but evolved into a style magazine with a radical agenda. It featured the opinions of 'ordinary' young people – their taste in music and fashion and their political opinions.

Street fashion was at the heart of all of these magazines. A flagging economy and rising unemployment were the backdrops for a burgeoning music and media industry. As a form of self-expression, street fashion thrived in the clubs and art colleges of Britain. And the style press gave it a voice.

A cover from an early edition of *The Face* showing the New Romantic pop trio the Human League. *The Face* was part of a new wave in magazine publishing that helped bring 'image' into the mainstream.

THE
FACE

NUMBER 17 SEPTEMBER 1981 65p
EIRE 91p (inc. VAT)

HUMAN LEAGUE

PHOTO: JILL FURMANOVSKY

IAN DURY
SLY & ROBBIE
CABARET VOLTAIRE
OK JIVE
JAH WOBBLE

VISIONS OF THE VIDEO AGE: Special Report
TATTOOS: The Mark of the Outsider?
STYLE: The Beat Goes On/History of the Zoot Suit

BRUCE WEBER

Fashion's all-American

It was Bruce Weber (1946–) who provided one of the most influential and controversial contributions to fashion photography, through his portfolios for *Vogue* and advertising campaigns that helped make commercial giants of the American brands Ralph Lauren (see page 324) and Calvin Klein (see page 444). He carved a niche for himself as cheerleader for the All-American fashion story. The defining theme, in all of his work, is the freckle-faced spirit of hearty outdoor leisure and simple romance. Weber was the supreme creator of fantasy at a time when fashion's obsession with the impeccably art-directed lifestyle was gathering momentum.

Typically, Weber would take a group of friends and stars to a remote spot on the map and photograph them over the course of a few days, producing pictures that had the intimacy and reality of a family album. Weber's subjects never really looked posed. They were often shot leaping off wooden docks into gleaming Adirondack lakes or engaged in wholesome pursuits such as lacrosse, soccer or surfing. He sought not so much to sell clothes as to project an image and a personality. The clothes were often secondary to the portraits and often at the mercy of the casual treatment meted out to them by the models.

Weber's Calvin Klein advertisements were hugely influential in the fashion industry but also highly controversial. The value of his work was often hotly debated or, as was frequently the case in the 1980s, decried – much along the same lines as the homoerotic photographs of Robert Mapplethorpe (1946–89).

The Olympic pole vaulter Tom Hintnaus appears on an enormous billboard in New York City's Times Square wearing nothing but his bikini brief. Bruce Weber's work for Calvin Klein, with its unabashed celebration (and commercialization) of the male body, was a startling innovation at the time.

Calvin Klein Underwear

Portable Component System.

JVC

BROADWAY

ONE WAY

QUALITY

GIORGIO ARMANI
Italian ease

In 1975 Giorgio Armani (1934–) opened his fashion house with a radically chic look – the unconstructed suit, which blurred the distinction between business and casual, and was made from supple materials that draped and rumpled gracefully. Then, in 1980, in the movie *American Gigolo*, Richard Gere was a walking Armani fashion show, putting the designer on the Hollywood fashion radar and soon making him one of the world's bestselling designers.

From Wall Street to West Hollywood, men of all pinstripes got into the Armani habit. The designer – who had spent an impoverished childhood in postwar Piacenza in northern Italy, started his career as a window dresser at La Rinascente department store in Milan, and found the money to start his company only by selling his Volkswagen Beetle – cast the same spell over a new generation of executive women who were unimpressed with the fussy figure-compressing haute couture coming out of Paris. Armani's soft, comfortable tailoring was a runaway hit in the feminist age.

The centrepiece of Armani's celebrity strategy was the Academy Awards, the biggest photo opportunity of the year. After Armani opened his Beverly Hills boutique in 1988, he single-mindedly set out to become the designer of choice on Oscar Night, and he succeeded. By 1991 *WWD* (*Women's Wear Daily*) was calling the Oscars 'The Armani Awards': the designer would forever be remembered as the first to sweep the Oscars without taking home a single trophy.

Giorgio Armani and models. For men and women alike, the Armani suit became the pinnacle of power dressing. Rosita Missoni told *Women's Wear Daily*, 'Armani put women in men's clothes. He is a genius.'

ISSEY MIYAKE
East greets West

Issey Miyake (1938–) was a survivor of the atomic bomb in Hiroshima. He studied graphic design at the Tama Art University in Tokyo, before moving to Europe to serve apprenticeships with couturiers Guy Laroche and Hubert de Givenchy (see page 54). He followed with a stint at the right hand of Geoffrey Beene in New York (see page 294). In 1973 Miyake showed his first collection in Paris and, along with Kenzo Takada (see page 248), blazed a trail for the later arrival of other Japanese designers such as Yohji Yamamoto, Mitsuhiro Matsuda and Rei Kawakubo (see page 348). Collectively, they exerted a seismic influence on the avant-garde aesthetic of the 1980s.

While Kenzo worked in the European fashion vernacular, Miyake offered the East to the West in a singularly undiluted form. He maintained a base in Japan and an unmistakably Japanese feel to his clothes. Concentrating on fluidity and texture, he combined these with the professional techniques he had honed in the studios of Laroche, Givenchy and Beene. Miyake allied traditional Eastern styles, materials, colours and skills, such a sashiko quilting, with ultramodern techniques of manufacture, to create loose, comfortable clothes.

Throughout the 1980s Miyake pursued his exploration of new ways of dressing the body, while collaboration with Japanese textile manufacturers enabled him to create uniquely innovative fabrics. In the 1980s he invented a concept that allowed a hot press to pleat a garment permanently after it was cut and sewn. It was a technique that proved so popular that it led to the launch of the Pleats Please label in 1993.

A shot from Miyake's ready-to-wear show, Spring/Summer 1982. The designer's cool colour palette and loose, fluid structures were seen by some as a badly needed corrective to the overstated styles of the 1980s.

NEW ROMANTICS
Perfectly posed pop

On the cusp of the new decade, the phenomenon we now call the 'New Romantics' was born at the Blitz Club, in London's Covent Garden. The establishment closed in 1981 but by then it had already spawned a generation of poseurs who helped define the 1980s. Among the 'Blitz Kids' were Steve Strange, Boy George (see page 384), Stephen Jones, Kim Bowen, Stephen Linard, Fiona Dealey, David Holah, Stevie Stewart, Julia Fodor, Willie Brown, Chris Sullivan, Judith Franklin and Darla Jane Gilroy. They made their first appearance en masse at the Saint Martins School of Art's Alternative Fashion Show, which featured a catwalk appearance by Boy George.

The New Romantics scrambled dress codes so much that at first people had difficulty labelling this brash new youth cult, but 'Peacock Punks' and 'Blitz Kids' were eventually discarded in favour of 'New Romantics'. The age of plunder had arrived and, as period dress became fashionable, Britain experienced a style revolution as past, present and future, sex and gender were all mashed up into one big kaleidoscopic potpourri. This was 'skip' (as in rubbish skip) culture, where something old, something new and something borrowed were all used to create the emperor's new clothes.

Whatever talents Steve Strange and (Boy) George O'Dowd had for courting publicity, they were entirely dependent on their elite corps of sharp-eyed trendsetters to create the clothes that defined their idiosyncratic and ever-mutating identities. Image was all-important, and soon pop stars began to furiously reinvent themselves as everyone did the resurrection shuffle.

The British New Romantic band Duran Duran in the early 1980s. The Blitz Club generation took punk and dressed it up, gave it a 12-inch dance remix and styled its hair.

STATUS DRESSING
Fashion goes bling

As a new age of wealth and conservatism dawned, the love affair of the newly rich with status dressing blossomed. The *grandes maisons* of luxury embarked on a boom that was to last uninterrupted for the next decade. The price of ready-to-wear rose and so did the number of women who lusted after it. Haute couture – the apex of luxury fashion and traditionally the preserve of the aged and uber-wealthy bourgeoisie – attracted a burgeoning clientele of younger women. The average age was between 25 and 35, and almost half were American.

Christian Lacroix at Patou (see page 392), Eric Bergère at Hermès and Karl Lagerfeld at Chanel (see page 388) particularly appealed to this market. Luxurious party frocks that came in at the same price as suburban homes became the badge of wealthy Arab ladies, trophy wives and international socialites. Hermès surfed the wave of status dressing: Grace Kelly twinsets, silk scarves and oversize 'Kelly bags' at £1,000 a time were sell-out items. Ironically, only a few years before, Hermès had struggled to sell a single one of what has now become one of the great iconic handbags.

Designer labels gained a new-found power. Brand names became status symbols to covet and show off, and were applied to goods as varied as sports gear, perfumes, luggage and sunglasses. The new rich, it seemed, did not want so much to consume as to be *seen* to consume.

Conspicuous wealth: model Kelly Emberg leans against a luggage cart at an airport, surrounded by pilots and wearing clothes by Calvin Klein, with a red quilted bag by Chanel, a brown leather shoulder bag by Mark Cross, and pullman bags by Lancel.

COVER QUEENS
Million dollar faces

In terms of tabloid handles, 'Million Dollar Faces' does not have quite the same ring as 'supermodels' but, in 1981 this is what *Life* magazine called a new generation of highly paid models who included Lauren Hutton (see page 260), Iman, Margaux Hemingway (see page 306), Janice Dickinson and Cheryl Tiegs. Glossy magazine covers, swimsuit spreads in *Sports Illustrated*, six-figure cosmetics contracts and the inevitable marriage to a rock star: the potent combination of beauty and fame ensured that this new breed was able to endorse anything from diet drinks to pick-up trucks.

The era of the supermodel may have been in its infancy but these ladies were trailblazers in the land of big bucks. Early in the decade, Inès de la Fressange became the exclusive face of Karl Lagerfeld's Chanel (see page 388). Carol Alt, Kim Alexis and Christie Brinkley were the power triumvirate of print, dominating *Vogue* and *Sports Illustrated* covers throughout the decade.

Gia Carangi (1960–86) was, for a time, the model's model. A favourite of Helmut Newton (see page 264), she could express the haughty exclusivity of couture and yet had enough of the common touch to make her commercially successful, too. Her career spiralled out of control owing to her heroin addiction. Iman (1955–) is another icon of the decade: an example of how to live quietly but still maintain your fame. The Somalian-born model was cited as a muse by designers including Halston (see page 296), Calvin Klein (see page 444) and Yves Saint Laurent (see page 288). She was the queen of the catwalk, a model of mesmerizing elegance.

Such was the power and presence of these women that gradually models started to move in on the glamorous and seductive territory that was the traditional preserve of the movie star. Their success transcended the catwalk and magazine covers. They built careers based not so much on their talent as individuals but on the power of their images.

Portrait of American model Janice Dickinson during a photoshoot for Italian *Vogue*, in 1983.

DIANA, PRINCESS OF WALES

Reinventing royalty

It was Diana, Princess of Wales (1961–97), who set a style of easy, youthful elegance for a new royal generation and became the star of the decade.

Her public debut, her wedding to Prince Charles in 1981, was conducted before a worldwide television audience of 750 million viewers. The silk taffeta wedding dress, designed by David and Elizabeth Emanuel, studded with 10,000 pearls and decorated with Carrickmacross lace, was of such billowing proportions that it made it difficult for Diana's father to accompany her in the glass coach to Westminster Abbey. 'Too much dress; too little princess' was one commentator's withering remark. Nevertheless, it set a benchmark for flamboyantly expensive 'fairy-tale' weddings and started a craze for gowns of meringue-like proportions.

Princess Diana was a perfect heroine for the yuppie decade. She had grown up with ponies and dancing lessons, lived in Chelsea and left her job as a nursery school teacher when she became engaged to the Prince of Wales. Before her wedding, her style was defined by pie-frill-collared blouses, Laura Ashley floral prints (see page 250), country tweeds and the ubiquitous strand of pearls. After her two sons were born, she was transformed into a svelte sophisticate and her every movement was documented. She hung out with rock stars, danced with John Travolta at the White House and wore designer fashion for every public appearance. Before the decade was out she had transformed from 'Shy Di' into '*Dynasty* Di', thanks to the statement-shouldered evening gowns and ladylike suits she favoured from British designers such as Catherine Walker, Victor Edelstein and Bruce Oldfield.

The 'early' Princess of Wales, during a trip to Australia in 1983. Here she wears a sprigged, romantic creation by Jan van Velden. As the decade progressed, she would be seen in increasingly more daring styles.

REI KAWAKUBO

Catwalk radical

Arriving in Paris in 1981, the ridicule and rejection that greeted Rei Kawakubo (1942–) was in inverse proportion to the respect she is afforded today. Her 1982 show, whose aesthetic flew in the face of European sensibilities, was denounced as 'post-apocalyptic'. The fashion press were stunned and delighted in equal measure.

Kawakubo was widely misunderstood. What appeared to be a mission to destroy the codes of Western clothing was, in fact, quite the opposite: Kawakubo set out to analyse and scrutinize the components of fashion, deconstructing them before reconstructing them in more interesting and exciting ways. Her avant-garde approach was influenced by the Japanese tradition of wabi-sabi, a philosophy derived from Zen Buddhism that finds beauty in imperfection and impermanence.

Kawakubo was all about change. For her, modern women no longer needed to submit to men, and the designer had a vision of how they could assert themselves – 'Comme des Garçons'. Out went the geisha of the Japan of her childhood, as did the sexily dressed Western doll. In came the new woman who did not seek to please, who defined her personality and power with clothes that were not for bimbos.

With her unsmiling face, her geometric bob and unyielding authorititiveness, Rei Kawakubo embodied this new woman. She garnered an immediate and dedicated following among artists and intellectuals, who appreciated the loosely cut clothes made from rare materials imported from Japan.

Rei Kawakubo at the opening of her Comme des Garçons shop in New York City's Henri Bendel store in 1983. The designer's deliberately unfinished clothes excited many who were questioning the definition of luxury.

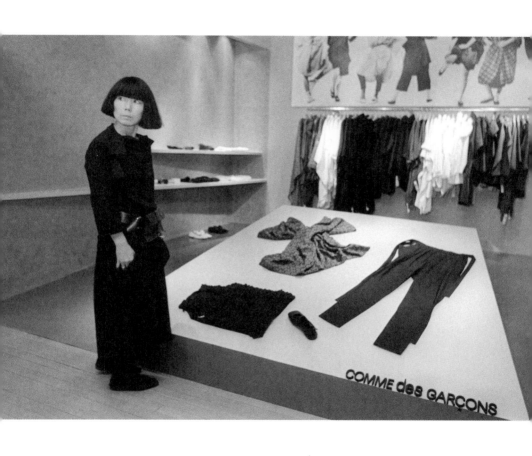

COMME des GARÇONS

WHAM!
Pastel popstrels

The combination of George Michael's (1963–2016) leonine blond locks and perfect teeth and Andrew Ridgeley's (1963–) smouldering stare, their perma-tans, bony ankles and bare chests under bomber jackets, the perky lyrics and aerobic choreography, perfectly summed up the frivolity of the decade.

For the debut performance of 'Young Guns (Go for It!)' (1983) on the BBC's *Top of the Pops*, George Michael wore espadrilles, a suede jacket with rolled-up sleeves and jeans with rolled-up hems. The boys from Bushey were an overnight pop sensation – heart-throbs with headlining hair and a catchy tune. By the end of 1983, Wham! was shouldering up to Duran Duran and Culture Club in the big league of British pop. Requisite notoriety with its attendant column inches was duly achieved when they were reported to have padded out their shorts with shuttlecocks on their Club Fantastic Tour.

Ridgeley was the stylist. It was he who was responsible for the dizzying wardrobe that spanned unlikely extremes, from the black-leather-clad bad boys of 'Bad Boys' (1983) to the pastel popstrels of 'Wake Me Up Before You Go-Go' (1984). It is still one of the great mysteries of the industry how Ridgeley persuaded George Michael to pitch up at the Brit Awards wearing a suit that made him look like Colonel Sanders.

Wham! on the Channel 4 television music show *The Tube*. George Michael looked back and admitted he and bandmate Ridgeley could have styled themselves better. 'I didn't use a stylist. I don't think I could have afforded one,' he said.

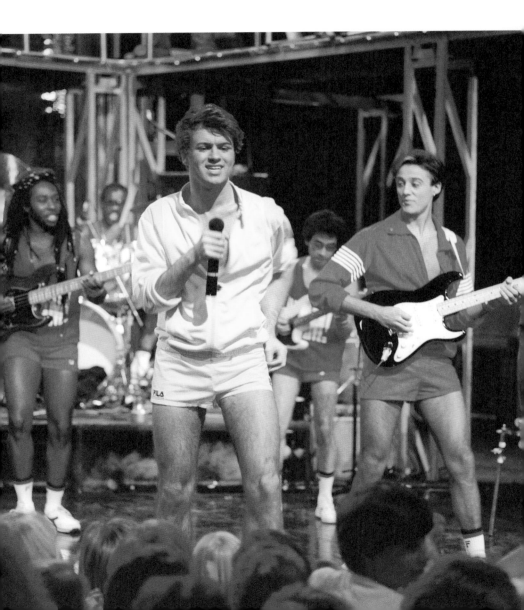

ANNIE LENNOX
She-man chic

In a decade of iconoclasts who recognized and revelled in the revolutionary power of the three-minute pop video, Annie Lennox (1954–) managed to be a game-changer. In the rising tide of rebels, she rose above the rest. She was 'the white Grace Jones', a style icon for the androgynous fashion outbreak of the 1980s – a style choice that provoked virulent speculation about her sexuality and even her status as a female.

With neither feminine nor masculine looks, her sharp tailoring and gender-bending performances in videos such as 'Who's That Girl' (1983), Lennox was so effective at confounding preconceptions that for years people thought she was gay. Lennox's presentation of her inner masculinity sparked endless controversy. Novelist Anne Rice wrote that she 'coolly jumbled all our safe ideas about gender'.

For Lennox, though, it was more about dressing up and image than sexual politics. She grew up in Aberdeen: 'A city so grey, I'd spend all my time in the art gallery because it was the only beautiful place to be. I was obsessed with bright, shiny things…' After the first Eurythmics album *Into the Garden* in 1981, Lennox quickly tired of being called 'the British Blondie', and the peroxide was replaced with a carrot-topped crew cut and mannish suits – the stark, transgressive look she donned for the 'Sweet Dreams' video in 1983.

Annie Lennox's distinctive image criss-crossed gender boundaries and brought a forthright sexuality to the world of the female singer-songwriter.

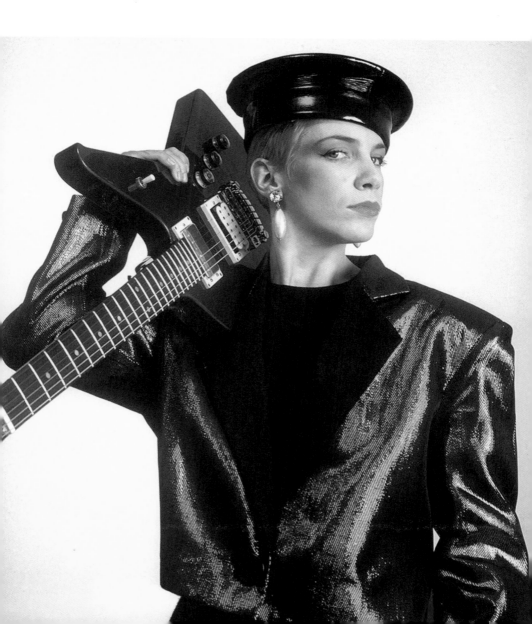

BODYMAP
London's dream team

In the 1980s the global fashion talent spotters once again turned to London for inspiration – thanks, for the most part, to a thriving music, street fashion and club scene. By 1982 a fledgling London Fashion Week was jostling for position on the international calendar, and the sensational arrivistes of the year were Stevie Stewart and David Holah (both 1958–), graduates from Middlesex Polytechnic who together had formed Bodymap.

Stalwarts of the Blitz Club (see page 340) with a following of art college acolytes, contemporary dancers, performance artists and pop stars, Stewart and Holah redefined the catwalk show. While even the wildest shows in Paris were still pretty conventional, opening with daywear and closing with the bride, Bodymap's presentations, by comparison, were a veritable romp. Their surreal titles hinted at the mayhem: 'Barbie Takes a Trip around Nature's Cosmic Curves', 'Querelle Meets Olive Oil' and 'The Cat in the Hat Takes a Rumble with the Techno Fish'. These were never going to be understated affairs.

The duo could always be relied upon to rally famous friends to make cameo catwalk appearances. Boy George (see page 384) was known to take a turn. The dancer Michael Clark and the artists Trojan and Leigh Bowery were regular enough to be considered part of the Bodymap 'family'. And long before Benetton's controversial advertising campaigns (see page 446), Stevie Stewart and David Holah used models of all sizes and ages (including their mothers) in a show called 'Family'.

In spite of adding affordable collections of swimwear and hosiery and a second line called B-Basic, aimed at expanding their youthful clientele, the pair's incandescent success fizzled out in the face of economic downturn in 1986.

Influenced by the distorted silhouettes of the Japanese avant-garde, Bodymap's sinuous jerseys and knits, along with textile designer Hilde Smith's prints, shaped a vision that was totally innovative in its hedonistic, youthful energy.

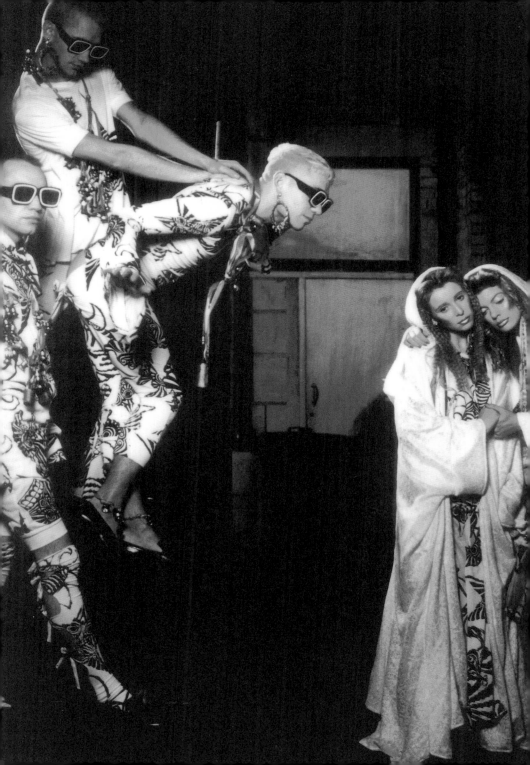

JEAN PAUL GAULTIER

Paris's eternal *enfant terrible*

Paris 1981: François Mitterrand became president of a country in crisis. People took to the streets to express dissatisfaction with economic stagnation and rising unemployment. Minorities, including gay men, demonstrated to assert their rights. It was in the context of this social change and unrest that Jean Paul Gaultier (1952–) became France's rising fashion star. In his own humble words, in a television interview at the time, his look was simply 'classical basics thrown together in a paradoxical fashion'. Dubbed the *enfant terrible* of the catwalk, Gaultier embodied the rebellious energy that was forcing change in a change-averse France.

Witty irreverence as well as sexual ambivalence became a hallmark of Gaultier's style. His Autumn/Winter 1984/85 show recast the corset as outerwear, with an exaggerated conical-breasted silhouette. For Spring/Summer 1985 he explored the theme of androgyny, putting men in skirts – an updated version of the kilt that would become an enduring motif in his collections. His work was a style salvo aimed at destroying the traditional masculine and feminine wardrobes and all the social snobbery and conventions that went with them.

Gaultier broke down levels of good taste and embraced 'low' culture. He presented men onstage as sex objects. He dabbled in ever-increasing extremes of exposure, cutting away everything but the structure, until dresses consisted of more exercise-toned body than cloth. He dressed male models in gingham and open-toed, high-heeled sneakers. He dressed Madonna (see page 360) in crucifixes and sex-shop corsetry, and produced the cone bra for her 1990 Blond Ambition tour.

Opposite: Jean Paul Gaultier poses with friends outside a Paris Métro station in 1985, wearing some of his ready-to-wear creations. Below: Gaultier sports a suit of his own design, 1984.

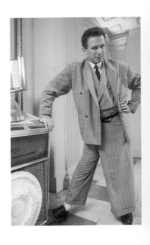

KATHARINE HAMNETT
Catwalk campaigner

In 1984 Katharine Hamnett (1947–) provided one of the defining fashion moments of the decade when she greeted Prime Minister Mrs Thatcher at a government reception wearing one of her T-shirts emblazoned with the slogan '58% DON'T WANT PERSHING'. Her inspiration was the anti-nuclear women's protests at Greenham Common airbase in England, where she herself 'manned' the barricades.

Hamnett founded her own label in 1979 and became the most copied designers in the world. Her show was among the greatest draws at London Fashion Week, pulling in audiences of press and buyers from around the globe. Her clothes were based on workwear: simple, utilitarian shapes in serviceable and comfortable cotton drill or billowy parachute silk. She managed to become something of a rarity in British fashion at the time: a global commercial success.

Slogan T-shirts became part of her collection in 1983 and were massively successful after they became standard issue for image-conscious pop bands. Andrew Ridgeley and George Michael (see page 350) wore the 'CHOOSE LIFE' slogan T-shirt for their 'Wake Me Up Before You Go Go' (1984) video. Hamnett later commented: 'Fashion gets so much publicity that it's almost disgusting. So I thought I'd put this to good use and send some political, social messages out there on T-shirts: messages people need to be aware of, which might make them think, talk to each other and maybe even generate some action…'

Fashion confronts the establishment in the famous handshake between Hamnett and Mrs Thatcher in 1984. During the 1980s, fashion went political in a way it had never done before.

MADONNA
Made on MTV

Madonna (1958–) burst into our lives in 1983 and for the ensuing quarter of a century rarely left our screens.

Crucifixes, fingerless gloves and ratty hair tied up in floppy bows were the instantly recognizable elements that added up to the 'bad girl' look she wore in Susan Seidelman's 1985 movie *Desperately Seeking Susan*. It was a thrift-store mash-up that inspired wannabes in shopping malls and on high-street corners across the globe.

Beyond that explosive debut, it was Madonna Ciccone's knack for reinvention, in the age of a nascent MTV, that really propelled her career. Her ability to serve herself up serially as dramatically different personae cast her as a direct descendant of David Bowie (see pages 246 and 254) – in the costume department at least. Whether in her Gaultier conical bras or any number of religious incarnations, Madonna's chameleon sense of style has never failed to keep the fashion world on its toes. The trashy punk dressed in lace and denim in *Desperately Seeking Susan* was soon ditched for a glamorous Marilyn Monroe avatar for 'Material Girl' (1984), which in turn would be discarded for the provocative Gaultier-dressed dominatrix of the early 1990s.

Arguably, her risqué style opened the door for a more individualistic trend in mainstream teenage fashion. However, Madonna's wardrobe not only created a signature 1980s look, but it also helped pioneer an empowered attitude among young women of both that decade and beyond.

Madonna with DJ Jellybean Benitez at the opening of the Manhattan club Private Eyes. Madonna's first incarnation married thrift style with high-end labels.

MIAMI VICE
Laid-back lotharios

Giorgio Armani (see page 336) enjoyed a huge windfall of publicity for something he had nothing to do with. The rumpled linen jackets worn, with sleeves rolled up, by Don Johnson and Philip Michael Thomas (both 1949–) in the hit 1980s television series *Miami Vice*, were widely credited to the Italian designer. The show attracted millions of viewers, who tuned in regularly just to check out the clothes. And retailers, worldwide, cashed in on the *Miami Vice* style of unconstructed blazers and pleated trousers.

The show's costume designer, Bambi Breakstone, defined the detectives' cover-boy style, drawing on the work of designers such as Hugo Boss and Gianni Versace, though it was Nino Cerruti who had created the original look. Breakstone admitted she had been briefed to be unashamedly fashion forward: 'The concept of the show was to be on top of all the latest fashion trends in Europe.'

The show drew heavily on 1980s culture and music. The producers would dedicate a significant budget per episode to buy the rights to original recordings, and promoters soon noticed that getting a song played on *Miami Vice* was a reliable way to boost record sales. But it is Italian men's fashion that owes most to the series. From Don Johnson's daily uniform of unstructured blazer, T-shirt, white linen trousers and slip-on loafers (worn without socks) to the duo's designer stubble and sunglasses, the cops' wardrobe became a defining menswear look of the 1980s.

The Italian-inspired costume design of *Miami Vice* inspired a generation of Armani-wearing urban peacocks, for whom rolled-up jacket sleeves, loafers and designer stubble were the ultimate style statements.

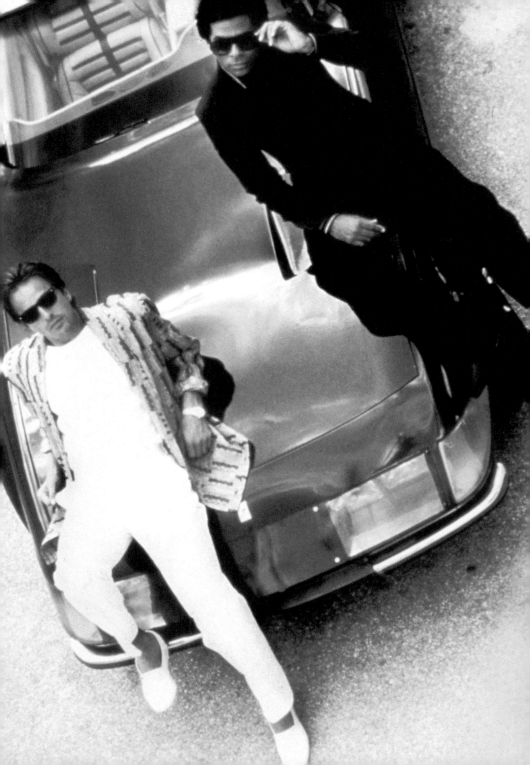

MICHAEL JACKSON
King of pop

The glove, the sequins, the regalia, the military jacket, the loafers, white socks and aviator shades: Michael Jackson (1958–2009) created an image in the 1980s that confirmed his status as 'King of Pop' for a generation of adoring subjects. Decades later, the look still resonates, both on the street and on international catwalks. From Balmain to Isabel Marant, from Chanel to Givenchy, there has barely been a design house that has not bumped into the style *oeuvre* of Michael Jackson at some stage over the decades between the release of *Thriller* (1982) and his death in 2009.

For 25 years, Michael Bush and Dennis Tompkins were the designers behind many of Jackson's tour costumes and personal wardrobe. They designed tens of thousands of pieces, working from a Michael mannequin in their studio that replicated the singer's exact measurements. Michael Bush recalls: 'Michael loved military style, Egyptian styles and the image of royalty as you can see in many of his most famous costumes and personal outfits. When we designed, we designed for showtime, no matter what the occasion.'

Accessories were key to Jackson's look. He embraced chunky belts, armbands, sequins, hats, straps, ties, patches and sunglasses. He gave pieces as simple as military badges, the fedora and white socks an imprint that, for a time, was as powerful as his music. But the most iconic Jackson accessory remains the legendary single white glove. No matter what Jackson wore, before or after he introduced the white glove to his aesthetic in the 1980s, it would be the defining fashion moment in a career full of memorable fashion moments.

Showtime! Jackson never essayed understatment. His glorious outfits were a fabulous 1980s mash-up of Las Vegas and West Point, carnival and military parade.

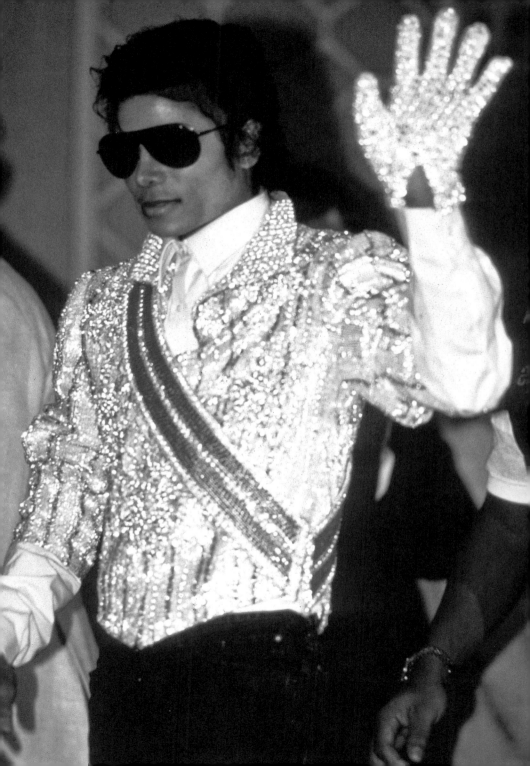

PRINCE

New rock royalty

Throughout the 1980s Prince (1958–2016) ploughed a singularly unique style furrow. The purveyor of sexually charged pop songs, with his powerhouse, multiethnic, feminized persona, he confounded audiences and critics alike. His stage presence might have seemed yet another example of strutting Latin machismo, but at the same time he was a mascaraed fashion plate, androgynous in chiffon ruffles. Prince was shocking and confusing in generously equal measures.

From 1978, the year his first album, *For You*, came out, to 1982, just before the release of *1999*, Prince rocked a disparate combination of fashion elements. It was a look that took the world, let alone his native Minneapolis, by surprise. While he could handle a guitar like a rock virtuoso, his wardrobe was a world away from the Bruce Springsteen leather jacket and raggedy jeans. His typical stage wardrobe consisted of skimpy shorts, skintight thigh-high socks, and vertiginous heels in which he could still leap from a grand piano and land in the splits. He was known to perform in nothing but boots and a pair of bikini underpants, his bare chest only occasionally covered by a coat.

In the context of American rock, Prince's preoccupation with gender-bending was startling. He went for bright eye makeup and dressed like a rococo street urchin. In 1983 he accepted an award from a Minneapolis weekly newspaper for Minnesota Musician of the Year, wearing a black trench coat and white go-go boots.

Prince on stage in the mid-1980s. *Rolling Stone* noted: 'Prince does not dress like your average rock star.' His diminutive stature and rococo stylings subverted the usual clichés of male rock 'n' roll culture.

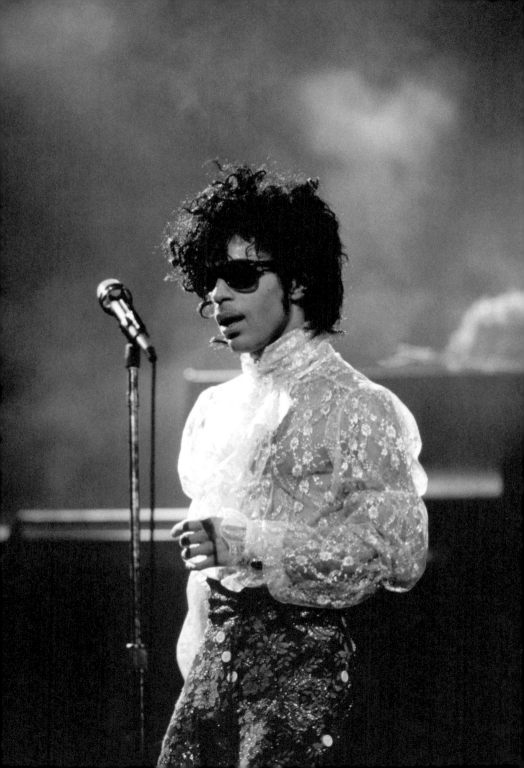

SADE

Siren of understatement

In the 1980s it was pretty difficult to get ahead in the music business without a look, and what a look Sade (1959–) had – the hair scraped back off a high forehead, hooped earrings, scarlet mouth and a dancer's body dressed in a backless black cocktail dress. She was instantly memorable.

Born Helen Folasade Adu in Nigeria, Sade studied fashion at Saint Martins College of Art when she moved to London at the age of 18. She started her own menswear line and her career course, it seemed, was set. Her singing voice was discovered when she obliged a friend with a favour and stood in to do some backing vocals. 'When singing came up, I didn't think about making a career of it,' Sade told *Rolling Stone*. 'I thought, I don't do crocheting and I don't play badminton. This could be a good hobby!' The success of her first single put paid to any ambitions she may have had to launch a menswear empire.

'Your Love Is King' was released in early 1984 and charted at number six in the UK. The song's video cemented Sade's status as a style star. She was featured on the cover of *The Face* that same year, and magazines from *Vogue* to *Elle* fought over the few interviews she agreed to give. Her debut album, *Diamond Life* (1984), sold more than four million around the world. In an industry of limelight-hogging showmen, Sade was the queen of cool understatement. She had an elegance based on absolute simplicity, her smooth, husky voice and her penchant for siren dresses and mannish suits recalling the great New York jazz clubs of the 1930s and 1940s.

Sade's pared-back style was for many a breath of fresh air in the overheated atmosphere of 1980s pop.

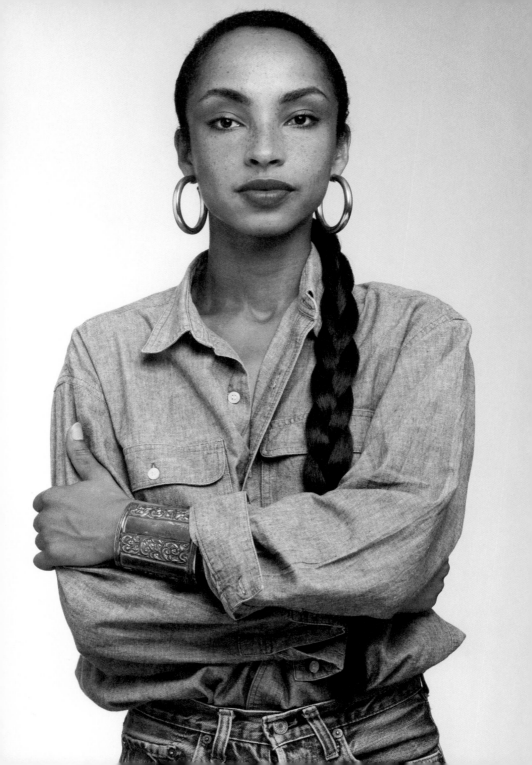

THIERRY MUGLER
Catwalk impresario

In the 1980s Thierry Mugler (1948–) became a formidable force on the French fashion stage. With the support of Melka Tréanton, fashion editor at French *Elle*, he had been building his own business throughout the 1970s. By 1978 he was ready to open his own shop on Paris's place des Victoires. Defying the luxury tradition, he went straight into ready-to-wear, resisting the call of couture. He also opened his own factory in Angers – he was the only European designer to make such an investment and it helped to establish him, not only as a creative visionary, but also as a successful entrepreneur.

Mugler changed the way fashion collections were presented, too. His shows took place, not in salons with little gilded chairs, but in vast tents and with dramatic staging. They were 'happenings' that attracted the press, buyers and hangers-on in numbers that rivalled rock concerts. 'Theatre is everything,' the designer once declared. 'My life is a stage.'

Mugler also insisted that 'a well-constructed body needs shoulders'. In this, the Mugler woman was never disappointed. She got those shoulders and much more besides: a hand-span waist, a plunging neckline and an air of haughty froideur that was perfectly in tune with the narcissism of the decade.

Mugler led the field in a return to an engineered, highly structured look – a Mugler suit was like the bodywork of a car, often complete with accessories such as handcrafted fins and hardware. In pursuit of his idealized futuristic power-babe, for two decades he called upon his Angers factory to deliver ever more extraordinary feats of fashion production.

Baroque splendour: a 'typical' Mugler creation, from his Autumn/Winter 1984–5 collection. Gold, with its connotations of fabulous wealth and space-age glamour, was an enduring leitmotif.

AZZEDINE ALAÏA

A unique body of work

A student of sculpture at the Ecole des Beaux-Arts in Tunis, Azzedine Alaïa (1940–2017) was to become the most Parisian of all couturiers. He arrived in Paris in 1957 and started as he was to continue, making his way *hors de l'établissement*. He managed a lightning five-day stint at Dior and a couple of seasons at Guy Laroche before abandoning the gilded couture salons to set up on his own to dress private clients.

The press were quick to spot him. *Elle* featured a coat he designed for Les Fourrures de la Madeleine in 1979, and a leather piece with a constellation of rivets was shot for the style magazine *Dépêche Mode* in 1980. Emboldened, Alaïa showed his first collection under his own name in 1981, in his small apartment in rue de Bellechasse, attracting a galaxy of stars that included Grace Jones and Tina Turner.

Alaïa created a new way for women to dress, but more by reinterpretation than reinvention. His work was radical, nonetheless. In a decade that celebrated style over substance, he dressed the female body without artifice, with no weapons other than skilful cutting and innovations such as seams that snaked around the body's contours with engineered precision. He created figure-hugging bodysuits and leggings that accentuated every curve while at the same time magically smoothing out imperfections.

But Alaïa remained a best-kept insider secret, mostly by the carousel of supermodels, artists and assorted intelligentsia who gathered nightly at his kitchen table (where he liked to cook dinner himself). In 1986 he was outed from the inner circle and established forever in the popular imagination through Robert Palmer's video 'Addicted to Love'. The singer's backing band comprised four Alaïa-clad women, their hair identically scraped back, lips identically scarlet and all in identical black-knit dresses.

Alaïa fits one of his contour-hugging dresses to pop chanteuse Grace Jones (see page 320). Alaïa's genius was to marry understated classicism with an avant-garde vibe.

THE BRAT PACK

Triumphing over the trials of youth

Diane Lane was the cinema sensation of 1982 when she starred as Cherry Valance alongside Matt Dillon, Tom Cruise, Patrick Swayze and Rob Lowe in Francis Ford Coppola's *The Outsiders*. In a reference to the hedonistic 'Rat Pack' of the 1950s, led by Frank Sinatra and Dean Martin, Andy Warhol dubbed Lane 'the undisputed female lead of Hollywood's new Rat Pack'. Three years later, following the release of John Hughes's *The Breakfast Club* (1985; starring Molly Ringwald, Emilio Estevez and Ally Sheedy) and Joel Schumacher's *St. Elmo's Fire* (1985; with Rob Lowe), *New York Magazine*'s David Blum christened the new generation of young actors the 'Brat Pack'.

Molly Ringwald, Martha Plimpton, Demi Moore and Winona Ryder were the undisputed queens of the scene. But what was different about them was that they weren't goddesses; nor were they sex kittens: they were just spirited adolescents with charisma overload. It was the era of the coming-of-age movie when disaffected youth took centre stage. Key fashion moments include Molly Ringwald's creative deconstruction of her hideous prom dress in *Pretty in Pink* (1986), Judd Nelson's fingerless gloves and shades in *The Breakfast Club,* and the dirty Converse trainers and plaid shirts, prefiguring grunge, in *St. Elmo's Fire*.

The Brat Pack channelled the teenage angst of white middle-class youth on the threshold of adulthood in an era of conformity. Their nod to rebellion was packaged in a style that was more flea market than high fashion. They mixed hand-me-downs and cast-offs: boyfriend blazers with rolled-up sleeves, T-shirts, ankle-length skirts and denim plastered with badges. It was the supremacy of DIY style.

The beginning of grunge? Movies such as *The Breakfast Club* popularized a déclassé style of denim, T-shirts and rolled-up sleeves. It was more yuppie than street, all the same.

THEY ONLY MET ONCE, BUT IT CHANGED THEIR LIVES FOREVER.

They were five total strangers, with nothing in common,
meeting for the first time.
A brain, a beauty, a jock, a rebel and a recluse.

Before the day was over, they broke the rules.
Bared their souls.
And touched each other in a way
they never dreamed possible.

THE BREAKFAST CLUB

A JOHN HUGHES Film · An A&M FILMS/CHANNEL Production "THE BREAKFAST CLUB"
Starring EMILIO ESTEVEZ · PAUL GLEASON · ANTHONY MICHAEL HALL · JUDD NELSON · MOLLY RINGWALD · ALLY SHEEDY
Written and Directed by JOHN HUGHES Editor DEDE ALLEN A.C.E. Music Composed by KEITH FORSEY Co-Producer MICHELLE MANNING Executive Producers GIL FRIESEN and ANDREW MEYER
Produced by NED TANEN and JOHN HUGHES A UNIVERSAL PICTURE Soundtrack available on A&M Records and Cassettes

R RESTRICTED
UNDER 17 REQUIRES ACCOMPANYING
PARENT OR ADULT GUARDIAN

N.S.S. #850002

JANE FONDA
Fabulously fit

Responsibility for the decade's obsession with the body beautiful can be laid squarely at the door of one woman: Jane Fonda (1937–). The movie star, political activist and Academy Award winner launched an entirely new (and very lucrative) career after injury on the set of *The China Syndrome* (1979) forced her to find an alternative to the ballet classes she took to keep in shape. She signed up for aerobics under the supervision of Leni Cazden, whose method evolved into the Jane Fonda Workout.

Technology helped Fonda reinvent herself as a fitness guru. Her first exercise video was released in 1982 and the uptake among owners of VCRs, then the cutting edge in home entertainment gadgetry, achieved sales topping a million. Over the next 12 years, 5 books, 23 videos and 13 audio tapes helped millions of women pursue Fonda's quest for 'the burn'. She explained: 'In order to have an effect, I would have to work out hard enough so that I could feel the sensation that I would describe as a burn. Go for the burn, go until you can feel that thing, and then you know it's going to make a difference.'

'Feel the burn' became a Fonda catchphrase, and a fitness craze swept Europe and America. The fashionable preoccupations of the decade became health, beauty, youthfulness and sex appeal. Accordingly, the diet, health-club and fitness-equipment industries boomed. Cycling shorts, headbands, sweatshirts and legwarmers became streetwear, and Lycra was transformed from a fibre known mostly to lingerie and hosiery manufacturers into a global mega-brand for its developer and manufacturer, DuPont.

Jane Fonda launched not just a fitness revolution but a streetwear revolution, too.

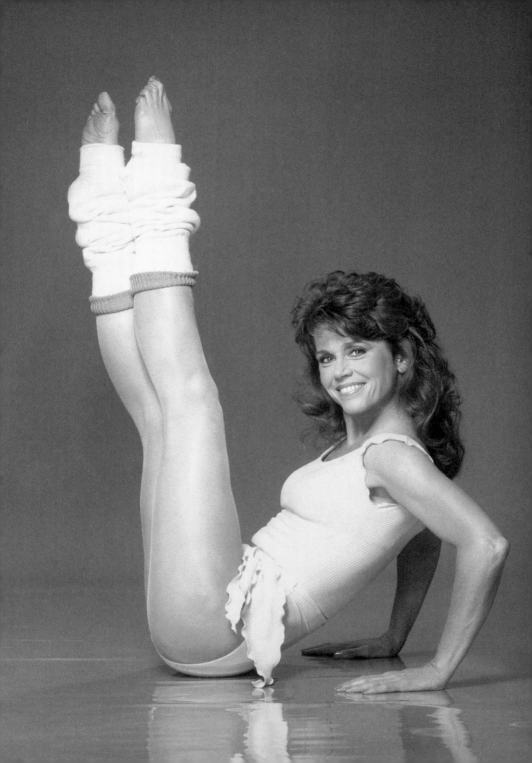

RAY PETRI : BUFFALO

The stylist's stylist

London in the 1980s was a melting pot of pop culture, politics and the rediscovered power of branded products. Ray Petri (1948–89) was the city's most articulate interpreter of the zeitgeist. Founder of Buffalo (a creative collective, a style manifesto, an attitude), he was the stylist's stylist, and one of the first. His work for *The Face*, *Arena* and *i-D* is still hauntingly powerful.

Petri couldn't find any models he liked at the established agencies. They specialized in the commercial look of the day, which was almost exclusively white, so he went out on the street. Petri is most often remembered for discovering Nick Kamen, who stripped off his Levi's in a launderette and made 501s the must-have of the decade. It was one of the most iconic images of the 1980s, but it happened largely because Ray Petri had managed to break the mould of accepted beauty. 'The models had to have the right spirit. The look wasn't enough. It had to go deeper. They had to be humble but proud at the same time,' remembers Buffalo collaborator Mitzi Lorenz.

Buffalo is mostly remembered for its boys. But it made stars of women, too. Talisa Soto was the only internationally established fashion model in the group, and her relationship with Nick Kamen was at the heart of the Buffalo family. Among the striking similarities they shared was their androgynous beauty: his with a delicacy that was almost feminine; hers with a toughness that was singularly male. They appeared together on a 1985 cover of *The Face*. 'Somewhere between Nick and Talisa was Ray's ideal,' says Nick's brother, Barry Kamen. 'The couple summed up what Buffalo was about. She was a tough Hispanic American from the Bronx and Nick was an English half-Burmese boy from Essex.'

Images from the Buffalo collective: the model Lindsey Thurlow (right) photographed by Jamie Morgan for *The Face*, and the pop singer Neneh Cherry (below), at the start of her career. Buffalo celebrated the extraordinary in the ordinary.

HIP-HOP
Rapping radicals

The years between the commercial breakthrough of Run-DMC and the arrival of gangsta rap (see page 428) with N.W.A. in the late 1980s are considered by aficionados to be hip-hop's golden years. In terms of fashion, Run-DMC is credited as being the pioneer of hip-hop, drawing a line under the disco dressing of Grandmaster Flash. Hip-hop came from the street, first as backing music for the local block party but then, as rap pioneer Chuck D put it, as 'The Black CNN', with lyrics commenting on social issues and reporting on conditions in the lives of those traditionally shunted to the edges of mainstream America.

Run-DMC's look was an expression of black power. They wouldn't be caught rapping in high-fashion labels. They stuck to their street clothes and to the brands their community was wearing: Adidas and Kangol. Typically, hip-hop artists wore tracksuits, bomber jackets, large glasses, Kangol bucket hats and Adidas Superstar shell-toe sneakers with oversized laces. Or they wore no laces at all, taking their inspiration from prison inmates whose laces were always confiscated.

Heavy gold jewellery was power play – a signifier of wealth and success. The guys wore heavy gold chains; the female equivalent was door-knocker earrings, as seen on female artists Salt-N-Pepa. For all its concern with street cred, hip-hop was not immune to the lure of luxury and, like the yuppies of the 1980s in their designer labels, the rappers gradually began to display their wealth through status symbols. Hundred-dollar sneakers and designer tracksuits were accessorized with blatant badges of wealth, such as the emblems of luxury cars.

The cover of Run–DMC's single 'Walk This Way' (1986). The group members sport the 'classic' hip-hop look: bomber jackets, jeans and white sneakers.

SOCIAL CONSCIENCE
The good deed decade

The 1980s are often dismissed as one of narcissistic hedonism, yet the decade also saw a surge in political awareness and heightened social activism. The face of fundraising changed for ever. Where once there were old ladies rattling tins in the shopping centre on a Saturday, funds and awareness were raised, 1980s style, through the consciences of pop stars, fashion designers and celebrities. Mass charity events such as Live Aid, in July 1985, raised money for famine in Ethiopia, while in November 1985 five-thousand people gathered inside London's Royal Albert Hall under the banner of Fashion Aid – 'for an evening of spectacle and glamour'… and fundraising.

Animal rights activism also got a makeover. Lynx was one of the most successful pressure groups of the 1980s. The charity, which boasted the support of celebrities including Neil Kinnock and Elton John, shot to prominence with a controversial advertising campaign. Photographed by David Bailey (see page 136), it featured a model trailing blood from a full-length fur coat. The caption read: 'It took 13 dumb animals to make this and only one to wear it.' In 1986 Liz Tilberis (see page 442) banned the running of fur features in *Vogue*.

The greatest challenge of all, however, was faced when HIV/AIDS decimated the fashion industry and inspired activism in an industry not naturally given to selfless acts of generosity. Few, eventually, would be left untouched or unaffected by the virus's terrifying spread.

Celebrities at 1985's Fashion Aid: Paula Yates (right) and Freddie Mercury and Jane Seymour (below). For all its frivolity, 1980s fashion was characterized by a new political engagement.

BOY GEORGE
Peacock of pop

In the early 1980s Boy George (born George Alan O'Dowd in 1961) blazed a trail for a gender-bender style that defied familiar tropes.

Fashion's fascination with the peacock parade that defined street and clubland style fuelled a very 1980s reboot of the phenomenon of the cross-dressing popstar. Men were dressing, if not to look like women, then at least as sexual ciphers. And, on the flipside, women dressed to look like men. Often, both sexes met midway to look neither male nor female, but some exotic asexual creature located somewhere between the two.

As a leading light among the 'Blitz Kids', Boy George had always dressed to dazzle. His posse was a disparate bunch of hedonists dominated by fashion students from Saint Martins, who turned the weekly club nights in London's Soho into a celebration of flamboyant fashion creativity. He was a driving force behind the New Romantic subculture. His early homemade looks incorporated everything from geisha drag, Rastafarian headdresses, hats worn traditionally by Hasidic Jewish men, sportswear and long, loose coats, often accessorized with flamboyant costume jewellery by Monty Don.

While his band backed him onstage in dungarees and T-shirts, Boy George's wardrobe evolved at a dizzying and limelight-hogging pace, from outsized Stars and Stripes coats worn with a top hat, through what he called his 'Egyptian headdress look' and, later, Hare Krishna saffron robes.

Nothing about Boy George's look was ever anything but idiosyncratic. As soon as it caught on, he moved on. His stage clothes were tailor-made one-offs by his friend and collaborator Dexter Wong, who operated out of a covered market that was the Hyper Hyper emporium on Kensington High Street.

Boy George's distinctive style was part showmanship, part radical statement, in a decade that subverted gender stereotypes and saw the first great commercial flowering of modern gay culture.

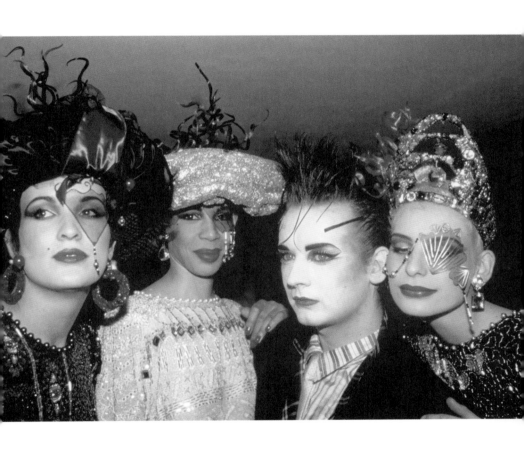

CLAUDE MONTANA

Drama king

In the 1980s Claude Montana (1949–) was *the* go-to designer for melodramatic glamour. His lofty, architectural style totally dispensed with any romantic vestiges of the 1970s bohemian hippie, but he was also diametrically opposed to the sombre cerebral style of Rei Kawakubo (see page 348) and Yohji Yamamoto (see page 396). Montana's clothes were all about Gallic sex appeal, hauteur and colour. He presented women with the armour he believed they wanted. The classic Montana silhouette was an inverted triangle with large shoulders and a tiny waist, and generally involved a liberal helping of glossy black leather. His high-vamp, high-price chic flaunted the sexual marketability of women.

Fashion fans flocked to see and be seen at Montana's catwalk extravaganzas. Wicked, aloof, glacial, bondaged, his catwalk queens stalked the runway with girded loins, tight skirts, aggressive shoulders, and revealing corsetry worn like armour plating. His love of leather coats and capes got him shot down more than once for their alleged Nazi references. Nevertheless, Montana's shows were colossal publicity magnets and, even in the chicest and most strait-laced boutiques, his look was a commercial winner. Even his fiercest critics had to admit he had his finger on a sociological pulse.

Montana invented the 'total look'. His pieces did not slip easily in and out of an eclectic wardrobe – people bought the entire Montana range. The 'look' filtered to the high street at cheaper prices, spawning a younger generation of sharp-shouldered sirens who brooked no nonsense.

Montana takes the applause at his Spring/Summer 1988 collection. Montana's heavily structured, fetishized style may not have been exactly 'politically correct', but it nonetheless caught the zeitgeist.

KARL LAGERFELD AT CHANEL
Fashioning a French icon

In 1983 Karl Lagerfeld (1933–2019) became chief designer of the Chanel couture house. He already had a reputation as a prolific designer: since the 1970s he had designed collections for Chloé (see page 258) in Paris and Fendi in Rome, stopping off at MaxMara in Milan along the way, while also taking the time to develop collections in his own name. Chanel, meanwhile, was a faded brand, although with the singular advantage that, unlike so many of its rivals and contemporaries, it had never sold its assets to licensees. But it had nothing much to offer beyond some dowdy tweed suits.

Thanks to the ingenious Lagerfeld and the company's careful handling of its branded perfume and accessories, within a decade Chanel was a $1 billion company. Lagerfeld was an inveterate modernizer, considering himself an outsider to the French fashion establishment, which he loathed for its conservatism. He had spent years minutely studying the legacy of Coco Chanel (see page 50) and now set about reinventing it. A natural communicator, Lagerfeld could host press conferences in five languages and had an instinctive understanding of the power of the media. He had an equal understanding of what women wanted.

Lagerfeld's collections for Chanel almost parodied the new status dressing, shamelessly exploiting the 'double C' logo and classic leitmotifs such as the camellia brooch and the diamond quilting. Nevertheless, the clientele took it seriously, sporting quilted leather handbags, large gilt CC earrings and miniskirts hung with chains on fashionable streets everywhere. Lagerfeld's appeal to the newly moneyed was a significant engine of Chanel's resurgent success.

Lagerfeld reinvented Chanel for the 1980s, trading on the brand's famous trappings to create a signature style for the ultra-rich, here modelled by Inès de la Fressange.

JASPER CONRAN

Embracing the business of British fashion

Though the international press may have focused on London as the provider of wacky amateurism, the city did have a hard core of professional designers. In the 1980s the ranks of Jean Muir (see page 204) and Zandra Rhodes (see page 300) were joined by Sheridan Barnett, Alistair Blair and Jasper Conran (1959–), who managed, in a world of flamboyant showmen, to combine creativity with business acumen. Back then, British fashion typically aspired to be art: fashion shows were 'happenings' and the clothes often came a poor second to the cult of the designer. Fashion entrepreneurialism was a gutsy position to take when the industry equated 'selling' with 'selling out'.

The son of Sir Terence Conran, Britain's best-known designer, Jasper was accepted at the Parsons School of Design in New York at the age of 16. There he caught the tail end of Manhattan hedonism, becoming an habitué of Studio 54 (see page 302) while still in his teens. He witnessed, too, the rise of a new generation of American designers – Donna Karan (see page 318), Calvin Klein (see page 444) and Michael Kors among them – who responded to the wardrobe needs of the modern woman in the most practical ways. In 1979, aged just 19, Jasper Conran designed his first womenswear collection under his own name, and the following year he was invited to show as part of the London Designer collections.

His New York experience shaped both his attitude to fashion and his strong commercial sense. American fashion appealed to what Conran calls his 'sensible approach'. He quickly learned to accept that sensible clothes didn't always make the headlines, but it was an attitude that did not hold him back. While other British designers enjoyed meteoric rises and dramatic falls, over the years he built up a faithful clientele who loved his quietly confident clothes – not least Princess Diana (see page 346), who often relied on Conran to dress her for public appearances.

Jasper Conran with Bianca Jagger in 1987. Conran brought a badly needed dose of sense and sensibility to British fashion of the 1980s.

CHRISTIAN LACROIX

Delightfully *de trop*

In 1982 Christian Lacroix (1951–) exploded onto the fashion scene as the couturier at the forgotten Parisian house of Patou. With the economic boom, luxury was back in style for the first time in years. And with it came a market for clothes in which the newly wealthy could dress up and show off.

The designers of the futuristic avant-garde may have been darlings of the fashion press, but Lacroix still captured imaginations with his diametrically opposed fashion language centred on the bustles, bows, corsets and crinolines found in the painting of 18th-century rococo artists such as François Boucher and Jean-Honoré Fragonard. Lacroix conjured a colourful, riotous fashion vision, mixing the ruffles and feathers of Henri de Toulouse-Lautrec's cancan dancers with lace and prints inspired by the gypsies of his native Provence.

The intricacies of Lacroix's embroideries and passementeries, and the work in feathers and flowers focused renewed attention on the skills of the artisans of the couture ateliers, who had fallen out of favour with modern designers following a less decorative and more utilitarian path. Through Lacroix's collections, their work once again inspired the audiences with wonder. 'Personally I've always hovered between the purity of structures and the ecstasy of ornament,' said the designer who always faced down the minimalists with a style that was defiantly *de trop*.

Christian Lacroix with Jane Seymour in 1987. Lacroix's puffball skirt – a balloon of taffeta or satin – would become the *fin-de-siècle* ballgown. A short version teamed with bullfighter's jacket, worn with sheer stockings and towering heels, ensured that legs became the decade's favourite erogenous zone.

WHITNEY HOUSTON

Pop's most glamorous girl next door

Whitney Houston (1963–2012) started working as a fashion model after a photographer saw her at Carnegie Hall singing with her mother, Cissy Houston. She worked for *Cosmopolitan* and *Glamour* and became one of the first black models to feature on the cover of *Seventeen* magazine. By the time she launched her career as a singer, she was already one of the most sought-after teen models of the time.

In the context of the gender-benders, bad-boy rockers and pop vixens of the 1980s Billboard charts, Whitney Houston was seen as a 'good girl' with a squeaky-clean image. Compared to Madonna (see page 360) or Annie Lennox (see page 352), she was not a fashion trailblazer, but her sorority style and peerless voice made her an inspiration for millions of young women. In the landscape of the 1980s it took guts to be the iconic girl next door.

Houston's styling choices were undoubtedly tame. She bounced around the stage dressed in sneakers, stonewashed jeans, box-fresh white T-shirts and modestly large gold hoop earrings. She wore a sweatshirt and tied her hair in a stretchy bandanna to sing the 'Star-Spangled Banner' for the opening of the Superbowl, looking more like she was on her way to a workout than the opening of America's largest televised sporting event. Houston's dressed-up options were scarcely more adventurous, often featuring spangled black or white stretch dresses. She had a penchant for wide-shouldered suits and white cloche hats.

In a world where stars universally aspired to radical, subversive images, Whitney Houston was the approachable diva.

The exception proves the rule: Houston's dress sense was usually determinedly girl-next-door, but would occasionally veer into wilder territory, as in this image from her 1987 video for 'I Want to Dance with Somebody'.

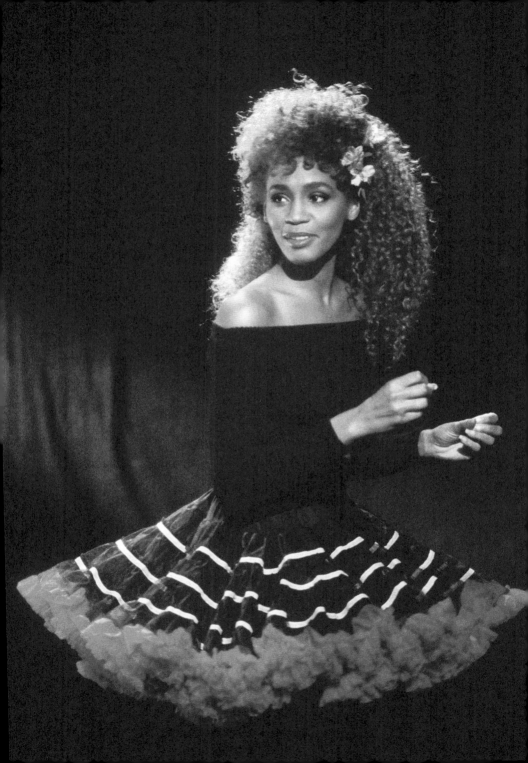

YOHJI YAMAMOTO
Catwalk minimalist

When the Japanese arrived in Paris in the 1980s, their pauper style was diametrically opposed to the theatrical modernism of Claude Montana (see page 386) and Thierry Mugler (see page 370). They were distinctly cerebral and more sombre than the hedonistic French. Yohji Yamamoto (1943–) was arguably *anti-fashion*. 'I don't follow the trend,' he asserted. 'I don't chase the trend.' Together with his partner of the time, Rei Kawakubo of Comme des Garçons (see page 348), he rocked the fashion world. The effect was cataclysmic, 'like a nuclear explosion or a natural catastrophe,' said *Le Figaro*. The models had a robotic way of walking, wore no makeup and had messy hair. There were no high heels, no sequins. Clothes had holes, were worn with clumpy shoes and had unfinished edges.

Yamamoto launched his first attack on that bastion of male refinement, the suit, breaking down its traditional appeal as a cloak of respectability. For women, he engineered a striking encounter between austere tailoring and pretty, loose-fitting softness. In his hands, black was revered as a true colour with depth and warmth; the simplicity of the white shirt was its luminous counterpoint.

The spirit of Japanese dress has always remained the foundation of Yamamoto's style. His clothing incorporates a fluid fullness and often conceals the body to increase its mystery. Unlike the superheroes who stalked the runways of Mugler and Montana, or the baroque flamboyance of a Christian Lacroix collection (see page 392), Yamamoto took his inspiration from real people and the way they lived and thought.

Yamamoto's designs were guided by the sensuality of the fabric, until finally the shape of the garment emerged. Structure was combined with yielding fluidity, as seen in this iconic photo by Nick Knight, one of the decade's key style influencers.

MANOLO BLAHNIK

Superlative shoes

1988

Manolo Blahnik's background goes some way to explaining his aesthetic breadth. He was born in the Canary Islands in 1942, to a Czech father and a Spanish mother. He studied literature and art at the University of Geneva before moving to Paris in 1968 to study art at the Ecole du Louvre. An encounter with the celebrated columnist and editor Diana Vreeland (see page 126) in New York City set him on his path as a shoe designer.

Blahnik moved to London in 1970 and, after designing shoes for Ossie Clark (see page 188), launched his own label in 1973. However, in the beginning he resisted calling himself a designer, finding the description pretentious. He said simply: 'I deal in shoes.' It was not until 1978 that he began to take his business seriously. His ascent to fashion stardom was meteoric. In 1980 the *New York Times* voted him the most influential shoe designer in the world, and his tiny shop in Chelsea became a mecca for celebrities, socialites and the *jeunesse dorée* alike.

In the 1980s Blahnik cemented a reputation for elegance and the dizzying height of his heels. He had a singular talent for creating harmonious combinations of materials and an ability to move effortlessly from purest classicism to dazzling strokes of boldness. Women adored his work for its extreme femininity and provocative sexiness. A Blahnik shoe was a concoction of rococo lightness, extrovert élan and worldly sophistication. No wonder so many of them were displayed on their owners' mantelpieces as mini works of art when not being worn.

Manolo Blahnik surveys his creations in his London salon. Blahnik continued the grand tradition of elegant women's footwear through the gaudy faux pas of the 1970s and '1980s.

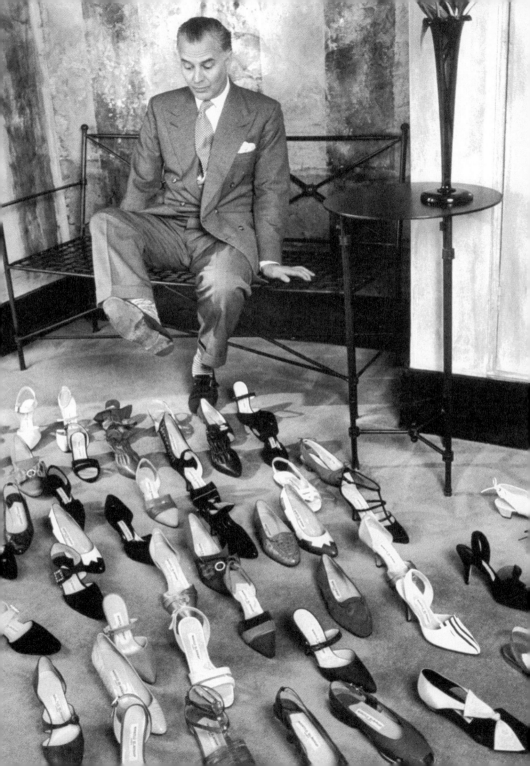

PAUL SMITH
Rethinking British menswear

Sir Paul Smith (1946–) was the accidental fashion designer who completely overhauled and revived the British male wardrobe in the 1980s. He is almost single-handedly responsible for the rediscovery of traditional British tailoring, simultaneously refreshing it with flourishes of his characteristic eccentricity and humour.

In 1964 Paul Smith was a cyclist with his heart set on professional status. An accident put paid to that ambition, and when he got out of hospital he took up with a group of art students in his native Nottingham, who introduced him to the world of contemporary art and music. Encouraged by Pauline Denyer, whom he would later marry, he took evening classes in tailoring. He showed his first own-label menswear collection in Paris in 1976.

In 1979 Smith opened a boutique in Covent Garden's Floral Street, launching the area as the epicentre of London's fashionable scene. They came in droves for his idiosyncratic mixture of Oxbridge dandy meets gap-year surfer; chairman of the board meets high-school dropout. In the staple Paul Smith suit, the burgeoning tribes of media, advertising and music industry executives of the 1980s found their perfect sartorial expression – serious, but not too serious.

The success of his style lay somewhere on the fine line where, as he put it, 'Savile Row meets Mr Bean'. Smith's blend of classic British style combined with unabashedly bright colours conveyed a spirit that was offbeat to the point of eccentricity. By the end of the decade he had turned a quirky idea of Britishness into a globally recognized language.

Photographic portrait of Paul Smith, 1988. 'My thing has always been about maximizing Britishness,' he said in an interview in 1981. 'I don't like stupid ideas that can't be worn.'

In 1975 John Molloy published his book *Women Dress for Success*. Corporate America, followed quickly by Europe and Britain, took his ideas to heart and women traded their mismatched separates for a sober suit. Molloy's argument was based on the premise that 'the simple tailored wool suit in neutral navy or slate blue grey, worn with non-sexual blouses, imitated uniform of rank, which by design was authoritative.' He used exhaustive research to back up his theory that both clients and subordinates accepted the word of a female dressed in a suit with better grace than if she were wearing a fashion outfit. It was a theory that ran and ran: by the advent of the 1980s the entire Western corporate world was in thrall to the concept of power dressing.

During the decade the number of women in executive jobs was on the rise. Women jogged or worked out before going to the office, dealt with domestic crises on the phone and swapped their Stephane Kélian heels for sneakers in order to hurry home to play with the baby before transforming themselves into sirens of glamour for a dinner out.

For the entire decade, fashion was obsessed with power dressing. The single most important element of power dressing was the shoulder pad, and barely a garment was constructed without them. In pursuit of an image that would convey assertiveness, affluence and success in the business and social world, large shoulder pads propped up everything from tailored jackets and cocktail dresses to pyjamas.

'I've got a head for business,' boasted Melanie Griffith in the movie *Working Girl* (1988), 'and a bod for sin'. By the late 1980s the female wool suit and 'non-sexual blouses' had taken on their own hard-edged glamour.

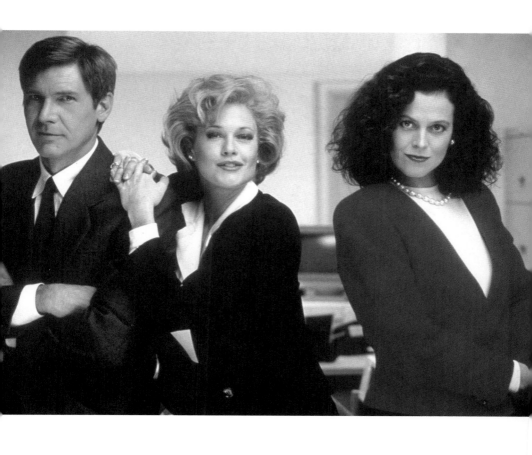

RIFAT OZBEK
Ottoman romance

Born in Istanbul, Turkey, Rifat Ozbek (1953–) moved to the UK in the 1970s. Initially, he studied architecture at the University of Liverpool, but soon transferred to Saint Martins School of Art to enrol on a fashion course. He graduated in 1977 and, after a stint in Italy and another with high-street clothing chain Monsoon, launched his own label in 1984, showing out of his parents' apartment in Belgravia.

The British fashion renaissance of the 1980s was more about creative idealism than industry domination. Life at his studio in Haunch of Venison Yard, in London's Mayfair, was as much about 'the happening' as building a business. Ozbek's eclectic, romantic style drew on influences as disparate as the actress Juliette Gréco, choreographer Martha Graham (see page 92) and the mariachi musicians of South America, and attracted the attention of some stylish heavy hitters such as Tina Chow, Grace Coddington (see page 482) and Polly Mellen, who were among the young designer's earliest supporters. In a fashion world obsessed with streetwear and minimalism, Ozbek offered a unique and global point of view, using rich and exotic fabric combinations – prints from Africa, silks from the Far East, raffia from Spain and woven cloth from South America.

The Ozbek look became known for its vibrant colour palette and rich textiles. He was comfortable styling glossy Venetian wools along with tribal ikat fabrics. He dressed sarong skirts up with city coats and accessorized evening dresses with a Turkish fez. An Ozbek collection was a visual feast that also managed to translate from the catwalk to real women's wardrobes.

An Ozbek ensemble from Spring/Summer 1988, modelled by Naomi Campbell. Rifat Ozbek introduced a cosmopolitan joie de vivre into what was fast becoming a tired London fashion scene.

ARTHUR ELGORT

Energizing fashion photographer

At the heart of an image is by Arthur Elgort (1940–) the captured moment: a spontaneous freshness that belies the painstaking attention to detail that goes into the set-up of each shot. Elgort's first job was as an usher working at Carnegie Hall, where he fell in love with dance. He took pictures of George Balanchine and the New York City Ballet, and central to his style has always been his love of unfettered and graceful movement. 'Move with your subject' is a piece of advice he has frequently offered to aspiring photographers.

While working for American *Vogue*, Arthur Elgort exploited the potential of its lavish production budgets to the full, travelling to increasingly exotic locations and bringing a cinematic dimension to his fashion spreads. What made him unique, however, was his ability to portray an intimacy within the grand scale. Women do tend to relax around Elgort, and that has been key to many of his most memorable images. He catches them backstage, during downtime, on the phone, with hair in curlers, smoking, in any level of undress. 'I always feel that it's a compliment when a woman reveals herself in front of the camera,' he wrote in his 1993 book *Arthur Elgort's Models Manual*. 'It shows she trusts me. That's what a good picture is all about.'

Elgort's iconic 'snapshot' style transformed the fashion landscape in the 1970s and 1980s, and he remains one of the most inspiring (and imitated) lensmen working today. 'You can take a picture or you can make a picture. I much prefer the latter,' Elgort told *Vogue* in 1989.

Linda Evangelista shot by Arthur Elgort in 1989. Elgort's images are always full of motion.

JOHN GALLIANO

English dreamer

John Galliano (1960–) graduated from Saint Martins School of Art in 1984 at the height of London's hedonistic decade. At that time, the Saint Martins campus bordered the heart of clubland. Young London lived to dress up, and the nights were a peacock parade led by larger-than-life characters such as Leigh Bowery and Boy George (see page 384). Galliano remembered how 'Thursday and Friday the college was almost deserted. Everybody was at home working on their costumes for the weekend.'

It was a time of outrage. And London was the perfect crucible for Galliano's rare imagination. His graduate collection, 'Les Incroyables', was fired by the flamboyance of the New Romantic club scene and driven by his determination to change the architecture of fashion – how it was cut, assembled and worn. With his ability to marshal a kaleidoscopic range of influences – a skill that was to define his work throughout his career – he also sought to capture the creativity and innocence of children. He was fascinated by how they dressed themselves haphazardly, with legs through armholes and arms through necks. 'It's all a mad mix,' Galliano explained. 'Everything is off balance. I break every possible rule and find different looks emerge by playing with how they are put on the body – fashion has never been so exciting.'

Working with Amanda Grieve, fashion editor at *Harpers & Queen*, Galliano became a London Fashion Week star with a succession of inventive, gorgeous and exorbitantly uneconomical collections. With visionary ideas but little business sense, he went bankrupt in 1990, a fitting end to the decade of excess.

An illustration by Howard Tangye showing a model wearing a Galliano hat and coat. The image captures the flamboyant Galliano silhouette of the late 1980s.

HERB RITTS
Athletic glamour

Son of a successful entrepreneur, Herb Ritts (1952–2002) grew up in Los Angeles in the 1960s and 1970s. His next-door neighbours were Steve McQueen and his wife, and as a child he would entertain the starry couple with puppet shows. In his twenties Ritts became friends with a crowd of rising actors and musicians, who gravitated to the city: people such as Richard Gere and Elton John and the cast of the *Rocky Horror Picture Show* (1975). It was during these formative years that Ritts honed one of his trademark skills – making famous people feel at ease. It was a skill that he would need on a daily basis when working as a contributor to *Vogue*, *Vanity Fair* and *Rolling Stone* over the following 20 years.

In the beginning, Ritts simply toyed with a camera using his friends as subjects. He was drawn to the style of George Hurrell, Man Ray and Horst, masters of light and strong classical lines. He followed in the footsteps of Robert Mapplethorpe and Bruce Weber (see page 334) in his fascination with the human form. But it was Ritts's familiarity with the California landscape, its light and seascapes, that really opened up his visual vocabulary and allowed him to create a truly modern style. It was this strong and harsh light that became his signature, a key, he felt, to unlocking a dynamic life force within his subjects.

In a decade defined by artifice, Ritts created an anti-glamour style, taking his subjects out of the studio and into natural light. It was the era when no glossy magazine was complete without Naomi Campbell, Claudia Schiffer (see page 438), Christy Turlington, Linda Evangelista or Tatjana Patitz. It was Ritts who arguably mythologized these Amazonian beauties and elevated them to a new status – that of supermodel. There was a current of sensuality running through all of Ritts's work, but it was always heroic rather than trivial. His iconic image of a quintet of naked supermodels, limbs intertwined (1989), manages to be about strength, elegance and poise rather than titillation.

Tatjana Patitz, as shot by Herb Ritts in Hollywood, 1989. It was through such iconic images that Ritts helped forge the mythology of the supermodel in the late 1980s.

JOSEPH
A fashion essential

Joseph Ettedgui (1936–2010), son of a shopkeeper from Casablanca, forged his first career in London as a hairdresser, but in the 1980s he redefined fashion retailing. In the postmodern age, fashion designers made chairs and furnishing fabrics, and world-famous architects designed clothes shops. Ettedgui pioneered the selling of furniture and ceramics side by side with frocks and became the beating heart of London's glamorous new brand of cool.

A Joseph advertisement from the late 1980s. Crisp silhouettes and ubiquitous black were hallmarks of the Joseph style.

In the wake of the deregulation of the financial markets in 1986, the Joseph store on Brompton Road (designed by Norman Foster) was the mecca for the newly style-conscious and newly rich. There, the customers could immerse themselves in two splendid floors of Ettedgui's meticulously curated selection of the best of catwalk fashion. No designer, anywhere in the world, could consider themselves to have made it until they were stocked by Joseph. Here the customer could browse the Gallianos and Gaultiers, swaddle themselves in statement sweaters from Joseph Tricot, and kit themselves out in 'basics' from his eponymous label.

Ettedgui brought the cool modernism of France to the UK. Subscribing very much to Andrée Putman's view that 'We are suffering from an overdose of colour', he wore only black in winter and only white in summer. By the end of the 1980s this asceticism was universal. Women in black sweaters, tight black pants and flat black ballerinas climbed into small black cars and drove home to minimalist black and chrome apartments. They wrote with fat black pens and put on black dresses to dance to black music in black clubs. Black was the only fashionable colour… and Joseph was the mecca of monochrome.

ROMEO GIGLI
Fashion's faerie prince

Romeo Gigli (1949–), an architect by training, showed his first fashion collection in Milan in 1985. Two retailing visionaries snapped it up: Joan Burstein of Browns, London, and Joyce Ma of the eponymous boutique in Hong Kong. By the end of the decade Gigli had moved his shows to Paris and had achieved superstar status, hailed as 'a fashion game-changer, the Armani of the '90s'.

In stark contrast to the power dressing and body-conscious clothes that dominated the runways, Gigli's style was an uncompromising vision of romantic individualism. His proposal was more like a fashion dream sequence than a sartorial passport to the boardroom: rhapsodic designs in rare fabrics, a rich palette of Indian spice colours and a treasure trove of cultural references. In Gigli's hands, fashion was approaching the realm of art.

The Gigli silhouette consisted of shawl-collar necklines, small unpadded shoulders, bandeau-swathed bodices and empire waistlines. Long, slim sleeves reached over the fingertips. Sensual velvets, diaphanous organzas, delicate silks and rich brocades, in gorgeous jewel tones, all harked back to the riches of the Renaissance. A Gigli show was, as one critic described it, replete with a 'luxury worthy of an Eastern potentate. So lavish were his designs, so intricate his embroideries…'

Such eclectic, historical and otherworldly references do not sound like a recipe for success in the late 20th century, and yet, his star status was assured because he also managed to be pre-eminently modern in those romantic silhouettes.

A fashion model wears a ready-to-wear off-the-shoulder blouse and ruffled skirt by Romeo Gigli. Gigli's clothes were both lavish and intellectual, combining a sensuality of form and texture with a wide range of cultural and conceptual references.

1990s

The financial boom and flamboyance of the 1980s ceded to a decade of soul-searching. A new generation of designers kicked against the accepted confines of high fashion and dedicated themselves to defining modernity. Political and cultural upheaval, economic crisis, famine in Africa and the fear visited by the Chernobyl disaster provided a backdrop for a fashion style that was dark and conceptual.

The Paris catwalks embraced the diversity of both traditional couturiers and the avant-garde, whose standard-bearers were the 'Antwerp Six' (see page 506). For the first half of the decade it looked as if anti-fashion would make the most lasting mark on the industry at the end of the century. The UK provided a much-needed injection of energy, flair and showmanship, as Alexander McQueen (see page 510) was installed at Givenchy and John Galliano at Christian Dior (see page 496).

The technological revolution blurred boundaries and divisions. Designers now planned their collections for maximum video impact and the international fashion shows become theatrical spectacles that only partly reflected the clothes for sale in the shops. Fashion writers crouched over word processers instead of typewriters. Pattern cutters worked on computers instead of card. Art directors laid out their pages using desktop publishing software.

Fashion was no longer a coterie of family businesses but a network of vast international conglomerates. In a world that had elevated the pursuit of luxury and at the same time demoted 'gowns' to 'frocks' and 'dedicated followers' to 'fashion victims', nothing would ever be the same again.

The Danish supermodel Helena Christensen backstage before a 1994 Autumn/Winter catwalk show. The early 1990s saw the second great flourishing of catwalk supermodels who became celebrities in their own right.

AIR JORDANS
Sneakers get serious

The 1990s were sneaker obsessed, as a growing number of sports shoes became the focus of a massive fashion cult. Trainers were endorsed by celebrities and sports stars alike, but the daddy of them all was the basketball player Michael Jordan (1963–).

Michael Jordan was famous for his ability to 'catch air', jumping higher than seemed humanly possible. But, in terms of money alone, his earnings as a fashion face would eclipse his most spectacular achievements on the basketball court. In 1985 'His Airness' became the crown prince of athletic shoe endorsements, with the launch of Nike's Air Jordan line. The shoe he helped design would go on to have a history almost as illustrious as that of the man himself. By 1998 Jordan had reportedly made more than $130 million from Nike alone.

The line was backed by a savvy marketing campaign, featuring 'MJ' himself. One of Jordan's more popular commercials for the shoe involved film director Spike Lee reprising the role of Mars Blackmon, a character from Lee's own *She's Gotta Have It* (1986), who is a fanatical supporter of the New York Knicks. In the commercials, Blackmon desperately seeks to track down the secret behind Jordan's abilities and becomes convinced that 'It's gotta be the shoes'. Such was the hype surrounding the sneakers that there was even a spate of 'shoe-jackings', in which people were robbed of their Jordans at gunpoint.

The AJ1 model. Ironically, the black detailing on Air Jordans made them 'illegal' on the basketball court, according to National Basketball Association rules. That didn't, however, stop Michael Jordan from repeatedly wearing them.

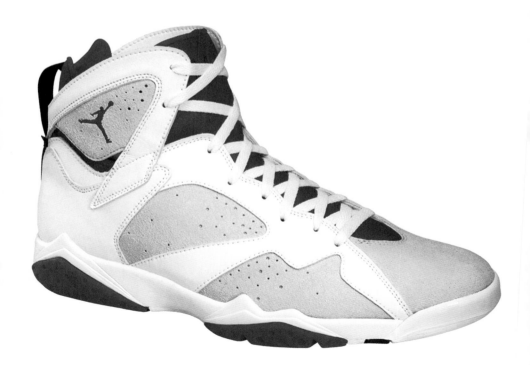

JULIA ROBERTS IN
PRETTY WOMAN
The decade's celluloid sweetheart

The wardrobe for *Pretty Woman*, the 1990 film that marked the turning point in the career of the then 23-year-old Julia Roberts (1967–), still looks remarkably chic. The polka-dotted brown dress (with matching hat) that Julia, as Vivian, chose for the polo match, the red gown she wore to the opera, and even the midriff-baring hooker dress are all silhouettes that could still easily be worn, decades after the movie's release.

But, aside from achieving fashion credentials, the costumes had a more subtle function. Every detail had to reflect the evolution of Vivian's character: her rags-to-riches transition from tart with a heart to trophy wife for the Richard Gere character, Edward. As the movie's costume designer, Marilyn Vance, explained, 'In the beginning, she's wearing so much "stuff": a jacket, those boots, the hat, it's all very busy. In each successive look, you begin to see her take his "less is more" direction. By the end, she's very simply put together – pure sophistication.'

Aside from a pair of Chanel heels and the tie that Vivian wears (with nothing else) to greet Edward when he returns to the hotel after work, the costume department created all of the iconic fashion moments in the Oscar-nominated film. The midriff-baring dress, for instance, was inspired by a vintage 1960s bathing suit that Vance herself owned.

If the studio bosses had got their way, the famous red dress would have been black. 'But I knew it needed to be red,' Vance said. 'Before the decision was made, we ended up having to create three different dresses. We took every colour, lit it and shot her...Finally, I was able to find the right shade and convince everyone to go in my direction.'

Opposite: From hooker to trophy wife – Julia Roberts's clothes in *Pretty Woman* mirror her Eliza Doolittle-like transformation.
Below: The famous polka-dotted brown dress.

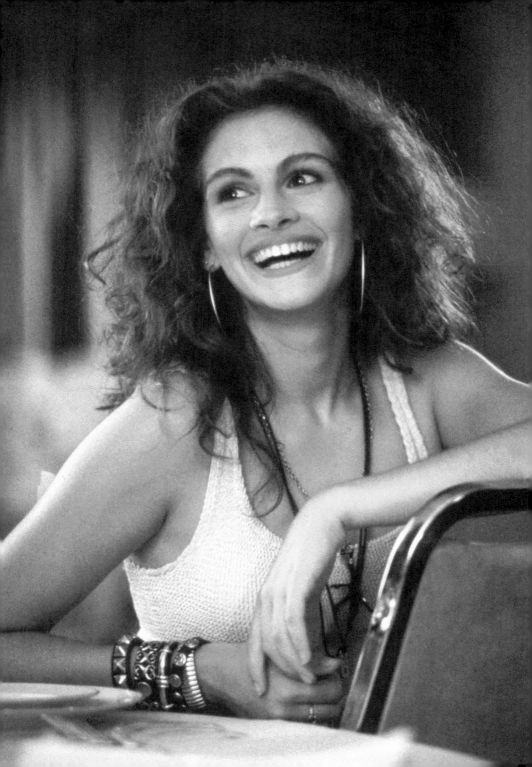

LADY MISS KIER
Deee-Lite reignites disco

Deee-Lite, and its lead singer Lady Miss Kier, shot to stardom in 1990 with the smash hit 'Groove is in the Heart'. She was born Kierin Magenta Kirby (1963–) in a small town in Ohio. She moved to New York to study fashion design and saw a ready-made market for her disco-ready clothing among friends whom she met on the club scene – Disney-princess-pink for the girls and blue glitter suits for the boys, all set off to perfection by silver platform boots.

One of her clients was the Russian DJ Dmitry Brill, who persuaded her to record a demo with him and the Japanese DJ Towa Tei. The result was the disco–house–funk fusion that was Deee-Lite, in which Kirby's gorgeously soulful voice was backed up by a funky, highly danceable beat. It was the music that came to define the early 1990s club culture of New York City.

It was Kirby who created the exuberant look of the band, forging for herself the fantasy alter ego of Lady Miss Kier, the ultimate club diva. With her white-powdered face, razor-sharp drawn-on brows and 7.6cm (3in) fake eyelashes, Lady Miss Kier was like a female drag queen. She took the colourful 1960s retro influences that were circling the club and street scene at the time and nailed them to the Deee-Lite fashion wall, creating a stage-worthy look that involved Pucci catsuits, candy-coloured minidresses, towering platforms, sculptural heels and a gravity-defying flicked-up hairdo.

The Deee-Lite team: for a few, dizzying, 1990s moments, some experts rated Lady Miss Kier as serious competition for Madonna herself.

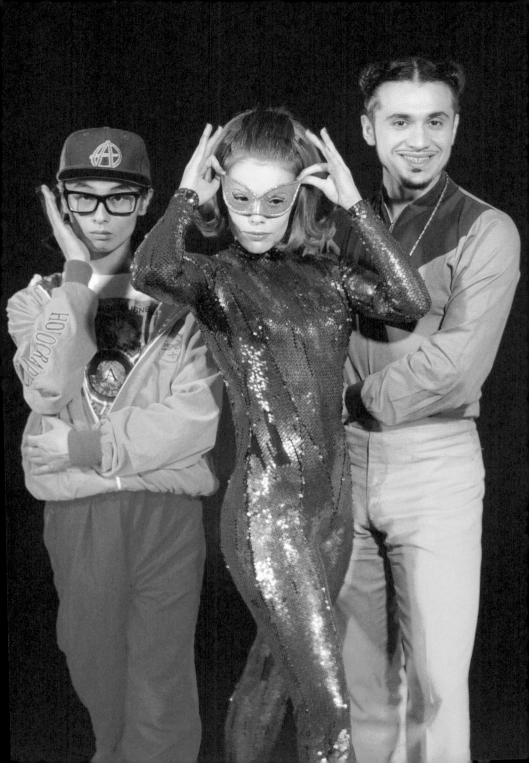

STEVEN MEISEL
The supermodels' Svengali

In the war between publishing giants Condé Nast and Hearst, photographers were the magazines' most potent weapons. Steven Meisel (1954–), signed exclusively to *Vogue*, ended up being the highest-paid photographer of the time. His very controlled, unashamedly artificial and often provocative style defined the look not only of fashion magazine spreads, but also of many of the big fashion campaigns of the decade – from Dolce & Gabbana (see page 452) to Valentino (see page 194), Calvin Klein (see page 444) and Gap (see page 450). And his was the lens that captured Madonna (see page 360) at her most unencumbered in her notorious book *Sex* (1992).

With his poker-straight black hair, unlined olive skin, arching dark brows and inscrutable black eyes, Meisel cut an exotic figure, even in an industry where the unusual is normal. In spite of only ever wearing black, he could easily be spotted across a dark runway in his 'uniform' of trench coat and flap-eared, rabbit-fur hat (winter) or black bucket hat (summer).

Linda Evangelista was his muse. He worked with her more than any of the other supermodels. His photographs of Christy Turlington, Naomi Campbell and Evangelista defined their iconic status. It was Meisel who packaged them as 'The Trinity', transforming them from individual superstars into a collective fashion force. Cindy Crawford once tried to explain his Midas touch: 'He makes you believe in what it is you are supposed to be the minute you walk in the door. You walk out thinking you took the most brilliant pictures ever.'

Steven Meisel out clubbing with Naomi Campbell in 1990. Despite his starry friends, Meisel is notoriously reticent with the media and dislikes being photographed.

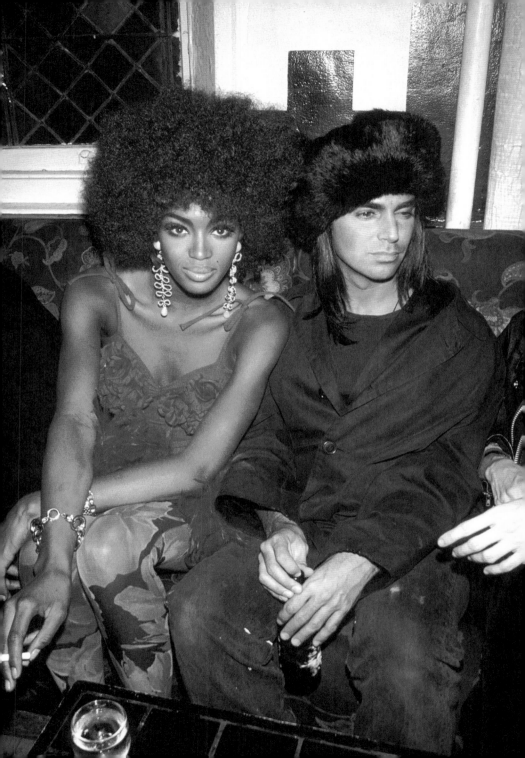

KATE MOSS / CORINNE DAY

Fashioning the world's most influential waif

Kate Moss's remarkable career was launched in the July 1990 issue of *The Face*. The photographer who was instrumental in her success was Corinne Day (1962–2010), who, with stylist Melanie Ward, shot the 16-year-old model on England's Camber Sands for the eight-page editorial 'The Third Summer of Love'.

Corinne Day had learned how to use a camera while she was working as a model in Milan. Her simple, documentary style was a reaction against what she saw as the remoteness of high fashion. She hated the models of the time, dismissing their look as 'stale, just about sex and glamour, when there are other elements of beauty'. The scraggy-haired Croydon schoolgirl Kate Moss (1974–), a rank beginner at the model agency Storm, instantly appealed to her. Together, they revolutionized fashion photography.

Model and photographer were commissioned for a cover shoot for the March 1993 issue of British *Vogue*, and Moss's transition from the niche style press to the mainstream was complete. The image of the doe-eyed Moss, staring out of that cover, her hair scraped back and her face unadorned, presented the fashion industry with a seductive alternative to the Amazonian 'Big Six' supermodels.

The potent combination of Kate Moss and Corinne Day turned fashion on its head and kicked off the whole grunge movement (see page 454) in the 1990s in a blaze of controversy. The bemused debate over how Moss could ever have become a model – at her height, with no boobs, bandy legs and such knobbly knees – would rumble on for years.

Kate Moss's fresh-faced looks and Corinne Day's unencumbered photographic style were first brought together in the July 1990 'Third Summer of Love' issue of *The Face*. Their relationship was cemented in 1993 when Corinne photographed Moss for the front cover of British *Vogue*.

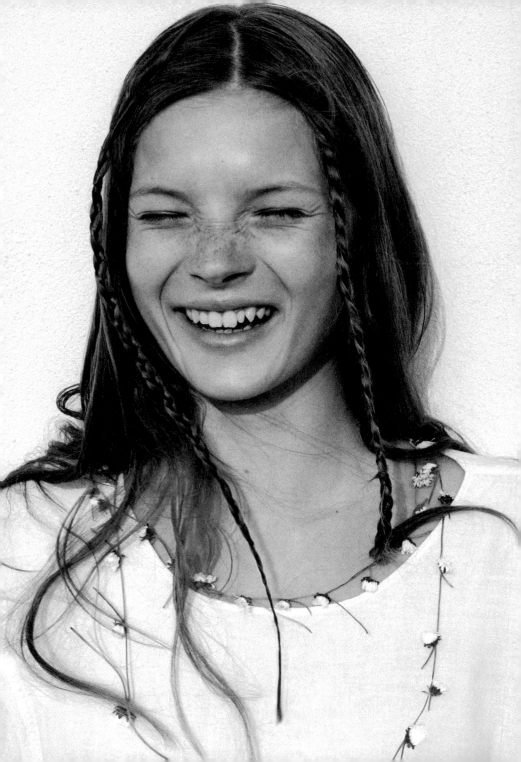

GANGSTA RAP

The sound of the mean streets

In the 1990s hip-hop (see page 380) ceded to gangsta rap. By the middle of the decade, the key influence in hip-hop fashion came from the dress styles of street thugs and prison inmates. Gangsta rappers such as N.W.A. (Niggaz Wit Attitude), Wu-Tang Clan and Gang Starr wore Chuckie's khaki pants, plaid shirts and white Champion T-shirts, Raiders Starter jackets and a plethora of logos. They accessorized with Carhartt and Timberland, Chuck Taylor sneakers, black Raiders baseball caps, and bandannas.

The style of wearing trousers saggy and low-slung, without a belt, emulated the look of offenders whose belts and shoelaces were removed when they arrived in prison.

Of the mainstream fashion brands, Tommy Hilfiger (see page 488) was anointed the rappers' brand of choice after Snoop Dogg wore a Hilfiger sweatshirt during an appearance on *Saturday Night Live*. Hilfiger's perceived waspy exclusivity made it desirable, and New York stores sold out of the Snoop Dogg shirts within 24 hours of the show. Hilfiger courted the new market, featuring black models in the company's advertising campaigns, and rappers such as Puffy and Coolio on his runways.

Hip-hop fashion became big business as white kids in the suburbs developed a taste for the streetwise wardrobe. Brands such as Phat Farm, Sean John and Rocawear made hundreds of millions of dollars dealing in mainstream hip-hop fashion.

Ice Cube, one of the founders of gangsta rap, in 1991. Gangsta's political and violent lyrics were matched by a look that was at once aggressive and aspirational.

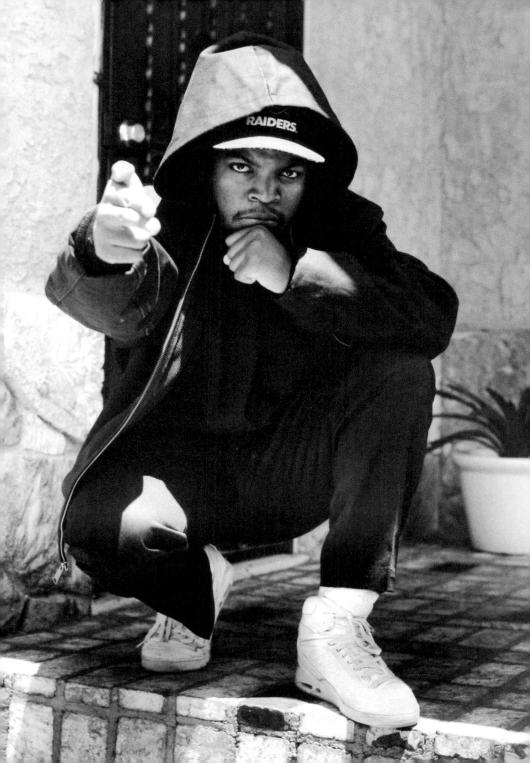

'HAMMER PANTS'
'You can move in 'em. You can dance in 'em'

In the beginning they were called 'parachute pants'. This, undoubtedly, had something to do with the way the fabric ballooned around the crotch and thigh whenever the wearer moved. But, in the 1990s, B-boys and B-girls (better known by their media misnomer 'breakdancers') loved them. The loose fit allowed them to move with ease. They were particularly useful if cut in nylon or some comparably slippery synthetic — all the better to spin or slide in.

Along with a nylon tracksuit, parachute pants were standard issue for any self-respecting B-boy at the time. As described by author Vicky Carnegy, 'serious dancing meant a serious dance style — clothes that were eye-catching but also comfortable to move in'. The athletic and often extremely dangerous dance moves caught the attention of the mainstream in a number of films — *Wild Style* (1983), *Breakin'* (1984) and *Delivery Boys* (1985) among them — and, consequently, their fashion influence spread.

Then, in 1990, along came Stanley Burrell (1962–), the artist known as MC Hammer, who inspired the term 'Hammer pants' after he appeared in a customized pair of parachute pants in the video for his hit 'U Can't Touch This'. Hammer's version were tight at the ankles and extremely baggy at the crotch, making them perfect for his onstage antics.

Burrell neatly summed up the appeal of the pants that ever after were known by his name: 'You can make a fashion statement,' he said. 'You can move in 'em. You can dance in 'em…It accentuates the movement, and it gives you freedom of movement…You move, and then the pants move, so it brings a nice little flair.'

MC Hammer's flamboyant stage outfits invariably included 'Hammer pants' — loose-fitting trousers, somewhere between Turkish harem trousers and the Indian dhoti.

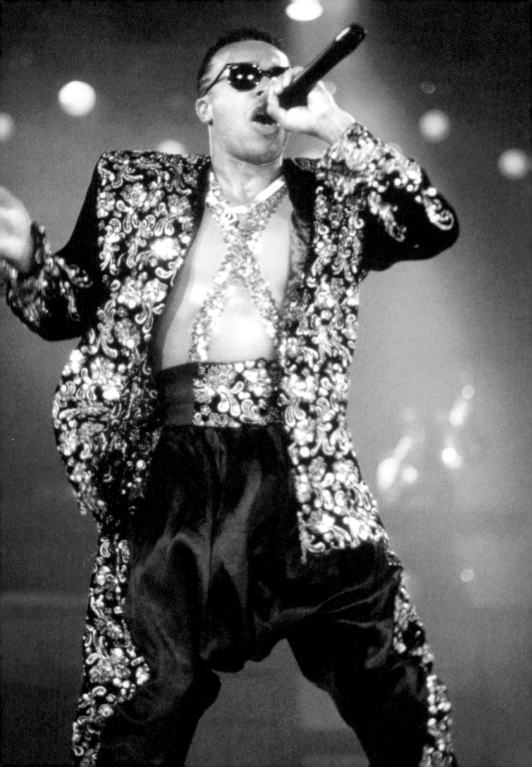

SUPERMODELS
Bankable beauties

Naomi Campbell (1970–), Linda Evangelista (1965–), Tatjana Patitz (1966–), Christy Turlington (1969–) and Cindy Crawford (1966–) officially crossed over into uncharted territory of modelling fame in January 1990, when they appeared on the cover of British *Vogue*, shot by Peter Lindbergh. This was undoubtedly the moment when these fabled beauties, all of them wrapped in Giorgio di Sant' Angelo jersey and all of them established household names, were raised to the pantheon of 'supermodels'.

Along with Claudia Schiffer (see page 438), they were termed the 'Big Six' and quickly established credentials well beyond the confines of fashion. They appeared on talk shows, dominated daily gossip columns, landed movie roles, dated or married film stars, and earned fortunes. Fame empowered them to market themselves as global brands commanding higher and higher fees. Christy Turlington's contract with Maybelline earned her $800,000 for just 12 days' work each year. In 1995 Claudia Schiffer reportedly racked up a startling $12 million for her year's work.

The supermodel phenomenon, however, scarcely outlasted the decade. By the late 1990s pop singers and actresses were already beginning to oust professional models from the covers of fashion magazines. Celebrity rather than outright beauty moved into the limelight. Schiffer theorized: 'In order to become a supermodel one must be on all the covers all over the world at the same time so that people can recognize the girls. That is, for now, not possible, not least because the advertising industry is very much taken nowadays by pop stars and actresses. Supermodels like we once were don't exist any more.'

Supermodels in the ascendance. From left to right: Linda Evangelista, Cindy Crawford, Naomi Campbell and Christy Turlington on the Versace catwalk in 1991.

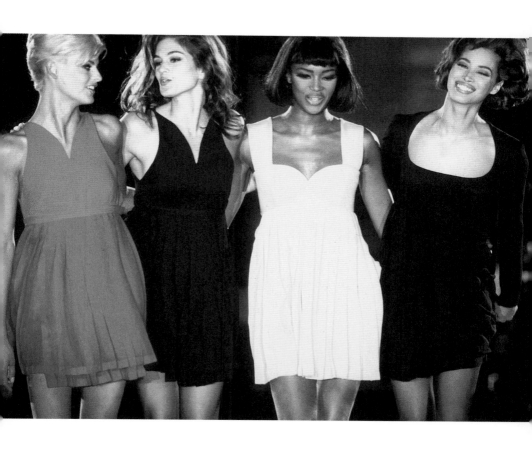

PATRICK DEMARCHELIER PHOTOGRAPHS DIANA, PRINCESS OF WALES

A new decade, a new Diana

In the 1990s the Princess of Wales's 'lamb dressed as mutton' wardrobe was gradually replaced with one of simple sophistication. She had worked out what suited her best and now favoured a style that was elegantly pared down and flattered a honed and fit body. After years of being celebrated as a fashion icon, she actually became one. The pictures that, arguably, changed everything were commissioned in 1991 by British *Vogue* editor Liz Tilberis (see page 442), for a cover of the magazine. They were styled by Diana's trusted wardrobe advisor, the magazine's deputy editor Anna Harvey. The photographer was the Frenchman Patrick Demarchelier (1943–).

Royal observers often labelled Demarchelier's photographs of Princess Diana as 'iconoclastic'. No one, it seemed, had ever imagined a royal portrait could look like that. Diana appointed Demarchelier her personal portraitist, which made him the first non-Briton to fill such a role for the Royal Family. He was to photograph her many times for British *Vogue* and, later, when Liz Tilberis moved to New York, for *Harper's Bazaar*. It was for *Bazaar* that he produced the well-known black-and-white photo of the Princess wearing a strapless dress, a tiara and a luminous smile. His pictures were borderline shocking at the time because of their informality and spontaneity.

Demarchelier astutely identified key things about the princess that no other photographer had managed to capture. 'Diana was funny and kind but fundamentally she was a very simple woman who liked very simple things,' he said. 'She looked both in control and sweetly vulnerable, with plenty of her typical coyness.'

Patrick Demarchelier at a photoshoot (above) and in his studio (below), where his famous photograph of Diana for the December 1991 cover of *Vogue* can be seen.

ABSOLUTELY FABULOUS

Sending up the fashionistas

In the television show *Absolutely Fabulous*, Edina (Eddy) Monsoon (played by Jennifer Saunders) and Eurydice Colette Clytemnestra Dido Bathsheba Rabelais Patricia Cocteau Stone, known as Patsy Stone (played by Joanna Lumsley) were career women on the London fashion scene. Eddy ran her own PR firm, which had only one regular client, the singer Lulu, and only one member of staff, an assistant called Bubble. Patsy was a well-paid fashion editor without portfolio on a glossy magazine, with an exaggerated sense of her own importance: 'One snap of my fingers and I can raise hemlines so high, the world is your gynaecologist.'

Edina was mildly overweight, a fact she tried to disguise with flamboyant layers of the latest designer must-haves. Patsy was comparatively stylishly dressed, often in something Chanel-esque, and wore her hair in a characteristic blonde beehive. She claimed not to have eaten anything since 1973. Precious little work ever seemed to be done, but the boozy besties could certainly put an eye-catching look together, spending their nights fuelled by a combination of 'Stoli' and 'Bolli', and many of their daylight hours engaged in marathon shopping sprees at 'Harvey Nicks'.

Despite its merciless and hilarious send-up of the fashion industry and the cult of celebrity, *Absolutely Fabulous*, first aired in 1992, had no shortage of 'celebs' lining up for guest appearances. Curiously, too, it often managed to hype what it sought to ridicule. *Ab Fab* made designer Christian Lacroix (see page 392) a household name after an episode featured him in a scene shot in his Sloane Street shop.

Patsy and Eddy strut their stuff during an episode of *Absolutely Fabulous*. The duo's ridiculous clothes satirized the gulf between glamorous image and imperfect reality that has always been the 'dark side' of fashion.

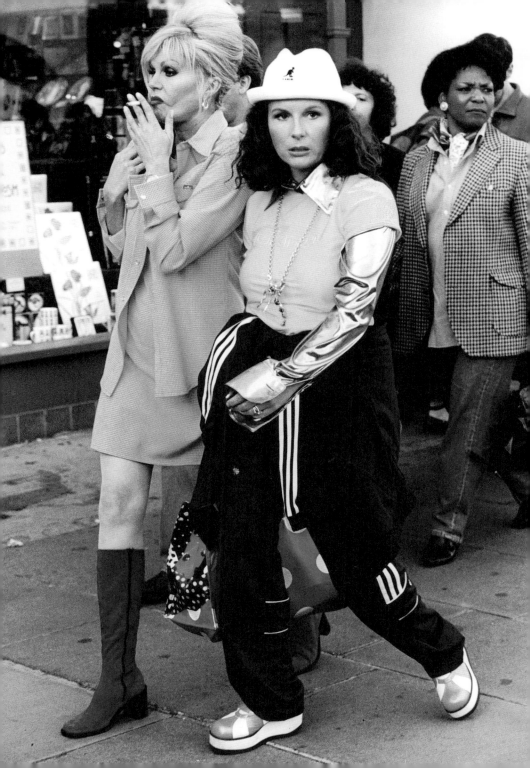

CLAUDIA SCHIFFER
Fashion's favourite sex kitten

In 1987 the teenage Claudia Schiffer (1970–) was spotted at a Düsseldorf disco by the owner of a modelling agency. She was aiming to go to law school, but her parents were persuaded to let her go to Paris instead. Schiffer, who at the time felt slightly awkward about her height and looks, was convinced that it would come to nothing: 'After I was discovered, and did the test shots, I was sure that they would realize they had made a mistake and send me back.'

As it turned out, there had been no mistake. Schiffer's springboard to fame came in 1990 in the shape of a Guess jeans campaign, shot by the then relatively unknown photographer Ellen von Unwerth. Von Unwerth created for the model a playfully sexy image that capitalized on her likeness to the kittenish Brigitte Bardot (see page 68). She rose to the dizzying heights of supermodel stardom as a favourite of Karl Lagerfeld (see pages 258 and 388) and would eventually appear on the covers of more than 500 magazines, including *Vogue, Cosmopolitan* and the iconic music magazine *Rolling Stone*, becoming the first model ever to do so. She walked the runway for virtually every major designer and became nearly omnipresent in marketing campaigns.

Schiffer was the first great supermodel of the 1990s, attracting fees as high as $50,000 a day and earning millions more through licensing and endorsements.

Claudia Schiffer in Paris in 1992. Schiffer's reign as queen of the catwalk in the early 1990s heralded the second great generation of supermodels.

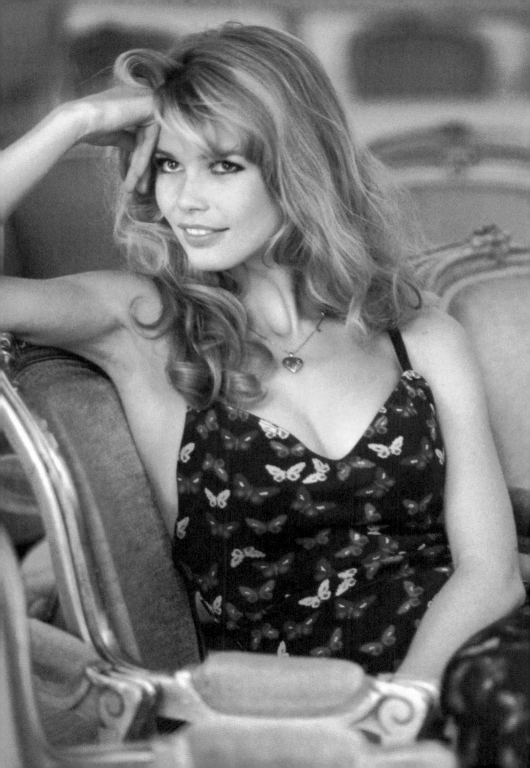

Joe McKenna may not be a household name, but he is the quintessential industry insider: the *éminence grise* behind some of the most influential fashion imagery of the decade. Whether it's for Calvin Klein (see page 444), Yves Saint Laurent (see pages 162 and 288), Versace or Jil Sander (see page 480), Banana Republic or Gap (see page 450), the McKenna signature is one of uncompromising simplicity and precision. In the decade when fashion was in thrall to the discipline of minimalism, he became the stylists' stylist.

Born just outside Glasgow, McKenna moved to New York in 1986, initially working at *Vanity Fair* and *Rolling Stone*. In the 1990s he styled Calvin Klein's CK One ads, working with photographer Steven Meisel (see page 424). He also started a long and close association with Azzedine Alaïa (see page 372) and Jil Sander, whose advertising images he styled, setting a new standard for high-fashion glamour. However, his most engaging and enduring projects have arguably been with Bruce Weber (see page 334). McKenna's discovery of the photographer's sexed-up naturalism was a career-defining epiphany for the boy from Kirkintilloch, and their collaborations yielded some of the most daring images of the time.

In 1992, and again in 1998, McKenna published *Joe's*, a magazine that was a showcase for the photographers he worked with, a soapbox for the designers who employed him and a shop window for ideas unencumbered by the commercial demands of the newsstand. There may only have been two issues, but they still change hands on the Internet at prices that are escalating faster than blue-chip stock. At the height of the supermodel era, McKenna gave his first cover over to the Virgin Mary, who was depicted gazing upward and serenely exhaling a ribbon of smoke.

A spread from the first issue of *Joe's* magazine featuring Stuart Friedman. Joe McKenna's high-concept journal helped to secure his position as the 'stylists' stylist'.

LIZ TILBERIS

The lady who rebooted American style

It can be said, without any exaggeration, that Grace Coddington (see page 482), Anna Wintour (see page 516) and Liz Tilberis (1947–99) were the three British women who forever changed fashion in the 1990s. All three had been colleagues at British *Vogue*. Coddington and Wintour went to American *Vogue* in 1988. Tilberis followed them to New York in 1992, to be editor-in-chief of the magazine's main rival – and the United States' first fashion journal – *Harper's Bazaar*.

At the time, the magazine was long past its heyday and competition in New York was fierce and relentless. It was feared that Tilberis, known for her warmth and humility, was a lamb to the slaughter. Certainly, it was a lonely time for her, as the industry waited with perfectly plucked eyebrows to see if she would succeed or fail. Her secret weapon, however, was the French art director Fabien Baron. Together, they helped usher in a minimalist aesthetic that perfectly reflected the fashion zeitgeist of the 1990s.

Baron's 1992 redesign is still a benchmark in the magazine world. The magazine's new style was characterized by layouts breezy with cool white space, tempered by the use of bold, overlapping typography. Photographs, and their creators, were treated with a new respect.

The style of the revamped magazine took all of *Bazaar*'s competitors by storm, and it was quickly dubbed 'the world's most beautiful fashion magazine'. With the winning combination of Baron's artistic virtuosity and Tilberis's vision of practical, democratic fashion, the duo created a magazine that was a few degrees cooler than its brasher rivals and which took understated glamour as its blueprint.

Liz Tilberis at her desk in 1992, freshly appointed editor-in-chief of *Harper's Bazaar*. Her reinvigoration of the venerable but tired fashion magazine first astounded and then delighted the New York fashion scene.

CALVIN KLEIN
Minimalism and provocation

Hard to credit it, but at the end of the 1980s Calvin Klein (1942–), the genius of the American designer jeans boom, was facing bankruptcy. In the course of the 1990s, he reinvented himself as fashion's master minimalist and made a vast fortune with his underwear, fragrance and secondary CK lines. Fashion was primed and ready for Klein's minimalist aesthetic. After the excesses of the 1980s and troubled by the political upheaval caused by the recession and the war in the Gulf, the establishment embraced the new simplicity. The language of architects started to appear in catwalk press releases.

But Klein's masterstroke was his ability to lace what could easily have remained a high-fashion aesthetic with outright provocation, and thereby spread his message on a mass commercial scale. He had already proved, with his controversial jeans ads featuring the young Brooke Shields in the 1980s, that he was not afraid of ruffling fashion's feathers. In the 1990s, now with the waif-like Kate Moss (see page 426) as the face of his brand, he explored the outer reaches of sex and androgyny. An especially controversial advertising image for Calvin Klein Jeans in 1995 even led to accusations of child pornography.

Klein cemented his high-fashion status in 1993 by being named both Womenswear and Menswear Designer of the Year by the Council of Fashion Designers of America. His advertisements may have been deemed inappropriate, but his design philosophy remained consistent: sexy, clean and minimal.

The image taken by Herb Ritts (see page 410) of the pop singer (and, later, actor) Mark Wahlberg was a typical example of Klein's provocative, in-your-face advertising, at once shocking and titillating.

444

BENETTON / OLIVIERO TOSCANI 1992
Politically incorrect advertising

In the 1980s Oliviero Toscani (1942–) created an iconic but cosy advertising campaign featuring multiethnic models for the mass-market knitwear retailer Benetton. But in the 1990s the ads became progressively edgy and more controversial. They tackled topics such as race, politics, social issues and sexuality. There were images of a nun kissing a priest, and the bloodied uniform of a Bosnian soldier. One of the most controversial was the picture captured of AIDS activist David Kirby on his deathbed, surrounded by his family.

During Toscani's time as art director and photographer for Benetton in the 1990s, the company's advertising never featured a single branded product in their mainstream campaigns. The brand gave Toscani free rein and he relentlessly turned up the heat of public outrage with each new set of photographs. He defined Benetton as a brand in pursuit of the provocative and controversial, one that was never afraid to engage in topical debate.

In spite of product playing second fiddle to the message, sales rose and Benetton became one of the best-known clothing brands in the world. Toscani himself seemed to believe he had a higher calling. 'I am not here to sell pullovers,' he said, 'but to promote an image…Benetton's advertising draws public attention to universal themes.' But, eventually, the ads began to cause costly rifts with consumers and retailers. In 1995 Benetton was sued by German retailers, who argued that Toscani's images sabotaged their sales efforts. An image of American prisoners on death row, including their names and the dates of their execution, proved the final straw. The furore that followed was the catalyst for Toscani's departure from the company.

The image of a nun kissing a priest was a calculated provocation, especially given the fact that Benetton was an Italian company, but its shock value was mild in comparison with what was to follow.

UNITED COLORS
OF BENETTON.

ACID HOUSE
The ecstasy of dance

After Britain's 'Second Summer of Love' in 1988, rave established itself as a massive youth subculture. Its beginnings were innocent enough. As in the hedonistic days of the Summer of Love in San Francisco two decades earlier (see page 182), the general idea was to 'turn on, tune in and drop out'. Impromptu (and illegal) raves drew revellers in tie-dyed T-shirts, first in their hundreds and then in their thousands. The repetitive, driving dance beats had a psychedelic flavour, and LSD once again became the fashionable drug of choice. It was when acid house became 'acieeeeed' that rave culture, in the eyes of the tabloid press at least, became a threat to the very moral fabric of society. But by then it had also been embraced by many as part of the mainstream.

The rave scene always had its own fashions, but it was not designer-led. The hedonistic DIY aesthetic of acid house was a spontaneous style statement that belonged to rave alone; these revellers needed no help from Paris or New York to get their look together. Acid-bright colours, luminous work jackets and white gloves popped under the strobe lights. Elements of boho chic, tie-dyed T-shirts and beaded jewellery, meanwhile, forged a link with hippie hedonism. Boilersuits, dungarees and Kicker shoes were easy to dance in for hours and hours on end. And the accessories of choice were whistles, glowsticks and adult-sized dummies. The London club Fantazia's smiley face T-shirt was one of the decade's must-haves.

Right and below: The often arcane stylings adopted by acid house revellers might seem puzzling, until you remember that the clinical white and Day-Glo colours were chosen especially to show up under the pulsating strobe lights, almost like a hallucinatory dream.

GAP
The global wardrobe essential

In the 1990s a desire for clothes that were unpretentious and comfortable drew customers to Gap in droves. An apparently magical formula of quality, classic design, affordable prices and a (relatively) cool image ensured that Gap became the fashion destination for millions.

Gap (as in 'generation gap') was founded in 1969 by a property developer, Donald Fisher, who opened his first store in San Francisco. It quickly grew into a juggernaut that encompassed clothing, shoes, accessories, fragrances and underwear. Not only did it serve customers' need for these items, but it also created them. 'Fashion ground to a halt in the 1990s and Gap was there to address the dress-down trend in a big way,' commented one pundit. 'Every six weeks Gap has a fresh assortment – not necessarily new designs but new colours. The customer gets the message straight away.'

Gap didn't just put paid to the idea that fashion was the preserve of the rich. It went further: it made designer labels start to look like a rip-off. Increasingly, it became a badge of honour to bag a bargain, even among the affluent. Marketing analysts termed the trend towards functional clothes the 'commoditization' of fashion. Some critics felt that the designer fashion industry had driven a nail into its own coffin by embracing 'classics', 'simple chic' and 'minimalism' as the key catwalk trends of the decade.

Not even the red carpet, that last bastion of glamour and couture, was beyond the reach of fashion democratization. When Sharon Stone, one of the biggest movie stars of the decade, pitched up onstage at the 1995 Academy Awards wearing a $22 Gap turtleneck teamed with a long black skirt, she sparked a frenzy among shoppers, who drove sales of 'the Sharon Stone shirt' into millions in the months that followed.

The creative collective Art Club 2000 used Gap as the first subject of its performance pieces about brands and their iconography. The images were later reproduced in *The Face* and *Dazed & Confused*.

DOLCE & GABBANA

Milan's rising stars

Domenico Dolce (1958–) grew up near Palermo in Sicily. His partner, Stefano Gabbana (1962–), is from Milan, the heart of the industrial north. As Dolce & Gabbana, the designers have always reflected the extremities of the Italian peninsula: the glossy style of the north and the sensuality of the south. Their catwalks are populated by every manifestation of the archetypal Italian woman: from the Madonna to the whore, from the diva to the debutante. Italian wives, mothers and lovers are the DNA of every Dolce & Gabbana collection.

The pair launched their label in 1985 but it wasn't until the 1990s that they started to achieve international status. The Italian fashion industry is dominated by long-established houses, businesses that operate on a massive industrial scale. It is difficult for a newcomer to break into that exclusive group and almost unheard of for minnows to measure up to the commercial giants. But, by the end of the 1990s, it was reported that Dolce & Gabbana sales had reached around $500 million per year.

The duo built their empire by making women look fantastically sexy. There is nothing groundbreaking about their silhouette or construction. On the contrary, many of their shapes are classics from the pre-feminist era reinterpreted for a contemporary audience. But the designers' keen appreciation of sex appeal and old-fashioned femininity struck a chord with many women, who fell for the promise that, in Dolce & Gabbana, everyone could look like a screen goddess.

Madonna (see page 360) wears Dolce & Gabbana at Wembley Stadium, London, in September 1993, at the opening performance of her 'Girlie' world tour. In the Italian arriviste brand, the 'queen of pop' found the perfect match for her (latest) persona – glamorous, playful and outrageously sexy.

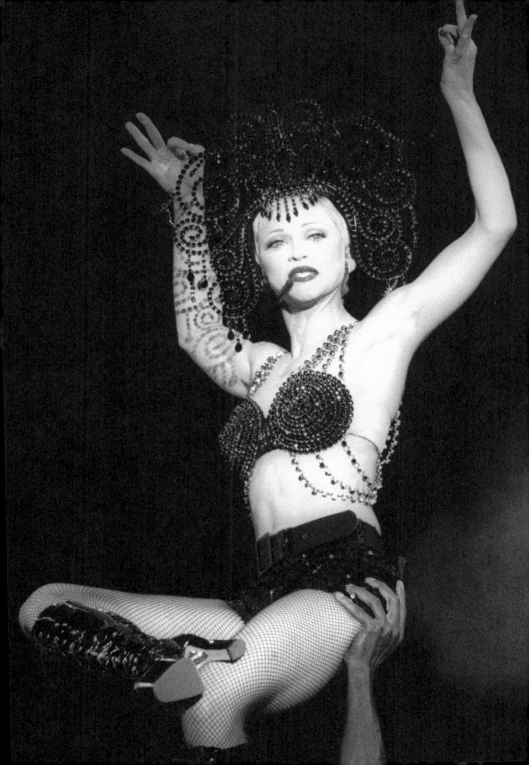

GRUNGE

The triumph of 'unfashion'

Grunge was never meant to be fashionable. In fact, it was so far removed from fashion that it wasn't even anti-fashion. Or, as James Truman, then editor of *Details* magazine, said in 1992, 'It's unfashion'. The fleece layers, flannel shirts, beanie hats and work boots were the everyday wardrobe of the Seattle working class and were adopted by the musicians and acolytes of the underground scene that grew up in the town. In the early 1990s one critic named Seattle 'the worst-dressed town with the best music scene in the world'.

Inasmuch as grunge became street fashion, it was about 'disappearing' as opposed to 'appearing'. It was a way of bowing out of the pressure to conform, a way of saying no to having to look good. The US media and popular culture had long been dominated by images of the body beautiful, and grunge was a look that united people who were striving to have a 'non-look'. Grunge clothes came from flea markets, charity shops and refuse bins, not from the rails of chichi boutiques.

Then, in 1992, Marc Jacobs (see page 456), designing for Perry Ellis, introduced his now-notorious Spring/Summer 1993 grunge-inspired collection, and turned a no-nonsense style of dressing into a catwalk statement. Jacobs certainly nailed the look: shapeless floral dresses were worn with flannel lumberjack shirts and combat boots by models with scrubbed-clean faces decorated only with nose rings.

This co-option of grunge by the establishment lasted barely a season. In 1994 the lead singer of Nirvana, Kurt Cobain – its poster boy – committed suicide, and the global recession lifted. Thrift shopping became passé and grunge was relegated to a phase that fashion preferred to forget.

American rock band Nirvana was the quintessence of the grunge sound and look. Kurt Cobain (1967–94), its lead singer, and Courtney Love, his wife, in 1993.

MARC JACOBS
New York's new star

A graduate of The New School, Parsons School of Design, Marc Jacobs (1963–) was only 25 when he joined the all-American sportswear house Perry Ellis. It was a risky but not a baseless choice. The young Jacobs managed to reinvest the label with some of its founder's energy, infusing it with a dose of Manhattan street-smart wit. Winners included a red-and-white tablecloth cotton shirt complete with embroidered black ants, and the 'Freudian slip', a shift dress printed with the brooding face of the 19th-century Austrian psychoanalyst.

Things took a turn for the interesting in October 1992 when Jacobs presented his now-legendary 'grunge' collection (see page 454). It was inspired by the cult that had built up around musicians in Seattle, a city Jacobs admitted he had never visited. It featured floral slip dresses, accessorized with combat boots and knitted beanie hats, and silk shirts printed to look like flannel. Although the collection never made it into the shops, and got Marc Jacobs fired from his first big job, it established him as a singular creative force on New York's Seventh Avenue.

In 1997 came another surprising career choice, when Jacobs accepted an appointment as creative director of the 146-year-old French luggage and handbag company, Louis Vuitton, as its owner, Bernard Arnault, believed that a fashion collection could put some sizzle into the brand. Jacobs's look for Louis Vuitton began discreetly enough, with LV logos hidden in out-of-the-way places, beneath buttons or on the soles of shoes, but bolder moves were not far behind. He embossed primary-coloured patent-leather bags with the logo and he made raincoats scattered with tiny LVs. The critical kudos his collections garnered was matched by an astounding commercial success, with a quadrupling of sales by the middle of the following decade.

Marc Jacobs and actress Tatum O'Neal arrive at the Fashion Designers Awards in New York in 1993. 'Talents like Mr Jacobs have become exceptional,' wrote Amy Spindler of the *New York Times*. 'He has become the most consistently strong, individualistic, real, live, kicking designer in New York.'

MARIO & DAVIDE SORRENTI

Shooting heroin chic

It is the photographer Mario Sorrenti (1971–) who is often credited with creating the controversial look that became known as 'heroin chic'. As the 1980s drew to a close, Sorrenti was introduced to Calvin Klein by Phil Bicker, the art director with whom he worked at *The Face*. In 1993 Klein commissioned him to shoot the advertising campaign for his new fragrance Obsession, and the images that Sorrenti shot of Kate Moss (see page 426) – his girlfriend at the time – launched him into the big league. The campaign proved highly contentious, with both Sorrenti and Moss subjected to a torrent of criticism for taking Twiggy's 'waif' look (see page 184) to another, more sinister, level.

Mario Sorrenti's downbeat approach had much in common with that of his younger brother, Davide (1976–97), also a fashion photographer, whose naturalistic documentary style was so startlingly opposed to the heavily airbrushed, unfeasibly glamorous images of the 1980s. Like his brother, Davide, too, faced accusations that the distracted, blank gaze of his models glamorized heroin addiction. One of Davide's best-known photos showed his painfully thin teenage girlfriend Jaime King lying on a bed, her clothes torn, surrounded by photos of celebrity drug victims, including Kurt Cobain of grunge rock band Nirvana. Davide died in 1997, at the age of 20, of causes that were probably related to heroin abuse.

The debate about the responsibilities of the fashion industry would rage on into the next decade. But, meanwhile, fashion's fascination with the natural, unvarnished look that once had been so radical gained acceptance through the work of photographers such as Juergen Teller, Craig McDean and David Sims. Having started as an underground trend, the approach soon went mainstream as more commercial photographers started copying the style.

Mario Sorrenti's naturalistic, downbeat style, evident in this advertising image for Calvin Klein's Obsession, featuring the young Kate Moss, heralded a new direction in fashion photography – away from airbrushed glamour and towards photorealism. The trend, however, had its darker side.

MARTIN MARGIELA
The thinking woman's designer

The Belgian designer Martin Margiela (1957–) graduated from the Royal Academy of Fine Arts in Antwerp and briefly worked as an assistant to Jean Paul Gaultier (see page 356). He astounded the industry by treating fashion as an intellectual exercise, in the manner of the Japanese designer Rei Kawakubo (see page 348). Calling time on the conspicuous consumption of the 1980s, he explored unconventional notions of beauty and worked in isolation, ignoring existing trends.

Margiela's uncompromising approach set him apart from his contemporaries. The unfinished seams and deconstructed shapes of a Margiela garment constantly challenged the notions of wearability. He gave catwalk presence to the humblest of materials – plastic bags, porcelain shards, even discarded car keys. In his hands, other people's rubbish became covetable again.

Experimentation did not end with his use of materials. Margiela felt that professional fashion shows had gone stale and, accordingly, held his seasonal shows in some outlandish places. From circus tents to supermarkets and subways, he invested every presentation with the frisson of the unexpected. His models were often women he had spotted in the street.

For all his industry kudos, Margiela rejected the cult of the designer, working anonymously and refusing interviews. Known as 'fashion's invisible man', he rarely had his picture taken. It was on the quality and nature of his clothes that he wished to focus the spotlight. At the end of his shows he even took his bow as one of many team members, all dressed in identical white lab coats.

Opposite: Margiela's contribution to the exhibition 'Le Monde selon ses créateurs' at the Musée de la Mode et du Costume, Paris, 1991. Margiela's rigorously conceived clothes pushed couture deep into the realm of conceptual art.
Below: Shot of Margiela's Paris studio.

PRADA, READY-TO-WEAR

Unpredictable beauty

Prada launched its ready-to-wear line in 1985 but it didn't really gain commercial traction until the 1990s. Miuccia Prada (1949–) started with simple shapes, knee-length skirts, unfussy knits and well-mannered coats. Her clothes were hardly the height of fashion: they were simply useful things made desirable by exquisite fabrics. Despite, or because of, this, her deceptively plain clothes became widely influential. As she gained confidence, Prada would revisit traditional garments, trimming nylon parkas with mink and making twinsets out of silk faille. By the middle of the decade it seemed as if the whole world was craving what *Women's Wear Daily* called 'Prada's ice-cool minimalism and deadpan eroticism'.

The designer's singular vision evolved rapidly over the decade. 'She never follows anyone else's lead, just her own original energy,' commented Julie Gilhart of Barneys department store in New York. Her ambivalence about the dictates of fashion set her apart. 'I love fashion,' Prada said, 'but I think it should stay in its place and not rule your life.' She would often focus on a silhouette or a colour she loathed because of the satisfaction it gave her when she could make something beautiful out of it. She accessorized flannel knickers with fishing waders, and once showed a raincoat that was transparent until it got wet and became opaque.

Prada elevated colours such as institutional orange, toxic green and sludgy brown to couture elegance. She used crunchy polyester, parachute nylon and stiff rayon alongside precious silks and cashmeres. She took her inspiration from everything from 1950s pin-ups and tacky Venetian souvenirs to French haut bourgeois clothes and geek chic. The one thing that could be relied on from Prada was the fashion house's sheer unpredictability.

Miuccia Prada at the launch show of the Prada sub-brand Miu Miu, in New York, 1993. The line was so called for the designer's nickname.

ELIZABETH HURLEY IN VERSACE

A career-defining dress

The year 1994 saw the debut of 'That Dress': a sinuous, safety-pinned, neo-punk number ensured that Elizabeth Hurley (1965–) would never again be remembered simply as 'Hugh Grant's girlfriend'. In the time that it took to navigate a red carpet at London's Leicester Square, she achieved lasting fashion notoriety and was projected overnight onto the global media stage. The event was the premiere of Grant's film *Four Weddings and a Funeral.* The dress was, of course, by Gianni Versace (see page 490).

The floor-length black gown was cut from silk crêpe. Its plunging neckline was secured by skinny straps that were attached to the bodice with Versace's signature gold Medusa-head buttons. The side seams were split wide open but held together with several oversized gold safety pins. There was clearly nothing between the voluptuous curves of Liz Hurley and her Versace. She managed to be both fully and barely covered. To onlookers, it seemed as if she was one deep breath away from full exposure.

'That Dress' became a Versace icon, and Hurley's debut became a memorable fashion moment for millions. When, 20 years later, Lady Gaga wore the identical dress, it was Hurley – and how much better she had looked in it – who was discussed in the gossip columns and blogs. The dress topped a poll conducted by the department store Debenhams that asked 3,000 women to select their favourite red-carpet dress. Hurley's came first, ahead of classics worn by Julia Roberts (see page 420) and even Audrey Hepburn (see pages 52 and 122).

Elizabeth Hurley is living proof of the life-changing power of the right dress on the right body at the right time. After 'That Dress', Hurley became the sex symbol of a generation.

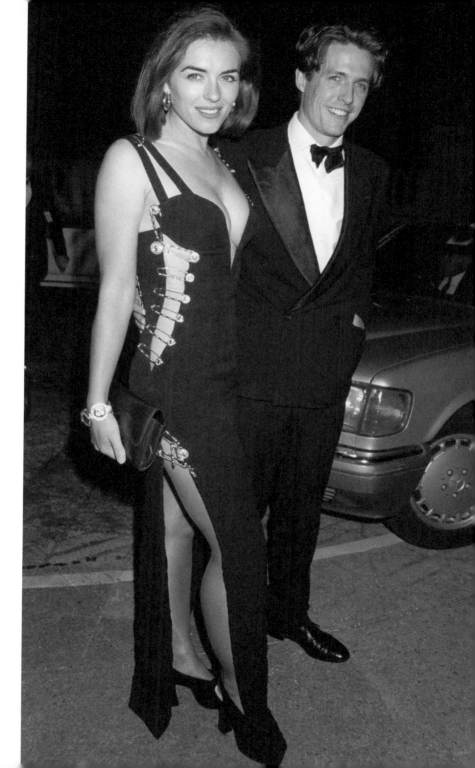

MADCHESTER

The brilliance of 'baggy'

In the late 1980s the British charts were dominated by the sounds of Duran Duran, Spandau Ballet and the pop pulp of Stock Aitken Waterman, and it seemed, as the *Guardian* stated, that 'the '80s looked destined to end in musical ignominy'. Then the 'Madchester sound' was unleashed, and packaged pop was blasted out of the cultural water as bands such as The Stone Roses and Happy Mondays forged a refreshing hybrid of alternative rock, psychedelic rock and dance music.

Manchester's Haçienda nightclub was a major catalyst, not only for the indie sound, but also for the distinctive fashion look that went with it. It was a scene that was baggy by name and baggy by nature. Loose jeans (often flared), teamed with brightly coloured or tie-dyed tops, and frequently topped off with a fishing hat, as sported by The Stone Roses' drummer Reni, became fashionable first in Manchester and then across the whole of the UK. The look was part-hippie, part-football casual. Vintage Adidas trainers (though not just any – Samba, Forest Hills and Stan Smiths were the models of choice) were worn with tracksuit tops from sports labels such as Fila and Sergio Tacchini.

Of course, this was not by any means the first time that fashions originating among working-class northern youth had become popular countrywide, but nothing had ever been picked up on by the mainstream to such a degree. For a few glorious years, Manchester, not London, defined British street style. Shami Ahmed's Manchester-based Joe Bloggs fashion label specialized in catering for the scene, and made him a multimillionaire, while brands such as Stone Island and Ralph Lauren (see page 324) cruised to commercial greatness off the back of the baggy look.

The Stone Roses (right) helped unleash not only a new sound but also a new look (below) – déclassé chic with a Manchester accent.

PIERCINGS & TATTOOS

Body art goes mainstream

In 1970 the well-known San Francisco tattooist Lyle Tuttle famously tattooed the wrist of Janis Joplin (see page 202) and from that moment the tattoo became an emblem of women's liberation. By the 1990s Joplin's torch of rebellion had been taken up by more and more women in the public eye. Carré Otis, Angelina Jolie and Drew Barrymore were among a number of high-profile female celebrities who unabashedly displayed their tattoos. Younger stars such as Britney Spears and Christina Aguilera were quick to follow suit.

The grunge 'revolution' (see page 454), meanwhile, brought about a growing interest in non-mainstream music and underground scenes as well as a resurgence of punk rock. And with it came a fascination with the hallmarks of these scenes and styles: tattoos and increasingly aggressive body piercings became commonplace. Initially, these body modifications may have been a way for people to set themselves apart from the mainstream, but, as with grunge itself, it didn't take long for the mainstream to co-opt these underground fashions.

Even fashion models, those paragons of female perfection, were at it. Stephanie Seymour and Christy Turlington both had tattoos. In the beginning most models were 'inked' in places that could easily be concealed for work. Others were less bashful. Jenny Shimizu arguably launched her career when she appeared as one of the tattooed rebels in the Calvin Klein CK One campaign and proudly sported her tattoos on the runway.

By the 1990s, people with body piercings and tattoos were no longer on the fringes of society. Body art may still have had the whiff of rebellion, but it was no longer the exclusive preserve of 'bad boy' rockers and gang members.

UMA THURMAN IN
PULP FICTION
The decade's *femme fatale*

One of the ultimate movie style icons of the decade was Uma Thurman (1970–), who played Mia Wallace in Quentin Tarantino's 1994 classic, *Pulp Fiction*. Mia, the wife of the terrifying mobster Marsellus Wallace, is the would-be star of a failed television show, *Fox Force Five*, who loves cheeseburgers, luxury milkshakes, Urge Overkill, air guitar and thought experiments. She is also a substance-abusing diva who sports a lacquer-black, blunt-cut bob.

Thurman's Mia was all understated simplicity: the perfect movie icon for the minimalist decade. Her black, cropped flares and crisp white shirt, worn with a black bra and ballerina pumps, became one of the defining looks of the decade. The former model's cool blonde looks were completely transformed by the black wig, turning her into an all-too-believable mobster's moll.

Those cropped flares happened, as many of the best movie wardrobe moments do, completely by accident. While working with the film's costume designer, Betsy Heimann, the 1.8m- (6ft-)tall actress couldn't find a pair of skinny black trousers with legs that were long enough. So Heimann just lopped 5cm (2in) off the hem, creating those slightly flared pedal-pushers that looked so good when Uma took to the floor with John Travolta.

Uma Thurman as Mia Wallace in Tarantino's *Pulp Fiction*. Her pared-back style of Cleopatra bob and cropped black flares made her the perfect femme fatale for the minimalist 1990s.

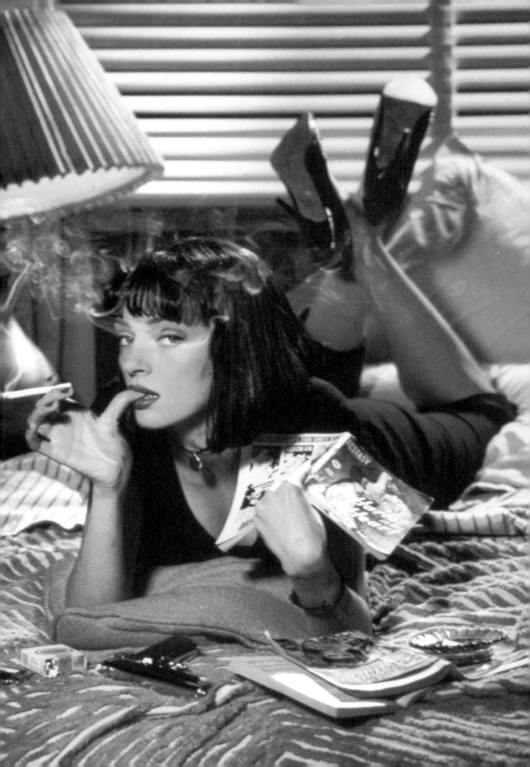

THE WONDERBRA

The decade's best supporting role

Sales of the Wonderbra had been ticking over nicely since the 1960s, when advertising for the underwired, padded cleavage-booster promised that it 'makes 34 look 36, makes 36 look pow'. In the early 1990s, the push-up properties of the Wonderbra were rediscovered by millions of curve-craving women who unabashedly wore their Wonderbras fully on display or barely hidden under mesh T-shirts or transparent blouses. (Lingerie as outerwear first became a fashion statement in 1990, when Jean Paul Gaultier (see page 356) designed the cone bra for Madonna's Blond Ambition Tour.)

Propelled purely by the momentum of the fashion fad, sales of the bra escalated at such a rate that, by 1993, it was estimated that one in eight of all the bras bought in the UK was a Wonderbra. The trend gathered momentum throughout the decade, with underwear being designed specifically to show under or through outerwear in eye-popping fluorescent colours and patterns, and often with a matching or clashing G-string showing above the waistband of jeans or low-slung trousers.

In 1994 giant billboards went up along major roads and roundabouts featuring the model Eva Herzigova smiling down at her voluptuous Wonderbra-enhanced cleavage with the caption 'Hello Boys'. The advertisement created a sensation. Urban myth has it that traffic flow slowed and car accidents increased around the location of the billboard sites. The cause was attributed to (male) drivers being distracted by the advertisements. Afterwards, there was a call for all large billboards to be subject to planning permission.

Pop star Simon Le Bon and actress Amanda de Cadenet at the Herb Ritts (see page 410) exhibition at the Hamiltons Gallery, London. The Wonderbra rode high on the 1990s trend for visible underwear.

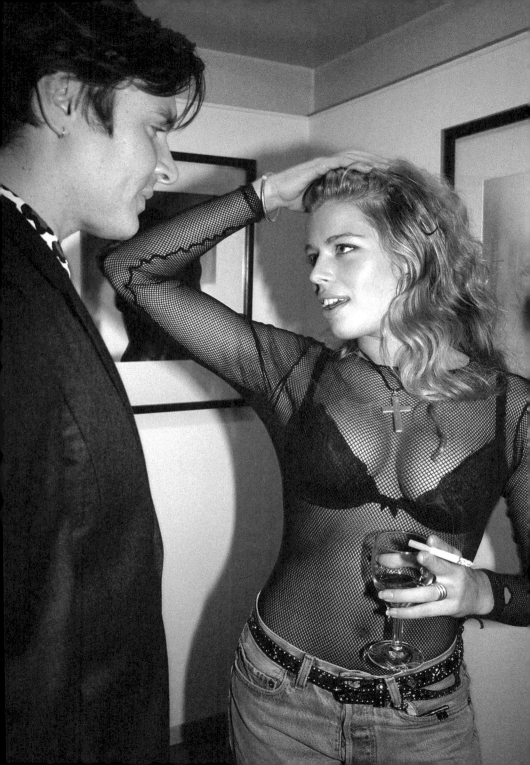

'THE RACHEL'
The hairstyle of the 1990s

In the 1990s hairdressers all over the world had to grapple with their clients' descriptions of the 'Rachel Cut'. Conversations in salons from Sidney to San Francisco opened something like this: 'So I'd like it a bit tousled, with some body, but not curly, because I'd like it smooth and sort of shoulder-length or maybe a bit shorter, with sort of layers, and I'd like it brown but with blonde highlights… Make that lowlights and a bit straight but with the ends turned under and some turned out…You know what I mean?'

What they were getting at was the bouncy layered hairstyle popularized by Jennifer Aniston in Season One of the hit American sitcom *Friends* and named after her character, Rachel Green. Rachel wore that haircut for the first two seasons of the sitcom – enough time for women all over the world to succumb to a hairdressing trend that reached epidemic proportions and which soon became known simply as 'The Rachel'.

Throughout the 20th century, female icons have been defined by their hair. There was Brigitte Bardot's beehive (see page 68), Farrah Fawcett's windswept mane (see page 276), Audrey Hepburn's chignon (see pages 52 and 122) and Twiggy's bob (see page 184). At times, it seems almost as if their personalities have become overshadowed by their iconic locks. It turns out that Aniston is a case in point. In an interview with *Allure* magazine, she admitted to hating 'The Rachel', confessing, 'I love Chris [McMillan, her hairstylist] […] but] I think it was the ugliest haircut I've ever seen.'

Jennifer Aniston sports 'The Rachel' – a haircut as redolent of the 1990s as Farrah Fawcett's flick was of the 1970s.

ALICIA SILVERSTONE IN *CLUELESS*
Teen queen in tartan

For a generation of teenagers, Alicia Silverstone (1976–) defined 1990s style. Or, rather, her fashion-fabulous character Cher Horowitz did, in the classic film of the decade *Clueless* (1995). The movie opens with our heroine going through her computer-organized wardrobe trying to find an outfit before class. And, in that moment, millions of adolescent girls wished they could be her. The plaid skirts, the berets, those sunglasses!

The movie-going public fell instantly in love with the ditzy Beverly Hills fashion victim. With the exception of Silverstone, that is. On first reading writer/director Amy Heckerling's script, the young actress was dumbfounded. 'I thought, "Who is this girl?" I had nothing in common with her at all. I thought she was a materialistic, annoying little bitch.'

Clueless is remembered for its slang ('Going postal'; 'Like, whatever!') but also for its style, which continued to ignite trends throughout the decade. The navy blazer, knitted tank top over poplin shirt and miniskirt ensemble was a classic Cher look, as was a button-down white cotton shirt, an argyle or plaid miniskirt, knee-high white socks and silver Mary Janes.

Silverstone's character won over the most cynical fashion viewer when, mugged at gunpoint in a parking lot, she protests that her dress was by the 'totally important designer…it's an Alaïa'. In the panoply of fashion muggings, it is equalled only by Carrie's brave effort to save her Manolos from a thief in the television series *Sex and the City*.

Clueless will forever be burned on the retinas of teenage girls as a blur of flamboyant tartans: reportedly, more than 50 different plaid patterns were used for the movie's wardrobe.

LAURYN HILL
Keeping it real

In the early 1990s Lauryn Hill (1975–) made her name as an actress and as the lead singer of the Fugees, whose 1995 cover version of Roberta Flack's 'Killing Me Softly' became part of the soundtrack to the decade. Then, in 1998, Hill released her solo debut album, *The Miseducation of Lauryn Hill*, and she became the first woman and hip-hop artist to win five Grammy Awards, receiving the honours for Album of the Year, Best New Artist, Best Female R&B Performance, Best R&B Song, for 'Doo Wop (That Thing)', and Best R&B Album. Her future success seemed assured.

Hill was an undoubted talent, but it was her flawless and, crucially, dark-skinned looks that attracted the most attention, along with a style that was glamorous and street, Hollywood and hip-hop, in equal measures. Her succession of Afro hairstyles drew particular comment and inspired a whole generation of young black women. In an industry where 'natural' African hair had once again become a no-no, her preference for kinky curls and cute dreadlocks was a breath of fresh air.

Hill's record company, Columbia, invested heavily in her follow-up album, but the pressure to submit to the image machine proved too much for the singer. Rightly or wrongly, Hill interpreted Columbia's actions as exploitation and, for a time, she disappeared from the industry altogether. *The Miseducation* remains her only solo studio album to date.

Lauryn Hill with the Fugees in 1995. Her Nefertiti-like beauty and savvy style were the perfect foil to the hip-hop vibe.

JIL SANDER
The new woman

The German designer Jil Sander (1943–) led the way in the minimalist fashion movement that began in the 1990s. Preferring to work in a largely monochromatic colour palette, she strove constantly to perfect construction and eradicate extraneous seaming and detailing. Popularizing the unlined, soft-shoulder jacket, she fitted in perfectly with the 1990s, a time when women sought some quiet respite from the flamboyant 1980s. 'Initially, it was the unpractical in fashion that brought me to design my own line,' she said. 'I felt that it was much more attractive to cut clothes with respect for the living, three-dimensional body rather than to cover the body with decorative ideas.'

In white shirt and black suit, Sander dressed a woman in touch with a new kind of power. The women who came of age in the 1990s were not like their sisters in the 1980s who tried to make their mark by expanding their shoulders. They were also quite different from Rei Kawakubo's women who haughtily rejected old-style femininity. Sander's women was not afraid either to wear a dress or to dress like a man, as long as she was wearing luxury fabrics. Detractors called it 'lesbian chic'.

Key instruments in Sander's success were the team she gathered around her to create the image that cemented her position as the 'Queen of Less'. The art director Marc Ascoli engineered the look of both her fashion shows and her advertising imagery, while Nick Knight was outstanding among the prestigious photographers she and Ascoli hired.

Tatjana Patitz in an advertising image shot by Nick Knight and art-directed by Marc Ascoli for Jil Sander's Spring/ Summer 1992 collection.

GRACE CODDINGTON

Power broker with a light touch

Grace Coddington (1941–), the creative director of American *Vogue*, burst into the wider public consciousness as the unexpected breakout star of *The September Issue*, the 2009 documentary about the production of the September 2007 issue of American *Vogue*. Although she had long been a towering figure in the industry, she was relatively unknown outside fashion circles. Yet she and Anna Wintour (see page 516) deserve equal credit for the cultural monolith that is American *Vogue*. As creative director, it is from her imagination that the magic and romance of the magazine spring.

After retiring from modelling in the late 1960s, Coddington took a job at British *Vogue*, an operation she remembers as far more amateurish and casual than its American counterpart. 'The solution to most problems was,' she recalls, '"Mmmm, let's have a nice cup of tea."' She quickly moved up the ranks to become photo editor before moving to New York in the 1980s, working first for Calvin Klein and then rejoining her old colleague Wintour at American *Vogue*. It was there that she created some of the iconic shoots of the 1990s, the hallmark of her work being an astonishing attention to detail. 'Everything has to be perfect,' she has said. 'You can't just fudge it…To do things right takes a lot of work…Life is tough. You have to work really hard, long hours.'

It is easy to see Coddington and Wintour as the heart and brain of American *Vogue*. Over the years they have settled into a kind of yin–yang relationship. Coddington dresses in minimalist black; Wintour wears fur and diamonds. Wintour peppers her magazine with the famous; Coddington tends to disdain Hollywood actors and their publicity entourages. They both fiercely champion the designers they love. Coddington's favourites include Marc Jacobs (see page 456), Miuccia Prada (see page 462), John Galliano (see page 496) and Helmut Lang (see page 494), all of whom rose to prominence in the 1990s.

Grace Coddington – until recently the unsung heroine of American *Vogue*.

MARIO TESTINO
The power behind the big brands

Mario Testino's big career break came in 1995, courtesy of Madonna. The singer was supposed to be taking part in an advertising campaign for Versace, with the great Richard Avedon (see page 158) as the photographer. Instead, having spotted the relative unknown in a magazine, she urged her friend Gianni Versace (see page 490) to book Mario Testino (1954–) instead. When the pictures came out, Versace decided to give the photographer a headlining credit. It was, however, while working with Carine Roitfeld, consultant to Tom Ford at Gucci (see page 486), that Testino truly went stellar.

Together, they unleashed a campaign of such sizzling sexuality that it would define the look of the end of the millennium. With his images for Gucci, Testino called time on the nihilism of 'heroin chic'. Before Roitfeld, Testino (who had moved to London from Lima in the 1970s) had been an enchanted Anglophile whose work channelled the charm and formality of Cecil Beaton and Norman Parkinson (see page 94). With Roitfeld, his style took on a new hard-edged glamour, creating glossy, seductive advertising images that would be instrumental in launching the phenomenon of the fashion label as a global superbrand.

Testino's career high point came when he was chosen by Princess Diana (see page 346) for her *Vanity Fair* photoshoot in 1997, which turned out to be her last sitting. The pictures were the most intimate ever taken of Diana, showing her at her most informal and – with prescient irony – her most vulnerable.

Mario Testino (below): The photographer's powerful visual style helped to define the new age of the global superbrand.

TOM FORD AT GUCCI

'Sexing up' luxury

Gucci (see also page 226), the apogee of Italian luxury in the 1960s and 1970s, was suffering from a blight of bad licences and dwindling into faded glory when its new creative director, Dawn Mello, snapped up the eager young designer Tom Ford (1961–) and appointed him as Gucci's women's ready-to-wear designer in 1990. The house was in such bad shape that it looked like it might go under at any time, and Ford, Mello recalls, was practically the only candidate for the job.

Ford had been an art history student at New York University and had also trained as an actor. His university career ended abruptly after a year, eclipsed by the distractions of Studio 54 (see page 302) and Andy Warhol's Factory, a lifestyle he financed with acting and modelling. He subsequently enrolled at The New School, Parsons School of Design, studying interior architecture, before finally transferring to fashion. By the end of the 1980s he was working under Marc Jacobs (see page 456), who was design director at Perry Ellis.

Dawn Mello's call from Milan was Ford's big break. In 1994, following Mello's departure, Ford was promoted to creative director. It was at this point that the years spent carousing, posing and people-watching in New York finally delivered. Ford's Gucci explored the glamorous limits of those disco years: with velvet hip-hugging jeans, skinny satin shirts and high-shine patent boots, or sinuous jersey dresses, notched-lapel jackets and over-the-knee boots. Echoes of Halston (see page 296) and Giorgio di Sant' Angelo were not lost on the house's now-burgeoning clientele, in thrall to the new sexed-up Gucci.

To elaborate on the Gucci story, Ford enlisted the help of stylist Carine Roitfeld and photographer Mario Testino (see page 484). Together, they created international advertising campaigns that reflected Gucci's new-found fashion power and which often, in their unabashed sensual appeal, courted outright controversy.

Tom Ford is credited with transforming Italian fashion house Gucci into a global superbrand, creating clothes that were at once erotically charged and sleekly sophisticated.

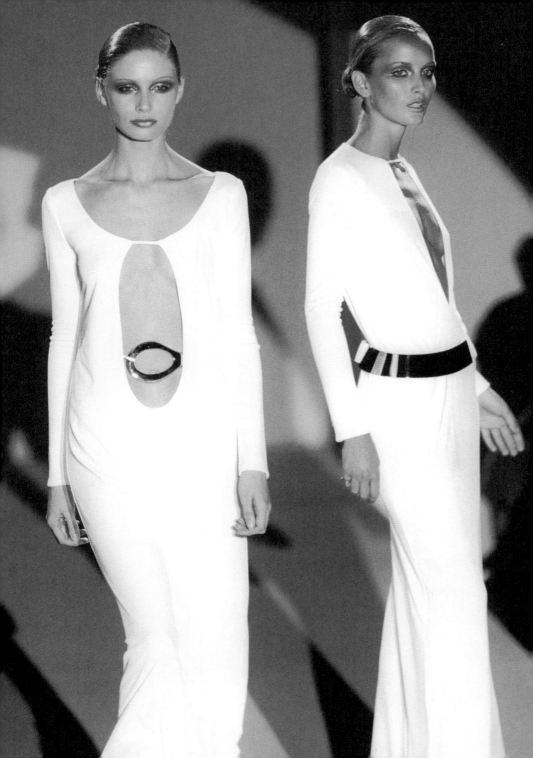

The new all-American

In the mid-1980s Tommy Hilfiger (1951–) undertook a public relations assault on the fashion firmament. He had no fashion background to speak of, but, in 1985, a huge billboard appeared in New York's Times Square alluding to Tommy Hilfiger as a great American menswear designer. Branded as fashion's great pretender at the time, he was likened by the industry to The Monkees, the prefabricated pop group of the 1960s modelled after The Beatles.

Ralph Lauren (see page 324) was Hilfiger's role model, and the newcomer followed the designer's every move. Lauren had cornered the market in the aesthetic of the patrician WASP, while Calvin Klein owned sex. Hilfiger spotted a niche for the clean-scrubbed romance of Middle America. His ads featured groups of young models at 4th of July barbecues, soccer games and downtown parades. Hilfiger simultaneously reinvented himself as a fashion celebrity. He went out on the road doing back-to-back store appearances, posing for pictures and signing autographs. His regional roadshows were the perfect opportunity to check out what the coolest kids all over the country were wearing. He came back to New York and had his team of designers make sure that they were catered to.

Hilfiger was blessed with street sense, a common touch and happy timing. With the arrival of the information age, America embraced a lifestyle outfitted in casualwear, and Hilfiger was ready to step up. He was the first to plaster his name on rugby shirts and tops, winning him a place alongside Puma, Adidas and Gucci in the rappers' wardrobes. He understood the power of rap culture, a genre that the fashion industry couldn't, or wouldn't, relate to.

Hilfiger may have started out as a Ralph copycat, but in the 1990s he was doing his own thing: a hybrid mix of preppy and street. In 1996 the Council of Fashion Designers of America voted him the best menswear designer.

Tommy Hilfiger crafted an all-American look that walked the fine line between preppy and street, cool and kitsch.

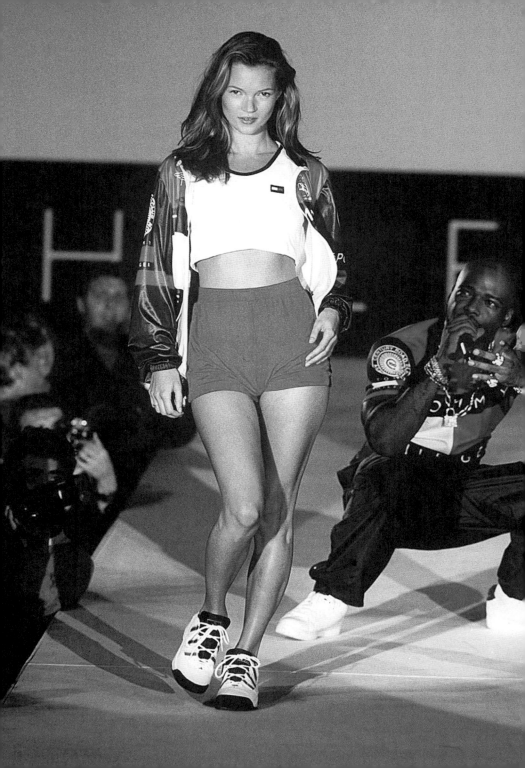

GIANNI VERSACE
The last emperor

Gianni Versace (1946–97) redefined the codes of elegance in the 1990s, though, for him, the lure of excess never lost its appeal. A Versace collection glorified the human form, enveloping it in an orgy of colour, print, embroidery and decoration. He dazzled at all times with the fearlessness of each new style statement, but he also drew huge respect for his mastery of his craft. The rich silk prints made by artisans in Como, the embroideries realized by craftsmen in Paris, and the faultless tailoring and construction that were produced by his team in Milan may not have been exactly to everyone's taste, but his clothes were always impeccably made.

Versace embraced every aspect of an industry that was undergoing rapid globalization. He quickly recognized the power of branding and put his stamp not just on clothes but on perfumes, cosmetics, watches and home furnishings. He was a media darling, his accessibility and openness rivalled only by that other great communicator Karl Lagerfeld. In addition, Versace pioneered the use of the Internet to complement the traditional media coverage of runway shows in New York, Paris, Milan and London. It was all about global communication.

Celebrity, too, was key, and Versace courted the flashiest stars – Sylvester Stallone, Tina Turner and Elizabeth Hurley (see page 464). But Versace also got in touch with people of more dubious reputation, once boasting that the rapper Tupac Shakur was wearing Versace both on the day he went into prison and on the day he was discharged. Fashion connoisseurs loved to quip that the wives of wealthy men wore Armani but their mistresses preferred Versace.

The media-savvy Versace knew how to put on a show, hiring the best photographers and legions of supermodels.

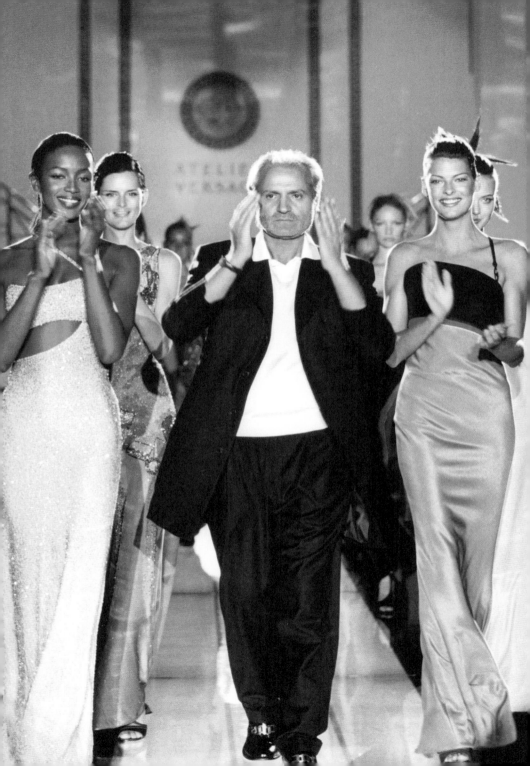

JFK, JR & CAROLYN BESSETTE

1996

The world's most beautiful couple

In 1989 Carolyn Bessette (1966–99) joined the PR department of Calvin Klein (see page 444), where she attended to the requests of journalists and helped dress the likes of socialite Blaine Trump and news presenter Diane Sawyer. It was Kelly Klein, Calvin's wife, who introduced her to the American socialite and lawyer John F Kennedy, Jr (1960–99).

Bessette was the embodiment of modern beauty. Although JFK, Jr had dated Sarah Jessica Parker, Daryl Hannah and even, briefly, Madonna, Bessette was the one of whom it was whispered, 'Jackie would have approved'. She had timeless style. She carried the Hermès Birkin bag long before Victoria Beckham amassed her million-dollar collection. Her wardrobe reflected an industry insider's appreciation of fashion: Yohji Yamamoto (see page 396), Prada (see page 462), Manolo Blahnik (see page 398), Miu Miu and, of course, Calvin Klein were the key labels. Bessette often dressed in black, the New York fashionistas' favourite colour.

She was rarely seen without bold red lipstick on her otherwise bare face, and her long blonde hair was either pulled back or worn straight. With a public aloofness that was invariably interpreted as 'mystique', Bessette had magazine and newspaper editors lining up for photoshoots and interviews.

The couple married in a secret ceremony on Cumberland Island, Georgia, in September 1996, in a tiny, wind-battered wooden church. For her wedding dress, Bessette turned to her former colleague and friend from her Calvin Klein days, Narciso Rodriguez.

The marriage of John F Kennedy, Jr and Carolyn Bessette seemed almost to be a second incarnation of the Kennedy–Bouvier relationship of the 1960s. Tragically, both husband and wife were killed in a plane accident in 1999.

HELMUT LANG

Ice-cool minimalism

The founding father of 1990s fashion minimalism was Helmut Lang (1956–). The Austrian designer was influenced not only by modernist architecture, but also by German expressionism and by Vienna, the city where, at the age of 23, he first set up his business. Lang, a business student and fashion autodidact, began by making made-to-measure clothes out of a small studio, but he soon relocated to Paris after presenting his work as part of an exhibition at the Centre Pompidou. In 1997 he would move camp once more, this time to New York City.

In his high-minded intellectualism, Lang has often been compared to Rei Kawakubo (see page 348) and Yohji Yamamoto (see page 396), though he has always been easier to wear than these innovative Japanese designers. Commercially, he enjoyed a huge success, especially in his New York phase. He rewrote the codes of not only the modern woman's wardrobe but the modern man's as well. The photographer Elfie Semotan, one of Lang's closest friends and a frequent collaborator, has said of him: 'He taught men how to look cool and elegant without looking like they had thought too much about their clothes.' Meanwhile, Lang also forged links between fashion and the art world, collaborating with artists such as Jenny Holzer and Louise Bourgeois, and frequently used art imagery in his advertising.

At the opening of a retrospective at the Bath Museum of Fashion, its curator, Rosemary Harden, wrote, 'Helmut Lang is the antithesis of the red-carpet celebrity dressing of the past 10 years…He has a very specific aesthetic, it is very pared down; there aren't frills and bows and ruffles.' Lang is, for many, the last of the great couturiers. With his chic white dresses and sleek trouser suits, Lang's meticulous designs were the perfect encapsulation of the 1990s credo of 'less is more'.

Simplicity and functionality: Helmut Lang injected fashion with a cleansing dose of Bauhaus-inspired modernism.

JOHN GALLIANO AT DIOR

Reinvigorating a fashion institution

The decade got off to a peripatetic start for London's brightest fashion star. John Galliano (1960–) had a big reputation (see page 408), matched only by the size of his overdraft. Faycal Amor, his latest backer, had cut ties, and, adrift in Paris – or so fashion legend has it – Galliano was surviving on baked beans cooked on a burner and by scrounging a bed for the night from friends.

Enter Anna Wintour (see page 516), a knight in shining Chanel and Manolos. In 1993 she introduced him to Sao Schlumberger, a socialite of fabled wealth and with a couture wardrobe to match. In 1994, in Schlumberger's empty *hôtel particulier* by the Jardin du Luxembourg in Paris, Galliano showed a capsule collection of 17 looks all made from the same bolts of black cloth, the only material he could afford. The invitation was a rusty key with a handwritten label attached. Models Kate Moss (see page 426), Linda Evangelista and Christy Turlington all walked for free as a favour to their old friend. It was a great fashion moment. Once more, the press, store buyers and fashionable women beat a path to the Galliano studio, a singularly unglamorous place in the, as yet, not quite fashionable Bastille.

The show began Galliano's upturn in fortune. In 1995 LVMH appointed him head designer at Givenchy and then, barely two years later, at Christian Dior – the ultimate prize. His couture debut collection in January 1997 in the Grand Hôtel, Paris, was theatrical yet reverent. The ballroom was transformed into a Dior salon with 800m (875yd) of the house's signature grey fabric and 4,000 roses. The first 17 outfits had names that were variations on the founder's name, such as Diorbella, Diorla…but this was no simple homage. Along with Dior signatures, such as the hound's-tooth checks and white lace, there were evening dresses in sinuous Boldini-esque silhouettes, oriental embroideries and whimsical accessories such as Masai collars. It was Dior, but reinvented.

Encore Dior... Galliano's reinvention of the Dior look teamed figure-hugging silhouettes with gorgeous orientalist *jeux d'esprit*. This transparent, topless dress from the Autumn-Winter 1997 collection took the style to its limit.

KRISTEN McMENAMY

A true fashion original

In the 1990s there was a shift away from the glamour that had so obsessed fashion in the 1980s towards a more unconventional take on beauty. Kristen McMenamy (1966–) spearheaded this developing trend, able to transform, with apparent ease, from classic *jolie laide*, to unvarnished anti-fashion icon, to head-turning beauty. This, together with her powerful personality and tenacity in pursuit of 'the perfect picture', made her one of the most fascinating fashion professionals of the decade.

McMenamy's breakthrough moment came in 1990, when she landed one of fashion's most prestigious ad campaigns working for the German designer Jil Sander (see page 480). Within a few fashion seasons, she was also the face of Prada, Moschino, Chanel, Armani and Versace. In 1992, another transformative year, she was featured, alongside Naomi Campbell and Nadja Auermann, in a fashion story shot by Steven Meisel (see page 424) for American *Vogue*. 'Grunge and Glory' was a celebration of the subculture that had become fashion's latest fixation and defined a shift in the mood of the decade. McMenamy's elevation to the pantheon of supermodels was assured.

McMenamy's startling, androgynous looks represented a shift away from the bland glamour of the 1980s towards idiosyncrasy and individualism. 'I represent the individual,' the model has said. 'I represent being happy with who you are.'

SPICE GIRLS
Girl power goes global

In the summer of 1996 the Spice Girls released their debut single 'Wannabe' in the UK, and the music journalist Paul Gorman wrote, 'Just when boys with guitars threaten to rule pop life – an all-girl pop group have arrived with enough sass to burst that rockist bubble.' The song stayed at number 1 for seven weeks, becoming the biggest-selling single by an all-female group of all time. In October 1996 they were the star turn at the British Fashion Awards.

At the heart of their success was the marketability of their image and their willingness to exploit it in an age that was increasingly media driven. The Spice Girls became icons of 1990s fashion, too. Victoria Adams – or 'Posh Spice', as she was dubbed – was known for her choppy brunette bob hairstyle and love of designer labels. Geri Halliwell – called Ginger Spice because of her 'liveliness, zest, and flaming red hair' – became notorious for her outrageous stage outfits. Her Union Jack dress was one of the most copied frocks of the decade.

Girl power took the world by storm. A ridiculously successful second album, *Spiceworld* (1997), continued the momentum, and by the time of the release of the single 'Spice up Your Life' there was barely a billboard or television screen on the planet that did not have their faces on it: a phenomenon they themselves parodied in the song's video, which shows the band flying around in a spaceship in a 'universe' of advertisements featuring their faces. The fashion industry was alert to the burgeoning trend and soon the high street was awash with platform shoes, minidresses and leopard prints.

From left to right: Posh, Baby, Scary, Ginger and Sporty. While they may not have embodied everything about the 1990s woman, the Spice Girls didn't just take part in 1990s culture, they *made* it. Worldwide, the phrase 'girl power' became a byword for the growing confidence of young women everywhere.

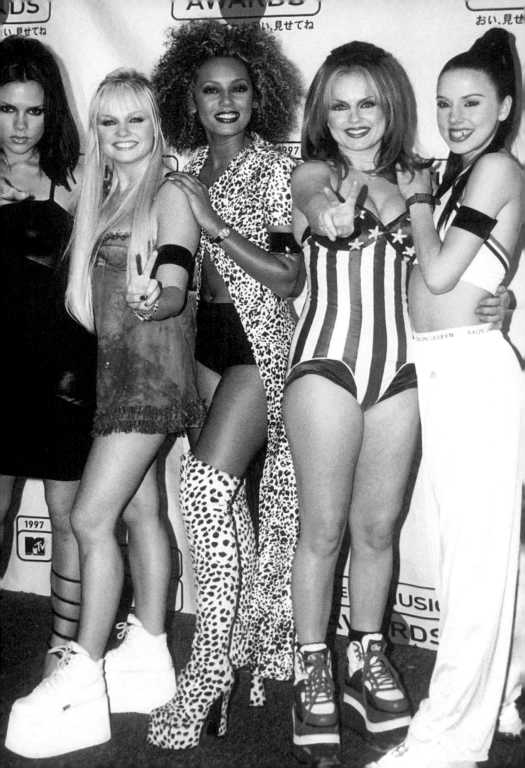

COOL BRITANNIA

British style blooms again

'Cool Britannia' was the moniker given to the surge of national pride in UK culture that secured enormous global influence for the country in the late 1990s. Tony Blair's Labour government came to power in 1997 on a platform of modernization, with its election theme song urging the electorate to believe that 'Things can only get better'.

Since 1994, Britain's National Lottery had been pumping capital into the arts. The Young British Artists had made London a hot spot for art and design: some London art dealers and collectors, such as Jay Jopling and Charles Saatchi, were more famous than their artists, and most artists were more famous than their art. The launch of magazines such as *Loaded* and *Dazed & Confused* at home, and the eminence of British ex-pats such as Anna Wintour (see page 516) and Liz Tilberis (see page 442) in New York had made London, once again, the focus of the global cool-hunters' attention. There was a resurgence of a distinctive British sound from bands such as Oasis, Blur and Suede. The Spice Girls (see page 500) were the most successful all-female pop group ever.

In the fashion world, Central Saint Martins College of Arts and Design was the globally acknowledged centre of excellence. London Fashion Week was surfing a wave of new talent, and in those heady days even the lofty Paris fashion houses were not immune to the pull of British talent. The luxury conglomerate LVMH installed Saint Martins graduates John Galliano (see pages 408 and 496) and Alexander McQueen (see page 510) at the couture houses of Christian Dior (see page 24) and Givenchy (see page 54), respectively. Ralph Lauren (see page 324), Louis Vuitton, Gucci (see page 226), Calvin Klein (see page 444), Donna Karan (see page 318) and Tommy Hilfiger (see page 488) all grappled for flagship stores on London's Bond Street.

Unfortunately, Cool Britannia was to suffer a near-fatal chill when, in 1998, *The Economist* was among several august publications to note that 'many people are already sick of the phrase'. By 2000 the fickle world of fashion had moved on and the moniker was being used mainly in a mocking or ironic way.

Meg Matthews and Noel Gallagher pose outside 10 Downing Street during Prime Minister Tony Blair's famous 'Cool Britannia' party. It could be argued that the UK pop 'renaissance' of the 1990s was at least in part a media creation.

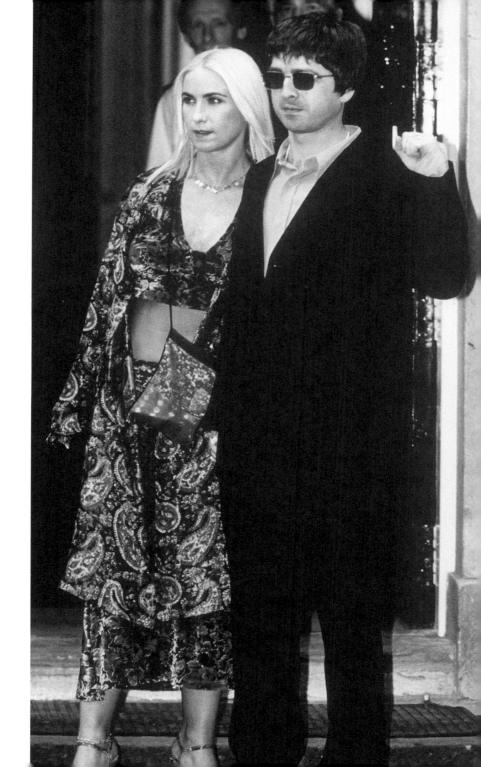

BRITISH MILLINERY

Getting ahead in hats

The 1980s and 1990s saw the meteoric rise of British millinery. In the space between the era when no polite lady would have dared leave the house bareheaded, through the 1970s, when a hat was anathema to the jeans-wearing population, hats struggled on the sidelines of mainstream style. The peacock parade that was street fashion in the 1980s changed everything. By the end of the 1990s Britain led the field in fashion millinery, and the two men behind its resurgence were Stephen Jones (1957–) and Philip Treacy (1967–).

Jones first made a name for himself with the hats he created for Boy George (see page 384), when both were habitués of London's Blitz Club. Jones went on to work with Jean Paul Gaultier (see page 356) and Vivienne Westwood (see pages 298 and 330) – he created her iconic Harris Tweed Crown of 1987 – and since 1993 he has been part of the team that works with John Galliano (see page 408).

Treacy graduated from the Royal College of Art in 1990 and, having come under the wing of Isabella Blow (see page 514), set up a workshop in the basement of her house in Belgravia. Treacy's career has never known anything but top gear, starting as it did with collaborations with Karl Lagerfeld at Chanel (see page 388), Versace (see page 490), Valentino (see page 194) and Ralph Lauren (see page 324). In 2000 he became the first milliner to have his own couture show during Paris Fashion Week.

While hats have always been the default option for designers in need of a show-stopping statement, the British milliners' greatest achievement lies in the fact that they reintroduced hats to the wardrobes of ordinary women. It is debatable whether, even with their unique talents, either Jones or Treacy could have flourished anywhere else but in London. Their work has always been the perfect complement to the national nonconformist style. As Jones has said, 'The hat is a certain British thing that people do love wearing.'

Above: The star British milliner Philip Treacy prepares the singer Grace Jones (see page 320) for a fashion shoot. Below: A shot from the Treacy-Jones shoot. By the 1990s, hats had regained their starring role in fashion, adding a final flourish of drama and spectacle.

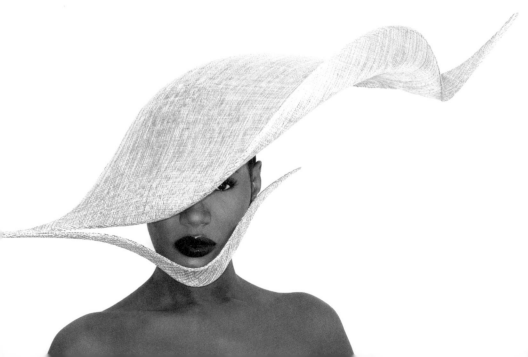

THE ANTWERP SIX

A new world view

After the Japanese, the next wave of newcomers to completely change the fashion landscape came from Belgium. They first alighted in London in 1986, choosing to show as part of London Fashion Week as the 'Antwerp Six'. Fellow graduates from the Academy of Fine Arts in Antwerp, they had all established businesses at home but were struggling for international recognition. Propelled by Belgian government grants, Dries Van Noten (1958–), Ann Demeulemeester (1959–), Dirk Bikkembergs (1959–), Walter Van Beirendonck (1957–), Dirk Van Saene (1959–) and Marina Yee (1958–) set out to conquer Europe.

By the early 1990s they had all moved to Paris and were among the hottest tickets on the Chambre Syndicale's schedule. They fascinated with their innovative take on luxury, distinguished by its powerful combination of austerity, utility and perfectionism. Their vision took Japanese deconstruction to its next natural step, breaking down the traditional elements of a garment and creating new silhouettes. 'We were ready to change the world,' remembers Ann Demeulemeester. 'People no longer chose clothes as a disguise. They chose them to express something. That's the whole difference between the 1980s and the 1990s. They no longer used clothes to impress other people – they used them to feel good about themselves.'

The original Antwerp Six would be joined over the course of the decade by Haider Ackermann, Veronique Branquinho, Raf Simons and Olivier Theyskens. They showed they were adept at developing their own labels and making them commercial without compromising their creative dynamic. 'I already thought there were too many clothes in the world and I shouldn't add to them,' said Demeulemeester. 'I could only add something that hadn't already been made.'

Dries Van Noten's cool, deconstructed elegance: ready-to-wear, Spring/ Summer 1998, Paris. The group of Belgian designers managed to marry intellectual ambition with marketability.

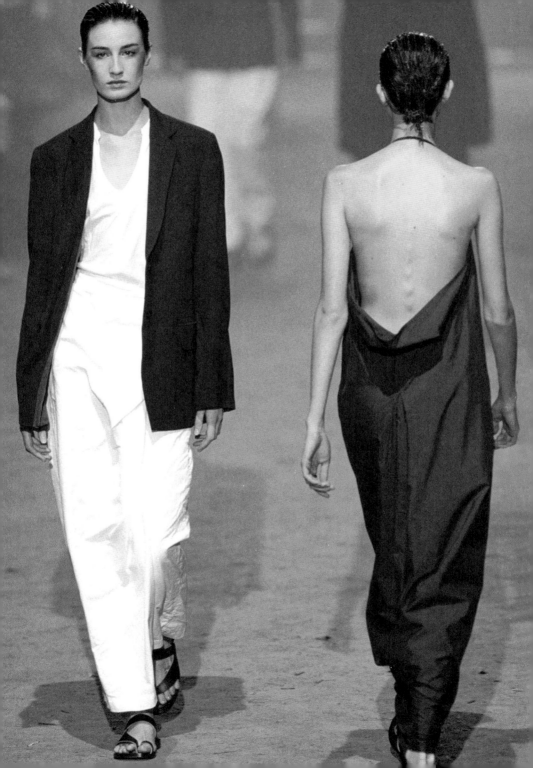

HUSSEIN CHALAYAN

Fashion as conceptual art

The only child of Turkish Cypriot parents, Hussein Chalayan (1970–) was born in Nicosia, Cyprus, and lived between the island and London. 'As a child, I would go from Cyprus, a more desolate place, a culture which has seen two wars, to London where, suddenly, there was everything, and then back again,' he has said. 'That allowed me to process any information, to contemplate things and develop any ideas in between.'

When Chalayan graduated from Central Saint Martins College of Arts and Design in 1993, global attention was on London's creative scene, though not yet on its fashion. It was Brit Pop and Brit Art that were on the rise. He and Alexander McQueen (see page 510), who had graduated from Central Saint Martins the year before, had to battle for recognition. With hindsight, both men had one important thing in common: the desire to create a universe beyond the conventions of the catwalk.

One piece from Chalayan's graduate collection sums up the aesthetic of this most conceptual of all fashion designers – a simple dress that he had sprinkled with iron filings and buried in a friend's back garden, leaving it to moulder into its elegantly decayed final state. In the context of the conventional 'sketch, cut, sew and show' of the fashion industry, his unique creative processes explain his status as one of commercial fashion's most intriguing outsiders. Part-organic, part-technical, part-scientific, part-archaeological, Chalayan's way of working not only defines him, it also sets him apart.

Chalayan's compelling originality makes him fashion's most authentic postmodernist. His approach, constantly re-examining accepted techniques and forms, is often political in nature and inspired by diverse subjects such as science, sculpture, technology and architecture. His designs are simple, organic and highly technical – a paradox evident, for example, in the fibreglass dress that mimicked the mechanics of an aeroplane's wings or the famous table skirt of the 'Afterwords' collection (2000).

In this dress incorporating a chair, from the 'Geotropics' collection, Spring/Summer 1999, Hussein Chalayan evokes one of his enduring themes – the condition of the immigrant in perpetual transit between cultures and nations.

ALEXANDER McQUEEN

British fashion genius

In 1992 Lee Alexander McQueen (1969–2010) graduated from London's Central Saint Martins College of Arts and Design with a collection provocatively entitled 'Jack the Ripper Stalks His Victims'. From the outset, McQueen was a designer with a singular and consistent point of view, laying down the signature ingredients that would persist throughout his career: notably his fascination with the Victorian Gothic, his passion for narrative and his penchant for the tailored silhouette.

In the audience of his graduate show was stylist Isabella Blow (see page 514) who, legend has it, bought every piece he had and adopted him as her protégé. In the four years that followed his graduation, McQueen gathered the team who would remain his trusted circle until his suicide in 2010. In 1994 Katy England became his creative director; in 1996 Sarah Burton headed up his design team; and that same year Sam Gainsbury joined the group as show producer.

In those days, Gainsbury was lucky to have £600 to foot the bill – their last project together ran to a budget of six figures. Regardless of budget, however, McQueen shows were produced on a lavish, theatrical scale, courting both wonder and shock in equal measure. In 1998 double-amputee model Aimee Mullins took centre stage, striding down the catwalk on intricately carved wooden legs. Later that year Shalom Harlow closed a show in a strapless white dress, rotating slowly on a platform in a hypnotic dance as two giant robotic arms sprayed her with paint.

In 1996, after only eight seasons showing his own label, McQueen joined Givenchy, replacing John Galliano (see pages 408 and 496). It was always an awkward relationship and he stayed with the French fashion house for barely five years, when the contract that he said was 'constraining his creativity' came to an end. From there, he went into partnership with the Gucci Group – a move that enabled his fashion house to develop into a global brand.

The McQueen at Givenchy Autumn/Winter 1999/2000 show, 'The Overlook', was inspired by Stanley Kubrick's movie masterpiece *The Shining* (1980). The catwalk became a Narnia-like world of falling snow and barren trees, through which the models ice-skated in luxurious furs, full-length coats and elaborate swan-like dresses.

GWYNETH PALTROW
Redefining the glacial blonde

After both starring in *Se7en* (1995), Gwyneth Paltrow (1972–) and Brad Pitt became the most beautiful couple in Hollywood. It was inconceivable that, thereafter, she would go unnoticed. Add some award-worthy screen performances – *Emma* (1996), *Sliding Doors* (1998) and *A Perfect Murder* (1998) – and Paltrow established her very own legions of dedicated fans, hooked on her talent and style. The pinnacle of her decade was the Academy Award she won for Best Actress for her performance in *Shakespeare in Love* (1998).

To accept the award, Paltrow wore a pink Ralph Lauren gown. This split the critics. *Vogue* may have gushed about 'Ralph Lauren's melting pink paper taffeta prom gown with Harry Winston diamonds', but even Blythe Danner, the star's own mother, admitted that, 'it didn't fit very well'. Nonetheless, Paltrow still managed to set off a trend for pink – a flotilla of cotton-candy princess dresses was launched in its wake.

Paltrow is not a fashion leader, as she herself admits. One of her greatest fashion influences, she once confessed to *Vogue*, was the uniform of her smart school on New York's Upper East Side: 'You have to wear this very posh, clean outfit every day – your white shirt and little grey kilt, and put it with black eyeliner or whatever. It's a great look.' Despite this, designers enthusiastically embraced her. Her all-American style was a perfect canvas – whether for Ralph Lauren's clean-cut, upper-crust clothes or for Calvin Klein's vision of minimalist perfection.

With her lean frame and blonde hair, it was almost inevitable that comparisons would be made with Grace Kelly, particularly after Paltrow's role in *A Perfect Murder*, the remake of the Hitchcock vehicle for Kelly, *Dial M for Murder* (1954). Her patrician presence in *The Talented Mr. Ripley* (1999) secured her position as Kelly's heir in the style stakes. Gwyneth Paltrow herself has never admitted to having pretensions to the crown, summing up the style that rivets millions of magazine readers as simply 'preppy'.

Paltrow at the 1999 Academy Awards. Her acceptance speech was as famous for her tears as for her Ralph Lauren cotton-candy-pink gown.

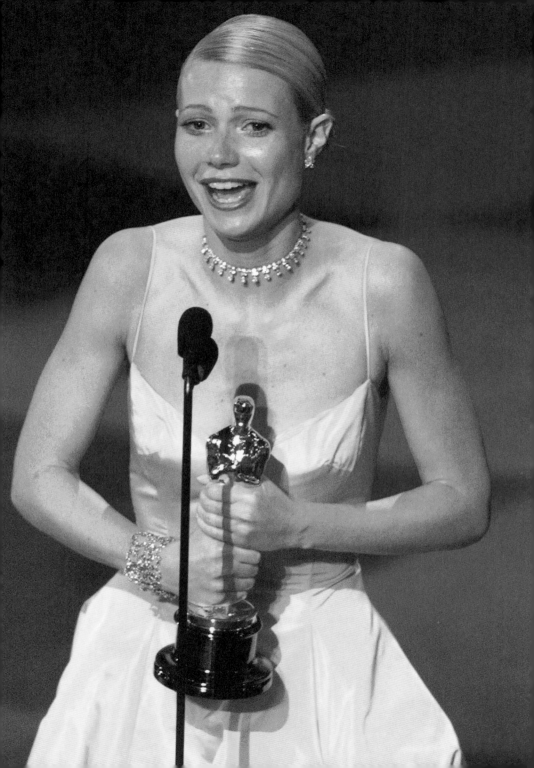

ISABELLA BLOW

Irrepressible style seeker

Isabella Blow (1958–2007) played the most ill-defined and under-appreciated role in the realm of fashion creation – that of a muse. Her extraordinary wardrobe fascinated fashion fans worldwide. She was photographed wherever she went, courted by street photographers and fashion superstars alike. To many, she epitomized the English eccentric. She earned a living as a fashion editor (*Tatler*, *The Sunday Times*) and as creative consultant to commercial companies, such as Swarovski, which had budgets that were able to stretch to her expenses.

Most of all, however, Blow was a discoverer and nurturer of raw fashion talent. She assembled a family of fashion foundlings around her, all of whom were singularly talented. Many of them got their first big break thanks to her, and some are indebted to her for their entire careers. Among them are the milliner Philip Treacy (see page 504) and the designer Alexander McQueen (see page 510). She worked with Julien Macdonald and Hussein Chalayan (see page 508). She was also a formative force in the fledgling careers of photographers such as Juergen Teller, Alastair Thain and Sean Ellis, and models including Sophie Dahl, Stella Tennant and Honor Fraser.

Blow's provocative image both buttressed and concealed a fragile personality. She once admitted that 'if I am feeling really low, I go and see Philip [Treacy], cover my face and feel fantastic'. In his biography, Blow's husband of 18 years, Detmar, wrote about how clothes were both 'armour' and 'a distraction for a woman fighting with inner demons'. Few outsiders knew how severe was Blow's depression – she committed suicide in 2007 at the age of 48.

Both armour and distraction: Isabella Blow's inimitable fashion sense attracted curiosity, wonder and the occasional sneer.

ANNA WINTOUR
Fashion's unflappable queen

In 1988, in a bid to revitalize its ailing flagship title, the Condé Nast bosses lured Anna Wintour (1949–) to New York to be editor of American *Vogue*. The 'Anna-effect' was immediate. She marked out her territory in no uncertain terms with her first cover. Out went the toothsome close-up shots taken in an artificially lit studio and in came the relaxed but glamorous lifestyle 'scenes'. The November 1988 issue featured the 19-year-old Israeli model Michaela Bercu strolling down a New York street, with beach hair, a big smile, a pair of distressed Guess jeans and a jewelled Christian Lacroix couture jacket.

Wintour established herself as a risk taker, with limited patience for the customary ways of doing things, a keen sense of the commercial, an instinct for the zeitgeist and a feeling for fashion that influenced the way millions of women dressed. She proved herself a proactive supporter of designers, too, supporting fledgling talents such as Marc Jacobs (see page 456) as enthusiastically as she endorsed established titans such as Karl Lagerfeld (see pages 258 and 388), Oscar de la Renta and Gianni Versace (see page 490). Under Wintour's watch, photographers, makeup artists, models and hairstylists all got credits on the fashion pages.

Her friends say it is her shyness that is behind her reputation for being haughty and aloof, although her 'Nuclear Wintour' nickname has become as emblematic as her bob and sunglasses. In the 1990s her style was still in its early evolutionary stages. Back then, though with an unmistakable leaning towards the glamorous, she had a strong sporty streak that favoured fur-trimmed parkas, T-shirts and even, on occasion, jeans. Rarely seen with a handbag (even then), there was more of a ready smile and less of the enigmatic smoulder.

A classic Wintour look, with the bob and sunglasses providing a trademark that adds to the glamour.

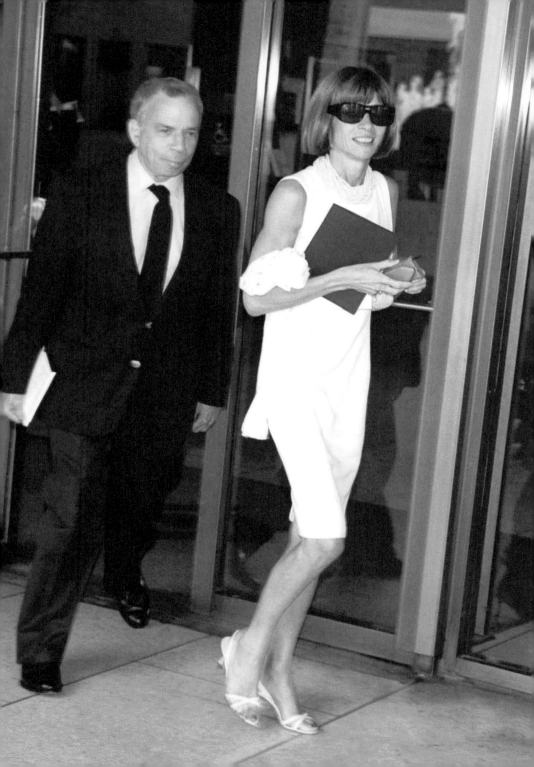

INDEX

Figures in **bold** indicate pictures.